Isa Hoepfner

Finnish Architecture and the Modernist Tradition

To the memory of two friends in search of modern Finnish architecture,

 Reima Pietilä and Aarno Ruusuvuori

Finnish Architecture and the Modernist Tradition

Malcolm Quantrill

E & FN SPON
An Imprint of Chapman & Hall

London · Glasgow · Weinheim · New York · Tokyo · Melbourne · Madras

Published by E & FN Spon,
an imprint of Chapman & Hall,
2-6 Boundary Row, London SE1 8HN, UK

Chapman & Hall,
2–6 Boundary Row, London SEI 8HN, UK

Blackie Academic & Professional,
Wester Cleddens Road, Bishopbriggs,
Glasgow G64 2NZ, UK

Chapman & Hall GmbH,
Pappelallee 3, 69469 Weinheim, Germany

Chapman & Hall USA,
115 Fifth Avenue, New York, NY 10003, USA

Chapman & Hall Japan,
ITP-Japan, Kyowa Building, 3F, 2-2-1 Hirakawacho,
Chiyoda-ku, Tokyo 102, Japan

Chapman & Hall Australia,
Thomas Nelson Australia, 102 Dodds Street,
South Melbourne, Victoria 3205, Australia

Chapman & Hall India,
R. Seshadri, 32 Second Main Road, CIT East,
Madras 600 035, India

First edition 1995

© 1995 Malcolm Quantrill

Cover illustrations
Front: Mount Angel Benedictine College Library,
Oregon, USA
Photograph: Malcolm Quantrill
Back: Marisauna, Bökars, Finland
Photograph: Aarno Ruusuvuori

Typeset in Plantin by Dual Developments Ltd, London
Printed in Hong Kong by Dah Hua Press Co. Ltd

ISBN 0 419 19520 3

A catalogue record for this book is available from the
British Library

Library of Congress Catalog Card Number: 94-74710

Apart from any fair dealing for the purposes of research or private study, or criticism or review, as permitted under the UK Copyright Designs and Patents Act, 1988, this publication may not be reproduced, stored, or transmitted, in any form or by any means, without the prior permission in writing of the publishers, or in the case of reprographic reproduction only in accordance with the terms of the licences issued by the Copyright Licensing Agency in the UK, or in accordance with the terms of licences issued by the appropriate Reproduction Rights Organization outside the UK. Enquiries concerning reproduction outside the terms stated here should be sent to the publishers at the London address printed on this page.
The publisher makes no representation, express or implied, with regard to the accuracy of the information contained in this book and cannot accept any legal responsibility or liability for any errors or omissions that may be made.

Contents

Foreword by Kenneth Frampton *vi*

Preface *ix*

1 Background and evolution *1*

2 The classicism of the 1920s *29*

3 Encounters with functionalism: 1927 to 1939 *57*

4 The years of conflict and reconstruction *87*

5 A second Finnish renaissance *105*

6 The 1960s: standardization *versus* architectural standards *135*

7 Reima Pietilä: form follows approach *161*

8 After Aalto: form and formalism in the 1970s and 1980s *181*

9 Fin de siècle *221*

Selected bibliography *232*

Acknowledgements *234*

Illustration acknowledgements *237*

Index *238*

Foreword

With this text an *aficionado* of Finnish architecture rises to the occasion with a study that not only re-situates the work of a number of lesser known architects within the Finnish modern movement, but also analyses in depth the specific character of their individual contributions. The principal heuristic device has been to establish the figure of Alvar Aalto against the general ground of Finnish practice, with the aim of illuminating both figure and ground; first one and then the other, in a kind of alternating critical dialectic. Ploughing through some 90 years of the Finnish journal *Arkitekten*, not to mention an equally daunting quantity of additional archival material, Quantrill succeeds not only in rescuing a considerable number of distinguished names from the oblivion of history, but also in articulating the vicissitudes of Aalto's own sensibility as it tacked back and forth across the first half of the twentieth century.

In many ways this book is a re-reading of an extremely complex map or, even more to the point, it is the meticulous construction of a new optic from which to review a familiar trajectory. As such, it depends on a number of *aperçus* that serve as catalysts in this subtle reworking of the received accounts of the Finnish modern movement. Above all, the reader is initially reminded that the young Aalto entered the cultural lists after the First World War, when the sovereignty of the country had already been assured and the dynamism of the national romantic movement had played itself out. Establishing this cultural datum enables the author to re-read the history of twentieth-century Finnish practice in the light of the purifying *episteme* of Nordic classicism. In contrast to the leading scholars of the 1950s and 1970s, who, subject to the ideology of functionalism, elected to expunge this 'reactionary' episode from the record, Quantrill, while acknowledging his debt to Simo Paavilainen and Juhani Pallasmaa, stresses the advent of Nordic classicism as a critical device with which to reveal the aporias of time.

While this is no longer an unprecedented point of departure it none the less affords a fresh vantage point from which to view the entire development. Above all it allows one to acknowledge the latent classicism of Aalto's own design method, even if the architect was as much given to the 'excavation' of his mass-forms as to their agglutination, notwithstanding the axiality that in his case invariably underlies both procedures.

More generally, this latent classicizing sensibility exerted an influence that surpassed the mere presence or absence of symmetry as may be sensed in the post-Jugendstijl, Biedermeier line of Paul Mebes and Heinrich Tessenow, particularly as this was reflected around 1920 in the perceptual delicacy of Carl Petersen's discourse to the Danish academy that would prove universally applicable to any building, irrespective of whether its morphology was classic or romantic. Petersen's astylistic disquisition on the way in which fenestration, material contrast and surface homogeneity contribute to the scale, articulation and unity of form seems to have been anticipated by Eliel Saarinen's Villa Winter, projected in 1907, wherein as Quantrill remarks 'the roof tiling dissolves the walls from above' just as the topography encroaches on the earthwork from below. As it happens, these were the two unifying strategies that Aalto habitually adopted in the neo-national romantic phase of his career after the Second World War.

The years 1920–23 would prove to be crucial for Finnish architecture, since these were the years in which Finnish functionalism acquired its neoclassical underpinning: a paradoxical procedure that is perhaps most evident in the long trajectory of development that extends, say, from Erik Bryggman's Hotel Hospits Betel, dating from 1926, to Viljo Revell's prefabricated Kaskenkaatajantie housing, realized in Helsinki in 1958.

The early 1920s were crucial because, as with the seminal Karelian studies of Yrjö Blomstedt and Victor Sucksdorff made some 30 years earlier, these were the years during which Bryggman and Hilding Ekelund visited first Sweden and then Italy in order to discover the true nature of the classical at its source. Something of their influence in this regard may be judged from the fact that it was their travel sketches and notes published in a special issue of

Arkitekten–Arkkitehti in 1923, under the title 'Italia la Bella', that prompted Aalto to spend his honeymoon in Italy the following year.

The year 1923 was the *annus mirabilis* in more ways than one, with one momentous event following another, from the competition of Ragnar Östberg's Stockholm Town Hall, as the swan song of Scandinavian national romanticism, to the definitive departure of Saarinen for the United States; from the opening of Aalto's own office in Jyväskylä to the atectonic classicism of Jukka Siren's design for the Finnish Parliament and, in contrast to this, the realization of the Helsinki suburb of Käpylä to the designs of Martti Välikangas. This idyllic work realized overnight Ekelund's ideal of an *architettura minore* by assuming the native timber vernacular and enriching it with atectonic tropes drawn from Gunnar Asplund's Villa Snellman of 1918. Oiva Kallio's Villa Oivala at Villinki of the following year is evidently a straw that points in the same direction, as one may judge from Aalto's Villa Väinölä of 1926. Kallio's essay in minor architecture was a quintessentially transitional work for, as the author notes: 'although the plan of this summerhouse is ostensibly classical and symmetrical, it has been freely adapted for its function, which is one of informality... Poised between the classical and the rustic, between architecture and nature, it also occupies a position (both historically and conceptually) between Eliel Saarinen and Alvar Aalto.'

Aside from precisely indicating the limited, but definable rescuing of Bryggman's reputation as an architect from the subsequent extent of his influence on Aalto's entry into functionalism, the critical thrust of this study continually returns to the proposition that the Finnish modern movement embodied a constant oscillation between two poles, that is to say between the organic on the one hand and the academic on the other. And although the author implies that Aalto was able to reconcile these countervailing impulses in his own work in the subtlest way imaginable, he goes on to note that, in the 1950s, the full ramifications of this ideological conflict could be found in the work of two distinctly different personalities, Reima Pietilä and Aulis Blomstedt. In retrospect, one may see this self-same opposition running across the entire period from the heyday of a national romanticism that bordered on caprice and displayed little regard for the niceties of the medieval past to which it ostensibly referred, to the perennial precision and academic rigour of the Helsinki Polytechnic. In his opening chapter, Quantrill sets the stage for his never-ending debate in a highly proactive way: 'Interestingly, when Aalto was at the height of his powers in the 1950s and early 1960s, the academic emphasis was once again swinging back to a formalist position under the leadership of Professor Aulis Blomstedt. After Aalto's death in 1976, Reima Pietilä continued the tradition of organic experimentation, but Pietilä's work and philosophy have been vehemently opposed by the students of Blomstedt and those influenced by his teachings.'

Along with Aalto's Muuratsalo Summerhouse of 1953, the 'minor' Finnish tradition culture came closest to reconciling this rift in the first half of the 1950s, as is evident, say, from Bryggman's Villa Nuutila or Aarne Ervi's Villa Ervi, or in the cluster of apartments that Ervi realized on Myllytie, Helsinki, a decade later and, on a larger scale, perhaps in Yrjö Lindegren's Snake House flats and Viljo Revell's Karjensivu terrace housing (of 1950 and 1955 respectively).

As the author indicates, this debate became implicated in the 1950s and 1960s with the priorities of the welfare state and with the need to adopt some form of modular standardized construction in order to effect the necessary economies and respond in the fullest way possible to the egalitarian demands of the time. Revell clearly played a larger part in this development than any of his colleagues, although the housing achieved by Kaija and Heikki Siren in Otaniemi clearly points in a similar direction. We need only compare the extremely economical units of Revell's Kaskenkaatajantie housing to the absolutely seminal, but ultimately more extravagant, 'patio' apartments projected in 1958 for Aalto's Hanaviertel block, Bremen, in order to understand once and for all the broader social implications of

the so-called academic versus organic conflict. However, we cannot simply conclude in retrospect that Revell was right and Aalto was wrong, although clearly the former was on the side of angels when it came to any kind of cost–benefit analysis.

The truth of history, as Manfredo Tafuri never tired of reminding us, is not as neat as the schemata we inevitably impose on it in order to write it at all. This aporia is surely at its most deceptive when we look back at the careers of Pietilä and Revell, for while they ostensibly stand on opposite sides of the 'organic/academic' fence, it is clear that Pietilä began in a totally modular vein, with his Brussels World's Fair Pavilion of 1958, while Revell, for his part, enters all too fully into organic expressionism with his brilliant, but none the less irrational and retrograde design for the Toronto City Hall (1958–66). This building, like Jørn Utzon's Sydney Opera House, achieved (after the Eiffel Tower) a compelling civic identity and image at the price of becoming dysfunctional.

Along these paradoxical lines, we may draw similar comparisons between the organicism of Timo Penttilä's Helsinki Municipal Theatre (1967) and Aarno Ruusuvuori's all but high-tech Weilin and Göös Printing Works, realized in the previous year at Tapiola, although clearly Ruusuvuori was not beyond indulging in excessive structural expressionism, as we may judge from his Hyvinkaa Church of 1961. Be that as it may, Ruusuvuori, like Revell and his younger associates Kristian Gullichsen and Juhanni Pallasmaa, were at their best in the late 1960s in their attempts at elegant prefabricated modular housing in wood, as we find this in Ruusuvuori's prototypes realized at Bökars for Marimekko or in the so-called Moduli single-storey prefabricated timber house designed and built by Gullichsen and Pallasmaa.

That Pietilä was a kind of genius *manqué* remained a common view of his career, however unjust. All in all, it must have been difficult for Pietilä to look back on the unsurpassable organic brilliance of Aalto's Vuoksenniska Church of 1959 as the *non plus ultra* of everything that he would attempt to do in his Dipoli Student Centre at Otaniemi of 1966 or in the church project for Malmi of the following year. In one way or another, Pietilä could never escape his nemesis and, with the exception of his New Delhi embassy and the Finnish President's residence of 1985, he fell into one digression after another.

What Pietilä was looking for seems to have lain elsewhere, namely in the legacy of neoplasticism that the Finns have been able to develop over the past 20 years into a free structuralist manner that, while it ultimately repudiates Van Doesburg's original principles, has proven remarkably applicable to a wide range if building types. Over the past two decades this syndrome has cropped up productively throughout Finnish practice, from Juha Leiviskä's trail-blazing St Thomas's Church, Oulu, of 1975 to Erkki Kairamo's Westend Espoo housing of 1982, and even to Helin and Siitonen's Torpparinmäki housing of the same date or their brilliant Sibelius Quarter building at Borås in Sweden a decade later. The best of this work seems to me to turn on an all but unthinkable synthesis between the fugal syntax developed by Van Doesburg and Van Esteren in 1923 and the fragmented, aleatory planning approach variously pursued over the first half of the century by Aalto, and by Bryggman and Ervi at their very best. This much is confirmed most strikingly perhaps by Leiviskä's secular work, but it is equally present in the brilliant output of Kari Järvinen and Timo Airas throughout the 1980s and there are in fact several other Finnish practices of which something similar could be claimed.

Aside from the indisputable critical acumen of the author, the great virtue of this book resides in the way in which it testifies to the workings of a great modern architectural culture that in a collective sense has never been equalled by any other country in the course of this century. Here in Finland, one fully encounters that late twentieth-century paradox that while the 'new is no loner new' in the avant-gardist sense, it simultaneously enters into the process of renewing itself, not in terms of the extrinsic stellar image, but by virtue of the precise way in which the built domain comes to be realized.

Kenneth Frampton
Ware Professor of Architecture
Columbia University, USA

Preface

In this study of Finnish architecture in the twentieth century, I have attempted a more-or-less blow-by-blow account of how modernism came into being in Finland and how it made its mark on Finnish culture and life. Nevertheless, it is not a completely straightforward narrative, and a note of explanation might therefore be appropriate.

This book was conceived as the third part of a series on modern Finnish architecture, the first two being: *Alvar Aalto: A critical study* (1983) and *Reima Pietilä: Architecture, context and modernism* (1985). In essence, the present volume was seen as providing the overall landscape of modern Finnish architecture against which the work of Aalto and Pietilä could be read. It is extraordinary, but no general comprehensive history of twentieth-century Finnish architecture yet exists. There was a great deal of interest in Finnish architecture of the 1950s and 1960s, and again in the 1970s and 1980s, but although there are passing references to Aalto's work of the 1930s, important architects of the inter-war periods such as Pauli Blomstedt and Erik Bryggman are seldom mentioned outside their own country. Perhaps because I am a child of the 1930s, I have always felt close to this relatively unknown work. Certainly, since I began work on this study almost a decade ago I have felt an increasing proximity to these extraordinary pioneers of modernism. The social history of Finnish modernism has yet to be written. Here I have concentrated on the tensions and conflicts in society that have generated or reflected the works catalogued and discussed. Naturally, not every architect in a period, nor all the buildings produced in a decade are mentioned here. I do not intend a catalogue at all in that sense, but rather listings and descriptions that impart an ethos, the flavour of a particular point in time: what Reima Pietilä called 'the basic smell of architecture'. So I have emphasized the beginnings, in the early years of the century, through the 1920s and 1930s up to the Second World War. With a few notable exceptions, the 1940s – what I have called 'the years of conflict and reconstruction' – were thin years for obvious reasons, with rather minimal evidence of

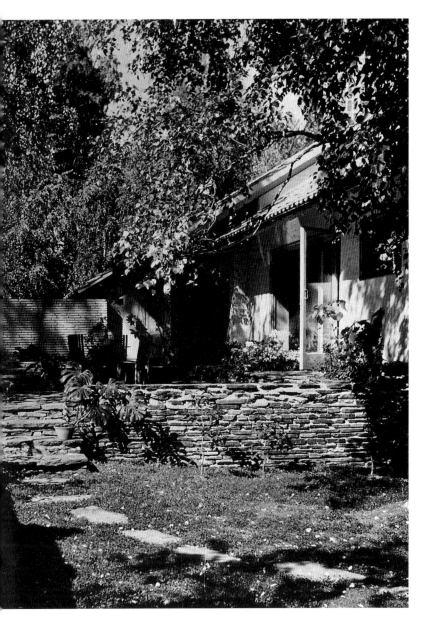

Aarne Ervi Villa Ervi, Kuusisaari, Helsinki (1950).

architectural activity. Similarly, although it is more difficult to assess and comment upon recent work – the architecture since 1980 say – I have given emphasis to this by way of illustration so that interest in this very varied and stimulating new production may be generated.

Furthermore, I make no apology for the fact that I have devoted an entire chapter to the consideration of Reima Pietilä's work. My reasons are straightforward: my own books on Pietilä, *Reima Pietilä: Architecture, context and modernism* and *Reima Pietilä: One man's odyssey in search of Finnish architecture* (1988) are both out of print, while Roger Connah's *Writing Architecture: Fictions, fragments, fantomas* (1989) is, as a cultural study, less accessible; and Scott Poole's *The New Finnish Architecture* (1992), although making oblique reference to Pietilä, omits illustration and discussion of his work entirely. Certainly, Pietilä cut a strange figure in twentieth-century European architecture. In that period, since the 1960s, when more and more Finns have attempted to become 'normalized' – more European in appearance and behaviour – Pietilä stood out as an exception to almost every European rule one can imagine, both in his writing and his architecture.

I do not mean to single out Poole's sin of omission, but to show it as part of a general conspiracy to keep this garrulous Finn quiet. The establishment of British architecture, supported by that of architectural journalism, has managed to exclude almost all reference to the man and his work, other than in obituaries. Pietilä's reputation throughout continental Europe and in Japan has not gained him recognition in Britain and the United States. My Pietilä chapter, called in his own words 'Form follows approach', is intended to overcome this censorship, this senseless protest against cultural eccentricity, this exclusion from 'the club' of a hero who won his spurs on the mythical battlefields of Finnish architecture.

It was Pietilä's lasting misfortune to be cast as Aalto's successor. He was set up to be ridiculed because, by any conventional standard, what Pietilä thought, said and did was nonsensical. This vulnerability was seized upon by a number of his Finnish professional colleagues. During the 1960s and 1970s, when there were so many uncertainties and ambiguities in architecture, it was extremely convenient for Finnish architects to have a butt for jokes that might otherwise have been directed at themselves. In this sense Pietilä was something of a martyr for Finnish architecture, a St Sebastian pierced by arrows deflected from his own colleagues. He died at the early age of 70, but he was already worn out by hostility and persecution in his mid-sixties.

Throughout his entire career, but particularly during the 1960s and 1980s, Professor Aarno Ruusuvuori remained a loyal, supporting friend. The work of Pietilä, an experimental alchemist, and Ruusuvuori, a mainline modernist, could not have been more different, yet they were bonded together in their tenacious explorations of modernity. Ruusuvuori, a long-time Director of the Museum of Finnish Architecture, was in every way a member of the Finnish architectural establishment, yet, serving on numerous architectural juries, he consistently gave obviously Pietilä solutions first prize. Ruusuvuori's integrity has never been in doubt, his respect for Pietilä was not just a crack in his rational being; rather, it was his realization that architecture is multidimensional and multicultural. For these reasons, this book is dedicated 'To the memory of two friends in search of modern Finnish architecture, Reima Pietilä and Aarno Ruusuvuori'.

There was a temptation to include in this survey the work of Finns who lived and built abroad. The obvious case in point is that of Eero Saarinen, who was born in Finland but who grew up and practised in the USA. I resisted this temptation because, although of Finnish birth, the younger Saarinen is correctly thought of as an American architect, and his entire production was built in the United States. To have included him in this book would have raised issues beyond the scope of my study.

In the past two decades a number of articles have appeared in architectural journals in efforts to iden-

tify and describe the unique characteristics of modern Finnish architecture. The significance of nature in Finnish life and thought, the frugality that characterized Finnish cooking and log-construction, the suggestion that Aalto belonged to an organic tradition, which Pietilä had extended in some of his own work, have all been explored by way of explaining the Finnishness of Finnish things and architecture. In fact, this Finnishness is more deep-rooted, with it origins in such great medieval churches as Hattula and Turku cathedral, and its network of elaboration spread through the neoclassical, the national romantic, the romantic classic and Aalto's post-functionalist periods. During the functionalist phase of modern Finnish architecture, that is from 1927 until 1939, leading Finnish architects such as Aalto and Bryggman reached out for international connections and recognition. This tendency towards internationalism also characterized the 1970s and 1980s and the work of such architects as Kaija and Heikki Siren and Arto Siipinen.

After Finland's economic recovery in the 1960s and the boom decades of 1970–1990 many of the barriers to the exchange of both goods and ideas were dismantled by the process of free trade. Although always expensive to visitors, Finland opened up towards the West and, in addition, many young Finnish architects found themselves as visiting professors in American universities. This form of exchange, which Aalto himself had pioneered through his appointment at MIT in the late 1940s, became common. The consequence was that the essence of what had been uniquely Finnish became diluted. Thus, we see as we approach the end of the twentieth century that Finnish architects, while retaining a different way of thinking about architecture and design, nevertheless look to traditional modernist sources such as De Stijl and constructivism as well as other external references for the new and complex eclecticism in both their modernist and postmodernist veins.

The new generation of Finnish architects, two generations behind Pietilä and no longer 'the young generation' because they are already in their fifties, is clearly committed to a Finnish internationalism. Helin and Siitonen with their Sibelius Housing at Börås, Sweden; Heikkinen and Komonen with their European Film School in Denmark, and then their Finnish Embassy in Washington DC; Juhani Pallasmaa with his Finnish Cultural Centre in Paris; as well as the truly young, student generation represented by the Monarch Group's Finnish Pavilion for the 1992 Seville World's Fair: all these architects are reaping the harvest of seeds planted in the 1930s to 1960s by Aalto, and in the 1970s and 1980s by the Sirens, Timo Penttilä and Reima and Raili Pietilä. Indeed, as Roger Connah indicates (at least for Pietilä) in *Writing Architecture* (1989), it was a peculiar Finnish capacity to absorb the international sources of modernism that preserved the uniqueness of Finnish architecture by giving it a broader, more embracing cultural base for its special characteristics.

The 'basic smell' of Finnish architecture produced in this kitchen does not at all suggest frugality as a label. Rather, arising out of Aalto's pioneering work and Pietilä's experiments in what may be termed the no man's land of architecture, we have moved on to a *nouvelle cuisine* – a product of fine quality and flavour that can only come from mastery of the art.

We are beginning to understand that the real quality of Finnish architecture is not something 'out there', but it is the result of an internalized process, a philosophical approach that can take any material, any form and, by intelligent detailing of the idea, generate an unmistakably Finnish quality in a wide range of architectural expressions. In truth, what Pietilä was searching for can only be found within the architect himself. Today Finnish architects grow up in a Finnish ethos, with its traditions, its climate, its nature, combined with a clearly demonstrated determination to embrace modernity and avoid the isolation from which Finland suffered for centuries. It is these ingredients that provide the basis for new recipes, and for the 'basic smell' of future Finnish architecture.

Malcolm Quantrill
Texas A&M University, USA
May 1994

A note to readers

My publishers have been generous in the number of illustrations – both colour and black and white – that they have allowed. As there is at present no other comprehensive history of twentieth-century Finnish architecture available it seemed appropriate to allow this extensive visual complement to the text to serve as a parallel commentary. For that reason, the captions are generally longer than is the usual convention. The intention is to provide a ready reference to the material, offering an *aide-mémoire* to reinforce the main body of arguments. Furthermore, the illustrations appear in chronological order whenever possible. The obvious exceptions are in the three colour sections, which each have their own discrete chronological presentation.

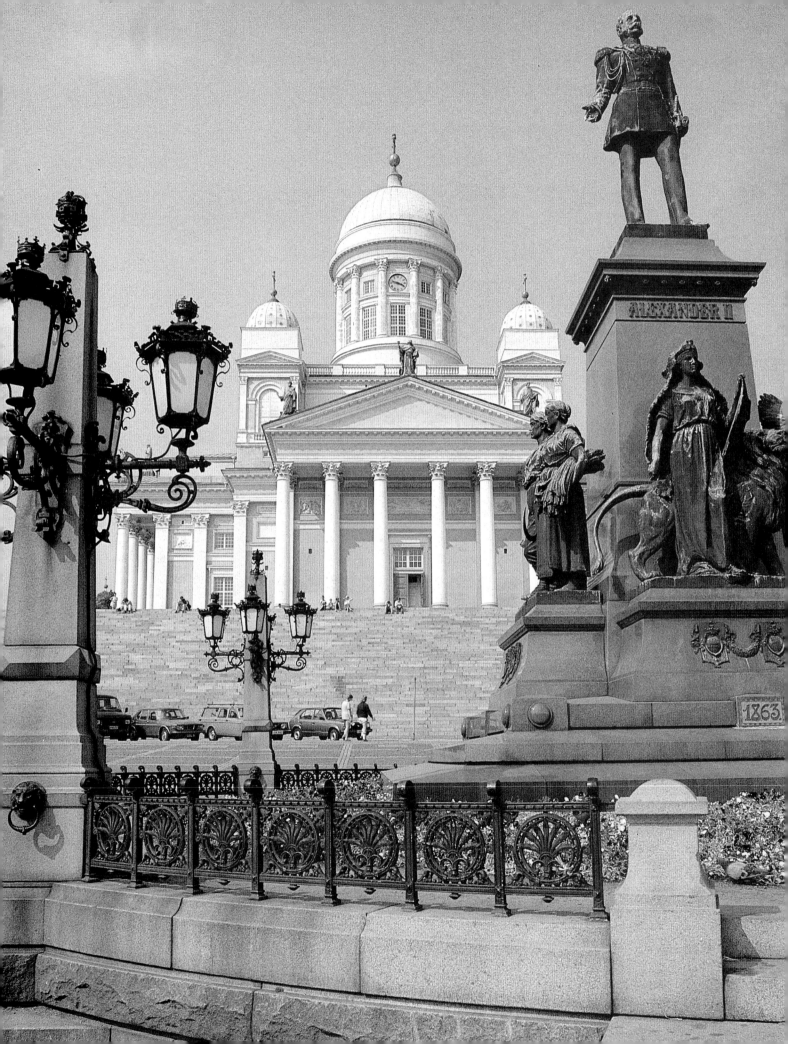

1 Modern Finnish architecture: background and evolution

Alvar Aalto dominated Finnish architecture for almost half a century, from 1927 until his death in 1976 at the age of 78. For most of that period his highly idiosyncratic buildings were difficult to place in relation to the work of other international masters. His use of traditional forms never produced a simple copy of any known original but rather demonstrated continuous development and transformation.

It was the perpetuation of an architectural tradition, rather than the evolution of an individual style, that was central to Aalto's creative thrust. This is not to say that external, international influences were not important in his development, but influences that did come from outside the Finnish tradition were grafted onto his own very deep understanding of that heritage making them intensely personal. By accepting his roots in a national idiom, particularly that of the immediate past, Aalto was able to extend the significant design attitudes that underlay the national romantic movement into his own personal interpretation of modern architecture. For him, the traditions of the 'modern' and the 'new' were inevitably rooted in an understanding of known geometries, the exploration of familiar contexts and the reawakening of vestigial architectural experiences.

As Reyner Banham reminded us,[1] Aalto did not stand alone in the Finnish architectural landscape any more than Eliel Saarinen had done before him. Our response to his genius generated certain special vibrations that have singled Aalto out, just as Saarinen was focused on in the early years of this century. But in order to fully understand his own unique contribution, Aalto's work should be considered in the context of what went before as well as what developed in parallel with his own experiments. Certainly, when one thinks of innovation in modern architecture Aalto's name springs readily to mind. Indeed, Aalto might well have echoed the sentiment of Francesco Borromini: 'I would not have joined the profession with the aim of merely being an imitator.' But Aalto's innovations, like Borromini's, must be seen within a framework of traditions, the forms and formulations of which they both relate to and rebel against. My concern here is to illuminate Aalto's contribution to the evolution of modern architecture within the context of modern Finnish architecture as a whole. Much of the difficulty of relating Aalto's work to the central themes of the modern movement has stemmed from the fact that he already anticipated in the mid-1930s the mood of postmodernism and deconstruction.[2] His intention was to humanize space and form; his method was to blend modern technology and standardization with a craft-based approach to the design and making of buildings.

The history of Finnish architecture is not as complex as that of central and southern Europe, but its traditions have clearly identifiable components and it is in the context of these that twentieth-century Finnish architecture must be viewed. Firstly, there is the tradition of materials, of stone and brick and wood, which is rooted in the construction of Finland's churches.[3] Then there is the formalism of the neoclassical period, an influence that was brought to bear at a critical stage in the evolution of modern Finland. As a reaction to the external force and character of neoclassicism, as initiated in Finland by L.J. Desprez and exemplified by the extensive work of both Carlo Bassi[4] and Carl Ludwig Engel[5] (Figures 1, 2), there emerged in Finnish architecture a modern tradition of formal experiment that was brought into being by the

Figure 1

Carl Ludwig Engel

Lutheran Cathedral, Helsinki (1830–40): seen from Senate Square, with a statue of Russian Tsar Alexander I in the foreground. Note the distorted Palladian form of the massing, with the drum and dome extended vertically to provide a skyline to the harbour approach.

Figure 2

Carlo Bassi

Church, Tampere (completed in 1824): south doorway showing the basic vocabulary of this wooden classic style that provided the model for Alvar Aalto's early designs of the 1920s.

national romantic movement.[6] Thematically, Finnish national romantic architecture expresses a strong historical bent, rooted in medieval imagery with some references also to art nouveau and symbolism; but formally it had little academic interest in the past and its characteristics embrace an almost exotic sense of caprice. The academic discipline of the polytechnic educational system, with its re-emphasis of the neoclassical vocabulary, must be considered in relation to those traditions. Interestingly, when Aalto was at the height of his powers in the 1950s and early 1960s, the academic emphasis was once again swinging back to a formalist position under the leadership of Professor Aulis Blomstedt.[7] After Aalto's death in 1976, Reima Pietilä[8] continued the tradition of organic experimentation, but Pietilä's work and philosophy have been vehemently opposed by the students of Blomstedt and those influenced by his teachings.

Aalto's uniqueness derived from his ability to extend, modify and blend these different traditions with international and historical themes, achieving a design approach that combined recognizable elements in new and original forms. In this way he anticipated late twentieth-century reactions against functionalism. Although he often presented himself as functionally oriented, there is embedded in his approach to functionalism a conscious irrationality, a softening and humanizing touch that subverts the functional intention of the plan or section beneath the building's surface. An Aalto building does not simply materialize in terms of the present; it links us with established forms and experiences of traditional architecture. Nor does the evolution of Aalto's work from the 1920s to the 1970s present a consistent or continuous development of one image or expression. Rather we find that, in common with many great artists, certain distinct themes and directions are established in the early period – in Aalto's case the 1920s and 1930s – which provide the basis for later variations on those earlier statements of intent.

The seeds of innovation were planted relatively early in Aalto's career, while much of his later work was rather backward-looking. His early innovations are clearly set within the decade between the late 1920s and the close of the 1930s. In his second major period, that of the 1950s, he combined a desire for refinement on the one hand with a new experimental approach on the other. The first period saw the transition from the international style of the *Turun Sanomat* Building (1927) and Paimio Sanatorium (1929–33) to the expressionism of the Villa Mairea (1937–39) and the New York World's Fair Pavilion (1938–39). The second period was characterized by the Säynätsalo Town Hall (1950–52), Muuratsalo Summer House (1952), the National Pensions Institute (1952–56), the House of Culture in Helsinki (1955–58) and the Vuoksenniska Church at Imatra (1956–59) There is little evidence of further development in the late 1960s and early 1970s. The sheer amount of later work, and in some cases its essential monumentality, seems to have militated against the experimental spirit of Aalto's earlier, smaller-scale and more intimate buildings. For example, although the National Pensions Institute is one of Aalto's largest buildings it nevertheless retains a small scale. This is consistent with the role of the building, since it has no public ritual function comparable with that of an important civic or cultural edifice; in continuation of this modesty, but also in common with many Aalto buildings, it has no distinctive major entrance.

Certainly, Aalto's contemplation of the Essen Opera House changed his fundamental attitudes towards the nature of public buildings and civic scale. The first scheme for Essen dates from 1958–59, when he entered and won the original competition. He produced a further design over the period 1961–64 and work on the project continued to occupy Aalto throughout the 1960s. It must have been an enormous disappointment to him that this, his most important international commission, was not realized in his lifetime. That sense of disappointment, coupled with the amount

of effort involved in such a vast undertaking, clearly affected the man and his creative resources. We must remember that Aalto was already 60 when work began on the Essen competition. During a period of his life when many senior partners in British and American practices would have been put out to grass, Aalto was still hard at it, attempting to bring his international career to its summit. In addition, there was a mounting sense of frustration that yet another of his major competition successes was not to be realized. The Essen Opera House promised to synthesize much that was outstanding in Aalto's previous achievements, bringing interest and quality to the detailing of the interior without becoming pedantically fussy about the massing and exterior expression.

The simple external form of the Essen project confirms that Aalto had mastered the art of translating the fine sense of scale he demonstrates at Säynätsalo and the House of Culture into the larger context of a metropolitan urban framework, just as some of his house plans succeed in miniaturizing his statements of urban form.[9] However, the work load in his office during the 1960s, together with the consequences of his advancing years, suggest that the extra pressures and burden of the Essen project may have begun to exhaust Aalto's fertile imagination. Certainly, when he had the opportunity, with the building of Finlandia Concert Hall and Congress Centre in Helsinki (1962–75), to achieve the qualities promised by the Essen project he was able to demonstrate these developments only in the interior of the main auditorium.

There are exceptions to the general deterioration of Aalto's performance during the last decade of his life. Consistent with his early interest in liturgical design, beginning with the restoration work at Kauhajärvi (1918–19) and Äänekoski (1924), the Jämsä competition (1925) and the Muurame Church (1926–29), these exceptions include the church and parish centre for Riola, near Bologna, Italy, begun in 1966 and completed posthumously in 1978; the new church at Lahti, designed in 1970 and completed by Aalto's widow, Elissa, in 1978; and the unrealized project for a Protestant Parish Centre at Altstetten in Zürich, Switzerland. Their interest is that they extend Aalto's long preoccupation with the fan-shaped plan motif (which dates back to the Enso-Gutzeit weekend house competition entry of 1932) into the section of the building. The last incidence of this third-dimensional reference to the fan shape was to occur in the abortive project for an art museum for the Shah of Iran at Sheraz in 1970.

The climate in which Finnish architecture emerged into the twentieth century is well demonstrated by the April/May 1903 issue of Finland's new professional journal, *Arkitekten* (later *Arkkitehti*),[10] which began publication in that year. The feature article of that issue 'Den nyare engelska byggnads konsten' ('The new English architecture') was devoted to a discussion of the work of William Butterfield, James Brooks, John Pearson, Norman Shaw, John Sedding and G.E. Street.[11]

This attention to English work clearly indicates not only the confidence of the architectural profession at the beginning of the century in producing its own critical journal but also that Finnish architects were eager to look beyond the boundaries of the then-Russian Grand Duchy of Finland.[12] From the beginnings of the national romantic movement in the 1890s the architectural profession had been dominated by practitioners from the highly educated and outward-looking Swedish-speaking community, whose domination of Finnish cultural life goes back to the colonization of Finland by the Swedes in 1362. Until the 1890s, the most important architects practising in Finland received their training either abroad or at least with a Swedish practice; while the new generation, led by Lars Sonck (1870–1956), Herman Gesellius (1874–1916), Armas Lindgren (1874–1929) and Eliel Saarinen (1873–1950), was trained in Helsinki at the Polytechnic Institute.

The principal originators of the Finnish national romantic movement in architecture were undoubtedly the architect Lars Sonck and the painter

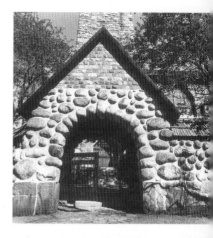

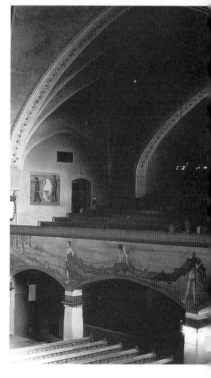

Figures 3 and 4
Lars Sonck
Lutheran Cathedral, Tampere (1902–07): the entrance gateway typifies Sonck's robust approach to detailing, again offering a clear model for Alvar Aalto. The interior is a confident exercise in spatial definition, enriched by Kurt Simberg's celebrated paintings and mural decorations.

Figure 5
Sigurd Frosterus
Entry for the Helsinki Railway Station competition (1904): this design, with its clear delineation of form and mass, heavily influenced Eliel Saarinen's final design for this building.

Figure 6
Gesellius, Lindgren and Saarinen Suur-Merijoki manor house near Viipuri, Karelia (1901–03): the plan is typical of the partnership's ability to combine free-flowing space (in the Wrightian manner) with compartmentalized areas.

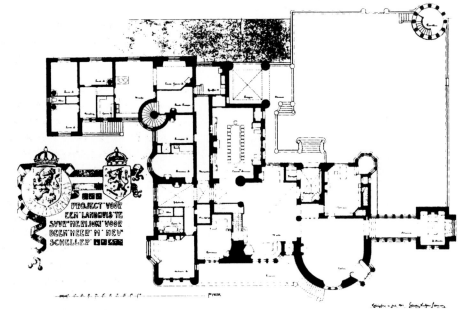

Figure 7
Lars Sonck
Eira District Hospital (completed in 1905): although at first glance this plan does not have the freedom and flexibility of Suur-Merijoki, it displays a forceful particularization of elements, which becomes a basic strategy in Aalto's planning after the Villa Mairea (1937–39).

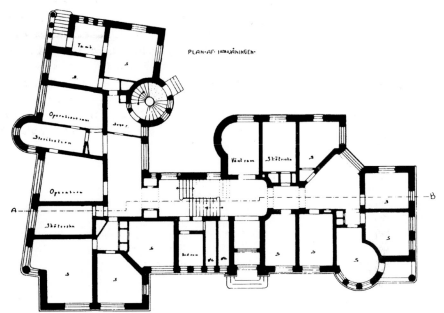

Finnish Architecture and the Modernist Tradition

Akseli Gallén-Kallela. As early as 1894 Sonck was the winner of a very important architectural competition. This was for the St Michael's Church in Turku,[13] finally completed in 1905, whose rear gallery clearly anticipates his planning of Tampere Cathedral (1902–07; Figures 3, 4).

To undertake the Turku commission, Sonck had to abandon another project that was dear to him. This was an excursion to Karelia, Finland's easternmost province, which he had for some time been planning to undertake with two artist friends. Nevertheless, he remained a keen student of Karelian folklore and the Karelian tradition of wooden construction. In fact, in 1894–95 and perhaps partially in compensation for the loss of the Karelian journey, he designed and erected his first two villas, which were clearly influenced by his study of Karelian wood detailing. The chalet-like character of these early villas, with their knotty log construction and bold, jutting cornices, left little doubt about the origin of their inspiration.

At the same time, Akseli Gallén-Kallela – one of the very first European artists to travel in Africa, paint there and collect African tribal art – was designing and constructing his studio home, which he evocatively named 'Karela'. An early model of the new freedom of plan and formal expression that was to characterize national romantic architecture, this studio was itself, in turn, clearly influenced by late nineteenth-century English domestic architecture.

After winning the competition for St Michael's Church, Turku, in 1894, when he was still a student aged only 23, Sonck went on in 1902 to win the competition for the cathedral in the fast-growing city of Tampere.[14] In his design for Tampere Cathedral he developed the concept already advanced at St Michael's and produced a monument of lasting importance in the realization of the new Finnish architecture. The simple medieval hall plan of Tampere Cathedral, which was completed in 1907, is modified by the introduction of a large gallery, which achieves an original and sophisticated solution that is clearly post-Reformation in inspiration.

The stonework of Sonck's Tampere Cathedral seems to owe a debt to the work of the East Coast American architect H.H. Richardson, while the detailing of the metalwork gives fairly obvious hints of his interest in the models provided by Louis Sullivan's mastery of that medium in Chicago. Indeed, as the true Finnish spirit began to exert its influence on a vital new expression in the arts and crafts, Sonck and his colleagues were quite clearly determined to be fully aware of international developments and to make appropriate connections through their own experiments. Thus the stonework and metalwork detailing that Sonck created for Tampere Cathedral provided the emerging generation of young Finnish architects with a brilliant example of style and craftsmanship. It also had a superbly ambitious scale, which was most fitting for the spirit of Finnish independence and Finnish national expression being born in their intensely romantic minds.

Sonck's handling of form, mass and detailing at Tampere remains unsurpassed in the evolution of modern Finnish architecture.[15] This cathedral church was one of Aalto's favourite buildings and its influence upon him is unmistakable. In Aalto's handling of granite and bronze there is a clear obeisance to the grand old master of Finnish architecture who, after all, did not die until 1956, at the very height of Aalto's own career. Aalto's most direct debt to Tampere Cathedral is perhaps found in the prevailing freedom of his lines, which reflect the power and simplicity of the north gallery window by Hugo Simberg depicting the Horsemen of the Apocalypse.

Irregularity of form, massing and fenestration became one of the characteristic imprints of Aalto's mature expression, and the spirit of this idiosyncratic playfulness can be readily traced to those inventions that characterize the evolution of the national romantic style. For example, the 'Sampos' Polytechnic Student House on Lönnrotinkatu in Helsinki, designed by Thomé and Lindahl and completed in 1903,[16] exhibits the kind

of door patterns and window arrangements that Aalto clearly found so attractive as models for his own fenestration, while Lars Sonck's annexe to the Eira District Hospital in Helsinki (completed in 1905) is an interesting precursor of Aalto's approach to plan forms (Figure 7).[17] Sonck's design combines an agglutinative plan form with a free association of geometrical organization in order to build up a formal muscularity that flexes itself against the shape of the site, yet conforms to the domestic character of the Eira neighbourhood.

Indeed, it was Sonck's propensity for the agglutinative plan and his skill in handling the resultant massing that make him such a significant figure in the establishment of the national romantic style. His entry for the State School Building competition in Helsinki,[18] also of 1905, shows Sonck literally dismembering the conventional tightly closed plan and creating in its place a number of linked 'pavilions', three of which have boldly rounded corners. In that same competition the entry with the pseudonym 'SOL' has a similarly agglutinative approach to the plan form.[19]

At the beginning of their partnership and in their early work, Gesellius, Lindgren and Saarinen looked not to their compatriot Sonck for inspiration but rather towards models from the German Jugendstil. Their residential building at Satamakatu 7 in Helsinki (completed in 1897) certainly reveals this influence, as does their Finnish Pavilion for the Paris World's Fair of the following year. The Finnish Pavilion, however, was an amalgam of Jugendstil elements with clearly recognizable derivatives from the tradition of Finnish medieval stone church architecture, while the overall approach to ornamentation suggested a move towards a distinctly new Finnish character. With their imposing Pohjola Insurance Company Headquarters in Helsinki two years later (1900–01), Gesellius, Lindgren and Saarinen successfully introduced the national romantic style into Finnish commercial architecture.

In the same year that the Pohjola offices were finished the partnership's design for the Suur-Merijoki Manor House, near Viipuri, arguably the finest example of national romantic domestic architecture, was already under construction (Figure 6). This house, built for a wealthy manufacturer, was unfortunately destroyed during the war in 1941. Fortunately Bertel Jung, editor of *Arkitekten*, has left us this description of its impressive central hall:

'The impression one gets upon entering the hall defies description, but it is equally impossible to forget it. One is immediately aware of many finely executed and colourful artifacts, all of which have been designed by the architects or made under their supervision. Painters and sculptors, as well as craftsmen in every field, have worked together... to create a work of art which is a credit to our country and brings glory to the understanding patron who financed all this activity. Here is one of the major achievements of our young art.'[20]

The destruction of Suur-Merijoki during the Second World War was a great loss to Finland's architectural heritage, although there is, fortunately, another good example of the partnership's domestic style remaining in the Hvitträsk House and Studio, located close to Helsinki.

Hvitträsk was built by the partners to serve as their studio and home (Figure 15). The three architects lived and worked there together, sharing not only the office accommodation but also their domestic life. The buildings are grouped dramatically on a wooded bluff rising up from Lake Hvitträsk, with the accommodation planned to range rather freely in response to the topography, producing an irregular massing of the elements around a main courtyard, which is characteristic of the grouping of Finnish farm buildings.

The lower walls of Hvitträsk are built of natural granite, plastered over in parts, while above them the facings of many of the upper surfaces are of timber. The roofing is made of pantiles with shingles on some of the upper walls. The original, square, timber-faced tower at one end of the

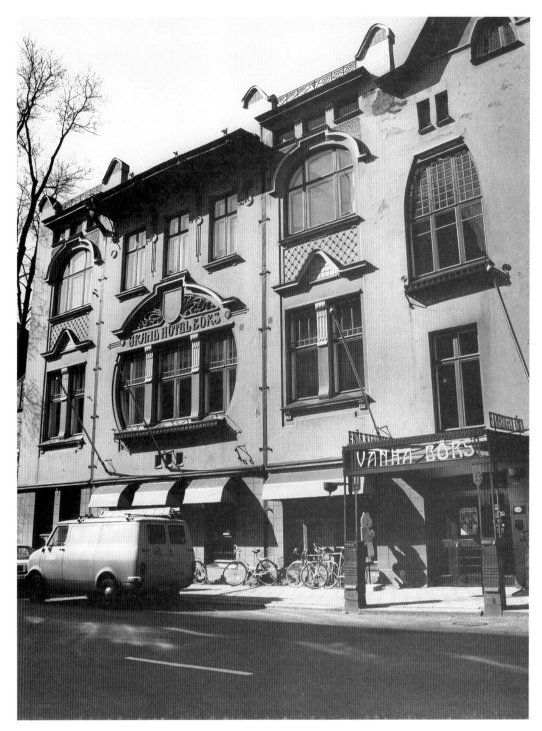

Figure 8
F. Strandell
The Grand Hotel Börs (Stock Exchange Hotel), Turku (1905–08): a rare example of Finnish art nouveau in a sea of national romanticism.

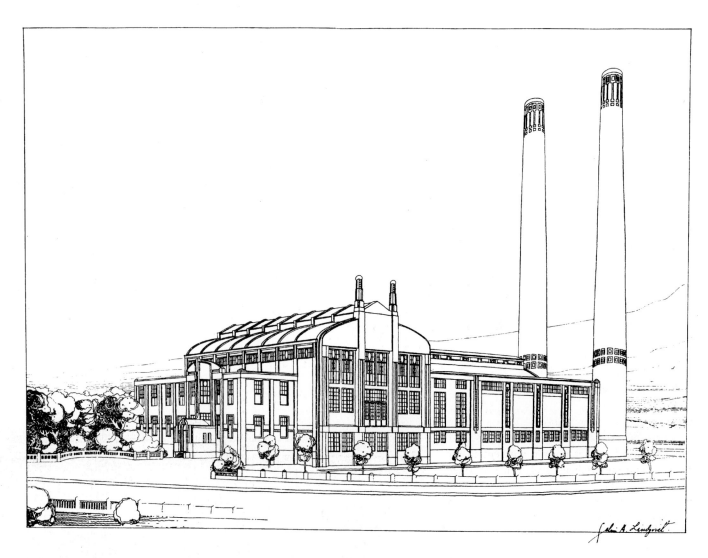

Figure 9
Selim Lindqvist
Suvilahti Power Station, Helsinki (1908–13): this original drawing for the project shows Lindqvist anticipating the general concept of Peter Behrens' AEG Turbine Factory in Berlin.

house, complete with a capping turret, was not replaced when part of the building was destroyed by fire. Hvitträsk developed the natural stone and wood elements of the Karelian building tradition into a large-scale and sophisticated villa architecture. The buildings are immaculately sited and retain their natural charm and picturesqueness in the landscape. The complexity of plan and massing and the variety of expressive forms, suggest that Hvitträsk was a model for some of Aalto's later design strategies. Originally, complete with its turreted wooden tower, Hvitträsk would also have possessed something of the romance of a medieval castle, giving a heightened sense of drama on approach.

The main part of Hvitträsk was constructed in 1902 and the building became habitable in 1903. It consisted of a studio and workshop, with a flat above in which the three young architects lived at the outset. This first stage drew most directly upon the traditional forms and detailing of Karelian vernacular architecture.[21] Gesellius chose to remain in the flat when the second part of the house was built across the courtyard. The new pavilion has a central, single-storey studio for the three partners, with an L-shaped two-storey dwelling at either end. Lindgren lived in that portion adjacent to the entrance and the original tower, while Saarinen occupied the other end of the building, where he eventually added an attic storey in the roof. After Hvitträsk became entirely his own residence and office,[22] Saarinen developed the gardens and other external features, including the loggias and terraces. He continued to adapt the form and style of Hvitträsk to his own taste and lived and worked there until he emigrated to the United States with his family in 1923. The Saarinens visited Hvitträsk annually for their summer holidays after 1924 and Eliel sold the house only in 1949, a year before his death.

It was Saarinen who controlled the character and detailing of Hvitträsk from the outset, designing most of the furniture and many of the fittings. His second wife, Loja, was a skilled weaver and she

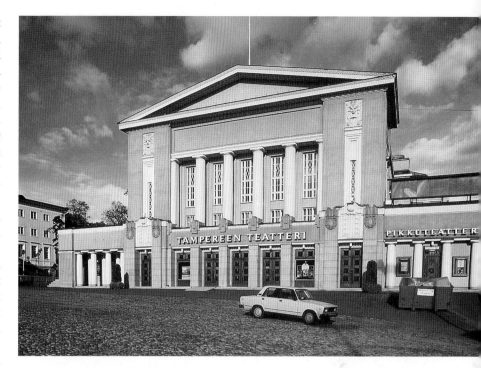

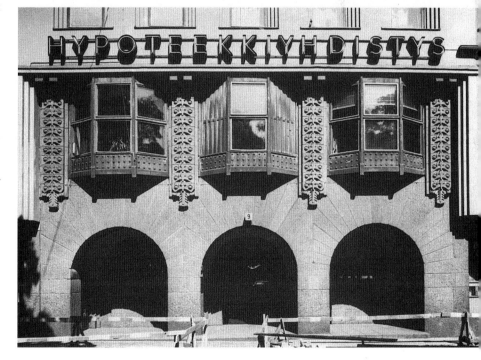

Figure 10
Kaunio S. Kallio
Civic Theatre, Tampere (1912): a bold and confident classical design that equals anything in all Scandinavia at this time.

Figure 11
Sigurd Frosterus
Taos House flats, Helsinki (1913): this shows Frosterus warming up for the bold volumetrics of his Stockmann Department Store.

Modern Finnish architecture: background and evolution

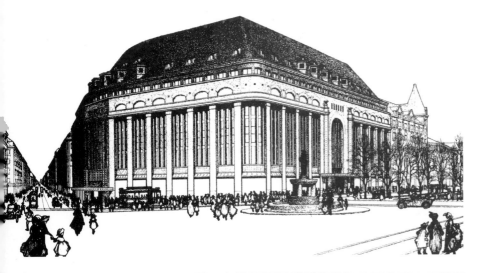

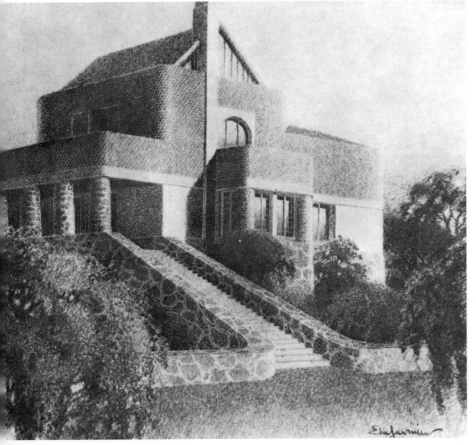

assisted Eliel with the design of the soft furnishings. The best contemporary artists and craftworkers collaborated under Saarinen's guidance to create the unified and harmonious effect of the interior. The painted decorations are by Gallén-Kallela and his 'Flame' *rya*[23] rug has a central position in the interior at the entrance level. There are tiles from Louis Sparre's Iris factory at Porvoo, as well as some chairs designed by Sparre[24] himself. Gallén-Kallela's pupil, Eric Ehrström, contributed some of the metalwork, with the remainder being executed under Saarinen's direction by the local blacksmith.

The interior design of Hvitträsk reflects many influences absorbed from the partners' contemporaries; the metalwork, for example, derives from Sonck and some of the furniture owes a debt to Henri van de Velde (an influence later absorbed by Aalto), while the nursery has distinct echoes of Charles Rennie Mackintosh. But the organization of the plan, with its ingenious changes of level to orchestrate the spatial continuity of the interior, is a highly original contribution, even anticipating Frank Lloyd Wright's evolution of the open plan and certainly that of Aalto's Villa Mairea.

Aalto's work seems clearly influenced by Saarinen's use of materials and attention to details. The covered ways of Aalto's Finnish Pavilion for the Paris World's Fair (1937), the Villa Mairea at Noormarkku (1937–39), Säynätsalo Town Hall at (1950–52) and the House of Culture in Helsinki (1955–58) all seem to owe their origin to the loggias at Hvitträsk.

In 1902, as the first wing of Hvitträsk was being completed, Gesellius, Lindgren and Saarinen began work on a major commission that focused public attention on the national romantic movement. Their design of the Finnish National Museum for the display of the national archaeological, historical and ethnographical collections was largely the work of Armas Lindgren and deliberately derivative of elements from the Finnish heritage of art and architecture in its overall stylistic collage. As a whole the building most closely

Figure 12
Sigurd Frosterus
Design for the proposed Stockmann Department Store, Helsinki: architect's competition drawing (1918), showing the simplification of form and mass, creating a building somewhere between a traditional warehouse and a modern one.

Figure 13
Eliel Saarinen
Proposed Villa Winter at Sortavalla (1909): although this house was not built, it gave Aalto a number of clues about architectural transformation. Here the 'landscape' climbs the steps, and even the columns are rusticated to 'belong to the earth'; also, the roof tiling dissolves the walls from above, so that only a thin band of 'architecture' remains between earth and roof. The Villa Winter is a very sophisticated 'primitive hut' indeed.

resembles a large medieval church but there are also distinct reminders of fortified architecture. Once again, the emphasis is upon a picturesque irregularity of form, with a high, granite-faced tower capped by a copper roof and brick spire as the focal point of the composition. The museum has granite walls, with the carved decorations executed in sandstone.

The interiors were designed to provide environments appropriate to the objects displayed in them: a church-like room houses the ecclesiastical collection, while weaponry is accommodated in a room reminiscent of a castle tower. On the exterior this approach is carried through in the great gable end complete with geometrical decorations that are the characteristic feature of the gables of Finnish medieval churches, for instance at Porvoo and Hattula. The main bronze entrance door and the stained glass of the great staircase are by Ehrström, while Gallén-Kallela contributed the frescoes, executed at a later date.

In his National Museum design Lindgren achieved the high point of the national romantic style. And, interestingly, although this was a determinedly urban building located in the very centre of Helsinki, the outlying walls and planting were designed to provide associations with the Finnish countryside and landscape. This treatment provides another clear precursor of Aalto's frequent confusion of the urban with the rural. In this connection it is also relevant to note that the original competition drawings show both the southeast and southwest facades partly obscured by creepers.[25] Aalto's inclination to allow climbing plants to modify the external form of many of his buildings led George Baird to go so far as to suggest that one of Aalto's romantic streaks was to cultivate an architecture of ruins,[26] a tendency that is openly opposed to both the pristine quality of neoclassicism and the 'factory-finish' of international modernism.

Gesellius, Lindgren and Saarinen followed the National Museum with two commissions that were originally both designed in the national romantic style. These were the Northern Joint Stock Bank at Unioninkatu 34 (demolished in 1934) and the Helsinki Railway Station. Both designs underwent substantial revisions before they were built, resulting in a new, transitional style. This was in part due to the fact that Lindgren left the partnership in 1905 to become the Director of the Central School of Applied Art. Gesellius severed his partnership with Saarinen two years later. The original railway station design, from the three hands, dates from 1904, while the revised drawings were published in February 1905.[27] Although these revised drawings still carry the name of all three partners, Saarinen was clearly responsible for co-ordinating the new design. Significantly, the character of the main entrance and the tower, which in the original design echoed the forms established only 200 m away in the Finnish National Museum, were substantially modified in the new design to reflect the more radical, but unsuccessful, design submitted in the competition by an architect who was later to become very prominent in modern Finnish building history, Sigurd Frosterus (Figure 5).

In his entry for the Viipuri Railway Station competition, which was held later in 1904,[28] Saarinen had already adopted the general features and character derived from the Frosterus drawings for the Helsinki Railway Station, which he was later to incorporate into his own revised Helsinki design. He was probably using the opportunity afforded by the Viipuri competition to try out the new transitional style he was in the process of evolving for Helsinki. In doing so, however, he successfully established the model for the new Finnish railway station for three decades. There was not another competition for a new station in Finland until that for Tampere, held in 1934 and entered unsuccessfully by Aalto. In a similar way, Aalto later developed a distinctly recognizable type in the libraries he designed, not only in Finland but also in the United States for the Mount Angel Benedictine College, Oregon (1965–70).

Lindgren submitted a separate entry for the

Viipuri Railway Station competition that offered a more lively and inventive approach to the design than Saarinen's adaptation of the Frosterus style.[29] Lindgren's capacity to be bold in his innovations was particularly demonstrated in his Viipuri project by the combination of the arched main entrance with the clock tower over it. In this design and other examples of his work there is evidence to suggest that Lindgren may have been the most significant innovator of the three.

Certainly, Saarinen's work went on to become increasingly formalist and sometimes even turgid. Had not Lindgren chosen to concentrate his energies into an academic career he might well have become the most successful architect of the three. For example, the house he designed and built for Mr Pietinen in Viipuri[30] offers much more anticipation of the modern movement than we find in Saarinen's work after Hvitträsk. Lindgren's work maintained this capacity for originality in the Wainemuine theatre, concert hall and clubhouse complex in Tartto, where he continued to progress from national romantic excesses towards more simplified forms and massing without the monumental pretensions favoured by Saarinen.

Before Saarinen embarked on his more monumental and oppressive style and while he was still in partnership with Herman Gesellius, he created one of his most stunning designs – again, interestingly, for a country house – the Villa Remer, built at Altrupp near Berlin (1905–1907).[31] The Remer house had especially fine interiors and some of the furniture was once more clearly indebted to Charles Rennie Mackintosh. Immediately after Gesellius left the practice, Saarinen designed a much smaller villa in 1909 for Dr G.J. Winter to be built at Sortavala.[32] The Villa Winter house appears to be Saarinen's last truly expressionist work and it is extraordinary in his opus for its extreme plasticity of form (Figure 13). It explores the limits of tile-hanging and provides a clear precedent for Aalto's own experiments in merging roof and wall to achieve a plastic continuity of building form. Also, the detailing of the stone walling at the lower level and at the approach stairway, culminating in the columns supporting the terrace over the entrance, blurs the distinction between garden and building, a theme again taken up by Aalto. The Villa Winter confounds conventional notions of scale as well, suggesting a monumentality far beyond the size of this modest house. Soon after the publication of the design for the Winter house, *Arkitekten* again devoted space to Hvitträsk and illustrated Saarinen's recent modifications.[33]

For more than a decade, from 1894 when he won the Turku Church competition until 1905, Lars Sonck produced a number of major building designs. These, taken with the work of Gesellius, Lindgren and Saarinen, form the core of Finland's national romantic architecture and the very substantial foundation on which were based later developments in Finnish building design, with its distinctive national characteristics. Of these main works, Tampere Cathedral and Eira District Hospital have already been discussed; there remain the Helsinki Exchange Building, Korkeavuorenkatu (1904–05; Figure 14), the former Private Bank (1904),[34] and the Stock Exchange in Fabianinkatu (1916–18; Figure 16).

Sonck was a man steeped in the tradition of medieval architecture and his buildings of this early period often reflect that preoccupation. But Sonck's adaptation of medieval forms and motifs were no mere superficial exercises in geometry or draughtsmanship. His early buildings are totally convincing statements which exude that most elusive of architectural qualities, authenticity. His total command of the language of medieval precedents offered by churches and castles allowed him to assimilate these influences into a completely original expression that was entirely his own. Unfortunately, when Sonck decided to move on, together with the other founding fathers of modern Finnish architecture, to the streamlining of forms that characterizes the spirit and expression of modernism, he was unable to achieve either a successful transition or further development. What

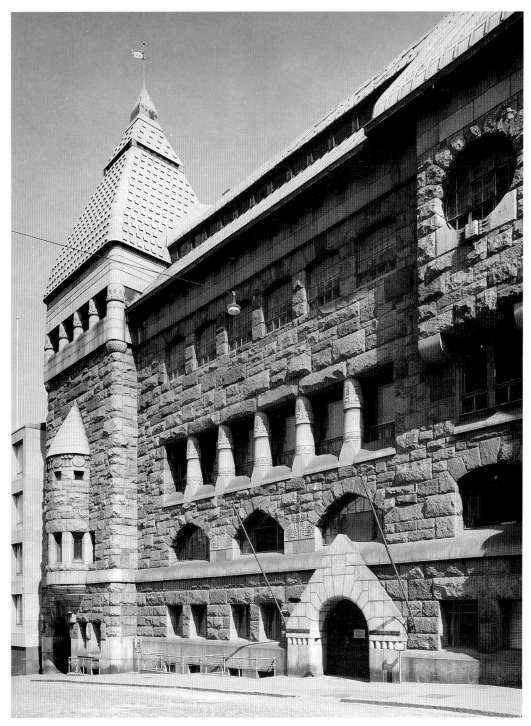

Figure 14
Lars Sonck
Helsinki Telephone Company Headquarters, Helsinki (1904–05): here the rational transformation of medieval forms, begun on Tampere Cathedral, is carried to a forceful conclusion.

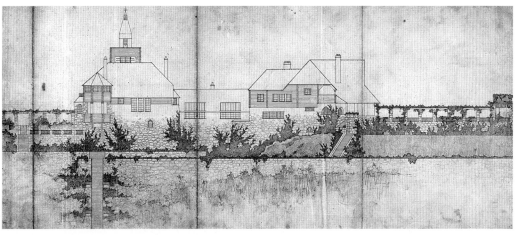

Figure 15
Eliel Saarinen
Hvitträsk, near Helsinki (1902): the studio and communal home of the Gesellius, Lindgren and Saarinen partnership and their families. This pencil drawing by Saarinen, probably dating from 1907, again shows an attack on the differentiation between garden, garden wall and house.

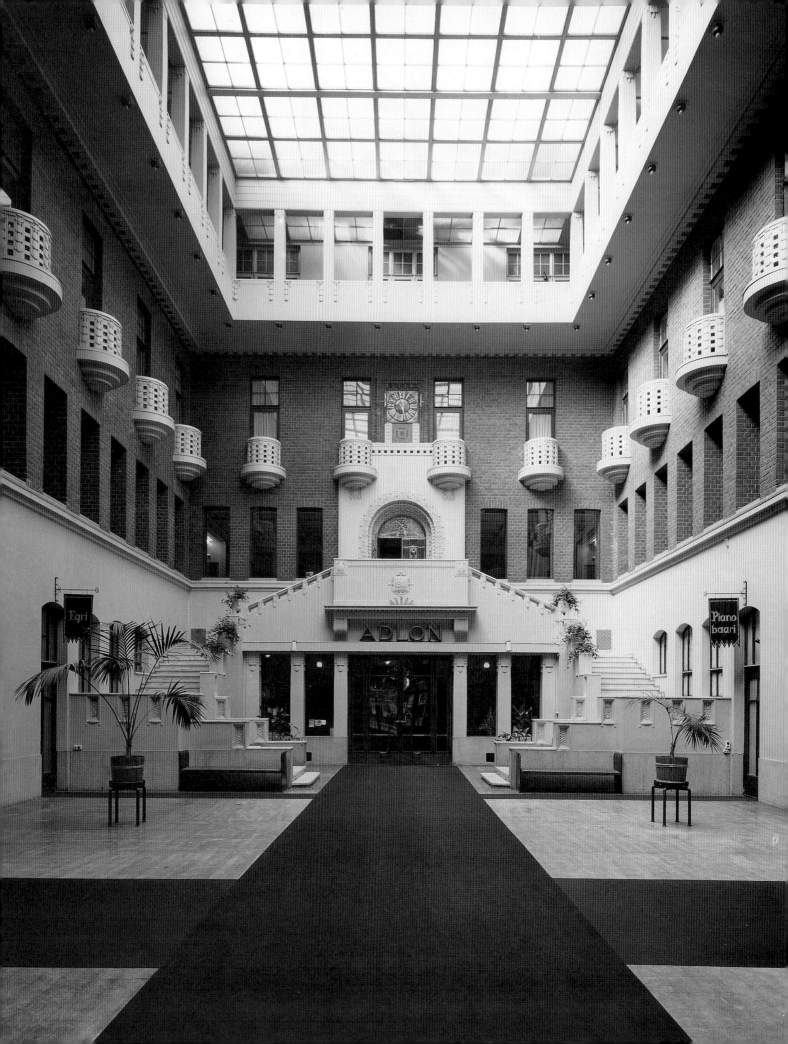

was important to Sonck's architecture was the sheer weight and massiveness of a building. For Sonck the process of streamlining involved only the shedding of the medieval vocabulary of detailing. Rather than embracing the modernist lightness and transparency exemplified by industrial production and open planning freed from structural constraints, Sonck hung on to the weight and inflexible expression of traditional construction.

Whereas Tampere Cathedral and the Eira District Hospital interpret the cultural and social values of the national romantic style, with their contrasts between monumental and domestic scales, the Helsinki Telephone Exchange and the Private Bank epitomize the movement's concern for exterior and interior expression of the commercial environment. In the Private Bank, where the banking hall had to be fitted into the volume of an existing neoclassical building, the emphasis is entirely upon interior qualities. This accounts for the low ceilings and the heavy arches and columns. But this sense of weight and strength is complemented by the uncluttered space between the columns. Walter Jung's furnishings, together with his carved and painted motifs and coloured glass, all of which greatly enriched Sonck's design, have unfortunately been removed. What remains, however, following Aarno Ruusuvuori's restoration,[35] confirms Sonck's command of the quality and character of the bank's interior. It combined the strength and dignity of its function with great richness of materials and careful restraint in its detailing.

The exterior of the Helsinki Telephone Exchange is equally restrained and its detailing gives the façade the superficial image of a long-standing military bastion (Figure 14). But Sonck's use of medieval forms and motifs in this building is far from being a simple historical catalogue. There are as many as 11 different window types employed in this elaborate composition, but their combination is not merely aimed at achieving a sense of medieval authenticity by the irregularity of their form and arrangement. In fact, the fenestration is grouped in a way which, at first glance, appears to give an overall sense of order to this complex façade. But this order is merely present in the basic geometrical division of the elevation. Within this overall gridding of the façade the elements take on a dynamic expression of their own. What is more, some of the carved decoration is an abstraction of telegraphic equipment components. The result is not at all expressive of the weighty stability of a medieval castle.

The elements themselves may be medieval in inspiration, but their organization within the elevation sets up conflicts stemming from apparent contradictions in architectural intentions. In the case of the turret at the left extremity of the elevation, which is superficially a powerful element, its qualities as a *tour de force* are diluted by the playful decoration of the cylindrical piers of the windows in the upper storey immediately below the great elongated pyramidal roof. This playfulness is repeated in the motifs immediately beneath the semiconical roof of the semicircular oriel bay that relieves the massiveness of the stonework below the upper gallery. And the scale of the oriel bay itself contrasts astonishingly with that of the turret it embellishes; in fact the oriel bay is thoroughly domestic in scale. This turret, it should be noted, is located as far as possible from the main entrance doorway to the exchange.

The other principal feature in the upper storeys is a bold, oversailing bay supported on two great undecorated corbel stones. This feature, with its decidedly art nouveau large circular window framed within its massiveness, is also not related to the entrance below, but is set off on the building's right extremity as a conscious counterweight to the turret at the other end. The entrance itself occupies an apparently arbitrary position in the organization of the façade. It is not simply off-centre: its smallness makes it relatively insignificant. Similar treatments of entrances became characteristic of Aalto's buildings. Although the shallow projection of the steeply pitched frame to the semicircular-headed door actually cuts through the string course located

Figure 16
Lars Sonck
Stock Exchange, Helsinki, with entrance to the Adlon Hotel and Bar (1916–18): the elegant formality of Sonck's Stock Exchange atrium was the space passed through frequently by Aalto as he visited the celebrated Adlon Bar.

at first-floor sill level, the scale of the doorway itself consciously denies the importance of its function. Rather than giving an impression of strength and importance, the ashlar door frame with its comparatively delicate decorations appears to be attached to the string course like the travelling marker on a slide rule. In fact the entrance seems to be a movable feature, that could occur at any point along the façade.

These apparent contradictions of architectural intention occur by design in Sonck's Helsinki Telephone Exchange. This is not the accidental composition of an amateur but the confident and fluent contrivance of an architect who was both master of the medieval vocabulary and a man well read in contemporary international developments. And just as Sonck apparently owes a debt to H.H. Richardson, it would seem that he was also aware of Frank Furness's handling of medieval elements in his public buildings for Philadelphia,[36] for the Helsinki Telephone Exchange shows Sonck confidently achieving a very sophisticated exercise in personal mannerism at the age of 35. The determinedly anti-rationalist elements[37] of this key work in the national romantic style provide yet another interesting comparison with Aalto's formal preoccupations and solutions. The highly mannered expressionism of Sonck's Telephone Exchange was a readily available source of just the sort of contradictions in scale and emphasis that characterize Aalto's work from the mid-1930s onwards.[38]

Sonck's Stock Exchange also houses the Adlon Hotel with its famous Adlon Bar, which was much frequented by Aalto (Figure 16).[39] To reach that bar Aalto had to pass through the magnificent central atrium of the Stock Exchange, undeniably a substantial influence on his urban building designs with atria, for example the Rautatalo office building (1952–55) and the Academic Bookshop in Helsinki (1962–69), an influence reinforced by Aalto's love of Italian architecture with its persistent *cortile*.

In January 1908 Sigurd Frosterus took over the editorship of *Arkitekten*. The following month the journal published the competition designs for the Landtdaghus (Local Government Headquarters) in Helsinki. Saarinen took first prize with a scheme that was determinedly monumental and suggests the form of the later design by Adams, Holden and Pearson for the Senate House of London University. His former partners, Gesellius and Lindgren, entered a much more interesting design that followed the line of the original partnership, with particular reference to the original Helsinki Railway Station proposal. They were awarded second prize. Fourth prize went to Sonck for a design that blended monumentality with plasticity and certainly had the most interesting plan form. In his editorial published in the March 1908 issue of *Arkitekten*, Frosterus compared Saarinen's solution with Sonck's and made his preference for the latter quite clear.[40]

In 1908 work also began on Selim Lindqvist's Suvilahti Power Station, Helsinki (Figure 9). Here we see a delightful combination of national romantic form and detail with a new industrial imagery. In its main pavilion Lindqvist's Suvilahti Power Station anticipates Peter Behrens' AEG Turbine Factory in Berlin (completed in 1909).

The atmosphere in the architectural world of Helsinki in the first decade of the twentieth century was keenly competitive. Both the social and professional worlds were small and tightly prescribed and the sense of close friendships combined with clear expressions of envy and enmity that were born then still characterize relationships between architects in the Finnish capital. Saarinen's position as leader of the profession was always a vulnerable one, which he constantly strove to defend in his efforts to develop a new post-national romantic style. Certainly, in his design for the department store Helsingfors Magasins (1911),[41] Saarinen once again put himself ahead of his colleagues, for this project clearly leads the way to the 1918 design by Frosterus for the Stockmann Department Store.

Indeed, Saarinen and Frosterus learned a great deal from each other in the period that followed.

For example, in his Taos House block of flats in Helsinki, completed in 1913 (Figure 11),[42] Frosterus developed a simplified plasticity of modelling in the façade that looked towards modernism, and the oriel windows over the ground-floor openings in his design were emulated by Saarinen in the Lahti Town Hall (1922–12).[43] The Kajana Primary School competition (1913)[44] shows Frosterus leaning on the inspiration of Saarinen's Helsingfors Magasins design while creating a stepping stone towards his approach to the Stockmann Department Store. Kauno S. Kallio was also influenced by the simple dignity of the modified Saarinen design for Helsinki Railway Station in his church at Alavus (1913–14),[45] which has nave vaulting reminiscent of John Soane's work.

By 1915 the emphasis in much new Finnish work was strongly eclectic. This element had already been present much earlier, for example in the work of Professor Gustaf Nyström. His predilection was for the Italian Renaissance, with his Föreningsbanken (Co-operative Bank) in Helsinki (completed in 1899) having a strong Palladian influence, while his Finnish Bank in Turku (completed in 1901) follows the design of the Florentine palazzo in its ground floor. The cornice is also Florentine, while the windows between are a hybrid of Italian and English Renaissance. In the interior, however, he used the Greek neoclassical style, with Doric columns in the entrance hall.

The pattern of Finnish architectural competitions frequently results in an architect other than the winner getting the actual building commission. This was the case with the Stockmann Department Store project (1918), where Valter and Ivar Thomé took first prize, while Frosterus won second prize and the commission. Interestingly, Saarinen's entry, which was awarded third prize, seems once again to be more progressive with its large areas of glass on both the ground and first two upper floors, giving a much lighter appearance to the building volume. But Frosterus's design was distinguished by its bold internal arrangement, which had an atrium in the centre with galleries on the upper floors looking down upon the open-plan ground floor (Figure 12). The national romantic influence was no longer evident in the entries to this competition and the design by Oiva and Kauno S. Kallio showed a distinct neoclassical preoccupation, both in the symmetrical, blunt 'arrowhead' plan form and the fenestration.

In 1916, Frosterus wrote a leader in *Arkitekten*[46] illustrating a Saarinen project for a commercial building on Keskuskatu (Central Street),[47] which is a variation on Saarinen's design for the adjacent Stockmann site. And yet a further variant of this design appears in Saarinen's drawings for the town hall in Turku, demonstrating that the architect was confident in this new mode of expression. With his Kalevala House project for an insurance company (1921),[48] Saarinen returned for the last time to the national romantic idiom, with a great medieval-style tower that recalls the Hanseatic architecture of the Baltic region (Figure 17).[49] On the other hand, Saarinen's Cinema Palace (1920–21),[50] also in Keskuskatu, continues the new urban brick style established by Frosterus's Stockmann Department Store project across the street, but with a new boldness in the *piano nobile* and a definite attic of two storeys. The use of red brick was to become an important element in Aalto's urban statements after the Second World War.

With the staging of the competition for a regional museum at Vaasa on the Gulf of Bothnia in 1922[51] a new medieval romantic revival style emerged briefly. Kaarlo Borg, Johan Sigfrid ('Jukka') Siren and Urho Åberg received the first prize, with Eino Forsman second and Arnold Erickson and Uno Moberg third. The new romantic revival of Ragnar Östberg's Stockholm City Hall (1909–23) was clearly experienced in Finland, too. Entries for the *Chicago Tribune* Tower competition (1922) were illustrated in the same issue of *Arkitekten–Arkkitehti*, with Saarinen's second-prize submission obviously pandering to the American historicist preference for medieval imagery. In a similar vein, the Jarl Eklund and Einar Sjöström entry for the *Chicago Tribune* Tower was

Figure 17

Eliel Saarinen

Kalevala House project for Helsinki (1921): this design already shows Saarinen settled into a tired and monumental formality just prior to his *Chicago Tribune* Tower competition entry and his emigration to the USA.

modelled on the traditional stepped-gable Danish church form.

By this time *Arkitekten–Arkkitehti* was in its twentieth year of publication and one of its avid young readers was Alvar Aalto. He was clearly impressed by issue No. 2 of 1923, entirely devoted to Italy and particularly by the article 'Italia la Bella',[52] which included travel sketches of the Italian landscape and architecture by Hilding Ekelund and Erik Bryggman. But one wonders how he must have reacted to the following issue of *Arkitekten–Arkkitehti*, which included illustrations of Sonck's competition entry for a church on the island of Suomenlinna.[53] Sonck's design was clearly modelled on the neoclassical architecture of St Petersburg and, in particular, the distinctive silhouette of the church on the fortress island of St Peter and Paul, although his plan form is reminiscent of Engel's Great Church in Helsinki (1830–40; Figure 1).[54] Sonck eventually incorporated this tower into his design for the St Michael Agricola Church, located close to his Eira District Hospital in Helsinki (Figure 7), which was completed in 1935.

The year 1923 brought Eliel Saarinen's fiftieth birthday and his emigration to the United States. Issue No. 7 of the 1923 volume of *Arkitekten–Arkkitehti* was designated as Saarinen's fiftieth-birthday tribute, but it was in fact mostly devoted to Swedish architecture, particularly the work of Ragnar Östberg.[55] For Finnish architects the most notable thing about 1923 was to be the competition for the Finnish Parliament Building. By 1924, with Saarinen safely in the United States, *Arkitekten–Arkkitehti* could devote a long section to his designs for the *Chicago Tribune* Tower and the Lake Shore development, including Grant Park, Grant Plaza and the Grant Hotel.[56]

The Parliament competition was formulated to allow the entrants in the first stage to propose their own ideal location. Aalto entered with a design for the harbour site immediately beneath the Russian Orthodox Cathedral, the location that was eventually to accommodate his design for his Enso-Gutzeit Headquarters (1959–62). Aalto's Parliament design was mentioned with the three first-stage winners and was purchased under the normal Finnish competition system by way of compensation. Hilding Ekelund won first prize; but once again it was the second-prizewinners – Borg, Siren and Åberg – who, as the result of a further stage of the competition, were eventually given the commission to build this important national symbol.[57] The design selected for execution represented something of a setback to the evolution of modernism in Finnish architecture (Figure 18).[58] Rather than being an expression of the new freedom of the Finnish people it represented a return to the classical formality of Helsinki's origin under the Tsar, but without the freshness and charm of Engel's designs. In spite of some experimentation in the detailing – the capitals to the interior columns are a fine example – the overall effect is heavy and pompous.

In strong contrast to the outcome of the Parliament competition, the designs entered for consideration by the Viipuri Town Hall jury later in 1923 showed the marked influence of the Stockholm City Hall designed by Ragnar Östberg. This influence can be observed especially in the entries of Jussi and Toivo Paatela, Hilding Ekelund and Uno Ullberg.[59]

Meanwhile, the strong-spirited Finnish designs that had characterized the development of a new national architecture at the beginning of the century faded more and more into the background. In his Arena buildings, a block of offices and flats on the corner of Hämeentie and Siltasaarenkatu, Helsinki, Sonck adopted a bland formula of neoclassical massing,[60] while Oiva Kallio's wooden Aurejärvi Church at Kuru (1921–24) was based upon traditional Finnish models combined with an open-posted, wooden, pyramidal tower that seems to derive more from Norwegian examples.[61]

The second-stage result of the Parliament competition only served to confirm Siren's monumental neoclassicism, with the second prize going to Hilding Ekelund's Italian Renaissance design and Armas Lindgren carrying off the third prize with an

extremely pious neoclassical solution.[62] Jussi and Toivo Paatela clearly thought it prudent to back two horses and, although adopting the general style and character of Östberg's Stockholm City Hall, managed to combine this with a distinctly neoclassical portico. But by far the most astonishing design was by Einar Wikander, who produced a cruciform plan with an octagonal drum and a dome in the Persian style. And, as if this were not enough evidence of eclectic propensities and talents, he added two untapered obelisks to his design, at the foot of which were copies of the equestrian sculptures from the top of the approach ramp to the Capitoline Hill in Rome.

When Aalto opened his first office in Jyväskylä in 1923, Finnish architecture was in the grip of extreme eclectic confusion. Following the strength and clarity achieved by the Saarinen, Lindgren and Gesellius partnership and Lars Sonck among others, the pathways established by Finnish architects in the last decade of the nineteenth century and the period leading up to the First World War became obstructed by stylistic snares scattered across the terrain. It seems ironic that the intense spirit of idiosyncratic Finnish nationalism should have failed at the very moment when the Finnish nation achieved its independence from Russia following the Bolshevik Revolution. Yet this liberation from centuries of a foreign imperialist yoke was bound to engender a reaction in the Finns, whose very individualism had been fed by alien oppression and the need to maintain an identity in the face of its humiliations and frustrations.

Indeed, the whole sense of nationalism and of a national style gathers strength from the compulsion to struggle and survive, the determination to preserve a national heritage in a climate of total political suppression. With the drive towards political and cultural freedom achieved, the intensity of nationalist fervour is bound to relax somewhat in victory.

This, then, might explain in part the state of confusion among Finnish architects in the 1920s, shortly after the triumph of Mannerheim's White Army over the Reds. But there is another equally significant explanation and that concerns a new passion among the liberated Finns. There was born with Finnish independence a determination among certain intellectual groups, including many architects, to overcome the isolation that both Swedish and Russian domination had brought to Finland and to forge links with the wider world of Western culture. Nationalism was therefore diluted by a desire, at least a covert desire, to become part of a more international cultural milieu. This propensity was to bring new conflicts in its wake. Eventually these conflicts generated a new sense of 'Finnishness' in Finnish architecture.

The landscape of Finnish architecture in the 1920s is therefore not only picturesque and colourful, but it also contains elements essential to our understanding of the emergence of Aalto's eclectic modernism and the birth of a distinctively Finnish modern architecture. We must now travel through that landscape in order to explore the Finnish terrain of Nordic classicism.

Figure 18
Johan Sigfrid (Jukka) Siren Parliament Building, Helsinki; architect's original perspective sketch for the competition (1923): the projection of an aloof, totalitarian granite 'box' has been well preserved in the executed Parliament. It represents the high point of probity in Nordic classicism and the low point of Finnishness.

References and notes

[1] Reyner Banham, 'The last of the new: the rise of modern architecture in Finland', *Architectural Review*, April 1957, pp. 243–59.

[2] Charles Jencks, *The Language of Post-Modern Architecture*, Academy Editions, 1978.

[3] 'My colleagues and I, in Finland, adhered to the theory that the nature of materials decides the nature of form. This was by no means an original thought; rather, it was a fundamental one. But this fundamental thought had for so long been buried beneath all kinds of accumulated stylistic nonsense, it was necessary to dig it out from its ornamental grave and reinstate it in its place of honesty. To do this, however, meant that one had to go backwards in time to a period when the employment of material was honest. Such a step was necessary to gain the necessary knowledge.' Eliel Saarinen, 1900.

[4] Carlo (Charles) Bassi (1772–1840), a Swedish-trained Italian architect.

[5] Carl Ludwig Engel (1778–1840), a German architect in the service of Tsar Alexander I of Russia.

[6] John Boulton Smith, *The Golden Age of Finnish Art – art nouveau and the national spirit*, Otava, 1975.

[7] Aulis Blomstedt (1908– 1979), younger brother of architect Pauli Blomstedt and a leading academic theoretician in the immediate post-Second World War period.

[8] Malcolm Quantrill, *Reima Pietilä: architecture, context and modernism*, Rizzoli, 1985.

[9] The courtyard house at Muuratsalo and the architect's studio in Helsinki reflect the development at Säynätsalo and the Vogelweidplatz project for Vienna.

[10] This is the first issue of *Arkitekten*, which was edited by the architect Bertel Jung. He remained as editor until Waldemar Wilenius took over with effect from January 1906.

[11] The article gave special emphasis to Butterfield's All Saints' Church, Margaret Street, London, W1; St Peter's, Ealing; and Norman Shaw's New Zealand Chambers and the Alliance Assurance Company in Pall Mall. In addition it discussed in some detail the work at Port Sunlight by Maxwell and Luke (Workers' Housing), Douglas and Fordham (School) and Grayson and Ould (the Post Office). There was also reference to E.W. Mountford's Northampton Institute in Clerkenwell.

[12] Finland was annexed by the Swedes in 1362 and remained part of Sweden until 1809, when it passed under Russian domination as a result of the invasion by Alexander I in 1808.

[13] *Arkitekten*, March 1905.

[14] Now the established industrial centre of Finland and known affectionately by Finns as its Manchester.

[15] Although he was highly critical of the design in his later years, while he was engaged in the building of the St Michael Agricola Church in Helsinki (completed 1935) – a highly mannered brick structure, which demonstrated Sonck's inability to work in the modern idiom.

[16] *Arkitekten*, October 1903.

[17] *Arkitekten*, October 1905.

[18] *Arkitekten*, December 1905.

[19] *Ibid.*,

[20] *Arkitekten*, March 1904.

[21] When the studio in the main wing of the house was finished and Lindgren and Saarinen moved to their new quarters, the original studio and workshop on the ground floor were converted into stables.

[22] The partnership was finally dissolved in 1907 with the withdrawal of Gesellius, Lindgren having left two years earlier.

[23] The *rya* is a deep-pile, handwoven and knotted rug traditionally used to decorate the interior walls.

[24] Louis Sparre (1863–1964) was a Swedish noble, who had been an art student in Paris with Gallén-Kallela. As an enthusiastic amateur, on a visit to England in 1896 he met Charles Holme, who had just bought William Morris's former home, the Red House. Sparre brought English Arts and Crafts ideas back to Finland and his Iris factory is modelled on Morris's earlier example.

[25] *Arkitekten*, September 1904, p. 66, for original competition drawings.

[26] George Baird, *Alvar Aalto*, Simon and Schuster, 1971, pp. 11–14.

[27] *Arkitekten*, February 1905, pp. 17–24, for this revised design.

[28] *Arkitekten*, October 1904, p. 70.

[29] *Ibid.*,

[30] *Arkitekten*, March 1908, pp. 34–35.

[31] *Arkitekten*, December 1908, pp. 122–131.

[32] *Arkitekten*, April 1909, p. 91, where Saarinen's pen-sketch perspective is published.

[33] *Arkitekten*, September 1909, pp. 124–125.

[34] Completed in 1906 and restored in 1968 by Professor Aarno Ruusuvuori, it now serves as an exhibition space of the Helsinki City public relations department.

[35] See above.

[36] Although not as extreme as Furness's mannerism, there are strong affinities between Sonck's handling of façade elements and those of Furness, as for example in Furness's Bank in Philadelphia.

[37] Nikolaus Pevsner and J.M. Richards, *The Anti-Rationalists*, Architectural Press, 1973.

[38] It is, for example, characteristic of Aalto not to give special importance or emphasis to the main entrance of a public building, as in the National Pensions Institute, or to virtually conceal it, as in the town hall at Säynätsalo and House of Culture, Helsinki.

[39] Ake Tjeder, Chairman of Artek Limited, told the author in 1979 that he would get telephone calls in the afternoons from Aalto, when the architect was bored by the office, with the suggestion that they hold a 'board meeting' in the Adlon Bar!

[40] *Arkitekten*, March 1908, pp. 29–30.

[41] *Arkitekten*, November 1911, pp. 119–120.

[42] *Arkitekten*, January 1913, pp. 3–5.

[43] The Lahti Town Hall tower provided the model, in turn, for Saarinen's later Canberra design.

[44] *Arkitekten*, October 1914.

[45] *Arkitekten*, No. 3, 1915, pp. 30–37.

[46] 'Den nya arkitetturen,' *Arkitekten*, No. 9, 1916, pp. 103–108.

[47] Keskuskatu or Central Street leads from the railway station square to the Swedish Theatre and Esplanade Street.

[48] *Arkitekten*, No. 3, 1917.

[49] *Arkitekten–Arkkitehti*, No. 3, 1921, pp. 7–12.

[50] *Arkitekten–Arkkitehti*, No. 6, 1922, pp. 81–85.

[51] *Arkitekten–Arkkitehti*, No. 7, 1922, pp. 97–104.

[52] *Arkitekten–Arkkitehti*, No. 2, 1923.

[53] *Arkitekten–Arkkitehti*, No. 4, 1923.

[54] Now the Helsinki cathedral of the Lutheran Church.

[55] *Arkitekten–Arkkitehti*, No. 7, 1923, pp. 145–160.

[56] *Arkitekten–Arkkitehti*, No. 7, 1923.

[57] *Arkitekten–Arkkitehti*, No. 6, 1923.

[58] *Arkitekten–Arkkitehti*, No. 7, 1924, pp. 85–98, for a review of the designs for the second stage of the Parliament competition.

[59] *Arkitekten–Arkkitehti*, No. 2, 1924, pp. 15–24.

[60] *Arkitekten–Arkkitehti*, No. 3, 1924.

[61] *Arkitekten–Arkkitehti*, No. 4, 1924, pp. 52–56.

[62] *Arkitekten–Arkkitehti*, No. 7, 1924, pp. 85–98.

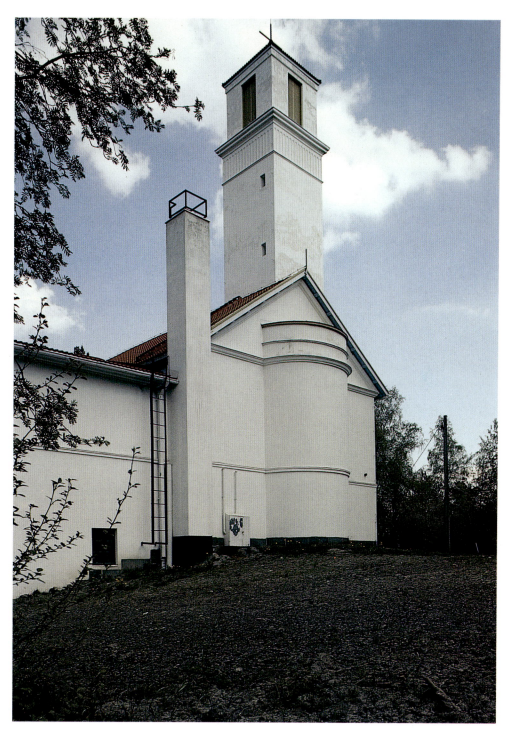

Figure 19
Alvar Aalto
Parish Church, Muurame (1926–29): a less familiar view of the apsidal end and tower, in which the classical forms are equally assertive.

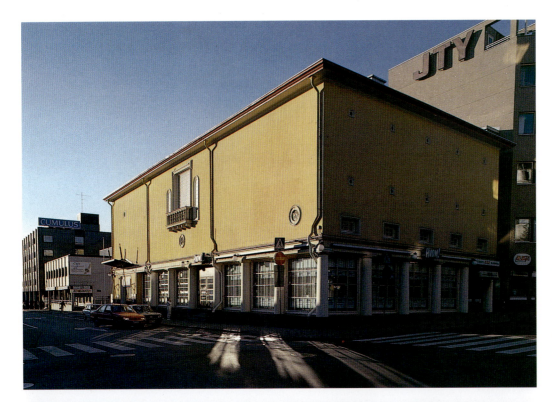

Figure 20
Alvar Aalto
Workers' Club, Jyväskylä (1923–25): view of long elevation from street corner, showing the Palladian window motif at first-floor level, with Doric columns below.

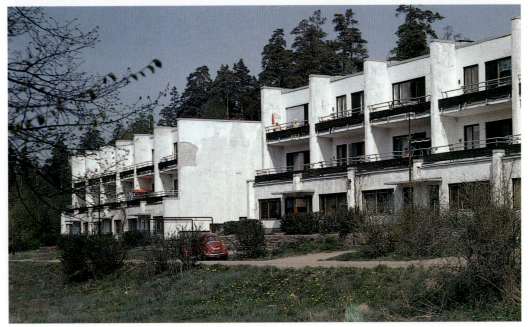

Figure 21
Alvar Aalto
Housing for pulp-mill engineers at Sunila (1938–39): this terrace is stepped in section and the plan is 'fanned' to increase privacy.

Figures 22–24
Alvar Aalto
Villa Mairea (1937–39): general view of rear garden, with studio (right); interior with main staircase and view of garden (below, left); detail of living room, with rattan-wrapped column (below, right).

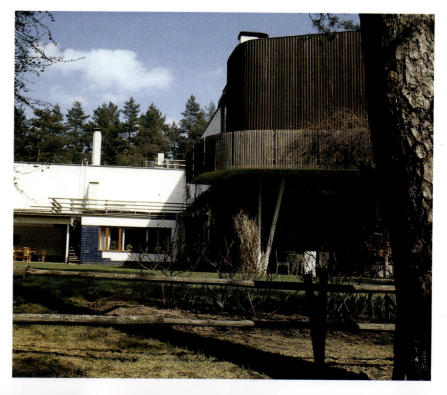

Figures 25–27
Erik Bryggman
Funeral Chapel, Turku (1938–41): tower from below (right); exterior view, on approach, of portico and chapel (opposite, top); interior of asymmetrical nave (opposite, bottom), with seating to left of aisle and natural lighting from windows in lower right-hand nave (giving views out across the garden).

Finnish Architecture and the Modernist Tradition

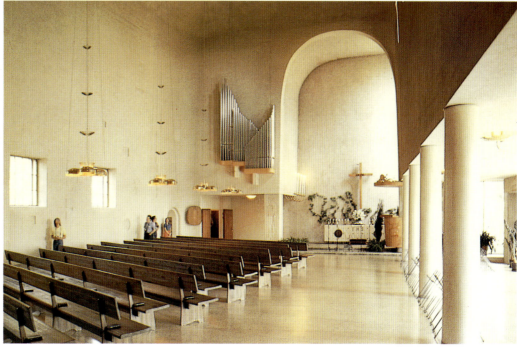

Finnish Architecture and the Modernist Tradition

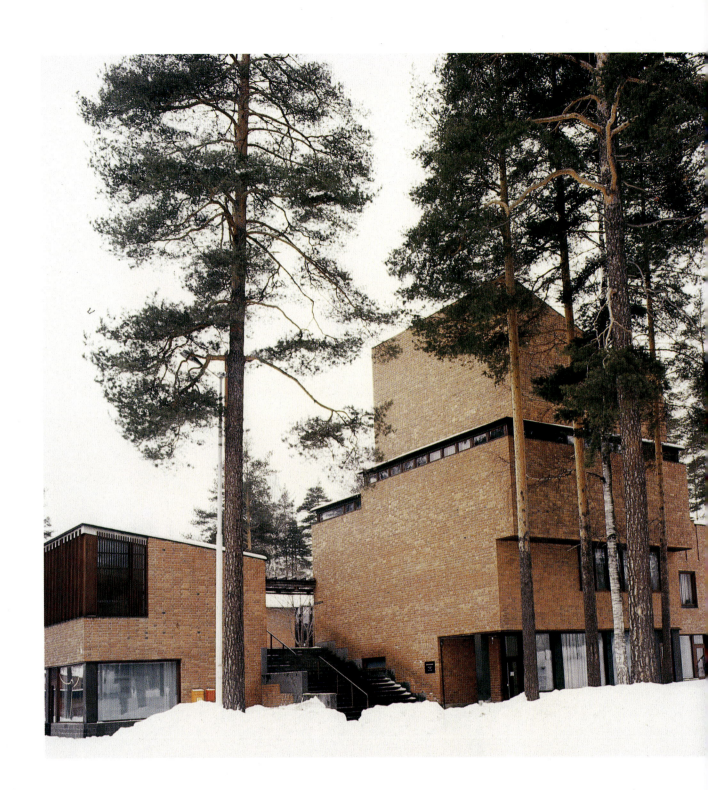

Finnish Architecture and the Modernist Tradition

Figures 28 and 29
Alvar Aalto
Town Hall, Säynätsalo (1949–52): the three-dimensional composition of the building masses, although superficially medieval, is based on De Stijl and constructivist premises (far left). The roof trusses in the council chamber recall a barn roof, appropriate for the farmer councillors. This building incorporates a myriad of ideas, yet is visually available to 'the man in the forest'.

Finnish Architecture and the Modernist Tradition

Figure 30
Aino and Alvar Aalto
Woodberry Poetry Room in the Lamont Library, Harvard University, USA (1948): an exquisite miniature of Aalto's approach to furnishing space, this relatively unknown work is a gem.

Finnish Architecture and the Modernist Tradition

2 The classicism of the 1920s

Recent re-examinations of Nordic classicism of the 1920s have begun to reveal the true complexity of eclectic attitudes during that period.[1] Previously there had been an inclination to suppress Alvar Aalto's complicity in those developments and concentrate instead on the emergence of the main line of his thrust into modernism. But it is increasingly clear that Aalto's involvement with Nordic classicism was more than just a passing fancy. Indeed, when we understand the historical roots of vernacular neoclassicism in Finland, then the broader spectrum of a common architectural language, which Nordic classicism was intended to reiterate and reinforce, becomes a significant and provocative cultural issue.

Central to the whole notion of Nordic classicism was a concern to identify and celebrate those elements of architectural language that thrive equally well in monumental classicism and its vernacular transformations (Figure 31). Far from being a superficial treatment that merely disguises a modernist intention, these universal images of classicism were proposed as an integral part of the familiarity and continuity of an established architectural language. The homogeneity of much functionalist architecture has been criticized for its failure to offer such cultural resonances, resulting in bland, repetitive volumes and surfaces. Of course, there are examples in the 1920s of a deterioration from the thoughtful uses of classicism to merely capricious attitudes in decoration. The underlying intent, however, was to replace what was seen as the arbitrariness of art nouveau exuberance with a new homogeneity and coherence that stemmed from the classical tradition. This notion of coherence was very much connected with the image of the street and town and clearly had its applications in new suburbs such as Käpylä near Helsinki (Figures 32, 33). Nordic classicism offered a full range of expression from a commanding authority to a seductive charm: it was an international movement; but its national variations drew upon vernacular classicism, which gave Nordic classicism its great diversity.

Although architectural expression in Finland during the 1920s was dominated by Nordic classicism, J.M. Richards makes no reference to this phenomenon in *800 Years of Finnish Architecture* (1978). Richards' treatment of national romanticism and its sister style, art nouveau, is relatively extensive.[2] When he comes to the decade that preceded Aalto's bold introduction of modernism in the Turun Sanomat Building (1927–29), however, he describes only two works. The first of these is the wooden housing at Käpylä, Helsinki (1920–25), by Martti Välikangas, of which he writes:

'....(based on) a plan devised by B. Brunila and Otto I. Meurman and others.... (it) clings to the English garden city principle, though with a rectangular grid layout and to an architectural style based on the Finnish tradition of building in wood.'[3]

Although Richards observes the difference of this Finnish example from that of the English garden city in the rectangularity of its overall plan, no connection is made between such a distinctive geometrical discipline and the historical associations implicit in the obviously classical intentions of the planners and architects. And the phrase 'clings... to an architectural style-based on the Finnish tradition of building in wood' is quite meaningless. Interestingly, also, we find that in his

Figure 31
Architect unknown
Late nineteenth-century residential building, Turku: an elaboration of the wooden classical style of the early 1800s, in which motifs such as keystones became exaggerated symbols.

discussion of 'Wooden town houses'[4] Richards gives prominence to the late Victorian work of, for instance, Augustus Helenius[5] at the expense of more consequential earlier classical examples in both Rauma (Old Town) and Tampere. Again, in his chapter on 'The rural vernacular' Richards describes a delightful piece of rural neoclassicism in Ostrobothnia, saying simply:

'In this province two-storey farmhouses became common in the nineteenth century. This is a typical example, standing in the flat countryside east of Vaasa. It has red boarded walls with white trim and window surrounds ornamented in a style similar to those in many of the neighbouring seaport towns'.[6]

Was it perhaps the critic's obvious delight in Victorian excesses that led him to seek out the picturesque and thereby miss the evident link between those Ostrobothnian farmhouses and Martti Välikangas's design for Käpylä? Richards' description of Aalto's Jyväskylä Workers' Club (1923–25; Figures 20, 37) appears to confirm his resistance to the evidence he examined. He refuses to connect the persistent neoclassical forms and ideals in Finnish nineteenth-century vernacular architecture and their virtual renaissance in the 1920s in sympathy with the Nordic classicism that prevailed in Sweden, Norway and Denmark; rather, he simply asserts that the Workers' Club is:

'... a typical example of Alvar Aalto's early work in his home town... The accommodation inside – a meeting room above and a restaurant below – is clearly expressed on the exterior and the sharply punctuated wall-surfaces echo some international fashions of the 1920s. These reveal an urge towards modernism which the superficial neoclassical treatment goes some way to disguise.'[7]

Although Richards visited Finland in 1934 to spend the summer with Viljo Revell at Aalto's suggestion, he makes no mention in his short essay 'A visit in the thirties'[8] to any of Aalto's earlier work of the 1920s. When Richards writes of 'the classics of Alvar Aalto's early period', he is referring not to that group of buildings which surely deserves this label, namely the National Guard Headquarters in Jyväskylä (1923) or the Muurame Church (1926–29; Figure 19), but to the *Turun Sanomat* Building (1927–29), Paimio Sanatorium (1929–33) and Viipuri Library, which was under construction during his 1934 visit. Richards does not say so, but it seems evident that Aalto did not show his English visitor these earlier works in the vein of Nordic classicism. Yet Richards must have known of their existence and we can only conclude that he did not know what to make of them either in 1934 or when he wrote *800 Years of Finnish Architecture* more than four decades later.

Simo Paavilainen summarized a prevailing view that the housing at Käpylä is one of two outstanding monuments of Finnish classicism in the 1920s and there is general agreement among Finnish critics that Jukka S. Siren's Parliament Building was the crowning achievement of that period.[9] In order to compete with the rest of Scandinavia in the romantic classic style, Finland needed a major public building to prove itself and the Parliament Building by Siren became that monument (Figure 18). Käpylä was, however, no less important an expression of Finland's emergence as an independent nation. But the Finns themselves were not unanimous in their endorsement of the Käpylä wooden buildings. It is almost as though, when comparing them with the monumentality of Siren's Parliament scheme, they found their homely qualities disappointing and embarrassing. Although it combined the ideas of a simple way of life, a straightforward use of materials and references to classical architecture, Käpylä seems to have reminded people too much of the modest rural past of Finland with its gently pitched roofs, plank fences and earth colours. If the architecture of this new classicism was to represent a search for an identity through agreed standards of beauty, then perhaps Käpylä was too rough and crude to inspire such admiration?

Figure 32
Martti Välikangas
Garden Suburb at Käpylä, Helsinki (1920–25): the wooden classical style is freely interpreted to create a housing development of intimate scale with references also to the tradition of rural Finnish wooden buildings. Keystones and other features are emphasized.

Figure 33

Martti Välikangas

Garden Suburb at Käpylä, Helsinki (1920–25): a typical gateway in the fences that link the different housing units.

P.E. 'Pauli' Blomstedt, himself a dedicated classicist, wrote an article in 1928 that ridiculed classicism, predicted its end and heralded the advent in Finland of the new Le Corbusier style. Nevertheless, Blomstedt's Union Bank in Helsinki, completed in 1929 (Figures 41–43), has a classical base, although the office storeys above the street arcade show the influence of Louis Sullivan's work, particularly the Wainwright Building in St Louis, United States (1890–91), its pilasters becoming mere vertical strips with windows and spandrel panels between. This device was closely followed by Gösta Juslen in his Fazer Office Building (1928–30).

Under the title of 'Architectural anaemia: a nation examines itself', Blomstedt attacked the over-refinement that the thesis 'only the simple is beautiful' had generated in Swedish work and the fact the Finns were content to follow Swedish examples. His particular target was the uniformity of appearance based upon the repetition of stock items of decoration – medallions, garlands, stars and standardized treatment of windows (planted on the surface in the lower storeys and sunken at the attic!). He accused architects of 'seeking a refined taste and copying the latest fashion in the manner of tailors'.

In *Finnish Architecture* (1959) Nils Erik Wickberg made no mention of Aalto's Jyväskylä Workers' Club. This is a surprising and significant omission, considering that the dual-axial plan of the building provides an important link between Aalto's early work in the national romantic classic mode and the planning of such key modernist works in the Aalto *oeuvre* as the Viipuri Library and the Villa Mairea. But concerning the Käpylä garden suburb, Wickberg's intuition is infallible and his perception reflects the clarity of the work:

'Brightly painted wooden houses, representing the typical classicism of the 1920s. This coherently planned residential area creates an attractive environment reminiscent of small Finnish towns of the Empire period.'[10]

Richards acknowledges Wickberg's *Finnish Architecture* in his bibliography, acclaiming it as 'The best general account by a Finnish historian', yet he clearly ignored the information Wickberg provided. Wickberg's *Empire Studier* (1949) is not included in Richard's bibliography, possibly because it appeared only in Swedish. But *Empire Studier* established Wickberg's right to be heard and relied upon in matters of Finnish classicism, as does his *Carl Ludwig Engel* (1970), which did appear in English and is acknowledged by Richards.

In *Finnish Architecture* Wickberg certainly drew attention to the need for studying the work of the 1920s and understanding this difficult piece of the Finnish architectural jigsaw. In his chapter 'Towards modern architecture' Wickberg wrote:

'In the 1920s, neoclassicism had gained a foothold in the Northern Countries. (A contemporary phenomenon on the Continent was, for instance, the neoclassical phase of Picasso, then just succeeding his earlier Cubism.) Finland had an abundance of models in her richly creative Empire architecture of a hundred years earlier. In addition, there was the Italian Classical tradition. But after the First World War there was a slump in building. Even if this is ignored, it is clear that the 1920s were characterized by a subdued atmosphere: it was a period of relative calm between two periods of vigorous creative activity. The historical significance of the classicism of the 1920s may lie principally in the fact that it paved the way for the coming Modernism, the functionalism of the future, for, with its cubiform shapes and restrained ornamentation, it was more prosaic and precise than the architecture of the previous decade.'[11]

Wickberg's view was endorsed by Juhani Pallasmaa and Simo Paavilainen in their preface to the catalogue for the Nordic classicism exhibition of 1982:

'Going round Copenhagen's much admired Museum of Applied Art, one can find only one chair

Figures 34 and 35
Oiva Kallio
Villa Oivala, Villinki (1924): although the plan of this summerhouse is ostensibly classical and symmetrical, it has been freely adapted for its function, which is one of informality. Informality is certainly the theme of the villa's atrium, which becomes more of a patio, where the space and forms are softened by vines and irregularity. Poised between the classical and the rustic, between architecture and nature, it also occupies a position (both historically and conceptually) between Eliel Saarinen and Alvar Aalto.

Figure 36
Oiva Kallio
Entry labelled 'Urbi' in the town planning competition for the Töölö district of Helsinki (1925): a dream of a formalized and regimented Helsinki, based on Carl Ludwig Engel's classical beginnings, that was never realized.

Figure 37
Alvar Aalto
Workers' Club, Jyväskylä (1923–25): Aalto's ingenious revamping of a classical plan/form, including the reorientation of the interior by entering on the short (*y-y*) axis on the long side then switching to principal (*x-x*) axis through the length of the building at first-floor level. This bi-axial approach to building plans became a typical strategy in his mature work.

Finnish Architecture and the Modernist Tradition

representing the furniture design of the 1910s and 20s – a period considered at the time as a new peak in the field. And there is little more in storage. The furniture designed by Asplund for the 1925 Paris exhibition lies in a back corner of the Nordiska Museet in Stockholm, with no label or text to explain it. Things are no better in Norway and Finland! Nordic classicism is a forgotten era...The pre-modern classicism of the North has been thought of as a mere interlude between two serious acts in architecture, art nouveau and functionalism. Yet classicism was a meaningful and consistent phase in the development of Nordic architecture. After the last rigorous phase of classicism, which took Palladio and Letarouilly as its models, there was perhaps only one possible move left – the shift to functionalism.'[12]

Henrik Andersson commented in the *Nordic Classicism* catalogue on the recent interest of American architectural students in studying the characteristics of immediately pre-modern classicism in Asplund's Villa Snellman (1917–18) and traced the origin of this classicism in Nordic countries at the time of the First World War to German influences. In particular he drew attention to the fact that the prevailing mood of the Cologne Werkbund Exhibition of 1914 was not that evidenced by Henri van de Velde's art nouveau theatre, the rational constructivism of Gropius's model factory or the expressionism of Bruno Taut's glass pavilion. It could be found rather in a modern, non-academic classicism involving simplification and stylization of classical motifs and manifested in the building of such masters as Josef Hoffmann and Peter Behrens. Andersson also cited the work of Hermann Muthesius and the significance of a number of German publications in disseminating a revival of classical and neoclassical ideas.

Among these are works with such unambiguous titles as Paul Mebes's *Um 1800* (1908) and Paul Schultze-Naumburg's *Kulturarbeiten* (1920). The latter, in particular, advocated a return to the forms of neoclassicism and empire-style architecture in establishing an appropriate character for the streets of small towns and country mansions. Schultze-Naumburg's stress was on imparting a simple dignity to unpretentious, everyday buildings and the creation of architecture out of the common stock of human shelter. Heinrich Tessenow's ideas were also very influential through their explicit illustrations, particularly his *Hausbau und dergleichen* (1916) which came out during the First World War and therefore had a delayed impact.

Already in the early 1900s, P.V. Jensen-Klint argued in Denmark for a greater sense of architectural homogeneity, with a more regional sense of style and awareness of materials. He believed that excessive emphasis on the individual expression of particular buildings dissolved the homogeneity of the urban scene into chaos. Ideas about craft skills and the honest use of materials, which on the one hand correspond to Eliel Saarinen's 'in the nature of materials' philosophy, were connected in Jensen-Klint's mind not with a natural architecture in the romantic sense, but with one that has been conditioned by the regularity of the classical tradition. Those who followed Jensen-Klint saw ridiculed dependence upon historicism in Schultze-Naumburg's *Kulturarbeiten* illustrations. Instead, the excesses of individualism associated with national romanticism, Jugendstil and art nouveau, were displaced by a more authentic regionalism that sprang from the marriage of vernacular forms and local materials, with details that would bring classical order and uniformity to the whole.

The prevailing notion of 'chaos' arose from what was considered to be the failure of individual buildings and parts of those buildings, to conform to an overall pattern of coherence. And this notion poses the interesting hypothesis that regionalism requires noticeable regularity in order to become common experience, even if that repetition courts monotony. In fact, it was argued, this repetition would give the everyday architecture its commonality, offering a scaled-down and adulterated

Figure 38
Architect unknown
Block of flats with shops, Turku (*c.* 1925): an Egyptian version of the classical style (the window frames are replacements *c.* 1950).

Figure 39
Jussi Paatela
Haarla Residence, Tampere (1924): a sombre interpretation of a Palladian theme that gives a dour rendering of Nordic classicism.

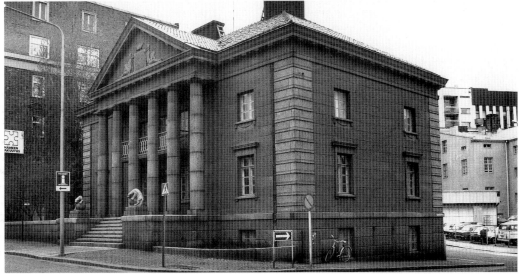

version of classical monumentality. Indeed, the very predictable nature of such a classical regionalism would provide the general architectural context, the background against which the occasional monument could be read as an exceptional event.[14]

These ideas found fertile soil in all the Nordic countries, but they had special relevance to Finland as an emerging nation. When, after nearly five centuries, the Finns exchanged Swedish sovereignty for semi-independence as a Grand Duchy of the Russian Empire it was Carl Ludwig Engel's elegant neoclassicism in the new capital of Helsinki that gave expression to this change of status. Following her achievement of complete independence in 1917, Finland faced the challenge of developing a modern architecture equally rooted in cultural tradition.

Finnish modern traditions stretched back for a full century, beginning with the work of Engel. Its most recent component was the experimentation with art nouveau that had produced Finland's national romantic style. But the true force of art nouveau and national romanticism was spent by the outbreak of the First World War. It was, furthermore, a style that was medieval in inspiration, reflective of dark ages and of struggle rather than of triumph and enlightenment. The close association of the national romantic expression with the revival of medieval forms and motifs in architecture endowed it with a certain resistance to modernity. Besides, there is an unwritten rule that a style that is lately dead cannot be successfully revived. Classicism, therefore, presented itself as the obvious candidate for revival. It had, after all, enjoyed several previous revivals at the hands of Leon Battista Alberti, Andrea Palladio and Christopher Wren, and more recently by Karl Friedrich Schinkel and Engel himself. Also, through the presence of Engel's work, Finland was in a real sense already in the grip of German classical culture. What could be more natural, or more tempting than to complement Engel's superb cornerstone monuments with an infill fabric of modernized classicism wrought on a more modest scale?

Of course, Engel was not the only architect to provide a historical context for Finnish classicism. L.J. Desprez's Hämeenlinna Church (completed in 1798) was the first neoclassical monument built in Finland, although even this was preceded by a long tradition of buildings constructed in a regional variant of the classical style: these included the Sederholm House in Senate Square, Helsinki (completed in 1757), Porvoo Old Town Hall (completed in 1764), Rauma Old Town Hall (completed in 1776), the Court House in Old Vaasa (completed in 1786) and the house on the Mustio estate by C.F. Schröder (completed in 1783). Carlo Bassi's Old University Building at Turku (1802–15) continued the development of neoclassicism under the Swedes, as did his later Åbo Akademi (1832–33) under Russian sovereignty.

Engel's work, beginning with the planning of Senate Square in Helsinki (1816) and continuing with the Senate House (1818–22), Guards' Barracks (1819–22), University of Helsinki Library (1836–45) and Pori Town Hall (completed in 1841) laid the foundation of Finnish classical work. This continued throughout the nineteenth century and included such diverse examples as Kristiinankaupunki Town Hall (1858) and Hampus Dahlström's University Student Union (1870), Theodor Hoijer's *Ateneum* (1887), Karl A. Wrede's commercial buildings on North Esplanade (1888), an office building in Erottaja by Theodor Hoijer (1889–91) and the House of Estates (1891) by Gustaf Nyström – all in Helsinki. These buildings clearly demonstrate that classicism remained alive throughout the period of national romanticism, making Kaunio S. Kallio's Tampere Civic Theatre (completed in 1912), in a modified version of early nineteenth-century neoclassical Doric style, simply further evidence of the survival of classical and neoclassical ideals for more than a hundred years. Kallio's design of the Tampere Theatre does have some art nouveau eruptions, but it is essentially a volume, or rather an assembly of flat surfaces, that depends upon the full modelling

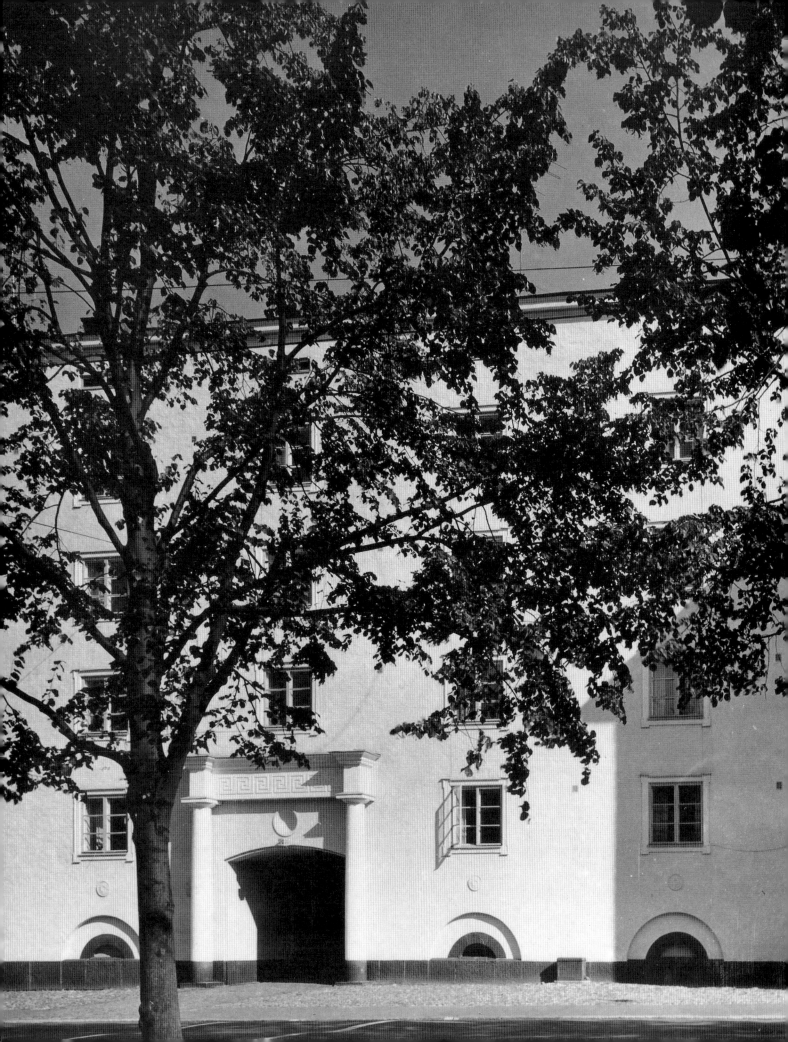

of the Doric columns for architectural quality. Certainly, the essentially Greek character of its main façade makes the Tampere Theatre a rather advanced design in the context of the Nordic countries on the eve of the First World War and Finnish independence.

As Paavilainen observed,[15] Finland did not flourish architecturally under Swedish rule and, although the nineteenth-century work of both Carlo Bassi and Engel provided significant examples in many key monuments, some Finnish architects sought to promote links with the classical tradition of eighteenth-century architecture in Sweden. After all, Finnish architects continued to be trained in Stockholm throughout the nineteenth century and it was perfectly natural that Elsi Borg, Hilding Ekelund and Eva Kuhlefelt-Ekelund, as Swedish-speaking Finns, should take an interest in Swedish gardens of the baroque and neoclassical periods and travel to Sweden to measure and draw them in the early 1920s.

Clearly, the continuation of classicism in Finland had several sources and stimuli. Hilding Ekelund also travelled and sketched in Italy, as already noted,[16] visiting and admiring Vicenza. But it was not only the work of Palladio that impressed him: he also fell under the spell of 'simple houses – just bare walls and holes – but with distinct, harmonious proportions' that make up *architettura minore*. Erik Bryggman, who went with him, became fascinated by the way the Italians built on slopes, while Martti Välikangas studied different combinations of building volumes. And Alvar Aalto, when he eventually followed in their footsteps, was to focus on the role of the atrium in classical planning. Although the national romantic movement in Finland is stressed as the predecessor of functionalist modernism, it is clear that there was a period of time between the two. This gap effectively spanned more than two decades, during which time classicism flourished in different forms.

Kaunio S. Kallio's Tampere Theatre is therefore a significant monument in the transition from nineteenth-century revivals to the advent of modernism. Although it cannot be compared with Hack Kampmann's New Carlsberg Glyptotek in Copenhagen (1901–06) in terms of purity of classical language and detailing, it nevertheless raises interesting questions about the relationship of architectural volumes to the use of classical columns and the treatment of planar surfaces, with particular reference to the use of freely interpreted forms of decoration. No other building designed or constructed in the Nordic countries between the turn of the century and the outbreak of the First World War raises these composite questions so effectively. Shortly after the war, however, Asplund's Villa Snellman (1917–18) grapples with the problem of surface decoration, while his Woodland Chapel (1918–20) and Ivar Tengbom's Stockholm Concert Hall (1920–26) focus on the use of columns against the volumetric composition. Kallio's Tampere Theatre attempts to take the classical tradition forward by proposing a composite of ancient and modern treatments. The next phase, entered after the war, focused instead on a simplification of the classical tradition, increasing the expanse of plain, untreated surfaces and making more sparing use of classical motifs that are essentially symbolic rather than archaeological in intent.

The relationship of surface and its enhancement or embellishment was treated by Carl Petersen in a lecture given at the Royal Danish Academy of Art in 1919, which is reprinted in the *Nordic Classicism* catalogue. Petersen's lecture, entitled 'Textures', refered specifically to his experience with the production of ceramics. His thesis addressed the interaction between the texture of ceramic objects and the glazes applied to them and his questions concerned how the one may enhance the other. He compared a poor result of glazing with a double image in a photographic print, arguing that the aim in producing the ceramic object ought to be 'solidity of surface' because 'a clear solid material surface is necessary to produce a pleasing textural impression'. The relevance of Petersen's arguments for a correspondence of

Figure 40

Gunnar Taucher

Public housing, Mäkelänkatu, Helsinki (completed 1926): a monumental solution in the classical vein – a sort of Finnish 'Karl Marx Hof' in intent that remained incomplete. The second block was not built.

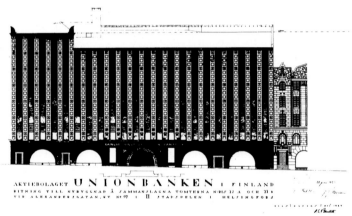

Figure 41
P.E. (Pauli) Blomstedt
Union Bank, Aleksanterinkatu Helsinki (1926–9): detail of classical entry level (with Greek-key motif) and junction with the pre-modern expression of upper floors. The Bank's plan (top, right) shows that it is distinctly derivative of a Pompeian villa layout. The elevation drawing (bottom, right) shows a classical arcade, surmounted by a pre-modern vertical strip treatment.

body texture and glazed finish in ceramics to the parallel problem of plain surface and enrichment in architecture is abundantly clear. Petersen's subsequent paper, 'Contrasts', given at the academy in 1920, emphasized this concept of 'clarity' which, he argued, resulted from contrasts of effect, producing a sense of changing scale, of frame and dispersal, of verticality and horizontality. And Petersen's conclusion in 'Contrasts' was that 'The same rules apply for ordinary dwelling houses as for great monumental buildings, namely, that proportions must be preserved and contrasts established.'[17]

He expressed his view of the necessary 'contrasts' with uncompromising clarity:

'In the old days, rooms seemed far more spacious because doors, windows and furniture were kept in smaller dimensions. As for the exterior of common dwellings... the more whole and simple it is, the larger and more monumental it will appear. Moreover, you will see that when you design a house on paper, you can make the building seem larger by making the windows and doors smaller.'[18]

At the very beginning of 'Contrasts', Petersen expressed regret that 'unfortunately, at present, we have no brilliant teachers of architecture as there are in music. Each of us must make do with personal experience and observation...' His personal observations relate to his experience of traditional architecture and urban forms, with a strong predilection for those contrasts and proportional relationships that can be observed in classical examples. Clearly, his ideas had great appeal for those who had just experienced the Great War and wanted to bring order out of the chaos of collapsing empires and changing values. Classicism was a natural vehicle for the re-establishment of order, but now, after the war, it was to achieve this regularity by different means.

Henrik Andersson confirmed that:

'Classicism may be regarded as a uniting feature: it brought the concepts of wood and stone building closer to one another and kept those of concrete materials near to traditional stone building. Swedish Classicism around 1920 does not strive after the abstract ideas of the Neoclassical; on the contrary, it exploits the effects of materials and surface by means of unity and economy of contrast.[19]

There is a significant shift in style evident between the publication of Eliel Saarinen's Plan for Munkkiniemi and Greater Helsinki in 1915 and the appearance of his design of the Helsinki Crematorium in the following year. The former mixes architecture and park in the English 'Garden City' mode, while the latter, which is also Saarinen's most monumental conception, is determinedly neoclassical in inspiration and form. This shift is perhaps an important clue to the demise of Saarinen's career in his native Finland; it is also indicative of the new beginnings we have outlined. The cement factory designed for the Kalkberg Company by Albert Richardson, also published in *Arkitekten–Arkkitehti* in 1916, has a neoclassical *parti* and details of what appear to be English Georgian inspiration, with only the manager's house conceived in a less formal, regional style.

The year 1917 brought the publication of two more classical designs. The first of these, in the regional, wooden form associated with Tammisaari and other western coastal towns, is a classical-style house by Gunnar Taucher at Kantvik. The second showed a proposal for a *Monumentalplatz* for Vaasa by Björklund, Helenius and Mÿntti. Two competitions of 1921 reveal that classicism had really taken hold: in the first, for Iisalmi City Hall, it is Oiva Kallio's design that conforms to classicist ideas, while Taucher's entry for the Kuopio State School competition follows suit. Further confirmation of this predilection for classicism was offered in the following year, when Borg, Siren and Åberg won the Vaasa Regional Museum competition with their entry and again in 1923 when Jussi and Toivo Paatela won the competition

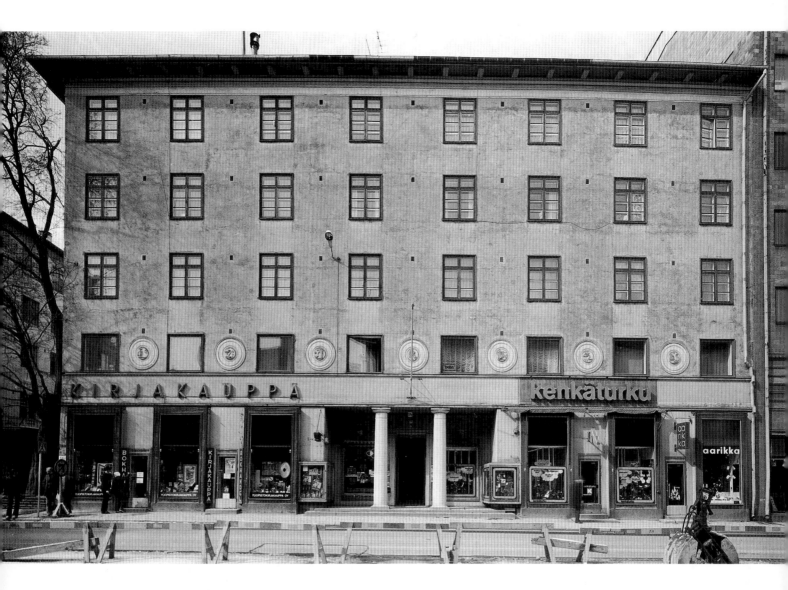

Figure 44
Erik Bryggman
Atrium Flats, Turku (1922–27): another example of the transition between a classical base and more neutral upper storeys.

for the original Tampere City Library. The publication of Lars Sonck's villa at Kirkkonummi later that year provided a strong national romantic contrast to the French classicism of Bertel Liljeqvist's villa and the American palladianism of another residential design by Juhani Vikstedt. Also in 1923, the work of Alvar Aalto appeared for the first time on the national architectural scene.

Among the architects whose work played an important part in the development of Finnish classicism are Jussi and Toivo Paatela, whose Tampere City Library was completed in 1925, followed by their Institute of Anatomy at the University of Helsinki (1926–27). Jussi Paatela also designed the sombre residence for the Haarla family in Tampere (completed in 1924). Oiva Kallio produced a plan for the reorganization of central Helsinki based on Siren's Parliament Building (1923–31), and his Villa Oivala (completed in 1924; Figures 34, 35) is a refined version of the work at Käpylä with its fine atrium. Bertel Liljeqvist's Crematorium Chapel for Helsinki (1924–26) provides the most austere example of the entire period, while Gunnar Taucher's housing in Mäkelänkatu, Helsinki (completed in 1926), remains the most monumental piece of Finnish domestic architecture from the 1920s (Figure 40).

Finnish classicism in the 1920s has three principal sources. First, the well-established tradition of classical architecture in Finland from the eighteenth century, both in its monumental civic forms and also in the everyday architecture of town and country houses. Second comes the twentieth-century revival of interest in classical forms and the inspiration drawn from travel outside Finland, connecting with new models throughout Scandinavia and ultimately to Italy and Italian examples as the true source. And finally, out of Italian explorations, particularly those of Hilding Ekelund, there is the connection back to the everyday aspect of the first source, the *architettura minore* of common building practice, which continues to feed on the spirit of the classical tradition, as in the *casa colonica* of Tuscany and the Veneto.

Hilding Ekelund occupies a unique position in the transformation of Finnish twentieth-century architecture. Born five years before Alvar Aalto, on 13 November 1893, his career spanned the classicism of the 1920s, the functionalism of the 1930s and the postwar rehabilitation period of the 1940s to 1960s. In addition, he served from 1931 until 1934 as Editor-in-chief of *Arkitekten–Arkkitehti*, the journal of the Association of Finnish Architects (SAFA), and was therefore at the very centre of the struggles and debate that surrounded the transition from classicism to modernism. According to Simo Paavilainen,[20] the entire history of classicism in the 1920s may be illustrated by Ekelund's personal contribution. Not only did Ekelund make study tours in Scandinavia, he worked in the office of the Swedish architect Hakon Ahlberg from 1920 until 1923, as well as immersing himself in Tessenow's book *Hausbau und dergleichen* and he travelled in Italy to acquaint himself with the subtleties of *architettura minore*. Thus, he prepared himself for a seminal role in the practice of architecture in Finland. In spite of all this preparation, however, he was never really successful in his professional career. As Paavilainen pointed out: 'Hilding Ekelund was the great star in the competitions of the 1920s, but he had incredibly bad luck as far as the execution of his plans was concerned. Almost everything he designed remained on paper.'[21]

Certainly, Ekelund's output of projects and drawings in the 1920s was phenomenal, and based upon this production Paavilainen suggested that Finland wasted an exceptionally talented town planner. He argued that Ekelund was accustomed to thinking in town-planning terms even when designing a single building; not content merely to satisfy traffic flow or to design noble monuments, 'he also thought of what the man in the street would like'. Certainly, Ekelund's perspectives, entered in the 1925 town-planning competition for the Töölö area of Helsinki, reveal his concern for a civic monumentality, in which vista and continuity are more important than individual buildings. The

Figure 45

Erik Bryggman

Competition project for Headquarters Building of the Suomi (Finland) Insurance Company (1928): Bryggman here demonstrates his facility with the essential language of modernism – the vertical staircase window, horizontal fenestration and roof terrace. He shared only second prize for this design.

Figures 46 and 47
Erik Bryggman
Competition projects for the South Karelian Tuberculosis Sanatorium and Paimio Tuberculosis Sanatorium (both 1929): in these designs, Bryggman demonstrates that his grasp of functionalist planning was equal to Aalto's (who won the Paimio competition).

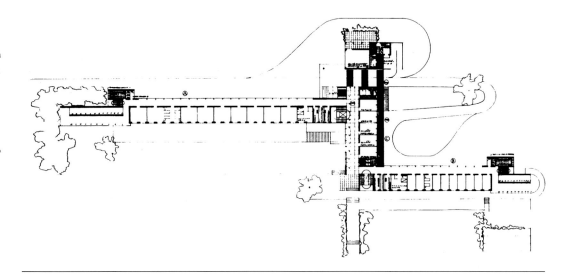

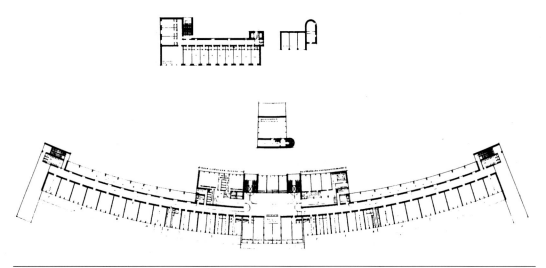

Figure 48
Alvar Aalto
Site plan of the Tuberculosis Sanatorium at Paimio (1929–33): here Aalto used for the first time the subtle change of axis that was to become his trademark. At Paimio this strategy has a strictly functional intent, opening up the forecourt to provide a generous and welcoming point of arrival.

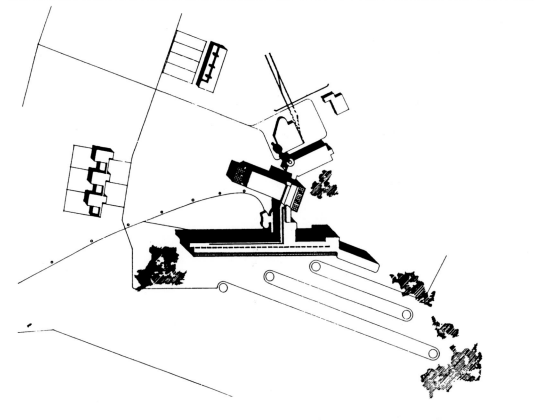

few public buildings by Ekelund that were realized, however, show a turgid formality or decorative fussiness that do not indicate a major architect of real talent. The Töölö Church competition of 1927, in particular, demonstrates the awkwardness of Ekelund's compositional ideas and forms, a difficulty already encountered in his second-prize design for the Finnish Parliament Building (1923). This problem seems to be connected with Ekelund's curious planning strategies, which may indeed be a consequence of his desire to think on a broader scale of town planning. Individual buildings do have to work as such, however, as well as contributing to the greater urban good.

In a situation where there is always the danger of seeing the evolution of Finnish modern architecture as a drama that has only the one actor, Aalto, it is important to value Ekelund's persistent efforts over five decades. Nevertheless, there is also the danger of overvaluing Ekelund's position on the basis of the breadth and extent of his drawing board production. His original design for the Viipuri Library (1927), although it took second prize and is even more indebted than Aalto's project to Gunnar Asplund's design for the Stockholm City Library (1920–28), should not be compared with Aalto's solution in its planning and formal subtleties. Ekelund may have been versed in practically all the main problems of architecture, as Vilhelm Helander proposed,[22] but it is unlikely that we are deprived of a significant contribution to modern Finnish architecture by the fact that only a handful of Ekelund's buildings was built. In the field of social architecture, however, as Helander reminded us, Ekelund's contributions were certainly not insignificant. The modest scale and thoughtful detailing of his public housing schemes perhaps show the true focus of his talents. And we can also trace through the process of simplification of forms in the Töölö Church (1927) and Helsinki Art Hall (1927–29) and in the functionalism of the Pohja Insurance Building competition (1928) and the Vallila Church competition (1929), the undeniable roots of the latter in the

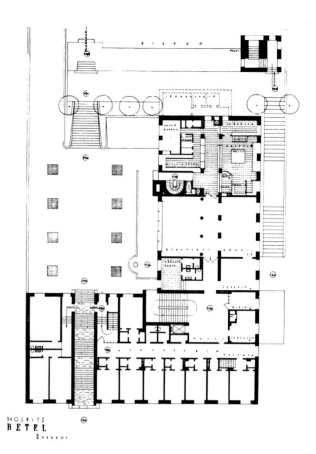

Figure 49
Erik Bryggman
Hotel Hospits Betel, Turku (1926–29): plan at first-floor level. The site slopes steeply and Bryggman combines this feature and the space between his Atrium block and hotel to suggest a Mediterranean urban space in the spirit of his experience of 'Italia la Bella'.

classicism of the former. Ekelund's strength as a town planner may possibly be a loss to the evolution of Finnish urbanity, but his architectural designs are only an indication of the average level of the struggle for new ideas in the 1920s and 1930s. Of much greater consequence, however, is the considerable and largely forgotten body of work by Erik Bryggman. Before introducing Bryggman's contribution, however, it is essential to trace here Aalto's own beginnings as an architect.

Aalto's first known involvement with building, the remodelling of the house in Alajärvi that became his parents' new home when they moved there from Jyväskylä in the autumn of 1918, was mainly concerned with the reorganization of the internal accommodation. The addition of a front porch, the supporting columns for which were placed away from the corners giving the triangular pediment a cantilevered appearance, cannot accurately be ascribed to the classical mode. This work, which dates from the winter of 1918–19, was demolished in the 1950s after Aalto declined a generous offer from the town of Alajärvi to move the house to another site because of some road improvements. Göran Schildt discusses five architectural projects form Aalto's student years 1917–21. These include: 'a park café' in a style reminiscent of nineteenth-century architecture in St Petersburg; 'Herrenäs Manor' with some distinctly neoclassical farm buildings in the composition; a 'Town Hall' with a massive central tower in the art nouveau style; and a design for the 'Grand Hotel Adalmina'. This hotel project is the most developed study and has neoclassical elements. For example, the façade above the street-level shops indicates green-painted stucco divided up by white pilasters that extend five storeys to support urns at the roof line. Also, the plan includes a covered winter garden that is centred on a fountain and surrounded by a colonnade.[23]

In July 1920 Aalto visited Stockholm, where he sought employment in the office of Gunnar Asplund. Although he also called at Ragnar Östberg's studio and visited the site of Östberg's emerging Stockholm City Hall, he seems to have fancied his chances of employment with Asplund. Asplund, however, who was still a confirmed neo-classicist at that point of his career (as shown by his recently completed Woodland Chapel), did not accommodate Aalto's ambition. Instead, the young Finnish architect was forced to travel on to Gothenburg to seek employment, eventually finding a job with Arvid Bjerke, one of the architects engaged in designing the Gothenburg Exhibition of 1923. He worked in Bjerke's office apparently for only a month or so, then returned to Finland by way of Denmark. In Copenhagen he visited the City Hall by Martin Nyrop (completed in 1892), whom the young Aalto admired alongside Östberg as representatives of a renaissance of Nordic design.[24]

Following his graduation from the Institute of Technology in the summer of 1921, Aalto visited the Latvian capital of Riga that autumn. The occasion was a modest exhibition of work by Finnish artists, for which Aalto had been appointed as a 'commissioner'. Early evidence of his aggressive professional opportunism is provided by the fact that several watercolours he had recently painted of Riga Old Town found their way into this exhibition. Aalto was invited to lecture at the exhibition opening; in his discussion of Baltic art, especially of Sweden and Finland, he made reference apparently to his pet notion of a Nordic renaissance.

After his return from Riga Aalto tried to establish an architectural practice in Helsinki during the winter of 1921. In fact, his first substantial commission did not come until the spring of 1922, when he was given responsibility for the architectural framework of Finland's second national fair at Tampere. Aalto's contribution to this project included a series of original pavilions that were well-received by critics, thus laying the foundation for his reputation as an exhibition designer.[25]

The Tampere National Fair opened on midsummer day 1922, after which Aalto was obliged to complete the compulsory military service that he

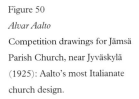

Figure 50
Alvar Aalto
Competition drawings for Jämsä Parish Church, near Jyväskylä (1925): Aalto's most Italianate church design.

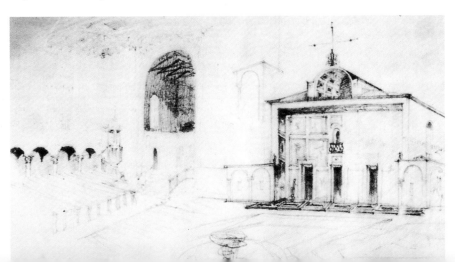

had been allowed to interrupt while finishing his studies. Following an initial period at the reserve officers' training school, Aalto served until June 1923. During these last weeks in the army he was already designing the villa for his relative, Terho Manner, in a neoclassical style with a pedimented, two-storey central pavilion entered from a robust Doric portico. Later that summer he designed another house, as well as a residential building in the Italian Renaissance style for a Jyväskylä tradesman, H. Heinonen, but neither project was built. While he was restoring the nineteenth-century Gothic revival wooden church at Toivalla he advertised that he also had an office in that town, although his main address remained at Töölönkatu 7 in Helsinki. He could not get work in the Finnish capital, however, and through his project in Jyväskylä he became aware that there was only one other architect in this important centre of middle Finland.[26] This realization persuaded him to return to Jyväskylä in October 1923 and establish his office there. He had not lived in his childhood hometown for seven years, although he had continued to visit his parents there from 1916 to 1918, prior to their move to Alajärvi.

While Aalto obviously had great ambitions for his new office, he began his business enterprise in Jyväskylä in one rented room, located in the basement of the City Hotel, which also provided his lodgings. He advertised his professional existence in the local newspapers and waited for clients to appear. During this waiting period he occupied himself in part with work for the Jyväskylä publisher, K.J. Gummerus, preparing illustrations and designs for book covers. He also engaged his first assistant, Teuvo Takala, who was the son of a local master builder.

Two important architectural competitions took place in Finland during 1923. The first of these, for the Finnish Parliament Building, eventually resulted in the romantic classicism of Jukka Siren's design (Figure 18); while the outcome of the second, that for Viipuri Town Hall, won by Aalto, showed a dramatic swing towards a revival of the national romantic style in emulation of Ragnar Östberg's Stockholm City Hall. Although Aalto demonstrated the eclectic variety of his own early interests in his designs for the 1922 Tampere National Fair, his work from 1923 until 1927 showed him almost entirely preoccupied with the romantic classicism that represented his own contribution to the Nordic renaissance.

The first stage of the Parliament Building competition was concerned with determining the location of the project (Aalto's entry proposed a site adjacent to Helsinki harbour). The significance of Aalto's entry for the original competition is that he saw the Parliament Building as the 'missing link' in Engel's composition for the centre of the new Finnish capital. In Engel's plan it was the Great Church, now the Lutheran Cathedral, that dominated the grouping of civic and university buildings in what was then the Russian Grand Duchy. But Aalto had the foresight of viewing the Parliament Building competition as the means of revising Engel's original design and completing its intentions by including the Parliament as the main political symbol of the new Finnish nation. His design, appropriately entered under the pseudonym of 'Piazza del Popolo', aimed to provide the Helsinki focus of the new national spirit, maintaining Engel's scale and simple massing in a single building expressed by a giant classical order. This design, had it been realized, would have closed the harbour frontage at its east end, framing Engel's City Hall and provided the major focus of civic activity and the cosmopolitan backdrop for a capital's 'downtown' that is still missing from Helsinki.

By the simple expedient of extending Engel's compositional framework right down to the harbour front and increasing the complexity of public space in the process, Aalto's design offered the possibility of concentrating the functions of the City Hall, Parliament and the Presidential Palace. This would have created a true sense of the capital city, perched at the edge of the sea with the dome of Engel's Great Church and the outline of the Uspensky Cathedral forming a powerful backdrop.

Figure 51

Alvar Aalto

Competition perspective for Parish Church at Viinikka (1927): Aalto's only proposal to use a round tower.

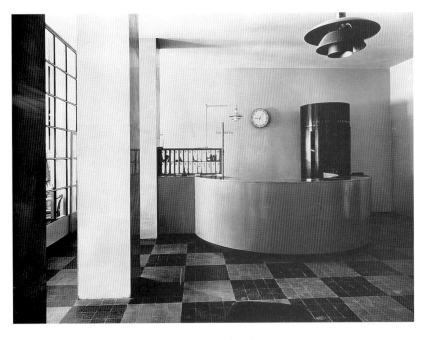

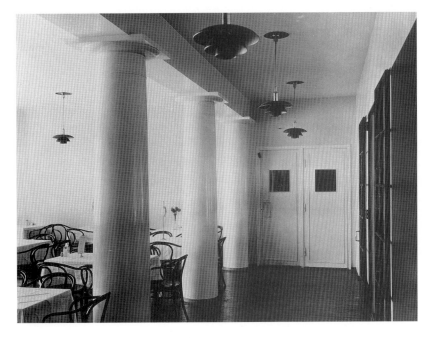

Figures 52 and 53

Erik Bryggman
Hotel Hospits Betel, Turku (1926–29): view of reception area (top illustration). The harshness of the chequered floor and square columns is relieved only by the cylindrical forms of the front desk and associated pieces. The dining room (bottom illustration), retains a reference to classical architecture (and the Atrium across the street) with a row of Doric columns that divides the dining area from the circulation spine.

The decision not to use the harbour site was a major factor in the irrevocable process of dismantling Engel's grand strategy to develop the natural centre of Helsinki. By selecting the Mannerheimintie site and attempting to create an entirely new urban focus based upon Saarinen's railway station (1904–14) and, later, the Central Post Office (1934–36), the political focus was lost in a confusion of civic and commercial elements. The opportunity of completing Engel's original statement therefore was gone forever. Furthermore, the attempt to generate a new structure for Helsinki's emerging form based upon this second nucleus of Siren's Parliament Building completely disregards the prerequisites of formal space and principles of classical composition in the city. As a consequence, the cold granite mass of Siren's Parliament Building remains aloof, detached and remote from its surroundings, a bleakly authoritarian monument that could hardly be further from the spirit of the newly liberated Finland.

When Aalto submitted his design for the second stage of this competition on the Mannerheimintie site in 1924 he abandoned the single, monumental building approach and the cohesive framework required by the context of Engel's buildings, offering instead a loose asymmetrical grouping of individual pavilions centred on the assembly chamber. In so doing, he showed, even at this early point of his career that, whereas one source of his design rationale had a distinctly classical basis, there was another complementary approach, which had its origins in the informal courtyard groupings of Finnish vernacular architecture. Indeed, from 1905 when his father bought Harjukatu 10 (Ridge Street) until 1918, young Alvar's home had been in such a group of buildings, comprising a single-storey wooden house, with board panelling and attic bedrooms with gable windows, a smaller house rented to tenants, stables and a baker's shop.[27] These two complementary forces – neoclassical formality and the informality of the Finnish farm and farmhouse (or the irregular Italian piazza) – were to remain

central to Aalto's design strategies throughout his mature career. These sources, coupled with the influence on him of the freely expressive planning and geometry of the national romantic movement, account for much of the elusiveness and sense of conflict in his later work.

There is a certain Italianate charm about Aalto's design for the Railway Workers' Apartments in Jyväskylä of 1923–24, although they do not have any remarkable quality other than the delicacy of the detailing. This was an essentially utilitarian building, with everything reduced down to absolute essentials and Aalto's decision to concentrate the decorative treatment on the arched doorways, balconies, the corbel brackets supporting the eaves and the rainwater downpipes is quite consistent with similar projects for workers' housing in England of the same period.

The commission to design the Jyväskylä Workers' Club, which also dates from 1923, provided Aalto with considerably more scope in the development of his classical design vocabulary (Figure 20). The planning and detailing of the Workers' Club established the standard for Aalto's design approach within this mode that was to continue through to his original, prize-winning entry for the Viipuri Library competition of October 1927. Whereas the Railway Workers' Apartments involved a stripping down to the barest architectural essentials, the Workers' Club gave Aalto the opportunity to design a truly civic symbol, albeit on a small scale. His response was to look towards a number of models of classicism. These included not only the Greek model of neoclassicism as developed in the nineteenth century by German architects, embracing Engel's and Carlo Bassi's work in Finland, but also the Danish derivatives Aalto would have seen in Copenhagen, and then something of Palladio, too, as well as the later details of the Palazzo Ducale in Venice. With the design of the Workers' Club, therefore, Aalto himself became part of the Nordic Renaissance.

The club was designed as a freestanding

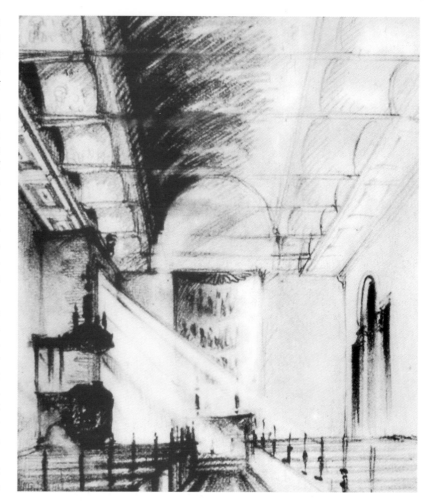

Figure 54
Alvar Aalto
Parish Church, Muurame (1926–29): architect's original perspective of the interior (1927), showing Aalto's marked emphasis on the use of natural light.

The classicism of the 1920s

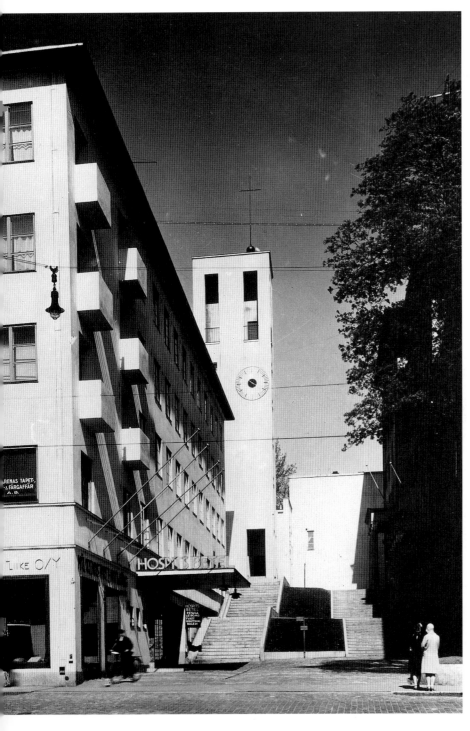

Figure 55
Erik Bryggman
Hotel Hospits Betel, Turku (1926–29): general view between the hotel and the Atrium block towards the tower. The severe mass of the hotel provides a marked contrast to the Atrium block across the pedestrian stairways. Although only symbolic, the tower fixes the space and clinches its urban character. This composition confirms Bryggman's superiority over Aalto in urban strategy.

pavilion, with windows on all sides. The accommodation was organized on the basis of a simple functional division, with the ground floor housing the club's restaurant and coffee bar, while the double-storey theatre was located at first-floor level. Simplified Doric columns, with windows between, gave an open, light and airy quality to the ground floor both inside and on the exterior. The internal arrangements demonstrate Aalto's already considerable planning skills (Figure 37). On the ground floor, for example, many of the columns necessary to provide support for the wide span of the theatre above are absorbed into the circular wall of the coffee bar. Aalto approached the problem of external form and internal arrangements by establishing the hierarchy of two axes, one $(x–x)$ representing the entry from the street and the other $(y–y)$ those of the internal functions based on the theatre and the restaurant. Half the restaurant wall is repeated as a semicircular drum in the first-floor foyer to the theatre, to emphasize the principal internal axis. On the other axis, however, as a consequence of placing the 'Palladian' window centrally within the theatre, the window does not occur in the centre of the long façade.

Clearly, there is a conflict between the functional programme of the Workers' Club and its classical expression. But what is equally obvious is that Aalto learned many fundamental lessons of axial planning in arriving at the design of this building. Interior details, in particular the fine plaster panelling to the curved rear wall of the auditorium that projects into the foyer and the matching panels of the entrance doors to the auditorium in their semicircular-headed arched frame, recall Roman and Romanesque examples. There is certainly nothing provincial about Aalto's handling of the classical forms and motifs of the Jyväskylä Workers' Club. Apart from the conceptual strength of the Parliament Building competition entry, his earlier work was not really distinctive or exceptional. But in the design of the Workers' Club he showed himself, aged only 26, to be the equal of any of his compatriots in connecting Finland with the

prevailing Scandinavian mode of expression. Indeed, Aalto's Workers' Club can be compared with Taucher's Mäkelänkatu housing in both its detailing and significance (Figure 40). Perhaps part of this new-found confidence may be linked to the fact that he had fallen in love with the second assistant to join him in the Jyväskylä office while he was designing the Workers' Club. Aino Marsio, who had graduated as an architect from the Helsinki Polytechnic Institute two years earlier than Aalto and was four years his senior, became Aalto's first wife on 6 October 1924. The couple spent their honeymoon in Vienna and Italy.[28]

The design of the Workers' Club also established a hierarchy of problems in the classical idiom that Aalto went on to tackle in his entries for two important church competitions, as well as that for the Southwestern Agricultural Co-operative Building in Turku. In 1925 the young architect was invited to participate in the first of these, a limited competition for the design of the parish church for the Jyväskylä suburb of Jämsä. His entry to this competition was based on the basilican plan, an unusual form in the context of post eighteenth-century Finnish church design, and was decidedly Italianate in form and character (Figure 50).

Aalto proposed a flat, coffered ceiling to the nave of the Jämsä Parish Church, with vaulted aisles and an arcade between the two, which was to have columns with Corinthian capitals and pew-height bases in the manner of Wren. To complete the Italianate style of the interior, even the aisle vaults were to have iron tie-rods! The west front showed a basically rectangular composition, a little longer than a square, with a design of rectilinear panels that is somewhat reminiscent of the Romanesque church of San Miniato al Monte outside Florence. Consistent with his dual-axial approach to the design of the Jyväskylä Workers' Club, Aalto provided a counteraxis to that of the nave in the organization of the piazza along the west front of the church. This piazza was to be located upon a hilltop, in an Italian manner familiar from Assisi and was to have been reached by a monumental flight of steps. There is another reference as well for these steps in Jyväskylä itself. A straight flight reaches up out of the centre of the town directly into the forest above; Aalto passed these steps, if not actually used them, almost every day.

Aalto's interest in things Italian was, however, certainly stimulated by the 'Italia la Bella' issue of *Arkitekten–Arkkitehti* at the beginning of 1923,[29] which was illustrated with travel sketches by Hilding Ekelund and Erik Bryggman. The following year, as already noted, Alvar and Aino Aalto spent part of their honeymoon in Italy and some of the travel sketches Alvar made on that excursion were included in the *Sketchbook* published by Göran Schildt in 1972. These sketches clearly establish a connection between Aalto's first trip out of Scandinavia and the Baltic region and the design attitudes that he formulated in the wake of that important visit to 'Italia la Bella'. In fact, Aalto's admiration for the qualities of Italian architecture – particularly those of the Romanesque, Renaissance and Baroque periods – can be traced to his Italian honeymoon: it might be said to have begun in earnest on this first journey abroad with Aino and was to continue throughout his long career. Ekelund set out to indicate to the younger generation of Finnish architects the promising quarry of sources to be found in the architecture of Italy. Aalto, certainly, was among those younger architects who sought a new and fresh expression that promised more elegance and lightness than the models of neoclassicism.

In his Jämsä Church competition entry, Aalto demonstrated beyond doubt his enthusiasm for the rediscovery of the true spirit of the Italian Renaissance. His interior perspective for this church, which was boldly featured in the *Arkitekten–Arkkitehti* review of the competition results, shows Aalto's interpretation of the Italian basilica as a warm and vibrant alternative to the many cold and austere renderings of the neoclassical theme in Scandinavia. The young Aalto took

part in this competition by invitation and in his design he revealed that he was not just a willing follower of Ekelund's lead. In the Jämsä Church design, Aalto showed he had studied the Florentine tradition at first hand and was familiar also with the work of Alberti. Although the plan does have some similarities with Eliel Saarinen's Emmanuel Church, Helsinki (1904–05), the spirit of the building is more original, with Aalto confidently drawing from a number of historical sources, including the upper portion of Alberti's façade for Sant'Andrea at Mantua (designed in 1470). Another interesting feature, in terms of Aalto's own progress as a designer, is the plastic quality of the nave arcade and aisle vaulting. From all these aspects, the Jämsä Church design represents a substantial advance in both confidence and freedom of expression, and the difficulties he had encountered in resolving conflicts of style and function in the Jyväskylä Workers' Club are clearly behind him.

From the very beginning of his career, even as a student, Aalto was involved in the problems of church design. As early as 1921 he was commissioned to add a belfry to the church at Kauhajärvi and in 1924 he undertook the furnishing of another church at Äänekoski. In addition, at the same time as he was completing the Jämsä design, he was remodelling yet another church at Viitasaari. And there is little doubt that, with this substantial experience by the time he was 27, he began to see a role for himself as a significant theorist and practitioner in the area of church design. He did not build a church to his own design, however, until the one at Muurame (1926–29; Figures 19, 54), which incorporates salient features of his earlier projects. Also of note is the fact that, in two interim designs, he abandoned the elegant Italianate style he had pioneered at Jämsä and returned to the more formalized elements of the neoclassical vocabulary.

His entry for the Töölö Church competition, Helsinki (1927) proposed another hilltop composition, with the four elements of the design – the church, priest's house, campanile and social facilities – grouped around a *piazzetta*, recalling his entry for the second stage of the Parliament Building competition. Although the compositional source of the Töölö design was Italian, the elements themselves were decidedly more neoclassical in their massing and detail. Similarly, Aalto's design for the Viinikka Church competition, Tampere (1927), once again shows in the perspective drawing his predilection for Italian hilltop compositions; although again these elements are only superficially Italianate in form (Figure 51). Whether the campanile is square, as in the Töölö design, or cylindrical, as for the Viinikka Church, these projects indicate more of the simplified massing of the romantic classic revival than the richly decorated surfaces and more plastic volumes of the Italianate Jämsä design.

In terms of site planning, however, both the Töölö and Viinikka projects represent further developments of the courtyard approach that Aalto first introduced in his entry for the second stage of the Parliament Building competition. The Viinikka design in particular balances the formal character of the church, campanile, social centre and presbytery with the informal grouping of these elements around the courtyard. Nevertheless, the resultant impression conveyed by these two interim designs is one of confusion between the conceptual intention and its formal expression, with a prevailing horizontality introduced into the church and campanile by means of a decorative moulding. This horizontal emphasis was also intended for the interior of the Viinikka Church. Significantly, both projects provided for a simple hall church, rather than an aisled basilica.

To a certain extent, the Muurame Church resolves these conflicts of style and offers a more coherent and unified whole. In his design for this church Aalto returns, for the most part, to the Italian inspiration of Jämsä. This is particularly evident in the organization of the west front which, in its use of a central triumphal arch motif, once again recalls Alberti's Sant'Andrea at Mantua.

There is also a finely detailed arcade in the return portion of the administrative wing at the east end. The interior, as well, reverted to an Italianate simplicity, with the painted decoration concentrated into the small apse behind the altar that is filled by a distinctly Florentine-style fresco; while in the ceiling treatment, the coffered panelling Aalto suggested for Jämsä was replaced by a design that cut away the flat panelling to expose truss ties with a simple, boarded vault revealed above. Aalto's solution may no longer be appreciated, as the interior of the Muurame Church was completely redesigned by Holma and Roininen in 1979. Although there were further church competition projects for Vallila (1929), Helsinki (1929) and Lahti (1950), it was another 30 years before Aalto again had an opportunity to express his theories of church design, when he built his most accomplished piece of ecclesiastical architecture at Vuoksenniska near Imatra (1956–59).

Erik Bryggman was born in Turku on 7 February 1891 and before he completed his architectural studies in 1916 he had already travelled with Hilding Ekelund to Sweden and Denmark in May and June of 1914. By 1920 he was sketching in Italy, again with Ekelund, when both architects developed an enthusiasm for the *architettura minore* of typical Italian rural buildings. The various influences of Bryggman's early travels in Scandinavia and Italy were to persist at intervals throughout his career.

Although Bryggman's work from the end of the 1920s is determinedly functionalist, his earlier designs, and those of the 1940s and 1950s, reflect his strong interest in tradition and its role in shaping buildings that blend with the landscape and the built form of their surroundings. The idea of the commonplace, whether classical or vernacular in origin, is thus of great importance in Bryggman's work and our approach to it. This is already apparent in his alterations to the Skogsböle House, an old country residence on the island of Kemiö, where the old and the new merge in the continuity of form and detail, with a fine balance between the interior axes and the exterior views across the landscape. The Skogsböle renovations date from 1924 and therefore represent Bryggman's first complete marriage of classicism and *architettura minore* in a vernacular context, capturing an intelligent restraint through careful detailing. In the Skogsböle design Bryggman gives a foretaste of the strength he could achieve with simplicity of means. The traditional yellow-ochre exterior, with white-framed windows, is complemented by the clarity and warmth of unfussy interiors, featuring natural wood floors and stair treads against the white walls and painted wood trim. Skogsböle has a consistent but economic elegance that is quite natural to a country house. This economy of means is still evident a quarter-century later in Bryggman's Villa Nuutila at Kuusisto (1948–49), where all traces of classicism have gone in favour of a full statement of *architettura minore*.

Bryggman built his reputation in Turku at the end of the 1920s with three works. These are the Atrium Apartments (1925–27), the adjoining Hotel Hospits Betel (1926–29) and the interior of the Hotel Seurahuone (1928). The Atrium Apartments, a modest five-storey structure, establishes a convincing urban street scale, with its Roman Doric entrance loggia, deep fascia and four floors of apartments above, which have simple fenestration and the façade capped with a deep, overhanging eave (Figure 44). At the first-floor level the apartment windows are square, with circular medallions between. The street level on either side of the loggia is entirely devoted to shops. This front block returns around the corner to face the Hotel Hospits Betel (Figure 55). Along the steeply sloping space between the two buildings two further apartment buildings step up the terrain, each of which is entered through a portico in a simplified Corinthian style. The deep fascia is repeated on these two pavilions, as is the pattern of fenestration. Thus the entry to the lower pavilion is pulled in from the street through the loggia, while the two rear buildings announce their entrances with porticoes that project out onto the terraced slope.

The Hotel Hospits Betel, which faces the Atrium Apartments across this terrace, represents an important transitional stage in Bryggman's work (Figure 49). On the exterior we no longer find much evidence of the classical vocabulary. The flat unadorned surfaces with almost square windows and the stark mass of the tower at the top of the stepped approach confirm the architect's sympathy with the new international style. This change of attitude and transition of form clearly took place during the progress of the work, as the original competition drawings indicate a pronounced correspondence between the Hotel Hospits Betel design and that of the Atrium block.[30] Although the deep matching fascia remains in the hotel building completed in 1929, the more obvious classical references have disappeared in the tower design. The interiors of the hotel are also determinedly functionalist in their crisp, unembellished geometrical forms. This new style is immediately evident in the reception area, with its square columns and the bold semicircular sweep of the registration counter (Figure 52). The lattice grid of the glass partition that gives access to the main staircase, and the painted concrete balustrade wall with its metal handrail, are indications that Bryggman has moved confidently on from his earlier classical vein. In the adjacent dining room, however, a row of sturdy Doric columns, supporting an undecorated beam on their thin, square abacus plates, separates the dining area from the circulation spine (Figure 53).

Bryggman's design for the dining room of the Hotel Seurahuone in Turku also uses Doric columns, which support a lowered ceiling over the dance floor in the centre. The columns at the Seurahuone are, however, of a more elaborate design than those of the Hotel Hospits Betel. While the column forms of both buildings have a small plinth and a band defined by a bead just below the capital, only those of the Seurahuone have decorative motifs within that upper band.

In addition to these two uses of the Doric column, there is a further example in the portico of the Villa Erstan at Kakskerta (completed in 1928). The villa's use of the Doric order is, like that at Hotel Hospits Betel, of a more simplified form, this time completely without embellishment. A flat triangular pediment, perforated by a semicircular opening, is supported by four attenuated columns. The slim proportion of these columns, combined with the detailing of the pediment and overhanging eaves of the portico roof, are reflections not of the correct use of a classical order but a vernacular interpretation consistent with the Finnish rural tradition and appropriate for a country house. There is a sense of play in the villa portico that speaks of the timelessness of vernacular transformation of the classical elements of architecture. Although on first impression it may appear to be mannered, the effect is more that of a carpenter's interpretation than an architect's whim, which connects the Villa Erstan with the commonplace. It is a modest design; the slimming down of the Doric columns diminishes their grandeur also, giving them that everyday touch of the vernacular.

In all his designs after that of the Atrium Apartments, Bryggman uses classical elements for emphasis, creating a memory by making a distinct reference. Clearly, by the time he was building the Hotel Hospits Betel he was setting aside classical references for specific contexts and moving into the realm of functionalist modernism, as is confirmed by his entry in the Suomi Insurance Building competition (1928; Figure 45) and that for the Paimio Sanatorium (1929; Figure 47).[31] In addition, Bryggman won the Sortavala Church competition at the end of 1929 with a design in the international functionalist style that had a very high tower and a nave with side aisles, plus a clerestory and side light to the altar.[32] In all, therefore, his active involvement in Nordic classicism spanned only three years, from the inception of the Atrium Apartments' project in 1925 until 1928 when the Hotel Hospits Betel was half-finished. However, the influence of this involvement stayed with him, and it reappears in his 1939 design for the Turku Funeral Chapel.

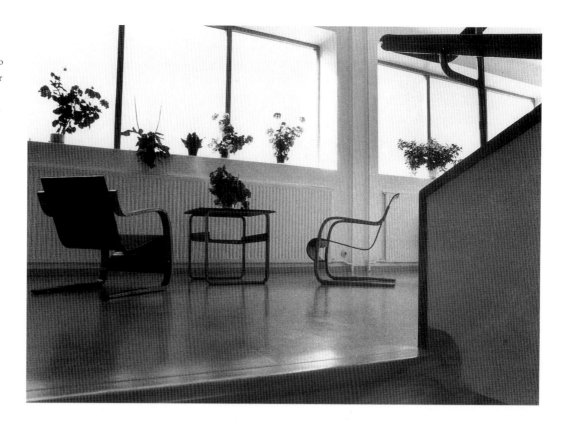

Figure 56
Alvar Aalto
Tuberculosis Sanatorium, Paimio (1929–33): interior view of upper corridor from staircase, showing handrail and skirting details, with Aalto's plywood armchairs and side table.

References and notes

[1] *Nordic Classicism 1910–1930*, catalogue of the exhibition arranged by the Museum of Finnish Architecture, Helsinki, 1982.

[2] J.M. Richards, *800 Years of Finnish Architecture*, David and Charles, 1978, pp.116–137.

[3] *Ibid.*, p. 141.

[4] *Ibid.*, pp. 94–107.

[5] *Ibid.*, p. 99.

[6] *Ibid.*, pp. 115.

[7] *Ibid.*, p. 142.

[8] *Alvar Aalto 1898–1976*, catalogue of exhibition arranged by the Museum of Finnish Architecture, Helsinki, 1978.

[9] *Nordic Classicism 1910–1930*, 1982, pp. 7–8.

[10] Nils Erik Wickberg, *Finnish Architecture*, Otava, 1954, p. 122.

[11] *Ibid.*, p. 86.

[12] *Nordic Classicism 1910–1930*, 1982.

[13] *Ibid.*, p. 11.

[14] Louis Kahn posed the question 'What is architecture' to a graduate design class at the University of Pennsylvania, of which the author was a member, in 1955. After five minutes of awesome silence, with nobody daring to answer, Kahn told his students: 'Architecture is the essential repetition of essentials.'

[15] *Nordic Classicism 1910–1930*, 1982.

[16] See Chapter 1.

[17] *Nordic Classicism, 1910–1930*, 1982, p. 47.

[18] *Ibid.*, p. 47.

[19] *Ibid.*, pp. 13–17.

[20] *Arkkitehti*, 1983, No. 8, pp. 18–29.

[21] *Ibid.*,

[22] *Ibid.*, pp. 32–51.

[23] Göran Schildt, *Alvar Aalto: the early years*, Rizzoli, 1984, pp. 111–112.

[24] *Ibid.*, pp. 113–114.

[25] *Ibid.*, pp. 115–116.

[26] *Ibid.*, pp. 120–122.

[27] *Ibid.*, pp. 43–44.

[28] *Ibid.*, pp. 131–134.

[29] *Arkitekten–Arkkitehti*, 1923, No. 2.

[30] *Arkitekten–Arkkitehti*, 1927, No. 2, pp. 15–28.

[31] *Arkitekten–Arkkitehti*, 1928, No. 11, pp. 171–173; and 1929, No. 3, pp. 42–46.

[32] *Arkitekten–Arkkitehti*, 1929, No. 12, pp. 202–208.

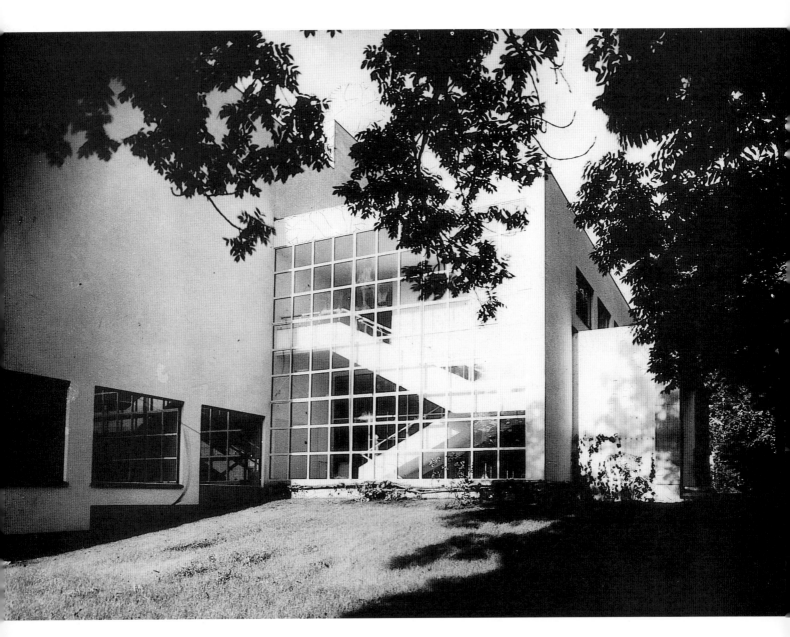

Figure 57
Alvar Aalto
Municipal Library, Viipuri
(1933–35): view of main entrance
and staircase wing from the park.

3 Encounters with functionalism: 1927 to 1939

The shift of direction in Eric Bryggman's work between 1927 and 1928 was paralleled by Alvar Aalto's development as a designer during the same period. There can be no doubt that their close relationship was a positive force on the evolution of their ideas and expression in those two critical years. In 1927, for example, Aalto assisted Bryggman in a competition design for an office building in Vaasa, entered under the slogan 'Waasas'.[1] Aalto's Tapani block of flats for Turku was also commissioned in 1927. A comparison of the two designs shows that the fenestration proposed for the Vaasa project is not as advanced as that Aalto used on the rear elevation of the Tapani Block. Although the design for the Tapani scheme was begun in 1927, the building was not ready until 1929, by which time Aalto had already completed the construction of the *Turun Sanomat* Building (Figures 59, 60) and was engaged on the post-competition drawings of the Paimio Sanatorium. Bryggman's design for the Vaasa project nevertheless raised two significant issues concerning the expression of a commercial building in the functionalist style: these are the continuous horizontal window for the upper office floors and the double-storey entrance at street level as related to the shopping units.

Clearly, the two architects were sufficiently compatible to allow them to work amicably together. They were also extremely adept at learning from each other. Bryggman's competition project for the Suomi Insurance Building of 1928, for which Aalto was a jury member, also forms a significant part of the design dialogue between them. This is true, too, of their collaboration on the overall design for Turku's Seven-Hundredth Anniversary Exhibition (1929), a remarkable example of early Finnish modernism (Figure 58). Both Bryggman's second-prize entry in the Paimio Sanatorium competition (1929) and his project for the South Karelian Sanatorium competition (1929) make it clear that he was second only to Aalto in the evolution of Finnish functionalism.[2]

On examining Aalto's original competition entry for the Viipuri Library (1927) we see that he was still working in the Nordic classical style, with a design strongly influenced by Gunnar Asplund's Stockholm City Library (1920–28). Although Aalto won the competition with that design, his revised proposal included a civic space to link the library across Aleksanterinkatu with the projected House of Culture in a plan that involved setting the buildings back into the trees that formed Viipuri's central park belt. A group ably led by the city architect, Uno Ullberg, and the chief architect in charge of planning, Otto I. Meurman, objected to this threatened loss of trees from the city centre. By the time this group had won the day and succeeded in having a new site designated adjacent to the cathedral, six years had elapsed. In the meantime, Aalto had left his Nordic classical period behind him, so that the design for the new library on the alternative site became part of his functionalist output. By this time, too, he had established his reputation as the leading Finnish exponent of this new international style. And it is against the background of this performance, achieved at the age of 34, that we must view the progress of Finnish architecture over almost the next half century.

In the design of his Southwestern Agricultural Co-operative Building for Turku (1927–28) Aalto responds to Bryggman's two recent buildings, the Atrium apartments (1925–27) and the Hotel

Figure 58

Alvar Aalto and Erik Bryggman
Seven-Hundredth Anniversary of Turku Exhibition (1929): the architects joined forces to design these abstract entrance pylons and other features of the exhibition.

Figures 59 and 60
Alvar Aalto
Turun Sanomat Building, Turku (1927–29): the street elevation shows the horizontal windows and roof terrace. The original two-storey newspaper display window has been modified (left) by recent tenants. The interior of entrance lobby at street level shows the complete restoration of the staircase and office screen (1985).

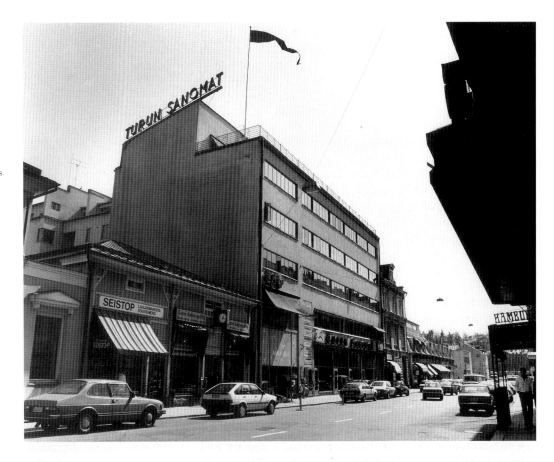

Hospits Betel complex (1926–29). Although the window design of the Co-operative Building is virtually identical to that of the Hotel Hospits Betel, Aalto dispenses with the wide overhanging eaves that characterize both Bryggman's Atrium block and the hotel. He also transforms the fascia above the shops, which in both of Bryggman's buildings is a deep element placed flush with the main wall. Aalto draws this horizontal element out into a projecting canopy, which clearly separates the larger elements of the shop fenestration from the smaller apartment windows above. This canopy treatment is then extended into the two-storey entrance recess on either side, with the result that the horizontal bond of the composition is strengthened and the vertical break of the entrance feature is diminished. Bryggman's Vaasa competition project, on which Aalto also worked, borrows the two-storey entrance feature from the Co-operative Building. He retains the deep fascia of his earlier designs, however, but pushes it up above the entrance to provide a continuous horizontal element on which sits the first level of almost continuous office windows.

Aalto's Co-operative Building is not as pure in form as Bryggman's Hotel Hospits Betel, of which it is an exact contemporary, but stands between the Atrium design and that of Bryggman's hotel complex. In his next three designs, however, namely those for *Turun Sanomat*, the Paimio Sanatorium (Figure 70) and the final Viipuri Library project of 1933 (Figure 68), Aalto outstripped Bryggman on the evidence of the latter's Suomi Insurance Building competition entry. The *Turun Sanomat* Building clearly established Aalto's claim to pre-eminence in Finnish functionalism. Bryggman had little success in the early 1930s, other than taking first prize in the Heinola Sports Institute competition (1930), although even this design was not built.[3]

By the end of the 1920s, other Finnish architects who had made their mark in that decade with work in the classical mode began to embrace functionalism. Most notable among these are Hilding Ekelund and Oiva Kallio. Ekelund's entry for the Vallila Church competition (1929) shows an L-shaped plan formed by the intersection of the church with the ancillary accommodation. In truly functional terms the church plan is too long and thin, with an impractical distance between the main body of the congregation and the altar. But the perspective demonstrates an uncompromising attitude towards the new style, with a bold, cubiform concrete mass, a great expanse of glass filling the framework of the west façade, a sweeping semicircular canopy over the entrance steps and vertical windows lighting the nave. The cylindrical tower that rises out of the narthex is matched by a large semicircular bay feature that terminates the social accommodation. It is a fresh design, in many ways unresolved and crude, but with tremendous vitality and force in its monumental simplicity.

In 1930 the first functionalist office building in Helsinki was completed – that for the Pohja Insurance Company, by Oiva Kallio (Figure 61).[4] This design is certainly informed by the work of both Aalto and Bryggman, with its bold horizontal strip windows on the upper floors and great clarity in the design of the main office hall and other interior spaces. But the overall treatment of the exterior does not have the resolution of either Bryggman's 'Waasa' or Suomi Insurance designs, or of Aalto's *Turun Sanomat* Building. The junction between the two-storey shop units at street level and the upper levels is not coherent, while the entrance design is also not effective within the overall composition of the Pohja Insurance Building. Although Kallio's design has obvious characteristics of the functionalist canon, including the horizontal strip window and recessed attic storey with a roof terrace enclosed by iron-pipe railings, there is not a strong overall conceptual form such as we find in the work of Aalto and Bryggman.

The Pohja Insurance Building is certainly a statement of functionalism, but only a partial statement. While using certain functionalist elements it does not add up to a functionalist whole. It could be seen, perhaps, as a compromise between two

Figure 61
Oiva Kallio
Headquarters of the Pohja (Northern) Insurance Company, Helsinki (1929–30): although this belongs with those transitional designs that have a classical base with modernist upper storeys, the horizontal windows are as uncompromising as any in Finland at this time, and it is Kallio's most effective and memorable contribution to modernism.

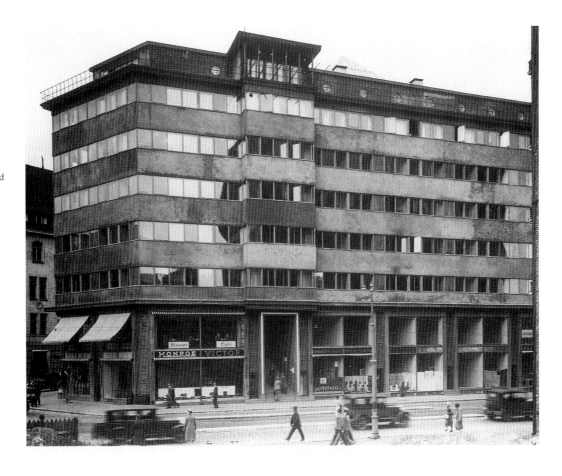

Figure 62
Erik Bryggman
Finnish Pavilion at the Antwerp World's Fair (1930): concrete modernism has been converted into the material of concrete formwork – plywood – offering a model for Reima Pietilä's first major building, the Finnish Pavilion for the Brussels World's Fair (1958).

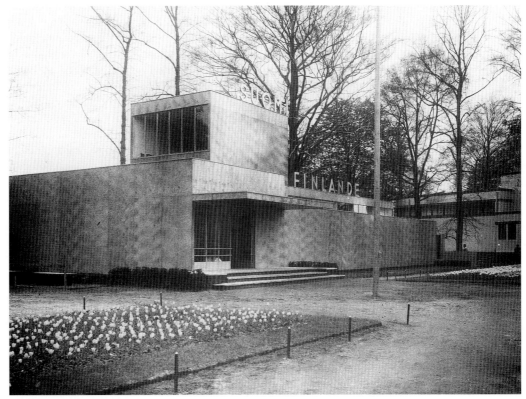

Finnish Architecture and the Modernist Tradition

Aalto designs, the Southwestern Agricultural Co-operative Building and the *Turun Sanomat* Building. From a proportional point of view there are also problems in the composition of the façade. These difficulties begin with the junction between the shopping units and the office floors, while the balance between the window depth and spandrel depth between the window bands is also unresolved. The Pohja Insurance Building is surely a brave attempt by Kallio in the Finnish capital at that time, but the overall effect is nevertheless somewhat monotonous.

In the transformation from the classical vein to the functionalist mode there are clearly new problems of proportion, balance and emphasis. Oiva Kallio was experimenting in the Pohja design without the benefit of personal experience gained from previous attempts to resolve similar problems. His designs for the reorganization of Helsinki (1927) and the sauna of his own Villa Oivala (1930) clearly show him to be more skilled in working with the earlier design models of classicism and national romanticism.

In contrast, Bryggman's perspective for his entry in the competition for the Student Association Building for Oslo, Norway (1930) reveals what is perhaps that architect's most confident and accomplished functionalist design. Its strength of massing, evolved from a skilful use of axes and stepping, combined with the bold pattern of fenestration add up to a powerful composition that sits convincingly in the landscape. Bryggman's entry for the Tehtaanpuisto Church competition (1930)[5] exhibits similar forcefulness and resolution of composition. The design of the approach, stepping up to the entrance canopy, the west façade, the tower and the loggia is uncompromising in the strength and simplicity of formal elements. Had it been built it would certainly have provided the best example of Finnish church architecture in the functionalist mode. Comparison of this design with Bryggman's entry in the competition for St Martin's Church in Turku (1931) shows that the architect may have reached the high point of his performance between 1929 and 1930. His competition project for Kotka Town Hall (1931) was, however, one of the best functionalist entries.

The tower of the St Martin's project is weakened by the introduction of arbitrary conventions, while the west front attempts a reconciliation with traditional forms by the use of a pitched gable. With the insertion in this gable of a circular window low down and close to the canopy and the cutting away of the corner of the tower, the same elements that were so successfully combined in the Tehtaanpuisto Church are diluted to effect a compromise between traditional and functional forms. This already gives an indication of Bryggman's inability to progress beyond his designs for Paimio Sanatorium, the Student Association Building in Oslo, Tehtaanpuisto Church and Kotka Town Hall. He was inclined instead to look back to earlier inspirations, as he did again after 1940. His later functionalist designs of the 1930s never fully recaptured his early mastery of that mode.

The only built design from the climax of Bryggman's first phase of functionalism is that for the Finnish Pavilion at the Antwerp Fair of 1930 (Figure 62).[6] This was a small-scale structure, which nevertheless seems to have captured in miniature many of the virtues of the Student Association Building project. It is a carefully articulated solution of interpenetrating planes and volumes that recalls the work of both Frank Lloyd Wright and Mies van der Rohe, with a national emphasis in the use of sheet plywood as the external finish. It was in such small-scale works as his Kinopalatsi Cinema (1935; Figure 74) and Sampo Insurance Office (completed in 1938), both in Turku, that Bryggman revived the best of his early functionalist skills, while in the Vierumäki Sports Centre (1935–37) he was less successful in recapturing that earlier clarity of expression.

The Finnish Parliament Building by Jukka Siren was completed in 1931 (Figures 64, 65).[7] Its construction over five years paralleled the emergence of Aalto as the leader of the younger, postwar

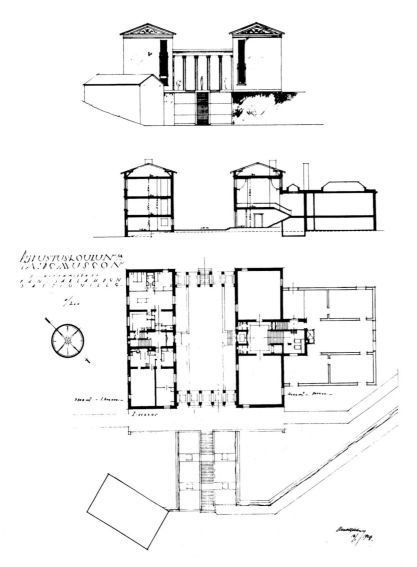

Figure 63
Uno Ullberg
Design for the Art School and Art Museum, Viipuri (1930): a last-ditch classical design by the City Architect, it should be compared with his Bensow Building, Helsinki (completed in 1941), which reveals the hand of a mature modernist.

generation of Finnish architects. Siren had gained wide respect both in the profession and in the country at large as the result of his Parliament design. The scale of the Parliament Building, its studied monumentality and high standard of detailing made it an obvious symbol of Finland's recent independence. Siren's Parliament Building dominated the eastern part of central Helsinki and therefore accorded its architect high visibility and the status of an establishment figure.

Although Aalto was pre-eminent among the younger generation, his early work was in Turku and Jyväskylä rather than the Finnish capital. He was still a provincial architect and, in spite of his successes in competitions and the undoubted quality of his work, he was still frowned on by the older generation. Senior members of the profession viewed his audacity as overaggressive and they certainly took little interest in his post-classical work. These things naturally told against him when he applied for a professorship at the Helsinki Technical University in 1930 at the mere age of 32. Those experts, like Onni Tarjanne, who gave their opinion on Aalto's candidacy thought they should not have to be familiar with the provincial work of this presumptuous young man.[8] Furthermore, they were obviously displeased to observe that, free from the authority of Helsinki, Aalto felt able to seek inspiration from abroad, specifically from Sweden and Gunnar Asplund. It was not at all surprising, in the circumstances, that Siren was given the professorship. Nevertheless, Aalto continued to dominate the new Finnish architecture of the post-romantic classic period, especially after the completion of the *Turun Sanomat* Building, Paimio Sanatorium and the final stage of the Viipuri Library design (1933).

In order to understand the further developments of Aalto's career and work after Viipuri it is essential to review the key stages of his progress between 1927 and the early 1930s. With the Co-operative Building in Turku (1927–28) Aalto proved himself to be more than the equal of his Finnish colleagues in the conventional mode of the

1920s. It was during the construction of the Co-operative Building, in the latter part of 1927, that Aalto was commissioned by Juhani Tapani to design a block of apartments based on the Tapani method of precast-concrete unit construction. The Tapani project introduced Aalto to the basic principles of rationalization in modern construction. This opportunity to combine theory with practice, linking the means of industrial production with the functional standardization of elements, clearly came at a critical stage for Aalto's future work. His Tapani design is acknowledged as the first truly functionalist building in Finland. Based on three structural entities, or spaces between cross walls, each has its own staircase and contains two apartments on each floor. But as each structural entity is of a different bay width, containing different accommodation, with only the two central apartments identical (mirrored on either side of the central staircase), five of the six apartments on each floor are different types. This makes the Tapani Block a demonstration of rationalization rather than standardization. As a consequence, the fenestration, which is based on the horizontal organization of windows of one, two or three vertical metal casements, is irregular on the street side.

Like the Co-operative Building, the Tapani design has lettable commercial units at street level. Some of these units have large, almost square windows subdivided by glazing bars and a separate door with clerestory light above, while others combine the two glazing elements by wrapping an L-shaped display window over the top of the door. The fenestration on the rear elevation, having only one type of three-light window above the ground floor with a vertical slit door and window ensemble expressing the staircase behind, is more regular than that to the street. Wide mezzanine balconies on the staircase landings have tubular-steel guard rails. Upon completion of this building in 1929, Aalto clearly became part of the mainstream of the European modern movement.

While the Tapani Block was still on the drawing board, Aalto entered a small competition organized

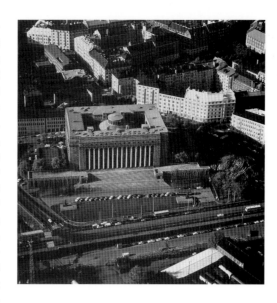

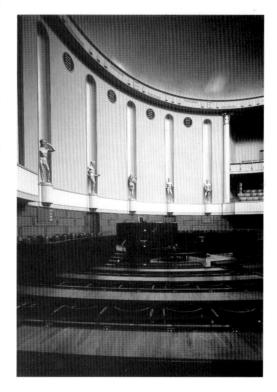

Figures 64 and 65
Johan Sigfrid (Jukka) Siren
Parliament Building, Helsinki (1923–31): a lasting monument to the brief period of romantic classicism that had come to an end by 1928, with the exception of work by Alvar Aalto and Uno Ullberg in the Karelian capital, Viipuri.

by the Finnish popular magazine *Aitta* in the spring of 1928. This involved two proposals, with Part A calling for a small family holiday cottage and Part B posing the problem of a three-bedroom summer villa. Aalto won both sections of the competition with functionalist designs, although he had played it safe in the design of the holiday cottage by entering a very conventional and traditional design as an alternative to his main entry. Both in the prize-winning Konsoli and the alternative Kumeli designs, Aalto combined the arrangement of a kitchen and one two-bed space at one end of the plan, with a central living area and the second bedroom at the far end behind the living room fireplace. The only real difference between the plan of the winning design and the alternative entry was that the former has a cylindrical fireplace while in the latter this became a square element. As far as external appearance was concerned, however, the two designs have little in common. The Kumeli entry has a low-pitched roof, while the winning Konsoli design is flat-roofed. Under the flat roof the veranda is recessed to produce a deep horizontal slot that runs almost the length of the cottage and the horizontal strip window is placed immediately under the veranda roof. The only non-functionalist element the Konsoli design shares with Kumeli is that of the earth-sod roof, a memory of the traditional Finnish country vacation cottage from Aalto's childhood.

In his design for a three-bedroom villa required by Part B of the competition Aalto once again used an open fireplace as the means of defining the internal functions. Behind the fireplace, the kitchen and bedrooms are accessible from a short corridor. This compact plan is then bent to form two-thirds of a circle, so that the living room and corridor look out onto a central, paved courtyard. In fact, this plan form repeats that of the fireplace in the Konsoli design. The segment of a drum form of this 'merry-go-round' entry seems to suggest a link between the past and future in Aalto's work. Its clear neoclassical source is contrasted with its use, the interpenetration of space and form being as important as the volumetric shape. As with the Konsoli design Aalto cuts into the basic building volume. In the Konsoli project the veranda is carved into the rectilinear volume, while the merry-go-round plan is wrapped around two-thirds of a circular central court.

Indeed, we can see a number of ideas in these simple and small-scale designs that were to remain hallmarks of the planning and spatial relationships of Aalto's mature work. Carving into basic geometric volumes became one of Aalto's cherished strategies of formal ordering. Also, Aalto went on to develop the use of the partially enclosed courtyard throughout his career. The ambiguity of what is outside and what is inside, which we observe for the first time in the *Aitta* projects, became another of Aalto's lasting preoccupations.

It is clear that Aalto was able to use the opportunity provided by the Tapani Block and *Aitta* designs to explore the technical problems, planning and volumetric resolution of the new, post-classical architecture. It will become equally evident that Aalto's classical training, and its implications for architectural form and order, were to remain part of his memory as a designer. In January 1928, while he was still working on the Tapani design, Aalto received the commission to design the *Turun Sanomat* Building. Thus, the problems of rationalization posed by the Tapani design and those of formal ordering that the Aitta competition brought were complemented by the challenge offered by the *Turun Sanomat* newspaper premises. The *Turun Sanomat* Building design became Aalto's first masterpiece of functionalism, preceded only a few months earlier by the first scheme for the Tapani Block of November 1927.

When we consider how closely these two functionalist designs followed upon each other at the end of 1927 and the beginning of 1928, the design of the original competition entry for Viipuri Library, submitted on 1 October 1927, may seem somewhat anomalous. This original Viipuri design represents Aalto's last exercise in the neoclassical mode: it owes its inspiration in part to Gunnar

Figure 66
Alvar Aalto
Project for the Military Hospital, Zagreb (1930): a design discovered by the author in 1979, which in both plan and section anticipates Aalto's later lecture-theatre designs, with its double natural-light sources.

Figure 67
P.E. (Pauli) Blomstedt
Competition project for Kotka Town Hall (1931): full-blown functionalism is given a sense of place, with the important transatlantic seaport given a dual identity of ship and lighthouse in Blomstedt's inventive design.

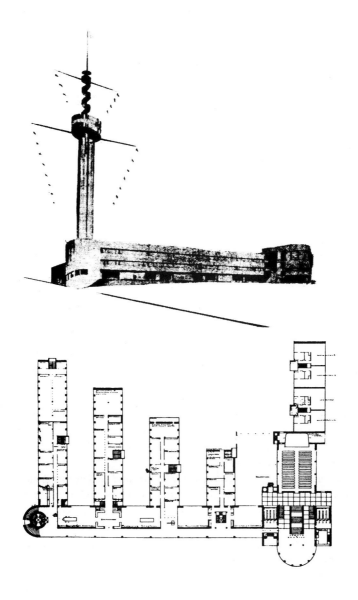

Figure 68
Alvar Aalto
Final plan for the Municipal Library, Viipuri (1933): while the overall planning and massing of Aalto's final design is functionalist, the interior arrangement of the library's reading rooms (upper left) is decidedly classical (completed 1935).

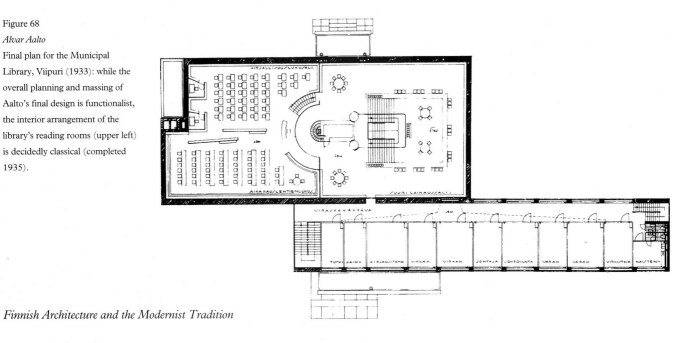

Finnish Architecture and the Modernist Tradition

Asplund's Stockholm City Library, repeating a sunken central room that Aalto had used already in his Finnish Parliament Building competition entry. Göran Schildt quotes Hakon Ahlberg's hall in the Palace of Industry at the Gothenburg Exhibition of 1923, which also had a sunken central area, as a possible further source for this feature of Aalto's design.[9]

The original 1927 competition design for the Viipuri Library was based on a simple rectangular volume, with the narrow wing of the entrance stairway placed at right angles to it and off centre. This asymmetrical composition was united by a frieze of classical figures shown to run the entire length of the plinth under the windows of the main floor. Apart from this frieze and the detailing of the entry stairway, this design, particularly in the section, was a compromise between the neoclassical and functionalist modes, although its external appearance was certainly calculated not to alienate those who opposed Aalto's progressive ideas. In the summer of 1928 Aalto prepared the second version of the Viipuri design, retaining the basic plan but radically changing the appearance of the simple volume. Significantly, this volume had always been split by a recessed window at each end. The 1928 design shows free-form fenestration on the main façade, while the neoclassical staircase entry has become a glass box and a rooftop terrace has been added. Indeed, re-examination of the original plan and section suggests that this transformational strategy was already in Aalto's mind. The asymmetrical arrangement of the plan and divided ends of the volumetric form are indications of this direction. This second design also includes a V-shaped concrete slab over the entrance of one end, which is certainly borrowed from Le Corbusier.[10]

After overcoming some local antipathy to his functionalist approach, Aalto prepared a third Viipuri Library scheme in January 1929 for the original Aleksanterinkatu site. This retains the general external appearance of the second design, but the plan has now become L-shaped to respond to the proposed House of Culture across the street. One side of the return wing is glazed to the staircase shaft, but a classical feature returns to the interior: the internal stair wall shows a relief depicting a classical scene with temples, gods and warriors. The horizontal strip windows of the 1928 design have also been replaced by rows of closely grouped individual units.

The decision by Viipuri City Council in the autumn of 1933 to build the library in Torkkeli Park freed Aalto from all the constraints of the Aleksanterinkatu site. He no longer had the problems of a street façade in relation to a public open space or the proposed House of Culture. The result was a completely new plan and building mass, although he did retain the sunken reading room, which became almost square compared with the long, narrow space of the earlier designs. The appearance of the final design, which was completed in December 1933, is uncompromisingly functionalist both externally and internally (Figure 68). But it is clear that throughout the various transformations of the Viipuri design Aalto gained invaluable insights into the planning of public buildings and the expression of his emergent individualism.

We have noted from his *Aitta* designs that Aalto was adept at offering alternative building forms based on the same plan solution. This skill, combined with the particular history of the Viipuri Library project, allowed him to win the competition with a classicist strategy. He then went on to achieve a masterpiece that combines the lessons he learned from classical planning with his newly acquired functionalist vocabulary (Figure 57). Spanning a period of six years, the various designs of the Viipuri Library effectively document the transformation of Aalto's expression from romantic classicism to his mature functionalism of the mid-1930s. Also, in the proposal to espalier the rear façade with ivy and his treatment of the library lecture room he embraced new design strategies that became central to his later work.

Before tracing Aalto's further development,

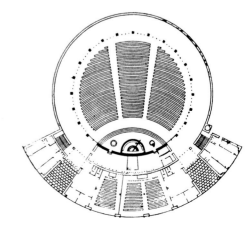

Figure 69

P.E. (Pauli) Blomstedt Competition project for the Temppelikatu Church, Taivalahti, Helsinki (1933): although the plan is a functionalist transformation of a classical *parti*, the design's weakness is its dependence upon a classical, full-dome section. Importantly its subterranean concept was incorporated into Timo and Tuomo Suomalainen's winning design in the third competition (1962).

however, we must now examine the limited but significant contribution of Pauli Blomstedt. During the 1920s Blomstedt's production was certainly meagre, with his success in the competition for the Union Bank, Helsinki (1926) providing the high point of his work during that period. Not only did he defeat all the major Helsinki architects to win first prize but the Union Bank remains an important monument of Finnish romantic classicism while, at the same time, providing a further bridge between that style and subsequent functionalism.[11] The high quality of the Union Bank design and Blomstedt's attention to detail gives credence to the notion that he had played an active part in Gunnar Taucher's designs for the Helsinki Workers' Institute (1926) and the block of flats on Mäkelänkatu (completed in 1926). Blomstedt had worked for the City of Helsinki under Taucher when those designs were executed and his share in those projects remains a matter of dispute. From the design of the Union Bank onwards, however, there is no doubt about Blomstedt's position in the transformation of Finnish twentieth-century architecture, and his functionalist work of the 1930s has a strength and clarity that is almost the equal of Bryggman's earlier designs.

The boldness of Blomstedt's ideas first becomes apparent in his competition project for Kotka Town Hall of 1931 (Figure 67).[12] Kotka is a major seaport on Finland's south coast, from which Finnish exports are carried to North America. Blomstedt's design for Kotka Town Hall has a distinctly nautical flavour. It is like a great ship, stretching across the site. At one end the semicircular columned entrance gives access to the council chamber and central administration. A three-storey spine runs the length of the site; this is fed by a corridor that gives access through the building to the administrative limbs projecting out to the rear. The horizontal emphasis of the long building, with its strip windows spanning the entire length of the spine, is counter-balanced by a tower. This is placed at the far end from the main entrance and council chamber, rising above a terminal, semicircular staircase. The tower has its own staircase and passenger lift, and rises high above the building. Its form combines a lighthouse with a ship's main mast. There is a circular observation room some 12 storeys above ground, then above that an open spiral stair rises to a 'crow's nest'. The tower is elaborated by spars that occur below the observation platform and at the crow's nest, which allow the structure to be decked with flags.

Blomstedt's entire town hall design, with its many references to ship forms and nautical lore, was conceived as a symbolic representation of Kotka. This unconventional and daring concept was obviously too advanced for provincial Kotka in 1931. The architect was never to realize a building as bold as that promised by this project, and the Kotka Town Hall design therefore remains the strongest evidence of Blomstedt's unfulfilled talent. Like Bryggman, he had to be content with building smaller-scale and more modest representations of his ideas.

An example of this is Blomstedt's design for the People's Restaurant in Helsinki of 1932, a commission from the State Alcohol Monopoly (ALKO). The functionalist forms of this interior are uncompromising, with exposed columns rising the full height of the cafeteria hall. A semicircular feature separates the servery from the kitchen, its only decoration being the simplified markings of a clock placed high up on the curved wall. The space is simple, monumental, impersonal and gives little scope for Blomstedt's inventiveness, but the detailing, such as the coat rails suspended from the structural columns, is of high quality.

The first competition to design the Temppelikatu Church on a prominent and difficult outcrop of granite in central Helsinki dates from 1933, and again Blomstedt's entry is of great interest (Figure 69).[13] Indeed, his design partially anticipates the solution proposed by the Suomalainen brothers, Timo and Tuomo, and completed on the same Taivallahti site in 1969. Blomstedt's competition project of 1933 shows a circular church buried in the granite, with the whole plan covered by a

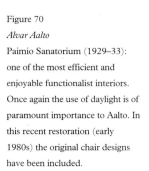

Figure 70
Alvar Aalto
Paimio Sanatorium (1929–33): one of the most efficient and enjoyable functionalist interiors. Once again the use of daylight is of paramount importance to Aalto. In this recent restoration (early 1980s) the original chair designs have been included.

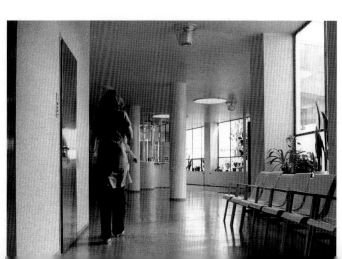

segmental dome that is clearly visible on the exterior. The altar is placed against the wall opposite the entrance and the seating is fanned out in three sections to fill the remainder of the circular plan. Blomstedt then arranged the ancillary accommodation in a broad segment of a circle immediately behind the altar. The design is a triumph of functionalist simplicity. In adapting a centralized plan form to an underground location the dome becomes the only element of expression.

The clarity of Blomstedt's solution, which was unsuccessful in the 1933 competition, remained buried in the archives for more than three decades. Although Blomstedt's section indicates that he was a long way from resolving the internal form and character of his design, there can be little doubt that his project must have influenced the Suomalainens' design of the 1960s. While the refinement of plan and section in the executed church are much more advanced than those of the Blomstedt proposal, his notional design was the first representation of a domed, underground church for this site. There is no question that the executed design greatly improves the architectural form and quality of the church over the proposals revealed by Blomstedt's competition drawings. This is particularly so in terms of the natural lighting of the interior, which was completely absent from Blomstedt's design and is such an integral part of the success of the Suomalainens' church. Nevertheless, Blomstedt must be credited with making the original proposal for a domed, underground church at Taivallahti, and that is yet another mark of his significance in the evolution of modern Finnish architecture.

Blomstedt's only executed church was that for Kannonkoski, designed in 1938 (Figure 88), which presents a stark contrast to his 1933 design for the Temppelikatu Church.[14] The functionalist image of the Kannonkoski Church is directly industrial; the nave has a wedge section with the windows cut along their tops to follow the line of the sloping roof and ceiling. A projecting balcony provides the only relief for the tower, which is a

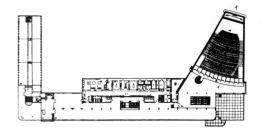

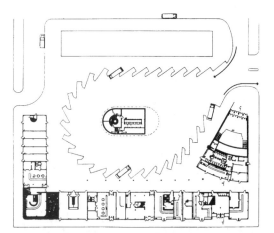

Figures 71–73

Kokko, Revell and Riihimäki
Glass Palace, Mannerheimintie, Helsinki (1933–36): this strategically placed commercial development had two subsidiary functions – to screen the Helsinki Bus Terminal from the city's principal street, and to hide the old Russian barracks on the hill behind. A night view from Mannerheimintie (bottom left) conveys the full impact of this building's total modernity. Its effect on Helsinki in 1936 must have been astonishing. The bold spatial treatment of the lobby for the Bio-Rex cinema (bottom right), with its sculptural, spiral staircase, shows the debt of Viljo Revell and his partners to the work of Erik Bryggman.

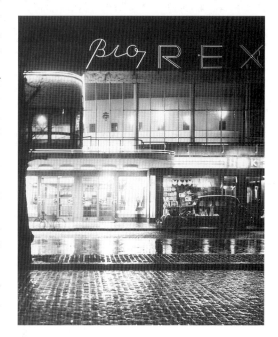

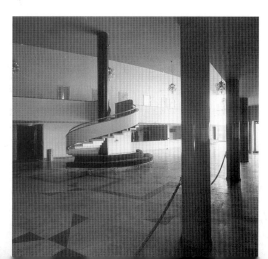

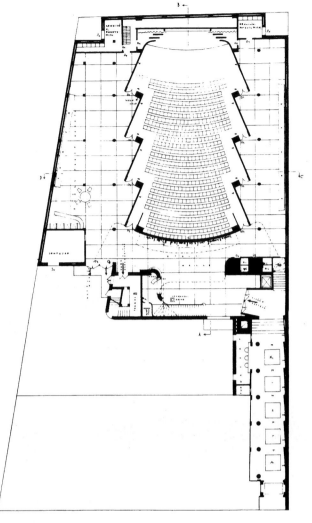

Figure 74
Erik Bryggman
Kinopalatsi cinema, Turku (1935): this plan reveals Bryggman's consummate skill in the ordering of fluid space and form. Although the sources are entirely classical – a centralized form set in a surrounding circulation space – the effect is completely functionalist. Kokko, Revell and Riihimäki had not yet absorbed this spatial fluidity in their Glass Palace Bio-Rex cinema.

Figure 75
P.E. (Pauli) Blomstedt
Savings Bank, Kotka (1935): an outstanding example of Blomstedt's full-fledged funtionalism – forms, materials and reflective surfaces all conspire to generate the magic of modernity.

Figure 76
Otto Flodin and Eero Seppala
Railway Station, Tampere (1934–36): the railway station tower remains, but is now a constructivist symbol of industry. The main entrance wall and over-sized 'window' are equally abstract.

Finnish Architecture and the Modernist Tradition

bow-fronted rectangle in plan, while the belfry is expressed with the slits reminiscent of a radiator grille. It resembles a silo or agricultural processing plant, sitting as it does in the open landscape of corn fields. The cross surmounting the tower is one of the few clues that this is a religious rather than an industrial building. In the Kannonkoski design we have proof of Blomstedt's deep desire to purge architecture of sentimentality and effete gesturing. It provides one of the most serious and severe Finnish exercises in functionalist form, comparable with that of the exterior form of the Viipuri Library.

Two other Blomstedt buildings of this period deserve our attention. The first of these is the Finnish Savings Bank for Kotka (completed in 1935).[15] This has a simple street elevation, with the entrance recessed into a two-storey opening beneath the projecting balcony to the third floor, the whole capped by a neon sign. The interior shows the elegant clarity Blomstedt developed using the same basic elements he employed in the People's Restaurant (Figure 75). The refined bowed front carrying the half-cylinder up to the balcony above, and such details as metal-framed glazed screens, low desks and counter tops, and minimal supports for the cashier's glass barrier, give a sense of openness and transparency that still characterized Finnish bank design in the 1980s when it had mostly been banished elsewhere in search of greater security.

Whereas the Union Bank confirms Blomstedt's contribution to the classicism of the 1920s, the functionalist work by which he will certainly be remembered is the design of the Pohjanhovi hotel in Rovaniemi, which was completed in 1936.[16] Although a smaller project than Kotka Town Hall, it is his major building of the 1930s and combines the boldness of form of both the Kotka and Kannonkoski designs with further clarity in the co-ordination of interior space and detail. Unfortunately, this hotel was destroyed during the Second World War. His own house of 1938 on the Baltic shore is an uncertain mixture of traditional and modern forms, which only serves to confirm the significance of Aalto's achievement in blending memory with modernism in the Villa Mairea (Figure 84).[17] Blomstedt's total production was small but the integrity of his approach to design, whether in the neoclassical mode that he so quickly condemned and abandoned, or the functionalist style, of which he became so forceful a champion, has assured him a significant place in the history of twentieth-century Finnish architecture.

Returning to Aalto's early functionalist work, let us consider his unsuccessful competition entry for the Tehtaanpuisto (later St Michael Agricola) Church in Helsinki (1930). Aalto's section reveals a continuous acoustic ceiling that begins with a shell over the altar and continues the length of the nave; this not only anticipates his mature church designs but also foreshadows the ceiling he incorporated into the lecture room of the Viipuri Library (completed in 1935). During the period when Aalto was just beginning to consolidate his grasp of the principles and forms of functionalism, he was also seeking to extend the language of architecture beyond those constraints. By introducing suspended wooden ceilings as an acoustical device and by softening the external mass with the creeper climbing on a wooden espalier, Aalto was literally 'furnishing' his functionalist volumes and masses both inside and out. He introduced an experiential dimension that takes architecture beyond the codified and the regulated forms of modernism. Certainly from the mid-1930s, that is from the design of the Viipuri Library lecture room ceiling onwards, Aalto's architecture exhibited a striking multivalency. His classical education, functionalist leanings and concern to make architecture act as a bridge between intelligent rationalism and communion with nature, all these attitudes generate a complex coexistence. Aalto moved his office from Turku to Helsinki in 1933, although during the next 15 years his only design built in the Finnish capital was his own house in Munkkiniemi (1934–36).

The design of Aalto's Munkkiniemi home is

Figure 77

Eero Saarinen and Jarl Eklund

Remodelling of the Swedish Theatre, Helsinki (1936): this smooth classical design avoids the Victoriana of previous designs by Chiewitz (1860) and Benois (1866). Olof Hansson added a winter garden (1978).

Figure 78

Erkki Huttunen

Parish Church, Nakkila (completed 1937): a combination of bold industrial forms with a stunted version of traditional buttresses.

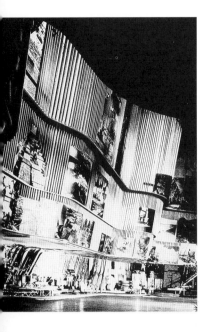

closely linked with that of a number of other buildings and projects between 1934 and 1939 in the formulation of this complex architecture that is at once truly modern and indisputably Finnish. In considering this body of work we must also recognize the other influences that came to bear upon Aalto immediately before that period, so we can see how significant these were in the strategic transformations of his designs. We have already mentioned Aalto's involvement with Tapani and the industrial process of standardization. His collaboration with Otto Korhonen, of Huonekalu-ja Rakennustyötehdas Oy, Turku, from 1927 onwards in the design and production of bent-plywood furniture and his subsequent work for the Ahlström Company as a consequence of his introduction to Harry Gullichsen, together provide the other essential catalysts for Aalto's development during the second half of the 1930s.

Aalto's earliest furniture designs were one-off pieces in the neoclassical style produced for family and friends. When he came to design furnishings for the sacristy of Muurame Church and various rooms of the Co-operative Building, Turku, in 1928, his approach changed radically. It was the manufacture of furniture for those two buildings that brought Aalto into contact with Otto Korhonen. One consequence of their association was the refinement of a stacking chair already designed by Korhonen that combined traditional wooden elements with plywood, which Aalto used for the auditorium seating of the Association of Patriots' Building, Jyväskylä (1927–29).

Aalto extended his experience with plywood in the design of a second stacking chair, commissioned by Korhonen for his company's pavilion at the Turku Seven-Hundredth Anniversary Exhibition of 1929, adapting a plywood seat form pioneered for use on public transport in neighbouring Estonia as early as 1908 by the Luterma Company. Having experimented with a cantilevered support system of laminated wood, Aalto found this too cumbersome and replaced it with a tubular-steel cantilevered frame. With the Paimio chair of 1930–33, originally designed for the Paimio Sanitorium, Aalto finally overcame the problems with wooden supports by abandoning the cantilever approach in favour of a system of continuous support and arm members, between which the seat and back spanned like a spring of bent plywood. By 1935 he had adapted the Paimio design in the first of a successful series of cantilevered armchairs that used the same principle but with U-shaped arms also acting as springs. The Viipuri Library lecture room had some of these armchairs.

The making of furniture provides an architect with one of his most demanding exercises, the challenge of detailing at a small and personal scale. Aalto's interest in furniture design from an early age, together with his involvement first with Korhonen and then his subsequent partnership with Maire Gullichsen in the formation of the Artek Company for the manufacture and distribution of his own designs, allowed him to develop one of the unique qualities of his architecture. The cohesion he achieved between the forms of his interior spaces and their furnishing directly connects him to both Eliel Saarinen's national romanticism and Frank Lloyd Wright's concept of organic architecture. At the end of his Turku period Aalto was engaged in experiments which were to lead to the evolution of the warm, personal variety of modernism that he made his own. These various explorations brought the realization that wood offered two important attributes that supported the creation of a new architecture. Wood is not only capable of responding to new industrial processes of mass production in achieving anthropometric sculptural forms, but also has warmth of texture and colour, a significant source of tactile experience in a world that was threatening, already in the 1930s, to overwhelm people with increasing mechanical harshness and brutality. The lessons of wood technology that he learned in the design and production of furniture helped shape his philosophy for making an architecture with which humanity can connect, 'to give life a gentler structure'.[18]

Aalto first met the Gullichsens on the initiative

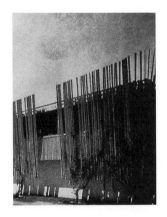

Figures 79 and 80
Alvar Aalto
Finnish Pavilion for the New York World's Fair (1938–39): view of main interior space, showing the new dynamism of Aalto's plan and form strategy after Villa Mairea. On the exterior of the pavilion's austere 'box' Aalto elaborates the unstripped sapling motif of Munkkiniemi, Kauttua and Villa Mairea.

Finnish Architecture and the Modernist Tradition

of Nils Gustav Hahl,[19] who had been trying to interest Maire Gullichsen in opening an avant-garde art gallery in Helsinki. Out of the first meeting between Hahl, Maire Gullichsen and Aalto the new Artek Company was born. Hahl suggested the formation of a company to promote new ideas in housing. These ideas would be centred on Aalto's furniture designs, but the company would also sell modern art, with Maire providing the financial base, Aalto contributing the creative force and Hahl acting as the business director. Harry Gullichsen was surprised that he had not heard of Aalto before, especially since the architect had been producing quite remarkable modern buildings in Finland for almost a decade by the time they first met. The arrival in Helsinki of this prophet, who was virtually unknown in his own country, was just what Gullichsen needed to inject some new ideas into the Ahlström Company of which he was chairman. Harry Gullichsen saw in Aalto not only the opportunity to modernize his company but also to create a new image for Finland, while Aalto's close working relationship with Gullichsen was soon translated into a steady flow of industrial commissions, allowing Aalto to keep his office open and persist with his architectural experiments when other work was denied him.

Aalto's first involvement in industrial architecture was the design of the Toppila Wood-processing Plant at Oulu in 1930. This project was for the Enso-Gutzeit Company, Finland's largest paper and wood-product manufacturer and later one of Aalto's most important clients. But Aalto gained little significant experience in the planning and design of the cellulose-production facility at Oulu, where he was really employed only to effect marginal improvements to the appearance of a plant that was already under construction. But at Sunila, adjacent to the Baltic port of Kotka, he was responsible for the overall planning and the detailed design of the pulp mill (1935–37) and the associated housing, which brought him face to face with the entire production process.

In the new industrial challenge at Sunila, as in others that confronted him at the beginning of his career, Aalto adopted his standard strategy of learning directly from contemporary examples. Deriving his design mainly from Väinö Vähäkallio's mill for Enso-Gutzeit at Kaukopää (1930–32), he added distinctive features of his own. These personal touches included the clear articulation of tall vertical and long horizontal windows and he also contrasted the sober brick masses with the use of bowstring trusses to support the roof of the central building. Unfortunately, Aalto's forceful interpretation of the established convention and his confident massing of the brickwork in relation to the rocky shoreline, are features now hardly visible among the subsequent profusion of later buildings. Aalto indisputably contributed to the fundamental reform of Finnish industrial buildings at Sunila, however, and the consequences of Aalto's contribution later became fully developed in the power stations of Aarne Ervi and Timo Penttilä.[20] The challenge of Sunila offered Aalto a marked contrast to the design problems that had been the focus of his romantic classicism in the 1920s.

The employees' housing that Aalto designed for the Sunila Pulp Mill complex forms part of his important transformational work of the mid-to-late 1930s. Of greatest significance in this context are the engineering staff residences of 1937–38 and the three-storey terraced apartments that were added in 1938–39 (Figure 21). In the engineering staff housing we see the first conscious development of Aalto's fan-plan motif, although this was already anticipated in the incomplete cylinder of the *Aitta* merry-go-round summer house project (1928) and the wedge-shaped sauna built for the employees of Paimio Sanatorium (1932). By gently splaying the arrangement of the five units Aalto ensured that no two houses in the terrace have exactly the same orientation. To maximize this benefit the units are stepped in plan, which also provides for optimum privacy on the garden side. The garden terrace of each house, neatly tucked in under the balcony above, also gains additional

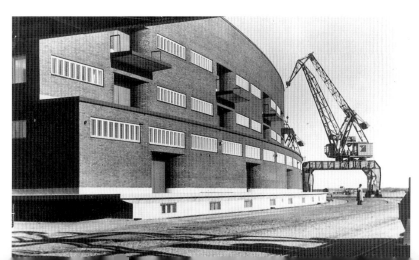

Figure 81

Vaino Vähäkallio

Customs warehouses, Port of Helsinki (1936): here the modern Finnish tradition of brick massing and detailing is established, which Aalto was soon to elaborate.

Encounters with functionalism: 1927 to 1939

privacy from this plan form.

While the planning of the terraced housing at Sunila clearly has a functional basis – the achievement of privacy normally associated only with detached houses – Aalto had another objective. The terrace is located on wooded slopes across from the pulp mill and has a sense of charm that is no part of the functionalist style. The scheme includes a return to the idea incorporated into the 1929 design for Viipuri Library, with the introduction of a large-grid rectilinear pattern of trellis, enclosing forecourts on the entry side of the house terraces. The trellises are made up of natural trunks of small trees and saplings, complete with bark, on which plants and vines are trained to further soften the white masses of the terraces. This addition of extraneous elements to building exteriors, often rough natural elements, can be traced back to the agglutinative techniques of plan and mass in the national romantic period, for example at Hvitträsk and the National Museum, and it characterized Aalto's mode of expression in this important transitional phase.

Aalto's reputation as a furniture designer was so well established by 1933, when he transferred his office from Turku to Helsinki, that his first exhibition abroad that year at Fortnum and Mason's store in London was entirely devoted to this aspect of his work. In fact, Aalto's most celebrated furniture designs, as well as most of the principles that were developed in his later furniture, date from the period 1929–35, that is, from the beginning of his work on the Paimio Sanatorium to the completion of the Viipuri Library. This intensive period of experimentation with bentwood forms had a direct impact on Aalto's solution for the suspended acoustical ceiling in the lecture room of Viipuri Library. His experience in small-scale detailing of furniture combined with his technique of 'furnishing' the exteriors of his buildings led to the development of his important transitional designs between 1936 and the outbreak of the Russo–Finnish War (1939).

This transition from the functionalism of *Turun Sanomat*, Paimio and Viipuri, to the unique blend of the romantic tradition with the principles of classicism and functionalism that was to become Aalto's own mature expression, may be traced in five designs. These are: his own house and studio in Munkkiniemi (1934–36); the Finnish Pavilion for the Paris World's Fair (1936–37); the Villa Mairea (1937–39); the stepped housing for Ahlström at Kauttua (1937–40); and the Finnish Pavilion for the New York World's Fair (1938–39; Figures 79, 80). This period also included four major competition entries – for the Finnish Embassy in Moscow (1935), the State Alcohol Monopoly (ALKO) Headquarters in Helsinki (1935), the Tallinn Art Museum (1937) and the Helsinki University Library Extension (1937). In this brief period, Aalto perfected a new architectural expression that remained essentially modern yet was every bit as Finnish as the work of Eliel Saarinen and Lars Sonck. Indeed, Aalto was clearly inspired by the agglutinative plans and massing as well the addition of such external elements as rough timbers that contributed to the essential character of national romantic buildings.

The other important component in the critical evolution of Aalto's architecture was his understanding of the courtyard as a generator of the plan and formal relationships. An examination of Aalto's approach to planning and formal strategies is therefore helpful in arriving at an understanding of his later expressionist work. When we speak of the plan as the generator of a building's form we are describing the classical *parti* in architecture, whereby those forms are constructed or 'built up' from the geometric outline of the plan, as is the case with the Parthenon or Pantheon. This interdependence of the plan–form relationship corresponds in part to the modelling technique of the sculptor, who adds material to a framework in order to achieve a positive form in space. However, a sculptor is not limited to the additive process of modelling; the sculptor also carves. An architect, unlike the stone-carving sculptor, is free both to model and carve. It is clear from Aalto's

experimental wooden structures, as well as his rough study models of building forms, that he had an equal interest in the techniques of both modelling and carving.

If we consider Aalto's mature work both from the point of view of the classically constructed volume, what we might call its 'positive form', and the carving out of 'negative' spaces within those volumes, then we can appreciate how this erosion of plan-generated volumes creates new forms and spaces within a total volume. This negative hollowing-out of volumes offers a counterpart to the classical *parti*, so that the whole expresses a romantic, organic, or eclectically reconstructed thesis/antithesis. This breaking with one set of rules in favour of combinations of rule sets, or even no rules at all, is what Aalto describes as 'autonomous' activity. When we understand the autonomy of the combined modeller and carver the apparent contradictions of Aalto's plan forms can be seen to offer simultaneously both the erosion of conventional spatial volumes and the exploration of new entities that are at once functional and ritual. In this way Aalto demonstrated that functionalism, like any other oversimplification of architecture, is an impoverished formula precisely because it ignores the complexity of the task and rejects the multivalency of the means.

Aalto was unsuccessful with his entry for the Tampere Railway Station competition (1934); the joint second prize was shared by J. Laasovirta and K.N. Borg.[21] But Aalto's design reflected the predominantly functionalist mood of that competition, as did the executed project by Otto Flodin and Eero Seppala (1934–36; Figure 76). The significance of a modern railway station design for Tampere, the industrial capital of Finland, cannot be overemphasized. The many passengers who arrived at, or departed from, Tampere Railway Station would have been forcibly struck by its clean lines, the raw concrete construction of the platform canopies and the fact that it is such an airy, well-lit building. It remains one of the important achievements of Finnish functionalism.

The year 1936 also saw the completion of Vaino Vähäkallio's new ALKO warehouse at Salmisaari, Helsinki.[22] This building is a massive, gently curved structure, with no detail other than the rounded entry bays to the doors and the heavily framed strip windows. It is a fine industrial structure in the lineage of the great nineteenth-century warehouses. Vähäkallio's ability to capture the monumental simplicity of those forerunners allows the building to remain, decades later, as striking and forceful as it was when newly completed (Figure 81).

Among other buildings of the second half of the 1930s is the redesign by Jarl Eklund and Eero Saarinen of the outer shell for the Swedish Theatre in Helsinki (1935–36; Figure 77). This new exterior replaced the earlier more robust designs by Chiewitz (1860) and Benois (1866) and represents a streamlined interpretation of a neoclassical *parti*. Standing as it does at an important junction in the city centre, on the corner of Mannerheimintie and Esplanadi and at the far end of Keskuskatu from Eliel Saarinen's Helsinki Railway Station (1904–14), the Swedish Theatre forms a critical hinge in the panoramic structure of Helsinki. Its present modest form, with self-effacing details, is really too weak to allow it to fulfill this role effectively.

The Helsinki Central Post Office (1934–36) was constructed at the far end of Mannerheimintie from the Swedish Theatre (1934–36).[23] Aalto was not successful in the competition for this project. Although it has some superficial affinities to functionalism, the Central Post Office of Erik Lindroos and Jorma Järvi as built remains the single most boring and unsympathetic mass in the centre of Helsinki. Indeed, it has an almost totalitarian presence in this democratic capital. Sandwiched between Saarinen's Helsinki Railway Station and Siren's Parliament Building, the Central Post Office represents a low point of modern Finnish architecture. Its tedious fenestration faces out across Mannerheimintie towards the Parliament Building, the repetitive windows resembling so

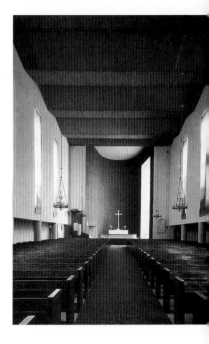

Figure 82
Erkki Huttunen
Parish Church, Nakkila (completed 1937): interior is indebted to Aalto's earlier designs, particularly in the undulating ceiling treatment.

Figures 83–86
Alvar Aalto
Villa Mairea, residence for Harry and Maire Gullichsen, Noormarkku (1937–39): the plan shows a collage of room and *Raum*, of functionalist enclosure and free space. This is a very sophisticated post-cubist statement. The general view from the front (below, right), shows Maire Gullichsen's studio (left) with living room (front) and *porte cochère* (right). Opposite, bottom shows a detail of the living-room corner (with terrace above) and Maire Gullichsen's studio. In contrast to the other entrance, this end is almost entirely finished in wood. Opposite, top is a detail of the sauna wall and door.

many mail slots in a United States post office lobby.

From consideration of the Central Post Office our expectations could only rise again to a higher level. Yet there is little work other than Aalto's which gives cause for optimism at the end of the 1930s. Among the architects who began to attract attention during this period, however, one of the most significant is Viljo Revell. He and his partners Nillo Kokko and Paavo Riihimäki made their mark as early as 1933 with the design for the Lasi-Palatsi (Glass Palace), which was built in 1935–36 on Mannerheimintie across from the Central Post Office and almost adjacent to the Parliament Building (Figure 72). It is a two-storey functionalist exercise that frames the Helsinki Bus Terminal departure court, contains shops at street level with offices above, and includes the Bio-Rex cinema.

The Glass Palace is a highly utilitarian structure that has always seemed synonymous with Finland's lean years in search of economic stability. Although intended as a temporary building to conceal some old Russian barracks from visitors to the planned Helsinki Olympic Games it remains as a vestige also of the struggle to implant the seeds of functionalism in the Finnish capital (Figures 71–73). Its form is somewhat minimalist and the external detail unrefined. The interior of the Bio-Rex lobby and cinema, however, are equal in quality to Bryggman's work of the same period. Revell demonstrated a considerable advance on the Glass Palace in his apartment project of 1939, which promised the clarity of form and detail of his later work (Figure 96). Like Aarne Ervi, Revell was an assistant to Aalto during the early days of the Helsinki office and both established major practices in the capital during the 1950s.

Other architects active in the evolution of Finnish functionalism include Erkki Huttunen, Martti Paalanen and Märta Blomstedt with Matti Lampen. Huttunen's main claim to membership of this group is certainly his severe and mechanistic Nakkila Church (completed in 1937; Figures 78, 82),[24] but he executed other work of note. This includes his Pharmacy at Lauritsalo (1937), which marks the arrival of modernism in Finnish small country towns, and his ALKO Factory at Rajamäki (1937).

Huttunen's main work, however, was as architect to the retail co-operative society, SOK, through which he initiated the so-called 'co-operative functionalism' and also spread functionalism into the countryside with the design of SOK shops. Also both his Viipuri Flour Mill (completed in 1937 but destroyed in the Second World War) and his warehouses in Oulu and Joeusuu (1938) were powerful structures. Martti Paalanen's Varkaus Church (1937–39) is one of the most important Finnish churches of the functionalist period, being superior to Huttunen's Nakkila Church in concept and detail. In addition, Märta Blomstedt and Matti Lampen made a substantial impact on everyday Finnish life with the design of their Aulanko Hotel for Hämeenlinna, which was completed in 1938.[25]

Recreation expanded steadily in Finland during the 1930s. Following the *Aitta* competition in 1928 there was a substantial increase in the number of vacation cottages and other recreational facilities in rural Finland, as efforts were made to attract tourists to important Finnish centres of beauty and cultural history. The Aulanko Hotel contributed to this development, presenting one of the most comprehensive examples of Finland's emerging modernity to visitors from Scandinavia and further afield (Figures 89, 90).

From every point of view – its planning, exterior form, the detailing of its balconies, and its interior design and furnishings – the Aulanko Hotel offered the model of a very modern country. It may have been a relatively isolated example, along with Viipuri Library, which would not have been much frequented by visitors to Finland other than architects, Paimio Sanatorium, which had its own clientele, and the Glass Palace in the middle of Helsinki's main street (Figures 71–73, 75). Like the Paris and New York World's Fair Pavilions, however, the Aulanko Hotel captured the spirit of Finland's courageous and exciting adventure with

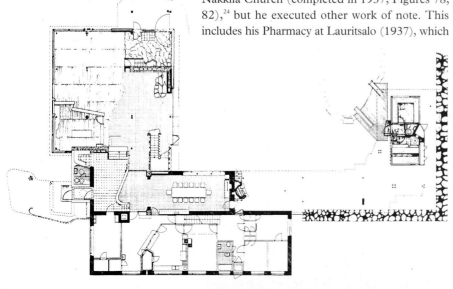

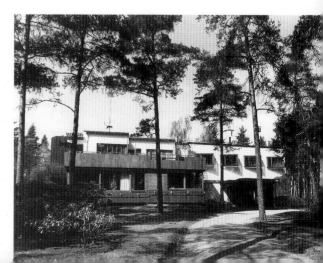

modernism. With the completion of the Aulanko Hotel the presence of Finnish functionalism was established not only in the minds of foreign visitors but also in the remote corners of Finnish culture. The international style that Aalto and Bryggman had pioneered in Finland at the end of the 1920s had become almost commonplace a decade later.

By the time Aalto was 30 both the external courtyard and a centralized ritual space, serving as a complementary internal focus, had made their appearance in his planning. For example, his competition design for the *Aitta* Holiday Cottage (1928) is planned around a courtyard that is a segment of a circle, while the interior space focuses upon a centrally located fireplace. Thus, the fireplace provides the centre for evening gatherings, a ritual place for the roasting of sausages and for conversation, reflecting internally at night the outward daytime focus of the sun-trap courtyard. We can also view the form of this *Aitta* cottage design both as the remodelling of a rectangular plan around the circular form of a courtyard and the erosion of the classical cylinder by carving away part of the total enclosure.

Aalto had already introduced an internal focus in his earlier classical design for the Jyväskylä Workers' Club (1923–25; Figure 20). In that case the circular central space, the café, expressed the true focus of the club's social life. In form it recalls the atrium of Engel's main University building in Senate Square, Helsinki. The atrium in Engel's design is on a quasi-mezzanine between the external approach steps and the internal circulation. On entering Engel's building we are in a courtyard that is apparently sunken, with monumental steps on three sides that form a stylobate for the imposing Doric columns, which create gateways to the corridors and main staircase. The use of a sunken space to provide an internal focus was adopted by Aalto and became a standard feature of his library interiors from Viipuri onwards.

Aalto's Munkkiniemi house (1934–36) near Helsinki has a simple L-shaped plan, but its volumetric projection is carved away to reveal a much more complex form. The basic L-form of the plan is made up of a main residential wing that is two rooms thick at ground level, with a thinner studio wing at right angles to the living accommodation. The studio, a two-storey volume with a gallery on two sides at first-floor level, has a separate entrance at the rear. At ground level on the garden side the residential wing is eaten into by a terrace which, for privacy, is located at the far end from the studio. On the upper level the volume is cut into again to create a partially covered terrace that separates the bedroom area from the upper level of the studio.

This cutting away of the basic rectilinear volume is, however, only the beginning of Aalto's reconstruction of the building's exterior. On one hand, a direct contrast of functions is drawn explicitly, with white-painted brickwork used for the full height of the studio wing and a large eight-light studio window placed at the upper level; while in the residential wing the upper, projecting portion is wrapped in vertical board. In this way one part of the volume, the two-storey studio, is apparently unified; the residential wing, in contrast, is divided and fragmented both volumetrically and in its materials. Within the studio wing there is tension, however, imparted by the different levels and the character of the three windows. As this was his private residence, rather than a public building, Aalto had the chance to experiment with his latest ideas about form and materials. The Aaltos had just arrived in Helsinki from Turku. What better opportunity would there ever be to demonstrate those ideas to the public and his clients? As this was both home and office it represented to the architect an investment in a permanent exhibition of his work.

What is evident and significant in this first building by Aalto in the Finnish capital is the virtual disappearance of the high functionalism that characterized the lineage of the *Turun Sanomat* Building, Paimio Sanatorium and Viipuri Library. Only in the organization of the fenestration on the northwest wall of the studio wing are we reminded of functionalist sources. Even there we detect a

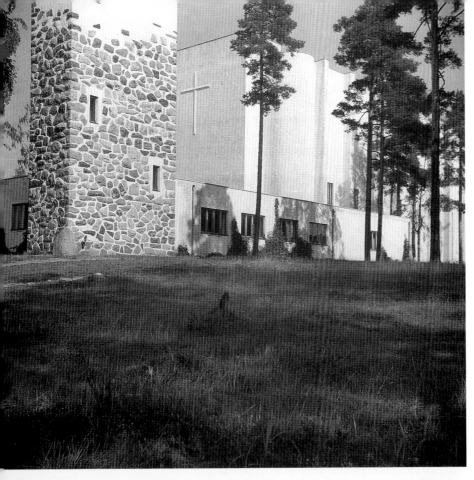

certain ambiguity, deriving from the rough rail fence placed immediately adjacent to it. This fencing detail picks up the textural reference established by clear-finish birch boarding used to clad the first floor of the residential wing. The purity of Aalto's earlier functionalism has given way in this building to the expression of functions in form and detail rather than to the subjugation of all functions to a formal discipline. Even so it is difficult to account for the introduction of the birch cladding, except as a reflection of the nearby woods, confirming that this is not an urban residence at all but a suburban villa.

The decision to build his house and studio in Munkkiniemi was a reflection of Aalto's family background in central Finland and also a projection of his new, personal interpretation of modernism as a gentler, more charming version of functionalism. Just as the irregular grouping of Finnish farmhouse complexes can be justified in terms of function, so can the treatment of the terrace balcony detail on Aalto's house. Varying from the solid treatment with pergola in front of the bedroom to the open, horizontal framework or rails screening the deeper, more public balcony, the terrace detailing allows Aalto to distinguish between privacy and semiprivacy. He also breaks down the rectilinear formality of the bedroom balcony, which is a timber variation on the cubic forms of international functionalism, into a more romantic variant evoked by three pairs of rough saplings acting as the enclosure for the rest of the terrace area.

This railing detail was also used at the Sunila Pulp Mill complex in the trellising of the engineers' housing (1938–39; Figure 21) and after the completion of his own house Aalto developed a composite variant of this treatment in the balcony rails and trellises of the stepped apartments for the Ahlström employees at Kauttua (1937–40). Four such blocks were proposed around the knoll of a steep hillside; the railing detail helps break down the massing to achieve a montage of building with environment, suggesting perhaps the influence of

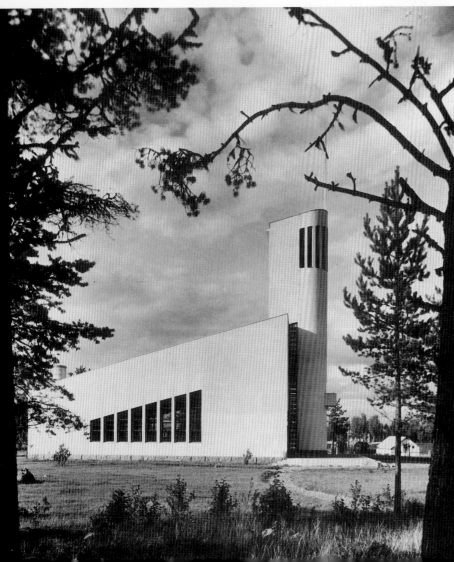

Italian *architettura minore* hillside houses of Tuscan villages. Contemporary with the Sunila housing is another incidence of the same idea, this time in the project for the Finnish Embassy in Moscow competition (1935). Aalto's proposal reveals a restrained but correct modernity in all but one detail. On the garden side, where the embassy banqueting and conference suites were to form a wing projecting on *pilotis*, Aalto contrasted the flat, smooth gable wall with the return elevation to the courtyard. There he once again introduced the rough pole trellis along the upper level of the façade, indicating that the shape of this wall was to be further dissolved by training creepers over these rough wooden elements.

In the Sunila housing, the Moscow Embassy project and Aalto's Munkkiniemi House we find a definite departure between 1934 and 1936 from the pristine masses of international functionalism. This deviation first occurs in 1934–35 and may well have initially been conceived in the design of the balcony handrails for the Munkkiniemi House. Certainly by 1936, when Aalto designed his entry for the Finnish Pavilion at the 1937 Paris World's Fair, these rustic elements have become an established part of his new vocabulary. The Paris Pavilion design is interesting, however, not only from the point of view of these details – the further development of the Munkkiniemi cladding, the lashed wooden columns in the garden and the fins added as column guards – but because it establishes precedents of plan form that were to continue to dominate Aalto's thinking well into the 1950s.

In his design for the Paris Pavilion Aalto returned to his earlier preoccupation with the courtyard plan. This competition project gave him yet another opportunity to present his latest ideas to the world – the designer of a national exhibition pavilion is in a privileged position to translate the aspirations of his country into a provocative form. Clearly, Aalto had been grooming himself to fulfil this role for the past decade. Even the motto he adopted for his main entry made his intentions abundantly clear. 'Le bois est en marche' literally implied the movement of the woods of Finland, and of course Aalto's own work, towards Paris. Here was an opportunity to implant the concept of a new, modern Finland in the French capital. This spirit, as evidenced by his experiments from 1927 onwards, was inseparably tied up with the indivisibility of modern Finnish architecture and the nationalistic use of wood. The image of 'le bois' therefore had a double meaning for Aalto in the context of the Paris Pavilion.

Aalto evolved an informal courtyard *parti* as the core of the Paris Pavilion design, a concept derived from the loose organization of farm buildings characteristic of central Finland and the actual grouping of the separate houses on the Harjukatu site in Jyväskylä where the architect lived from the age of seven. At the Paris Pavilion Aalto brought in the visitors from the highest point of this sloping, triangular site. They progressed into the interior under covered walks that led them into a garden court. The roofs of those walkways were supported by columns, some of which were made up of four separate vertical members bound together by thin lashings of wood. In addition to this column detail, Aalto used here for the first time shaped, projecting fins that were attached to the rough tree-trunk columns that supported the remaining walkways. Having passed around the garden court under these walkways, visitors arrived at an introductory exhibition area in another enclosed court with skylights. Under the central opening of this court were grouped[32] wooden poles, representing the Finnish forest within the architectural framework. By the time visitors reached the main hall they had passed through a variety of external and internal spaces that introduced Finland as a country of forests. In the process they had also experienced the symbolic undertow that binds humanity to nature. The creation of this building in the heart of Paris, in the very centre of the modernist terrain dominated by Le Corbusier's work and ideas, clearly constituted a statement of significant cultural and intellectual force.

The main hall of the Paris Pavilion was also

Figure 87
Martti Paalanen
Parish Church, Varkaus (1937–39): the bold silo forms reappear, here accompanied by natural stone insets to the base of the rectangular tower (an echo of Finnish medieval practice, as at Porvoo).

Figure 88
P.E. (Pauli) Blomstedt
Parish Church, Kannonkoski (1938): here the building elements are formalized and made abstractly geometric to avoid any historic references.

Figures 89 and 90
Märta Blomstedt and Matti Lampen
Aulanko Hotel, Hämeenlinna (1938): an astonishingly bold and well-detailed expression of Modernism, a clear symbol of the young Finnish state. The interiors, by Märta Blomstedt, are equally bold in form with great clarity of detailing.

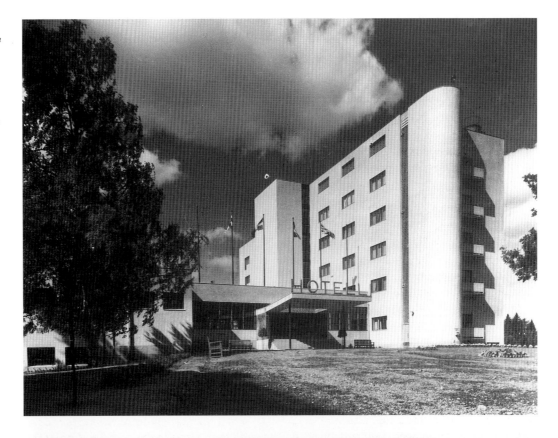

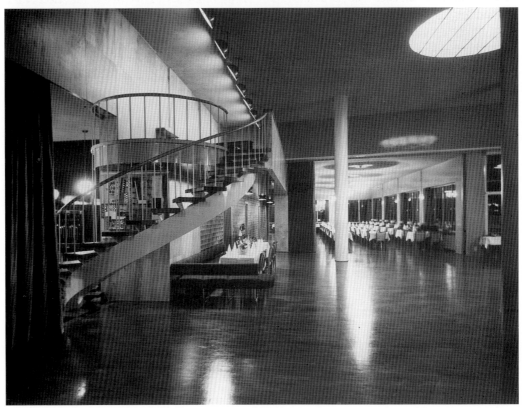

Finnish Architecture and the Modernist Tradition

clad in wood. When visitors reached the lowest point of the site they entered a rectangular building with rounded corners. It was entirely covered in a closeboard-and-batten system, the boards shaped to a distinctive concave form. Within, the main hall was two storeys high, which had become characteristic of Aalto's concept for this type of space, and it was naturally lit from above. At first-floor level there was a gallery on all sides, similar in design to that of the Itämeri Restaurant in the Co-operative Building at Turku, while the rooflights were almost identical to those he had used on the Viipuri Library. Designed immediately after his Munkkiniemi House, the Paris Pavilion showed how Aalto's new planning strategies were beginning to be supported by a certain degree of standardization in the volumetric treatment and external detailing of building forms.

Aalto's competition design for the Tallinn Art Museum (1937) is important not only in the evolution of his approach to public buildings but for a number of other reasons. It is certainly linked to the reorientation of the classical planning axes in his final design for the Viipuri Library (1933; Figure 68). In the Tallinn competition, however, the internal 'court' of the stepped main reading room is replaced by an open courtyard intended for the display of sculpture. This open court also admits daylight to the adjacent main circulation area, which in turn gives access to the stepped display areas that are themselves top-lit. The toplighting Aalto used for the stepped reading room at the Viipuri Library was later incorporated into the design of his internal court spaces, making the naturally lit internal court a salient feature of Aalto's mature architecture. This can be understood as a functional response to the Finnish climate, with its long winters and only a few hours of daylight for several months of the year. As he learned from Sonck's Stock Exchange atrium on those early visits to the Adlon Bar, daylight brought into the very heart of a building can transform interior space.

In his proposal for the Tallinn Art Museum, the circulation space links the external open space with the top-lit galleries, a solution that would have provided a subtle transition from the open-air courtyard to the environment of the indoor display areas. The Tallinn plan contrasts strongly, therefore, with that of a neoclassical art museum, where preoccupation with externalization of the building form to fit a classical mould frequently achieves an ill-lit approach and circulation system leading to the glass-roofed atria of the galleries.

The Villa Mairea (1937–39) is another of Aalto's courtyard designs. It bears a strong relationship to the Finnish Pavilion for the Paris World's Fair, with its rectangular high main hall and a stepped wing of low display rooms. In the design of the Villa Mairea, Aalto was able to summarize several of his principal preoccupations of the 1920s and 1930s before the long freeze effected by the Second World War. Although he did not speak of an autonomous architecture free from foreign influence until 1941, the Villa Mairea already anticipates the full range of Aalto's mature expression.

In the design of the Villa Mairea, Aalto achieved a closer relationship between architecture and landscape than in any of his other buildings. Although it is a large residence, the irregularity of the plan form serves to diminish the effect of the total volume (Figure 83). The *porte-cochère* belongs in its construction more to the surrounding forest than to the automobile, with the screen that masks the roof supports formed by young saplings complete with bark (Figure 84). On the garden frontage, too, the detached sauna and the loggia that links it to the house are roofed with turf.

The family's accommodation on the ground floor is rather simple, comprising only an entry vestibule that gives access up three steps into the main living area, a separate study for Harry Gullichsen, a garden room (that doubled as Maire Gullichsen's plant-potting area) and a long, thin formal dining room off the living area. A main staircase rises out of the living area, leading to the upper floor of bedrooms and nursery. At right angles to this family wing is a narrow service wing,

Figures 91–94
Erik Bryggman
Funeral Chapel, Turku (1939–41): in his original competition elevation drawing, Bryggman shows perfectly how he transforms traditional forms into a statement that parallels modernism. The plan generates an ingenious composition of forms, with a slight tapering of the nave towards the altar, an attached portico of rest (for the arrival of the coffin) and a detached tower. The view of the portico shows the chapel beyond. The tile cladding of the portico columns anticipates Alvar Aalto's use of this motif by more than a decade. The door handles to the main doors reveal a motif that Aalto refined in the 1950s, removing door handles from the arts and crafts genre to that of industrial production while retaining the sculptural essence advanced by Bryggman.

containing the kitchen and servants' quarters. The basic form of this plan therefore has a superficial resemblance to that of Aalto's Munkkiniemi House. But in the Villa Mairea this basic form is modified by the dining room, which steps out against the service wing, and by the sculptural character of both the *porte-cochère* and the thrusting outline of Maire Gullichsen's studio at the upper level.

The living area, if Harry Gullichsen's study is included, comprises a large square, which for most of one wall opens directly onto the garden, looking towards the sauna (Figure 85). Thus the open plan at ground-floor level opens out again to another 'room', that of the garden (Figure 22). The garden also intrudes into the house in the form of the garden room, with its collection of large-leafed tropical house plants (Figure 24). This interior garden element is combined with the concept of the trellis that is formed by the extended balustrade of the main staircase (Figure 23). The balustrade forms a subtle screen that has two functions. First, with its climbing plants it acts as a daylight filter, blurring the boundary between interior and exterior space. It also acts as a spatial fulcrum, the point of transformation at which the full, generous living room becomes the long, narrow dining room. The result is an interior court, the living room itself, approached by way of the *porte-cochère* and the entry vestibule, both of which are umbrageous areas that reflect the rhythms of the partially tamed forest by means of those familiar vertical elements of wood. As we climb from the *porte-cochère* into the living room we recall the similar arrangement in the plan of the Paris Pavilion.

The living room looks across a tamed garden to the sauna (Figure 86). There is something distinctly Japanese about this garden. It is partially framed by the more refined 'forest' elements of the staircase balustrade. The progression from the forest clearing at the front of the house, through the *porte-cochère* and vestibule, passing the filter of the staircase screen, all with their architectural memories of the forest, conveys the impression of being suspended between the two worlds of outdoors and indoors.

In addition to the intrinsic interest of its plan, the Villa Mairea also offers an almost complete vocabulary of Aalto's architectural language, a language that depends for its expression upon what he himself describes as the 'simultaneous reconciliation of opposites'. This vocabulary might be categorized as having six characteristics: a main entrance that is obscured, partially concealed or extremely informal so as to reduce its importance and impact; apparent freedom of planning that runs counter to classical arrangement, although the building form itself may be reminiscent of, or even retain some vestiges of, a classical *parti*; complexity of massing or skyline that does not derive directly from the 'footprint' of the plan; the generation of a deliberate conflict between the apparent geometrical ordering system of the façade and the overall structural rhythms of the façade as a whole; a deliberate blurring of boundaries within both the plan and three-dimensional form, so that containment is dissolved; and conscious confusion of parts of the building with the surrounding landscape, the architecture being assembled with ambiguities that reduce its formal presence, implying a *raison d'être* of self-effacement in which the forms of nature – present or induced – determine the formal expression within the site, while the building itself avoids architectural formality.

Four of these characteristics may be clearly observed in the Villa Mairea: apparent freedom of planning (although the plan is in fact constructed upon two intersecting axes at right angles, disguised by stepping the section); complexity of massing that does not reflect the plan; deliberate blurring of boundaries in plan and form; and conscious confusion of parts of the building with the surrounding landscape. Also, the entrance is partially disguised. Clearly, the Villa Mairea provided Aalto with the greatest opportunity to experiment he had so far been offered.

Aalto's unsuccessful entry for the competition to extend Engel's University of Helsinki Library

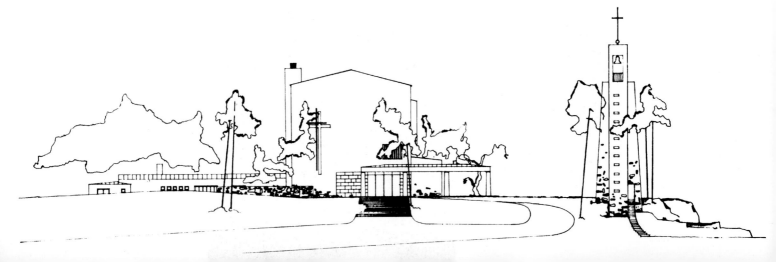

(1937) is also of some significance in his development. Once again Aalto was confronted by the problem of the reading room. The scale of this project was, of course, very different from that of the Viipuri Library. He located the main reading room at the same level as the principal floor of Engel's library, maintaining Engel's axis through the front of the building to the main circulation area at the rear. He then set the main reading room to one side, with the new stacks at right angles to it along the rear of the site. In the design of the reading room he projected the first truly monumental use of his new mode. The three-storey-high volume offered a vast, top-lit space free of any internal structure. His treatment of the ceiling derives from the Viipuri lecture room. The perspective shows close-boarding, which is perforated at the top by closely packed rooflights and sweeps down in a curved incline through the two upper storeys of the north wall. Then, supported and broken only by the great splayed concrete frames at the lower floor, the boarding dips over the concrete and flattens out as the ceiling of a single-storey extension of the reading room on the north side, eventually curving again to meet the windows on the external north wall.

Aalto's success in winning the 1938 competition for the Finnish Pavilion of the 1939 New York World's Fair, coming immediately on the heels of the Paris Pavilion and the Villa Mairea, became his crowning achievement of the second half of the 1930s. This intense period of building activity between 1936 and 1939 was in stark contrast to his lack of success in competitions so typical of his early years in Helsinki. In 1934 alone, for example, he entered three competitions with disappointing results: Tampere Railway Station, where he was unplaced; National Exhibition Hall, Helsinki, for which he received only third prize; Helsinki Central Post Office, in which he was again unplaced.

Originally, the New York Pavilion had to be fitted onto a rectilinear site that would allow only a windowless volume 16 m high (Figure 80). The programme included a restaurant for Finnish snacks and a cinema to present Finnish documentaries. Aalto entered three schemes and won all three prizes, providing conclusive evidence of his pre-eminence in Finnish architecture at the close of the 1930s. The cinema and restaurant were combined in each of his designs, with both first- and second-prize entries placing these functions behind the main display wall. His revised design of the winning entry, 'Maa, Kansa, Tyo, Tulos' (Country, People, Work, Product) separated out these elements, putting the cinema–restaurant opposite the display wall, as proposed in the third-prize submission, 'USA 39', which was otherwise the weakest of the three.

This revision allowed Aalto to move his open vertical volume into the centre of the pavilion on an axis that lay almost diagonally across the longest possible dimension of the building. As a result, the arrangement of the free form that characterized the winning design became more disciplined (Figure 79). Also, the clear use of the diagonal gave the maximum apparent length internally. Relocating the cinema–restaurant allowed it to take on a functional wedge shape that presented a straight balcony to the central court. This sharp edge in turn gave more impact to the undulating battened wall across from it that dominated the full height and length of the interior, billowing out over the spectators. The wall leaned out for a functional reason, allowing the giant photographs displayed on it to be experienced from below with more dramatic effect. This functional condition was once again freely interpreted by Aalto, resulting in a sensuous curving wall that leaned out almost threateningly as it soared upwards in horizontal bands of increasing projection, recalling the dizzying perspective effects of Francesco Borromini. These effects derived from Aalto's distortion of the plan across the diagonal axis to increase the apparent long dimension, combined with the upward and outward tilting of the wooden display wall.

There is no licence for such spatial manipulation in the functionalist canon, but we may explain

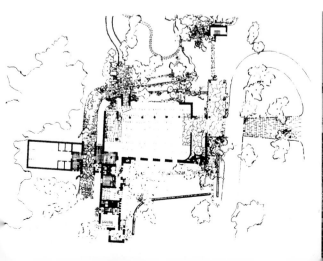

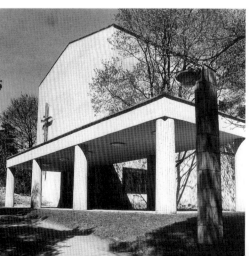

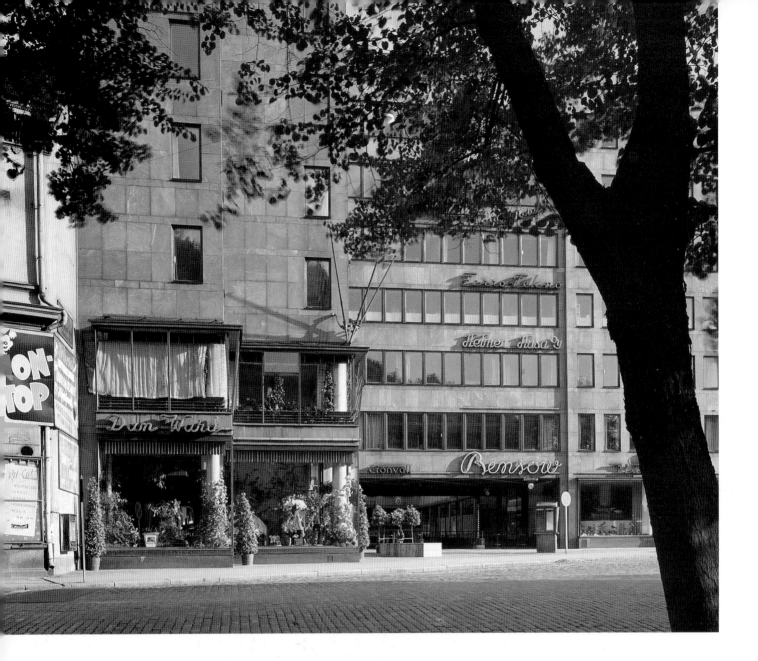

References and Notes

[1] Malcolm Quantrill, *Alvar Aalto: a critical study*, Secker & Warburg; Schocken, 1983, pp. 47–49.
[2] *Ibid.*,
[3] *Arkitekten–Arkkitehti*, 1930, No. 3, pp. 60–64.
[4] *Arkitekten–Arkkitehti*, 1930, No. 8, pp. 121–126.
[5] *Arkitekten–Arkkitehti*, 1930, No. 12, pp. 201–209.
[6] *Arkitekten–Arkkitehti*, 1930, No. 1, p. 11.
[7] *Arkitekten–Arkkitehti*, 1931, No. 5, pp. 65–84.
[8] *Nordic classicism 1910–1930*, Museum of Finnish Architecture, 1982, p. 90: article on Aalto by Simo Paavilainen.
[9] Göran Schildt, *Alvar Aalto: the decisive years*, Rizzoli, 1986, pp. 27–29.
[10] *Ibid.*, p. 29
[11] *Arkitekten–Arkkitehti*, 1930, No. 2, pp. 19–31.
[12] *Arkitekten–Arkkitehti*, 1931, No. 10, pp. 160–167.
[13] *Arkitekten–Arkkitehti*, 1933, No. 2, pp. 24–32.
[14] *Arkitekten–Arkkitehti*, 1935, No. 3, pp. 42–43.
[15] *Arkitekten–Arkkitehti*, 1936, No. 5, pp. 68–72.
[16] *Arkitekten–Arkkitehti*, 1936, No. 9, pp. 134–144.
[17] *Arkitekten–Arkkitehti*, 1938, No. 8, pp. 116–119.
[18] Alvar Aalto. 'Zwischen, Humanismus und Materialismus'. Lecture to the Austrian Institute of Architects, Vienna, 1955.
[19] Malcolm Quantrill, *Alvar Aalto*, 1983, pp. 68–69.
[20] *Ibid.*,
[21] *Arkitekten–Arkkitehti*, 1934, No. 1, pp. 25–29.
[22] *Arkitekten–Arkkitehti*, 1941, No. 3, pp. 33–43.
[23] *Arkitekten–Arkkitehti*, 1940, No. 3–4, pp. 17–24, 27–32.
[24] *Arkitekten–Arkkitehti*, 1938, No. 5, pp. 71–76.
[25] *Arkitekten–Arkkitehti*, 1939, No. 1, pp. 1–16.

the dramatic and sculptural qualities of the New York Pavilion by tracing the progress of Aalto's strategies in the Viipuri Library and Villa Mairea. At Viipuri Aalto modified the neoclassical *parti* and introduced a counteraxial plan; he also used the free-form, space-modifying ceiling. The Villa Mairea presented the same contrapuntal double axis, but the exterior volume and spaces between were substantially modified by the plastic forms added to the basic plan format – the *porte-cochère*, projecting first-floor studio and swimming pool. In the Villa Mairea these elements were essentially additive in the national romantic tradition. But in the New York Pavilion the diagonal axis and the undulating wall with the heightened sense of drama induced by its threatening angle, were the actual generators of both plan and section.

The masterful grasp of volume, scale and movement that Aalto demonstrated in the New York Pavilion was not repeated until the Essen Opera House project 20 years later. His organization of movement through the New York exhibition, a mature development of the pattern he used in Paris to ensure the greatest variety of spatial experience as visitors progressed around the one-way system, surely has its origins in the representations of movement contained in the work of such futurist painters as Umberto Boccioni. But it has its origins more particularly in that no-man's-land between futurism and surrealism found in the paintings of Marcel Duchamp, culminating in *Nude Descending a Staircase*, which established the modernist space–form problem in terms of time and motion. The New York Pavilion was truly a 'magic box' internally, from a spatial point of view, while it remained a simple functional box on the outside. The only decorative elements on the exterior were the vertical wooden strips to screen the restaurant window, which became possible when a less constrictive site was allocated after the competition. These strips had no other apparent function than to deny the functionalism of an otherwise bare box. Thus, in the New York Pavilion, Aalto once again blurred the boundaries of the architectural form, dissolving the limits of the spatial container. And this blurring of boundaries, of building plan and form, remained a characteristic design strategy throughout Aalto's mature period.

Figure 95
Uno Ullberg
Bensow Office Building, Helsinki (1940): a remarkable transition of Ullberg's mature style, exhibiting complete command of the modernist vocabulary. The building includes the famous Dan Ward flower shop (closed 1991).

Figure 96
Viljo Revell
Project for a residential building, Helsinki (1939): the architect's skilful interpretation of the balcony motif shows him already prepared for the detail problems he went on to tackle in the 1950s.

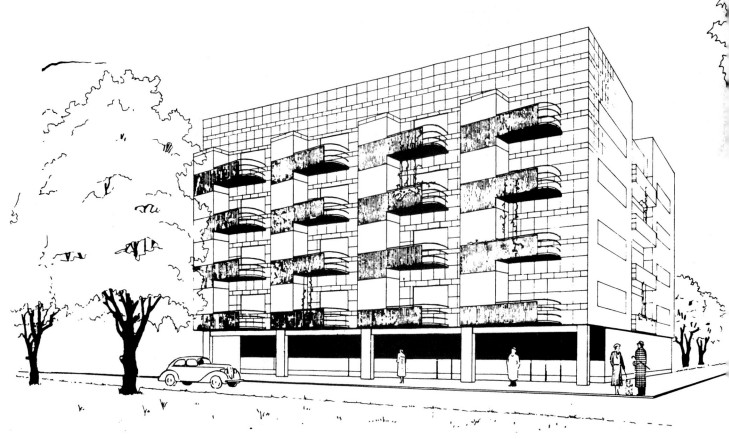

Figure 97
Aino and Alvar Aalto
Artek Company Exhibition Building, Hedemora, Sweden (1946): this extraordinary and virtually unknown work has several important Aalto features. First of all, it comes closer to his idea of autonomous architecture than any other Aalto building. Then, it has a vigorous functionalist/structural logic (note visible cross-bracing on this entrance side). Also, by the use of large-scale furniture details it suggests a surreal approach to building.

4 The years of conflict and reconstruction

The emergence of the modern Finnish nation, and the growth of her industrial economy and prosperity, were adversely affected by her brief winter war with Russia (1939–40) and her subsequent alliance with Nazi Germany in the Second World War. By agreeing in 1941 to allow German troops free access through her territory to the Russian front, Finland incurred the war reparations agreed with Stalin by Churchill and Roosevelt at Yalta in 1944. The result was confirmation of the annexation of the Finnish province of Karelia, amounting to 10% of the entire country on her eastern border, by Russia.

As 1939 ended, Erik Bryggman won the competition for the Turku Funeral Chapel,[1] the construction of which was completed in 1941 (Figures 25–27). Ironically, as the war raged throughout most of Europe, 1940 brought the *Arkitekten–Arkkitehti* review of Jarl Eklund's festive restaurant Kalastajatorppa (Fisherman's Cottage) in Munkkiniemi.[2] Pauli Blomstedt died in 1940 and his Kannonkoski Church was completed by his widow, Märta Blomstedt.[3] Martti Paalanen's fine functionalist church for Varkaus (1937–39) was also reviewed for the first time in *Arkitekten–Arkkitehti*,[4] adding support to Alvar Aalto's earlier functionalist work in that city. Erkki Huttunen's functionalist church for Rajamäki (1939), too, was illustrated.[5] Another important competition, this time for Härmälä Church, went to Märta and Ragnar Ypyä (1940)[6] for a much more interesting design that provided a softer, gentler interpretation of Bryggman's Turku Funeral Chapel. In the realm of industrial architecture, Toivo Paatela's warehouse and offices at Satamakatu 3 in Helsinki[7] recalled the robustness of Väinö Vähäkallio's work. While in the important area of sports and recreation, the Helsinki Olympic Stadium was completed in 1939. Designed by Yrjö Lindegren and Toivo Jäntti, it was reconstructed in 1950–52, when the original timber siding that had formed a vertical wall was modified to reflect the influence of Aalto's canted display wall of the New York World's Fair Pavilion.[8] Towards the end of 1940 Gunnar Asplund, Aalto's Swedish hero, died. Aalto's obituary essay appeared in the final issue of *Arkitekten–Arkkitehti* for that year.[9]

During 1939 a substantial amount of modern housing in the Helsinki area was also completed, replacing old, outmoded stock. The new housing included work in the suburbs of both Töölö and Lauttasaari by such prominent architects as Gösta Juslen, Kaarlo Borg, Matti Finell, Ole Gripenberg (whose work was rather traditional), Jalmari Peltonen, V. Leisten and Arvoo Aalto.

The movement toward modern housing continued in the 1940 Social Democratic Building Society (HAKA) competition, where the emphasis was on so-called high-rise development. Actually, the project ultimately involved some medium-rise blocks of ten storeys, considered relatively high at the time. The HAKA competition was won by Hugo Harmia and Woldemar Baeckman, with Ekelund, Välikangas and Bergström coming second. Ekelund also took third prize in partnership with his wife, Eva Kuhlefelt-Ekelund, and Marjanne Granberg, while Aalto and Aarne Ervi, who submitted a joint entry, were not placed.[10]

In 1941 another important competition called for the design of standard wooden houses. All three prizes were won by teams of women architects, the first prize given to Marjatta Korvenkontio, second to Marja Pöyry and the third to Marjanne Granberg and Eva Kuhlefelt-Ekelund.[11] This success by

women architects took place as Wivi Lönn approached her seventieth birthday, which she celebrated in 1942. As one of Finland's first women architects, Lönn had been a prominent and successful practitioner during the national romantic period.[12]

Gunnar Taucher died in 1941.[13] In the same year the Bensow Building at Esplanadi 22 in Helsinki was completed by Uno Ullberg,[14] whom we have already encountered as City Architect of Viipuri during the period of the library competition and construction. More conservative, or perhaps more 'conservationist', was Jukka Siren's project to extend the Helsinki University Library of 1937 with a 'same again' exterior.[15] Modernism suffered another setback in the competition for the Helsinki Commercial High School (1948–50; Figures 105, 106), in which the picturesque solution of Hugo Harmia and Woldemar Baeckman was awarded first prize over the much stronger entries of both Aarne Ervi and Erik Lindroos.[16] The interior of the Helsinki Commerical High School, especially in the design of the lighting, is nevertheless one of the most successful of this period. In contrast, Hilding Ekelund and Martti Välikangas resurfaced with their delightful and thoughtfully detailed Olympic Village in Helsinki (1950–52).

With such a variety of completed work and projects, so much quality in building production and the clear survival of modernism in Finland, it is difficult to appreciate that most of Europe was at that time being ravaged by war. The return to the picturesque in Finnish architecture must, to some extent, be related to the success of the Turku Funeral Chapel, a halfway house between modernism and national romanticism by Bryggman, who was 50 in 1941. On the architectural front, however, it is clear that the war of styles was still going on. Aalto's lecture, 'The reconstruction of Europe is the central problem of our time', therefore offered a timely and poignant note of reality.[17]

By 1942 Ragnar Ypyä, who had first made his mark with the design of the Viipuri Commercial High School (completed in 1938),[18] had established himself as one of the leading members of the new generation. He continued to contribute to the development and expansion of Viipuri with his new Funeral Chapel for that city (1942–44).[19] This design, which possibly owes a debt to Pauli Blomstedt's project for the original Temppelikatu Church competition, is for a semisubmerged, underground building, which basically presents a wall and a mound to the outside world, with a stepped-entry chapel leading to a main, domed chapel within. It can certainly be seen as the antithesis of Bryggman's Turku Funeral Chapel.[20] Ragnar and Märta Martikainen-Ypyä made two other significant contributions to the evolution of modern Finnish architecture in 1942 with the completion of their grain silo[21] and the Pielishovi Hotel in Joensuu.[22]

Aalto's long involvement with the United States began in the summer of 1937 when the West Coast architect William Wilson Wurster and the American landscape theorist Richard Church visited him at his Munkkiniemi home. Wurster's interest in natural materials, and wood in particular, quickly promoted a bond between himself and Aalto. They struck up a firm friendship and their correspondence stimulated Aalto's connections with the American architectural profession and schools of architecture. Little more than a year after their initial meeting with Wurster, Aino and Alvar Aalto made their first visit to the United States in October 1938. The real purpose of their journey was to sort out various problems of construction and detailing for the Finnish Pavilion at the New York World's Fair. Aalto had been prevented from going to New York in March 1938 by the pressure of work in his office, so he was unable to attend the opening of the first major international exhibition of his work at the Museum of Modern Art. March 1938 was also the month when the New York World's Fair competition was announced and Aalto must have known that this was imminent. In any case, by the autumn of 1938 he was involved not only in the World's Fair Pavilion but also

serving as a jury member for an important planning competition for the Kemi district of Finland. He was commissioned in 1938, too, to design a small pavilion for the forestry section of the National Agricultural Fair at Lapua, which provided the perfect context for the blurring of boundaries between forest and architecture.

Aalto's design for the irregular, undulating box of the Lapua Pavilion created a completely plastic expression. Through the movement of its sculptural form, the external wall of natural tree trunks, complete with their bark, simulated the rhythms of a dense forest. Quite unlike the freestanding poles of the Paris Pavilion, this dense enclosing wall at Lapua translated the forest references of the Villa Mairea's *porte-cochère*, entrance and stair balustrade (Figure 23) into a robust architectural form. Certainly this Lapua Pavilion would have been on Aalto's drawing board at the same time as the New York Pavilion; in both material and form the Lapua Pavilion links the domestic experiments of the *porte-cochère* and Mrs Gullichsen's studio at the Villa Mairea to Aalto's far more dramatic solution for the larger-scale New York Pavilion. This change of scale is important, for it permitted Aalto to realize in the New York design an architectural quality of which he had little first-hand experience, namely urbanity. His original design for Viipuri Library shows quite clearly his lack of confidence in grouping urban elements. With most of his other commissions having either a garden or woodland setting, there is only one commission of the 1920s and 1930s that was sufficiently large and monumental to free him from the constraints of provincial scale. That scheme was, of course, the Sunila Pulp Mill complex.

American architects were as curious about Aalto and his innovative ideas as he was about the United States, and during his 1938 visit he was invited to lecture not only in New York but also at Cranbrook Academy of Arts. As his English was still not very fluent he gave rather simple talks with the aid of slides, using gestures as much as words. His friend Wurster arranged for the Aaltos to be invited also to exhibit their Artek furniture and fabrics at the 1939 Golden Gate Exhibition in San Francisco. Aalto worked on his English during the winter of 1938 so that, when he returned to New York in March 1939 to supervise the final details of construction on the Finnish Pavilion, he was able to explain his ideas with much greater clarity. Feeling a great deal more confident and wanting to take every opportunity of promoting himself while on American soil, Aalto launched the idea of a lecture tour of the United States. Wurster invited him to lecture at Berkeley but, although the Aaltos visited San Francisco to see their display at the Golden Gate Exhibition, Alvar apparently gave no lectures at the University of California. He did, however, give several talks at Yale following the opening of the New York World's Fair and before he left for the West Coast.

These presentations during 1938 and 1939 sowed the seeds of Aalto's interest in discussing the philosophical basis of his work. They also opened up another phase of his international career, that of the visiting professor. Almost certainly Aalto saw in these new contacts the possibilities of developing an alternative career, for the situation in Europe in general and Finland in particular was extremely uncertain at that time. His increasing popularity as a lecturer prompted him to revive his earlier vision, from the 1920s, of establishing himself as a prominent architectural theorist and thinker.

It is only since the publication of Göran Schildt's second volume of the Aalto biography[23] that we have really become able to begin piecing together the scattered fragments that make up Aalto's oblique and frequently whimsical notions of an architectural philosophy. After his early experiments with modernism, the pragmatism and functionalism in Aalto's design equation were modified by the more elusive element of 'feeling'. Aalto believed that the environment was not only a question of science but also one of the poetic. In his own terms, certainly, he had been concerned both at Paimio and at Viipuri with the effect his design

Figure 98

Aino and Alvar Aalto

Artek Company Exhibition Building, Hedemora, Sweden (1946): this rear elevation adopts a simple, economic strategy, returning to the unstripped log aesthetic of the Moscow Embassy project (1935) and the Agricultural Exhibition Pavilion at Lapua (1938), only here the whole structure is supported on *pilotis*.

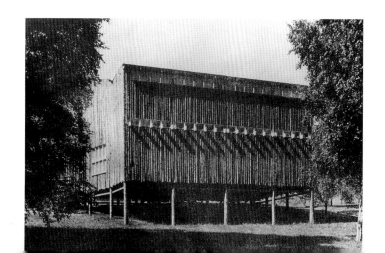

Figures 99 and 100
Alvar Aalto
Baker Dormitory, Massachusetts Institute of Technology, Cambridge, USA (1946–47): this serpentine plan is highly functional, as it gives all rooms an equally good view over the Charles River. The aerial view shows the dormitory in relation to the MIT campus.

strategies had upon people who were the users of his buildings. While he was in San Francisco in 1939 he conceived the idea of forming an institute for architectural research, which was probably his first perception of rational techniques playing a part in the practice of architecture. It is abundantly clear from his preoccupations after 1935, however, that the architectural qualities which were most important to him were precisely those that are difficult to calibrate on any sort of rational scale. In this context it is essential to understand, therefore, that Aalto's design coherence did not evolve from any long-standing concept of a generally applicable design method, but rather developed from a consistent series of interpretive responses to individual architectural programmes in which the architect's environmental memory, his knowledge of pre-existing contexts and constructs, was a key factor.[24]

The very nature of Aalto's multivalant and fragmentary attitude to design would not allow him to adopt a simplistic view that depended solely upon a defined hierarchy of practical problems. It was such practical problems, however, that occupied the minds of the majority of American architects in 1939. Nevertheless, Aalto's assessment that much of the technical research and development in progress in the United States was neither being absorbed nor evaluated by the architectural profession certainly places him a good 20 years ahead of his time. Primarily, Aalto wanted his proposed institute to tackle the broad theoretical issues that confronted the profession. In other words, he seemed to be concerned with formulating philosophical questions rather than locating answers to specific problems.

It seems that his American colleagues, who were fundamentally pragmatic in their approach, found it difficult to grasp the benefits of a general philosophy of architectural problems. They believed that there were more immediate issues to be confronted, not least the threat from the speculative developer, which did not permit indulgence in Aalto's level of abstraction. Perhaps Aalto had misjudged American enthusiasm for his ideas. Certainly, his American colleagues were interested in the variety of his built work and equally intrigued about his architectural intentions. Clearly, however, they were less enamoured of his generalized theories of architecture. In the United States at that time he was regarded as a very talented and inspired architect, but certainly not as a messiah.

Aalto returned to Helsinki from the United States in the summer of 1939. Within a few weeks of his return Russia invaded Finland and the Winter War broke out between the two countries. That war did not last long; a peace treaty was signed in Moscow on 13 March 1940. By the end of the month Aalto was once again back in New York, on this occasion to make some changes to the Pavilion before the reopening of the World's Fair for its second season. Although the Winter War was brief, the cost to Finland was high in the loss of lives and in property damaged or destroyed. Worst, perhaps, in terms of national pride, was the great loss Finland suffered from Russia's annexation of the Karelian isthmus. Quite apart from the problems posed by war damage and the necessity for reconstruction, Finland was faced in addition with the difficult task of rehousing half a million Karelian refugees. As a consequence of Aalto's experience in the assessment of the Kemi district-planning competition, he soon became officially involved in the planning of Finland's strategies for reconstruction.

In the autumn of 1940 Aalto was appointed as a visiting professor at the Massachusetts Institute of Technology (MIT). This appointment was sponsored by the Alfred J. Bemis Foundation as a direct response to Aalto's experience with Finland's reconstruction and it reflected the foundation's bias towards prefabricated, modular, low-cost housing as an integral part of such reconstruction processes. Following the Winter War, Aalto became the principal advocate in Finland of the advantages of standardization in both temporary and low-cost housing. He pioneered these developments also in the Association of Finnish

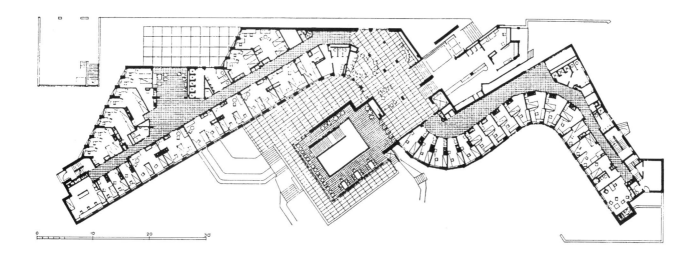

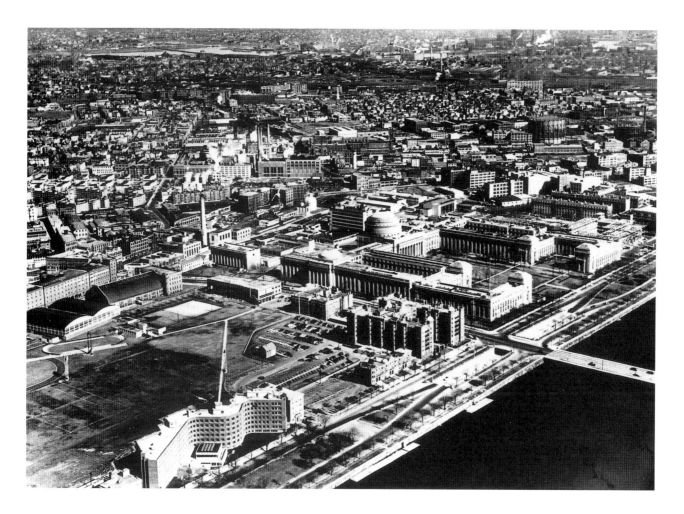

Architects (SAFA) from 1940 onwards. Aalto's involvement with standardization, which built upon his industrial experience in designing furniture, first for Otto Korhonen and subsequently with the Gullichsens, is a significant and often overlooked aspect of his design philosophy. He was deeply concerned to have high-quality, straightforward and inexpensive furniture and basic, well-planned housing within the reach of every Finnish worker.

The opportunity never came to develop his early housing ideas for Sunila (Figure 21) and Kauttua or his work with the Tapani system, nor did Aalto have the chance to evolve a substantial contribution to the general standard of Finnish housing from those promising beginnings. However, there is no question that these works were influential. His ideas certainly permeated the architectural profession in Finland, particularly through his participation in the SAFA standardization committees of the 1940s and 1950s. He did produce designs for low-cost, single-storey, single-family wooden houses, based on some of the ideas incorporated in his earlier 'A. Ahlström System' houses (1938) and examples of these were erected near Helsinki in the early 1940s. Another Ahlström commission involved Aalto in 1945 in the planning of a factory for low-cost housing at Varkaus, for which he also designed some house types that actually went into production.

The Social Democratic Building Society (HAKA) competition was announced in the late summer of 1940 with a proposal for 580 apartment units, and this offered a chance for Aalto to demonstrate his housing ideas on a large scale. His entry was unsuccessful and the first prize won by Harmia and Baeckman. Aalto's failure in this competition should not surprise critics of postwar housing towers, for his solution consisted of four 12-storey blocks. This was an astonishing development in relation to Aalto's housing attitudes of the 1930s and it was clearly out of tune with Finnish thought at the time. But Aalto's solution has two interesting aspects: it looks towards European modern movement housing trends of the 1930s, which never found sympathy among Finnish architects of that period; and it reintroduces an earlier planning motif that was to play a major part in Aalto's later development. In his HAKA towers Aalto uses a single-loaded corridor plan for the first time, developing it into a segmental progression or 'fan' shape. This device influenced his planning of the Baker Dormitory for MIT (1946–47; Figures 99, 100) and was ultimately perfected in the housing tower he designed for the Neue Vahr district of Bremen (1958–62).[25] This fan motif had been anticipated, of course, in the previous decade, for example in the radial site planning of the Sunila 'village' (1934) and the plan arrangement of the engineers' apartments at Sunila (1936).

Aalto began teaching at MIT at the beginning of October 1940 and should have resided in Cambridge, Massachusetts, for three months. When, in early November, increased tension between Germany and Russia persuaded him to return to his family in Helsinki, he had already been absent from his office at the time when the HAKA competition entry was submitted. The Finnish President, Kyösti Kallio, resigned on 19 December. War broke out again on Finland's borders in June 1941, when Germany invaded Russia. Aalto was soon caught up in the consequences of the Second World War, which included Russian air attacks on the civilian populations of southern Finnish cities in the summer of 1941. Although there have been several references to Aalto's return to MIT in 1941, these are in fact erroneous as he was not able to resume his work there until the end of the war in Europe.

Following the Russian air attacks the Finns launched a counteroffensive with German advice and aid, succeeding in recapturing the Karelian isthmus in the summer of 1941. Preparations were then made for a long war. This involved not only plans to protect citizens from future Russian attacks but also the reconstruction and rehabilitation of Viipuri and the rest of Karelia. It was necessary to relocate and expand industry, as well as to

Figure 101
Aulis Blomstedt
Valhalla restaurant, within the fortifications on the island of Suomenlinna, Helsinki (1947–48): it encapsulates the Finnish brick tradition.

build new hospitals and air-raid shelters. There was also the need for an overall planning policy to resite and rehouse the population, a strategy that necessarily involved the design of new towns.

During the remainder of the war Aalto's output was limited, consisting mainly of planning and development projects for government and industry. His industrial work in this period was principally for Harry Gullichsen, commencing in 1941 with the preparation of a masterplan for the Kokemäki River Valley, which surrounds the city of Pori and is one of the country's richest agricultural regions. It also includes Noormarkku, an operational centre for Ahlström industries, where Aalto had already built the Villa Mairea. The masterplan problem introduced Aalto to the principles of regional planning, involving him in both the theoretical and practical aspects of a mixed agricultural and industrial community. This combination of characteristics brought into play his own personal experiences of growing up in a rural area as well as those of his early professional career in both Jyväskylä and Turku.

Aalto won the competition staged in May 1941 to provide a major public air-raid shelter for the important traffic intersection at Erottaja in Helsinki.[26] This reconfirmed his pre-eminence among Finnish architects and provided him with his first experience in the mechanics of town planning. The site was the intersection of central Helsinki's three main streets – Mannerheimintie, Bulevardi and Esplanadi. Aalto's proposal involved a sophisticated traffic-engineering solution, with the separation of trams from other vehicles and pedestrian access to the underground shelter. Included in the jury were three of Finland's other leading architects, Erik Bryggman, Hilding Ekelund and Uno Ullberg. Unfortunately, Aalto's winning design was not realized and a more austere subterranean facility was built by the City instead.

His experience with the masterplan for the Kokemäki River Valley provided Aalto with an excellent background for his participation in the limited competition for the Oulu River in 1941.

Bertel Strömmer was the only other competitor and the two architects also submitted designs for a related project, that of the Merikoski Power Station. Strömmer won the power station project, which really only involved restyling. But Aalto's success in the main Oulujoki competition gave him the chance to get involved in one of Finland's most important projects since the country gained independence. The development of the Oulujoki valley, particularly in the area immediately adjacent to the city of Oulu, formed an integral part of Finland's strategy to concentrate the generation of hydroelectric power. This project, which had its origins in the establishment of the Oulujoki Company in 1941, was eventually completed in 1958.

Aalto's Oulu River project[27] builds on his experience with the Kokemäki River Valley masterplan, and his expertise and reputation in town and regional planning stem from his proposals for the development of Oulu. These involved the use of land on and between a group of islands in the Oulu River, in the very heart of the city, with zones for residential, recreational and school facilities, as well as projecting a plan for the University of Oulu.

Aalto had no formal training in planning techniques, but gained invaluable experience from the Oulu project and from various industrial commissions for Harry Gullichsen. His planning exercises, being limited to Finland, were nevertheless always small in scale and he never really had the scope to develop an international reputation as a town planner. His emphasis instead was on urban design. Even in this area, however, the limits of his experience in terms of scale and magnitude are all too evident in his later planning work at Seinäjoki and Rovaniemi. His proposals for the Oulu River, and for another important hydroelectric development at Imatra in eastern Finland (1942–43), were a major component of Finland's strategic plan for industrial and economic recovery after the ravages of the Winter War. Also, in his sketches for the Merikoski Power Station[28] we can see evidence of a link to Aalto's design thinking that originated in his

Figures 102–104
Erik Bryggman
Villa Nuutila, Kuusisto (1948–49): here the derivations from Finnish traditional models are confirmed by random stonework and the recurring roof pitch. The plan seeks after a traditional, rural character and *architettura minore*, rather than the progression Alvar Aalto made through Munkkiniemi and the Villa Mairea. The elevational study (opposite) confirms that the intention is towards *architettura minore*.

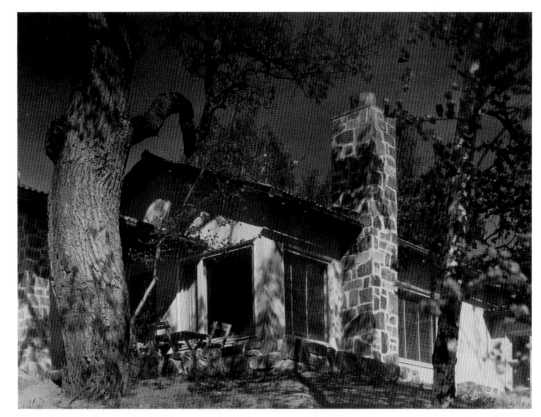

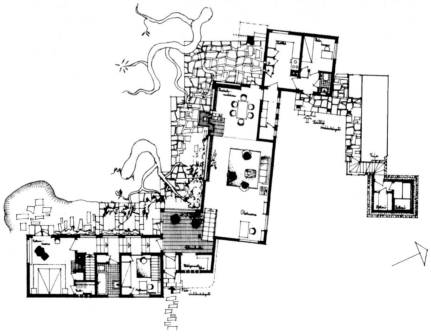

Finnish Architecture and the Modernist Tradition

entry for the Tampere Railway Station competition and culminated in the industrial expression he evolved for the Sunila Pulp Mill. Aalto subsequently abandoned this approach but it was faithfully developed by his former assistant, Aarne Ervi, when he designed one of the Oulujoki upstream power plants in the mid-1950s.

Between 1943 and 1945 Aalto initiated two further planning studies that provided significant directions in his later career. The first of these was for the design of a new town for the government-controlled Enso-Gutzeit Company at Säynätsalo, on a wooded island in the lakes immediately south of Jyväskylä. His project for this 'forest town' was similar to his later entry for the Säynätsalo Town Hall and Centre competition (1949), which he won and subsequently executed. In the original proposal the Town Hall was located on the southern base of a large, triangular space or clearing which was framed on the other two sides by apartment buildings that were stepped in relation to the open area. In the executed design of 1952 the Town Hall was moved to stand at the other end of the site, on the highest point of ground at the apex of the triangle.[29] The stepping of parallel apartment blocks has its origin in Aalto's earliest site-planning exercises and is a variation of the stepped and fanned layout of the Sunila village. It remained one of his favourite planning motifs and was avidly followed by his disciple, Aarne Ervi, in his housing layouts, for example in the garden suburb of Tapiola. In the realized project for Säynätsalo Town Hall Aalto treated the central courtyard as an almost completely enclosed element, isolated from the external surroundings by its location one floor above street level (Figure 28). The original project for Säynätsalo was therefore a watershed in his career: it was mainly based on earlier concepts of spatial relationships and site planning and it marked the end of Aalto's loose frameworks of external spaces other than those later examples for Seinäjoki and Rovaniemi.

The Germans withdrew from Lapland in the autumn of 1944, an event which was to present Aalto with another challenge. His proposal for the replanning of Rovaniemi, the principal city of Lapland, dates from 1945 and depends on a low-density development with a proliferation of open spaces for recreation. Although this Rovaniemi Plan is frequently quoted as one of Aalto's most successful and authoritative proposals it is, in reality, further evidence of his limited and provincial attitude to town planning. It includes such distinctly suburban elements as detached, one-family houses, no longer grouped like those built near Helsinki, but spread out and served by a non-gridded road system similar to an American subdivision pattern, with individual driveways and garages.

The development of the Rovaniemi city centre at the end of Aalto's career confirms his addiction to the 'loose weave' of new-town suburbia that has its roots as early as 1915 in Eliel Saarinen's proposal for the decentralization of Helsinki and the design of Munkkiniemi. It might be argued, of course, that it was Aalto's desire to humanize that prompted such a loose-fit design. His image of the suburban house may also have been influenced by his visit to California before the outbreak of war, when he had seen Frank Lloyd Wright's Hanna House at Palo Alto (completed in 1936). But Aalto's work never achieved the density and complexity that characterize the pattern and rhythm of life in a true urban locus.[30] Saarinen had already begun to erode Finland's urban foundations with his plan to decentralize Helsinki, while Aalto's work at both Seinäjoki and Rovaniemi was based on the theory of the 'forest town' but without the forest.

Just before the end of the war, in late 1944, Aalto received from the Ahlström Company a commission that was less ponderous than all these strategic planning studies. The project was an extension to the top of the Varkaus Sawmill, posing the problem of enclosing the incoming log conveyors. It was a task that gave him the opportunity for free play, a chance to have a bit of fun at a smaller scale after the ponderous responsibility

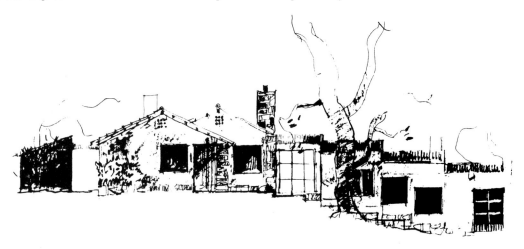

attached to master-planning. He evolved a penthouse structure that has an essentially sculptural quality, creating an interesting skyline in the baroque sense by combining traditional board-and-batten construction in abstract geometric forms that recall both the Villa Mairea and the New York Pavilion. It demonstrated his awareness of the functional needs of industrial architecture combined with an element of playfulness that characterizes much of his best work. Also, the Varkaus Sawmill extension marks a further watershed in Aalto's design thinking. It was again a backward-looking gesture, while from 1946 onwards his work begins to map out new terrain.

Erik Bryggman's contribution in the early 1940s is of considerable significance. His Turku Funeral Chapel, considered by many to be his masterpiece and certainly his most memorable building, was completed in 1941.[31] It is a model of sensitivity in the relation of architecture to landscape and context, comparable to Aalto's Villa Mairea and Säynätsalo Town Hall from that viewpoint. Sited on a high-point in the Turku Cemetery, the chapel is approached by a long flight of gently ramped steps, which arrive at the left end of a three-bay portico (Figure 26). In contrast to the general form and expression of the chapel, which is a subtle blend of modernism and national romanticism, this portico is decidedly classical. Indeed, it seems to represent a fragment of a past age, the age of those who have passed on, an age of quite different principles and sense of order, an age of substance, dignity and decisive values. And it stands on the hilltop like the gateway to another world, a *propylaeum*, a final resting place on earth before the traveller proceeds on the eternal journey.

The columns of this portico are simple shafts, without capitals, but their tile cladding is in vertical strips that gives the appearance of modular fluting. Beyond this gateway of the portico are two paths. One passes through the chapel, by way of the altar and the last rites of the church, then out again to the cemetery. The alternative path links the far end of the portico back across a stepped terrace to the exit from the chapel's sanctuary. Once through the portico and into the chapel the wooded glade of the cemetery is visible beyond a nave arcade of five columns and through a continuous glass wall that is punctured by the solid masonry 'box' frame of the processional exit. This masonry frame is etched with bas-relief carvings that are also visible through the nave arcade and from the side aisle. The simple, asymmetrical interior, with the arcade and aisle on the south side only, the glass wall to the wooded surroundings and the masonry frame that pierces this wall, is determinedly modern in form although the details, like Aalto's at the Villa Mairea, are equally post-functionalist (Figure 27).

This post-functional mood is set already with the classical portico, the columns of which certainly influenced Aalto's later tile cladding of columns from the 1950s onwards. It is continued in the bronze door handles and the interior light fittings, both of which abandon the industrial character of functionalism in favour of a return to the craft tradition. These door handles might again be cited as the inspiration of Aalto's bronze door handles, which certainly retain the spirit if not the form of Bryggman's examples on the Turku Funeral Chapel. Bryggman's tower is also an intriguing blend of modern forms with memories of Finnish medieval walling at Porvoo Cathedral and other churches (Figure 25).

The entire design of the Turku Chapel is carefully calculated and finely tuned to achieve a lasting balance between what is positive in modern functionalism and what persists as reinforcement from memories of past structures. The skilful plan, which is at once modern and yet agglutinative in the spirit of the national romantic tradition, is the key to an overall form that although simple volumetrically is nevertheless complex in imagery. Apart from the element of the classical portico and the masonry box frame that might be read as a memory of the Erechtheium's caryatid portico in Athens, there is the gentle pitching of the roof that reduces the harshness of the west front. Although

in overall appearance there may be little to suggest a connection between Bryggman's Turku Chapel and Aalto's later work, there are nevertheless many clues in the planning,fragmentation of form and complex imagery that appear to have much in common with Aalto's significant change of direction from the Villa Mairea onwards.

Bryggman built his own house, the Villa Nuutila, at Kuusisto (1948–49). In this work, however, the similarity between Aalto and Bryggman virtually disappears. With the Villa Nuutila Bryggman returns to his earlier preoccupation with entirely traditional forms and techniques. Although the plan has a random and fragmentary character, this is again largely traditional in its sources from Finnish farms and rural architecture (Figure 103). And the purpose of this randomness of plan and form, with many breaks in the pitched tile roof and deep overhanging eaves, is to achieve a picturesque effect. The Villa Nuutila corresponds precisely with the *architettura minore* that was much admired by Bryggman and Ekelund in the 1920s, and therefore seems to represent a backward step in Bryggman's architectural development (Figure 104).

Whereas in the Turku Chapel Bryggman reflects Aalto's discontent with the lack of charm implied by pure functionalism, in the Villa Nuutila he parts company with Aalto's intent 'to make functionalism more human in modern terms'. The Villa Nuutila, for all its charm, is a romantic reconstruction of past values and is not at all to be compared with the Villa Mairea. If there is a weakness in Bryggman's Turku Chapel it lies in the hints of pastiche, but its memorable virtues are the strength of its concept and the simplicity with which this is carried out. From this point of view the details of the Turku Chapel, while they dissipate a little of this strength, remain incidental to the powerful effect of the whole. In the Villa Nuutila, however, the desire to charm with picturesque effect takes over, 'la recherche du temps perdu' therefore blurs the statement of 'the present' (Figure 102).

The Turku Chapel was certainly a watershed in Bryggman's career, as the Villa Mairea and the New York World's Fair Pavilion were in Aalto's, but the difference is that Aalto continued to go forward during the late 1940s and 1950s, whereas Bryggman's work reverted to a more traditional course. This is confirmed even in Bryggman's prefabricated wooden Workers' Housing for Turku (completed in 1947), where the use of deep overhanging eaves, stepped plans and fencing shares the themes he revived in the Villa Nuutila, although this revisionism might be thought partially defensible in the immediate postwar years when the old values were even more dear to the Finns, who ironically found themselves sharing the ignominy of Germany's defeat.

The competition for Sakkola Church (1943–44)[32] clearly demonstrated the influences of Bryggman's Turku Chapel on the new generation of Finnish architects. Although Bryggman received only the purchase prize, Hugo Harmia and Woldemar Baeckman, who won first prize, followed the return to romanticism that Bryggman had already outlined in his detailing of the Turku Chapel. During 1943–44 Bryggman was engaged in the reconstruction and restoration of Turku Castle, following the Russian bombing of 1941, and this conservation project must have been close to his mood at that time. In that same period Aalto's main project was the design for the centre of Avesta in Sweden, which he undertook with the Swedish architect Albin Stark.[33] There was, however, a considerable amount of new construction in Tampere, including that of the Bus Station, new factories, a power plant, housing and banks, which involved the work of Bertel Strömmer, Jarl Eklund and Harry Schreck among others.[34]

In 1945, the competition for Meilahti Church, Helsinki, once again confirmed the persistence of Bryggman's influence.[35] The winning design by Markus Tavio was a direct interpretation of Bryggman's Turku Chapel. But this competition revealed no other clear line in Finnish architecture at that moment. Although Jukka Siren's entry

displayed a revised form of classicism, ironically that in itself resembled Bryggman's style of the 1920s. But standardization rather than style was the order of the day in 1945.[36] Following the war, hospital design was also a priority and the Finnish Red Cross Hospital competition for a new large-scale facility (1946) was won by Jussi and Veli Paatela.[37]

Thoughtful reconstruction, as Aalto had already said, was the great priority. Rebuilding the Lapland city of Rovaniemi was one of the principal focuses of this process and in this spirit Aalto prepared his Rovaniemi Plan.[38] In his introduction to the 'Rovaniemi Rediva' proposal, he wrote:

'... the opportunity accorded to us by the interval between the two wars of gaining experience in planning made it possible for us to set about the reconstruction more rapidly than some other countries. Finland is now a noted exporter of prefabricated houses.'[39]

During 1946 Aalto continued his collaboration with Albin Stark in Sweden, this time preparing a proposal for social housing at Nynäshamn, which revived his ideas for the HAKA competition of 1940.[40] A minor work, but an important gesture of affection, was Aalto's design for the gravestone for Uno Ullberg (1879–1944).

Aarne Ervi established himself as a leading architect of the new generation by 1946 with two projects. He won the Jyväskylä Sports Centre competition at the end of 1945,[41] and the following year he completed his justly celebrated Kestikartano Restaurant in Helsinki.[42] Kestikartano was an important symbol of Finland in the years immediately following the war. A traditional restaurant with entirely Finnish dishes served by young Finnish women in national dress, it became a focus for Finns and visitors alike. Located in the very centre of Helsinki, on Keskuskatu it was immensely popular until Finland was overtaken by internationalism in the late 1960s. Ervi's design for the restaurant, which was entirely an interior design, was based on traditional Finnish log construction, given a post-national romantic interpretation in the tradition of Lars Sonck. It was eventually dismantled and remains in storage, awaiting a return of Finnish chauvinism about its *voileipäpöytä* (the Finnish equivalent of the Swedish *smörgåsbord*). Aulis Blomstedt's log sauna at Evitskog,[43] of the same year, has the same stylistic roots as the design of Ervi's Kestikartano Restaurant.

In terms of personal architectural development, Aalto's most important work in 1946 is the little-known exhibition building that he and Aino designed for the display of Artek furniture and fabrics, located at Hedemora in Sweden.[44] In contrast to the traditional themes explored by Ervi in Kestikartano and Blomstedt at Evitskog, Aalto continued his radical approach to the use of timber and wood technology in this pavilion (Figures 97, 98). Its appearance is undoubtedly influenced by his design for the Lapua Pavilion, although its braced structure is an innovation. The exterior is clad on three sides entirely by whole saplings, with a glazed entry wall that reveals the trusses. Unlike the Lapua Pavilion, however, the Artek building is lifted up on tree-trunk *piloti*, like a primitive-hut version of Le Corbusier and it is approached by a bridge that has the same rough, forest character as the railings at the Villa Mairea. Little evidence of this intriguing structure remains, but what little we have indicates that it was a seminal work in terms of plan, form and expression.

Immediately after the war, there was a great deal of interest in the tradition of the Finnish sauna bath, which was vigorously promoted by *Arkitekten–Arkkitehti*.[44] Among the sauna designs published at this time was that for the Villa Mairea, which was added after the war in 1947. Finnish architects were encouraged once more to look beyond their immediate borders in exploring the art of landscape and garden planning. At that time *Arkitekten–Arkkitehti* published a review of the Japanese, French and English landscape traditions written by Aulis Blomstedt and the female pioneer Finnish modernist, Elsi Borg.[46]

Important in terms of Finland's need to increase exports and tourism was the completion in 1947 of Erik Lindroos's new factory for the Arabia Company.[47] Arabia is the main producer of ceramic products in Finland and its products range from sanitary ware to ovenware, fine china and ceramics as an art form. Lindroos's factory was considered a model for ceramic production at the time it was completed but is, like much of his work, quite undistinguished in architectural terms.

In Finland 1947 was not a rich year, architecturally speaking. Hugo Harmia and Woldemar Baeckman maintained their leading position within the profession by taking a joint second prize in the Tampere Technical High School competition. The other second-prize winner was Yrjö Lindegren of Helsinki Olympic Stadium fame.[48] A posthumous work by Uno Ullberg in partnership with Erkki Linnasalmi, the Helsinki Children's Clinic, should be mentioned as an important social contribution of this period.[49] Following the ravages and stresses of the war, such a children's facility was much needed in the capital at that time. There were also some private houses of interest, notably those at Nurmijärvi by Aarne Hytönen and Riisto-Veikko Luukonen and at Westend by Viljo Revell.[50]

In 1948 Aino and Alvar Aalto celebrated their twenty-fifth wedding anniversary. In the same year Alvar published his celebrated essay 'L'œuf de poisson et le saumon'[51] and prepared the design for the Strömberg Factory and Sauna at Vaasa.[52]

The results of the Salla Church competition (1948) once again showed that the winners, Eero Eerikäinen and Osmo Sipari, had been successful by following the direction set by Bryggman in his Turku Funeral Chapel.[53] What this competition really revealed, however, was a general tendency to move away from modernism towards this more romantic mode of expression. And indeed, the result of the Rovaniemi Church competition, which was announced at the same time, further confirmed the faltering of modernism in favour of such a compromise.[54]

From 1948 onwards there was also increasing contact between Finland and the United States. In that year, Ervi followed up the success of his Kestikartano Restaurant with a Finnish Restaurant at 39–41 East 50th Street in New York City.[55] *Arkkitehti* had previously only published the work of two contemporary American architects, Frank Lloyd Wright and, of course, Finnish-born Eliel Saarinen. In the autumn of 1948 the Association of Finnish Architects' journal reviewed two houses by Richard Neutra, one for Edgar Kaufmann at Palm Springs and another for a Mr Tremaine at Montecito, and in addition published some work by Walter Wurdeman and Paul Nelson.[56] Viljo Revell came into increasing prominence with the competition for a housing project in Vaasa,[57] while Erik Bryggman moved increasingly into the background when his design for the Turku University Library competition was unplaced in the winter of 1948.[58] Modernism, however, appeared to be set for a revival, at least at the hands of one of the younger generation of Finnish architects. Aulis Blomstedt's submission for the Turku University Library competition was certainly uncompromising in its functionalist expression.[59]

Unfortunately, one of the consequences of wars is the attention that must be given in their aftermath to the design of graveyards. Turku Cemetery (1929–35), the site of Bryggman's Turku Funeral Chapel, is acknowledged throughout the world as a masterpiece of Finnish graveyard design. It is a popular spot for relatives to this day and many continue the pagan and early Christian tradition by picnicking there during their visits on warm summer afternoons. In 1949 two outstanding graveyard designs were completed: one at Saynätsälo by Aulis Blomstedt and another at Hyvinkää by Erik Lindroos.[60]

Otherwise, the end of the decade is marked mainly by the construction of industrial and commercial work. Erkki Huttunen's mill and silos for SOK were completed during 1949,[61] as was his most memorable design, that for the SOKOS Building between Eliel Saarinen's Railway Station and Mannerheimintie in Helsinki.[62] The latter is

designed in a sort of refined modernist style and is one of the largest buildings in the capital, with a floor area of 140 000 m². Most significant, perhaps, at the end of the decade was the arrival of the truly modern office complex in Helsinki with the competition for the site at Eteläranta 41–60 (1949–52), which provides an important foreground to Engel's cathedral from the Kaivopuisto. This competition for the building that eventually became known as the Palace Hotel and Industrial Centre was won by Viljo Revell and Keijo Petäjä and provided one of the most effective new landmarks in central Helsinki.[63]

Aalto's principal work during the late 1940s focused on two buildings: the Baker Dormitory at the Massachusetts Institute of Technology (MIT) in Cambridge, Massachusetts (1946–47; Figures 99, 100) and the National Pensions Institute in Helsinki (1948–56; Figures 99, 100). Only a year after his appointment as a visiting professor at MIT, Aalto was commissioned to design a new dormitory for undergraduate students. As a result, from 1946 onwards he spent less and less time on teaching, devoting most of his biannual visits to the supervision of planning and construction of what was to become known as the Baker Dormitory. Required by American law to work with a local office, Aalto associated himself for this purpose with the Boston practice of Perry, Dean and Shaw.

The design of the Baker Dormitory advanced Aalto's development in a number of significant ways. In the first place it was his largest commission since the Sunila Pulp Mill of 1934–35. Secondly, following the change of site for the Viipuri Library, it provided Aalto with his first real challenge in urban design. Thirdly, it allowed him to further explore his predilection for the 'fan' motif through its undulating plan form. It also introduced him to the possibilities of brick expression for public buildings, a feature that was to prove of great importance in his work of the 1950s and 1960s.

In the design for the Sunila Pulp Mill Aalto experienced his first exercise in brick expression, adhering to the largely nineteenth-century European tradition of using brick in the construction of warehouses, mills, factories and breweries. During his visit to The Netherlands in 1928, Aalto saw the brick buildings of modern Dutch architects, notably Wilem Dudok in Hilversum; this early stimulus would have connected him to the environmental memory of the entire brick tradition of the Baltic region of which Viipuri is, of course, an integral part. Aalto's use of brick for the Baker Dormitory, however, followed more closely the examples of red-brick buildings on the Ivy League university campuses of Harvard, Yale, Princeton and Pennsylvania. We have already noted Aalto's earlier interest, inspired by Eliel Saarinen, in using vines and creepers to help blur the boundaries between buildings and their surrounding landscape. Clearly, the ivy-clad brick buildings of those American campuses had a strong appeal for Aalto and both the fourth and final stages of the Baker Dormitory design illustrate, in the perspective sketches, proposals to incorporate vine-covered trellises onto the façade facing the Charles River.

The size of the Baker Dormitory commission was of particular importance to Aalto. Its location on the north bank of the Charles River, facing onto a main Cambridge thoroughfare, Memorial Drive, was also of great significance. Even in his earliest sketches Aalto responded to the site in his characteristic way, grouping the accommodation into a number of stepped pavilions that complement the winding path of the river. In developing his design Aalto converted this initial rectilinear geometry, which still conformed to the parallel blocks of buildings on adjoining sites, into a more free and sympathetic interpretation of the site's relationship to the Charles River. From these intermediate sketches there evolved a serpentine wall that faces onto the river, mimicking its path. He achieved this by changing the angle at which the building composed itself on the site, opposing the regular rectangularity of the adjoining buildings. In this way the serpentine form, although conforming to a

parallel grid of its own, was shifted to allow the plan to respond to the course of the river. This curvilinear form, however, derived only in part from site conditions; it owes a debt also to similar forms of quite different purpose that Aalto developed before the war in the New York Pavilion (1938–39). In addition the curved form corresponds to Aalto's sense of the functionality of the plan, giving the occupants of the study–bedrooms a wide variety of views across the river frontage.

Even the boldly expressive, cantilevered staircases on the rear, north wall, with their rather mannerist effect, were considered by Aalto to be part of a direct functionalist response to the fire marshal's ordinances.[64] By making this subsidiary element of the staircases into a prominent design feature Aalto emphasizes the importance of vertical circulation in dormitory design. This significance was further stressed by his radical treatment of the fenestration within the staircase element. That treatment can, of course, be traced to Aalto's functionalist approach, in that the windows are stepped to follow the outline of the staircase. But the actual organization of the sash elements and the triangular, fixed casements that make up the staircase fenestration is highly irrational in the irregularities and inconsistencies it develops. These anomalies are particularly noticeable from the inside, when ascending the stairs. Although the long, straight flights recall, for example, the office stairway in the *Turun Sanomat* Building, this functional source does not explain the window design. In fact the window detailing is highly reminiscent of sash designs found on the summer verandas of Eastern European villas, particularly along the Baltic coastline.

The Baker Dormitory is not merely an American anomaly in Aalto's work. Its bold use of apparently conflicting geometries and the equally confident handling of the fenestration, both towards the river and on Memorial Drive, give strong indications of Aalto's direction during the next two decades. In addition, the placing of the cafeteria to nestle into the curve on the river front, with its overhead artificial light fittings on the roof, carries Aalto's interest in the top-lighting of the principal internal space a stage further. The MIT dormitory afforded Aalto invaluable insights into the design of his Helsinki brick buildings of the 1950s. By accepting an invitation to teach at MIT he put himself in line for this important commission, which in turn initiated the formulation of Aalto's mature expression in urban architecture.

In 1948 Aalto received his first major commission in Helsinki, that for the Institute of Engineers' Headquarters . During that year he also participated in two major Helsinki competitions, both in association with his wife, Aino. These two competition entries constitute their last collaborative works. Aino did not live to see the development and completion of these projects, which by their magnitude, scope and importance were to ensure the security of Aalto's Helsinki office and therefore vindicate his decision to abandon his American aspirations.

The first of the 1948 competitions was for the headquarters of the National Pensions Institute, the size and social significance of which attracted 42 entries. Proposals were originally requested for a site located on the west side of Mannerheimintie, opposite Töölö Bay, immediately to the north of Saarinen's National Museum, where the Intercontinental and Hesperia hotels were eventually built. The jury included Aulis Blomstedt, the Helsinki Technical University professor who had such a strong influence on the post-Aalto generation of Finnish architects, and Yrjö Lindegren.[65] The Aaltos won first prize with their main project, the motto for which was 'Forum Redivivum', while his former assistants Viljo Revell, Heikki Siren and Arne Ervi also shared the awards.

The original site was essentially triangular in shape and framed by streets on all sides, with the main frontage on Mannerheimintie. Aalto's main entry responded to this alignment and presented two principal elements to this major thoroughfare. He proposed a 13-storey slab office block at the southern end of the site, with four storeys of offices

Figures 105 and 106
Woldemar Baeckman and Hugo Harmia
Commercial High School, Helsinki (1948–50): this is a strange, early postwar hybrid – a brick-covered, framed building with some Swedish influence. While the two-storey panel above the central entrance has a super-scale mural of realistic ceramic figures in bas-relief. A bold, but unsuccessful attempt to be modern and nationalist at the same time, it nevertheless remains a symbol of Finland's revival. The plan is an interesting transformation of a classical model, with its superficial symmetry abandoned in the courtyard treatment and height variations in the north and south wings.

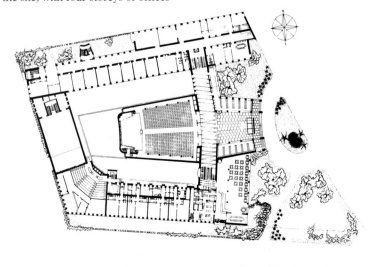

around an internal top-lit court at the north end. These elements were placed on a podium more than one storey high that formed an open courtyard between them within the site. This raised courtyard was to be reached from Mannerheimintie by two flights of steps, a monumental one running parallel with the street up to the lower block, while the subsidiary one provided direct access to the tower.

The original National Pensions Institute project shows Aalto's first use of a monumental external staircase since the second Viipuri Library design of 1928 but, whereas the Viipuri proposal was for an unbroken flight, the Forum Redivivum design of 1948 reflected the Baker Dormitory fire-stair form by introducing major landings. The podium in this design was used in the mode of the classical *parti* as a circulation link between the office elements. Unlike Asplund's use of the podium in his Stockholm Library, however, Aalto developed the 'bridge' of the podium between the two staircases as the principal entrance to the complex, proposing an anti-classical thesis by cancelling out the notion of axiality and reducing the dominance of the main entry. This relationship of staircase to entrance, with the subservience of the principal entry that became a feature of Aalto's work, was retained in the final design built on the alternative site farther north on Mannerheimintie.

With his entries for the World's Fair competitions for Paris in 1936 and New York in 1938, Aalto established a pattern of hedging his bets with alternative designs. He continued this practice by submitting a Forum Redivivum B entry. This alternative proposal embraced an additional plot of land to the south that allowed Aalto, by bridging the intervening street, to realign his building elements in relation to Mannerheimintie, creating in the process his characteristic split-axis and fan-plan motif. By lowering the height of the accommodation on the podium at the south end of the site and opening up the space between it and the tower, he contrived a wedge-shaped deck at first-floor level that opened out towards the lower, top-lit accommodation at the north end.

Aalto's idea in both entries was to treat the building form not as a single entity but as a reconstruction of the urban environment in relation to the functionality of the architectural programme. His concept of the urban function of the programme therefore involved a number of separate buildings spatially linked by the podium. This podium formed a base building, a single-storey structure perforated by courtyards around which Aalto devised the internal circulation within the site. The Forum Redivivum designs are therefore a valuable key to Aalto's postwar architecture, as through them he conducted vigorous experiments in the evolution of his 'urban fragments'. In them we can observe his technique of eroding forms and masses, which has already been noted in his Munkkiniemi House (1934–1936) and the Villa Mairea (1937–39), combined with a reconstruction of his earlier use of the neoclassical *parti* in the Viipuri Library stage three design (1929).

The Forum Redivivum designs, particularly 'B', also mark a return to one of Aalto's even earlier preoccupations, that of the model of the Italian piazza, as seen in his Parliament Building competition entry (1923) and that for the Viinikka Church competition (1927). In this approach he returned to themes he had explored early in his career, with the entries to the second stage of the Parliament Building competition (1927) and the Töölö Church competition (1927), where a number of separate buildings are grouped around a piazza-like space. A variation of this urban form is found in the Paris World's Fair Pavilion (1936–37) and the Tallinn Art Museum project (1937), where the elemental grouping is transformed and compacted to surround a courtyard rather than a piazza. We shall see that the Säynätsalo Town Hall (completed in 1952; Figures 28, 29) became the most cogent realization of this urban model. In the 'B' solution, for which he was awarded the first prize, Aalto not only shifted the axis of the piazza adjacent to Mannerheimintie but also created a further *piazzetta* in the northwest corner of the site enclosed by the public concert hall (omitted from the final

building programme) to the south, with an apartment block along the northern edge that returned partway along the east flank. The disjointed, almost casual relationship of these two spaces recalls the non-alignment encountered in the evolution of many Italian piazzas.[66]

These Forum Redivivum entries permitted Aalto to develop a strategy for his larger, postwar buildings. In the design of the Baker Dormitory he began to grapple with the problems of urban scale and complexity. Also, in the MIT building he used red brick for the first time and this external finish became the core of his postwar expression. In the Forum Redivivum entries he also formulated guidelines for the ordering of urban sites. His understanding of the essential complexity and variety that contribute to successful urban space and form is nowhere more apparent than in the Forum Redivivum 'B' design. He retained many of its original qualities and even added others in the executed design on the larger, more northerly site; but the building as realized is very different in form and profile, if not in essence, from the original concept.

Aalto's entry for the Helsinki Passenger Terminal competition (1949), although anticipating the plan form of the Säynätsalo Town Hall, is in contrast a low-key and relatively uninspired work that has none of the energy or urbanity of the Forum Redivivum projects. Although it might be said to represent his concept of an autonomous architecture, it certainly does not suggest a gateway into Engel's neoclassical centre of Helsinki, nor does it have any of the resolution of Aalto's later Enso-Gutzeit Headquarters constructed on the opposite side of the harbour.[67] The Helsinki Passenger Terminal project is undoubtedly one of Aalto's least successful designs, perhaps reflecting the strain upon him of the advanced stage of Aino's terminal illness and her death from cancer in 1949.

References and notes

[1] *Arkitekten–Arkkitehti*, 1939, No. 11–12, pp. 166–171.

[2] *Arkitekten–Arkkitehti*, 1940, No. 5–6, pp. 38–41.

[3] *Arkitekten–Arkkitehti*, 1940, No. 7–8, pp. 49–52.

[4] *Arkitekten–Arkkitehti*, 1940, No. 7–8, pp. 53–57.

[5] *Arkitekten–Arkkitehti*, 1940, No. 7–8, pp. 58–60.

[6] *Arkitekten–Arkkitehti*, 1940, No. 7–8, pp. 62–63.

[7] *Arkitekten–Arkkitehti*, 1940, No. 9–10, pp. 60–66.

[8] *Arkitekten–Arkkitehti*, 1940, No. 11–12, pp. 85–108.

[9] *Arkitekten–Arkkitehti*, 1940, No. 11–12, p. 81.

[10] *Arkitekten–Arkkitehti*, 1941, No. 1, pp. 5–16.

[11] *Arkitekten–Arkkitehti*, 1941, No. 2, pp. 28–32.

[12] *Arkitekten–Arkkitehti*, 1942, No. 5, p. 20.

[13] *Arkitekten–Arkkitehti*, 1941, No. 3, pp. 33–43.

[14] *Arkitekten–Arkkitehti*, 1941, No. 5, pp. 65–74.

[15] *Arkitekten–Arkkitehti*, 1941, No. 7–8, pp. 101–109.

[16] *Arkitekten–Arkkitehti*, 1941, No. 11–12, pp. 70–80.

[17] *Arkitekten–Arkkitehti*, 1941, No. 6, pp. 75–80.

[18] *Arkitekten–Arkkitehti*, 1938, No. 9, pp. 139–144.

[19] *Arkitekten–Arkkitehti*, 1942, No. 2, pp. 17–20.

[20] *Arkitekten–Arkkitehti*, 1942, No. 7–8, pp. 81–98.

[21] *Arkitekten–Arkkitehti*, 1942, No. 11–12, pp. 111–116.

[22] *Arkitekten–Arkkitehti*, 1942, No. 11–12, pp. 117–123.

[23] Göran Schildt, *Alvar Aalto: the decisive years*, Rizzoli, 1986.

[24] Malcolm Quantrill, *The Environmental Memory*, Schocken, 1987, pp. 160–173.

[25] Included in a review of recent work, *Arkitekten–Arkkitehti*, 1959, No. 12, pp. 193–228. Discussed in Malcolm Quantrill, *Alvar Aalto: a critical study*, Secker & Warburg; Schocken, 1983, pp. 205–207.

[26] *Arkitekten–Arkkitehti*, 1942, No. 1, pp. 9–11.

[27] *Arkitekten–Arkkitehti*, 1943, No. 1, pp. 1–5.

[28] *Arkitekten–Arkkitehti*, 1943, No. 1, pp. 6–11.

[29] *Arkitekten–Arkkitehti*, 1953, No. 9–10, pp. 150–158.

[30] Malcolm Quantrill, 'The urban locus', *Royal Institute of British Architects Journal*, 1975, No. 2, pp. 22–35.

[31] *Arkitekten–Arkkitehti*, 1942, No. 7–8, pp. 81–98.

[32] *Arkitekten–Arkkitehti*, 1944, No. 3–4 pp. 22–35. Yryö took third prize, while Bryggman got only the purchase prize.

[33] *Arkitekten–Arkkitehti*, 1944, No. 10, pp. 108–113.

[34] *Arkitekten–Arkkitehti*, 1944, No. 11–12, pp.

[35] *Arkitekten–Arkkitehti*, 1945, No. 5–6.

[36] *Arkitekten–Arkkitehti*, 1945, No. 7.

[37] *Arkitekten–Arkkitehti*, 1945, No. 9–10, pp. 104–117.

[38] *Arkitekten–Arkkitehti*, 1945, No. 11–12, pp. 129–145.

[39] *Ibid.*, p. 127.

[40] *Arkitekten–Arkkitehti*, 1946, No. 7–8, pp. 83–87.

[41] *Arkitekten–Arkkitehti*, 1946, No. 1.

[42] *Arkitekten–Arkkitehti*, 1946, No. 5, pp. 53–58.

[43] *Arkitekten–Arkkitehti*, 1947, No. 4–5, pp. 64–65.

[44] *Arkitekten–Arkkitehti*, 1946, No. 7–8, pp. 91–94.

[45] *Arkitekten–Arkkitehti*, 1947, No. 4–5, pp. 54–80. The design of the Ahlström sauna at Kauttua is here specifically credited to both Aino and Alvar Aalto.

[46] *Arkitekten–Arkkitehti*, 1946, No. 9–10.

[47] *Arkitekten–Arkkitehti*, 1946, No. 7–8, pp. 97–105.

[48] *Arkitekten–Arkkitehti*, 1947, No. 1, p. 11–12.

[49] *Arkitekten–Arkkitehti*, 1947, No. 9–10, pp. 125–140.

[50] *Arkitekten–Arkkitehti*, 1947, No. 6–7.

[51] *Arkitekten–Arkkitehti*, 1948, No. 1, pp. 7–9.

[52] *Ibid.*, p. 5.

[53] *Ibid.*, pp. 3–5.

[54] *Ibid.*, pp. 38–44.

[55] *Arkitekten–Arkkitehti*, 1948, No. 7–8, pp. 91–94.

[56] *Ibid.*,

[57] *Arkitekten–Arkkitehti*, 1948, No. 9, pp. 118–120.

[58] *Arkitekten–Arkkitehti*, 1948, No. 12, pp. 153–163.

[59] *Ibid.*,

[60] *Arkitekten–Arkkitehti*, 1949, No. 8, pp. 117–119.

[61] *Arkitekten–Arkkitehti*, 1949, No. 1, pp. 11–14.

[62] *Arkitekten–Arkkitehti*, 1949, No. 4, pp. 61–65.

[63] *Arkitekten–Arkkitehti*, 1949, No. 3, pp. 41–60.

[64] Elissa Aalto confirmed this to be the case in a conversation with the author in Helsinki, February 1978.

[65] *Arkitekten–Arkkitehti*, 1950, No. 1, pp. 3–10.

[66] Malcolm Quantrill, *The Environmental Memory*, 1987, pp. 160–173.

[67] Malcolm Quantrill, *Alvar Aalto*, 1983, pp. 161–165.

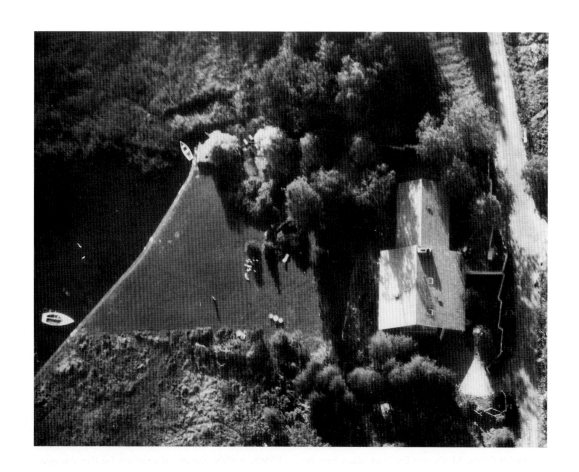

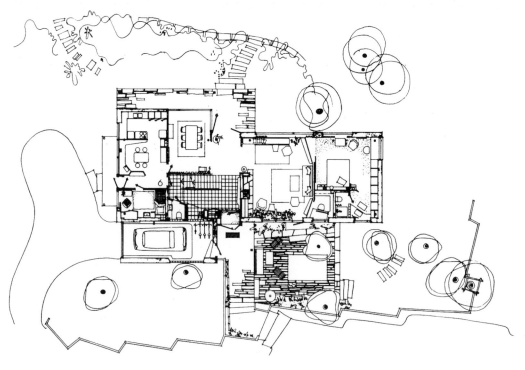

Finnish Architecture and the Modernist Tradition

5 A second Finnish renaissance

To anyone visiting Finland for the first time in the early 1950s it was immediately apparent that architecture of high quality and lasting significance was being created, not only by Alvar Aalto but also by a whole generation of talented architects.[1] Although the Aaltos' winning design for the National Pensions Institute (Figures 124, 148, 149) revealed the superiority of its urban vision over the more conventional morphologies of the other entries, this competition (1948) also brought forward other architects who were to remain significant in the evolution of Finland's postwar modernism. These included the second-prize winners, Viljo Revell and Keijo Petäjä; the third-prize winners, Heikki and Kaija Siren; and Jorma Järvi, who received the purchase prize.[2] Early in 1950s the pattern of emerging talent continued with the Helsinki University Institute competition, in which Keijo Petäjä and his wife Marja took joint second prize with Pentti Ahola and Iiro Tukkila, while the purchase prize went to Aarne Ervi (with Olof Hansson) who eventually got the commission for what became the Porthania Building (1955–57; Figures 135, 136).[3] At the beginning of 1950 Aalto received first prize in the Lahti Church competition with a curiously monumental design that bore little relation to his other work of that time. Interestingly, Elissa Mäkiniemi, who was destined to become Aalto's second wife, was already on the design team for that project, which went through a number of revisions before being completed in 1979 by Elissa after Alvar's death.[4]

More derivative works also made their appearance as the decade opened. Salla Church, by Eero Eerikäinen and Osmo Sipari,[5] and the Helsinki Commercial High School (1948–50; Figures 105, 106), by Harmia and Baeckman, both compromised the clarity of Finnish modernism.[6] Jukka Siren's restoration of the main building at Helsinki University, following Russian bombing in February 1944, inevitably revived notions of a national and monumental architecture.[7] The influence of Aalto is clearly evident in Yrjö Lindegren's celebrated Snake House (completed in 1951),[8] which offers a distinctly personal housing solution on a restricted site (Figures 109, 110). In preparation for the rescheduled 1952 Olympics Lindegren also rebuilt his Helsinki Olympic Stadium of the 1930s, with the angled timber walls to the extension providing an impressive solution of the external form (Figure 116). Lindegren's work was later uneven, however, as is confirmed by his winning entry for the Kajaani Technical High School competition published in December 1950.[9]

The construction of new permanent housing also began to flourish once more in the early 1950s, with a variety of projects by the younger generation. These included schemes for the Ruskeasuo suburb of Helsinki, by Harmia and Baeckman and by Sysimetsä, Ypyä and Malmio.[10] Meanwhile Aarne Ervi produced housing designs for ALKO and Asunto Osakeyhtiö in Turku.[11] Ervi acknowledged Aalto as his master and his work shows some debt to Aalto in its general form, although his detailing does not have the same strength of expression. For example, Ervi always favoured open public staircases, which occupy central spatial volumes without giving them formal resolution. In his own house, the Villa Ervi, (1950–51),[12] he in fact leans more towards Bryggman's Villa Nuutila than towards the Aalto of Munkkiniemi or the Villa Mairea. Nevertheless, the Villa Ervi remains a model of the postwar Finnish private house, adapting Aalto's Japanese-

Figures 107 and 108
Aarne Ervi
Villa Ervi, Kuusisaari, Helsinki (1950): aerial view, showing the idyllic, seaside location. The plan, which nestles a quasi-traditional form into a gently sloping site, develops an elegant informality in house and garden.

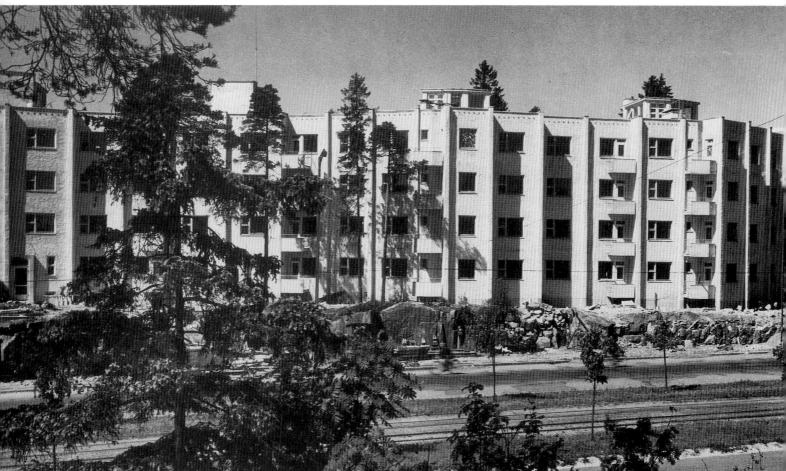

Figures 109 and 110
Yrjö Lindegren
Snake House block of flats, Helsinki (completed in 1951): the plan form is a sort of re-jigging of modernist minimalism – a functionalist tango. In the third dimension the dance rhythm seems to work and monotony is replaced by variety (see how Pietilä uses similar rhythmic notions in the Suvikumpu Housing in Tapiola and Sief Palace Area Buildings in Kuwait).

Finnish Architecture and the Modernist Tradition

influenced relationship of villa to garden and garden design.

There is no doubt that Ervi was an extremely sensitive modernist, but in his best work he is inclined to borrow more than he contributes. The result is a delicate balance of clean modern lines and colours with a certain traditional warmth of detail and texture. His large spaces are, in consequence, more modern, while at the smaller scale he achieves something close to Aalto's sense of intimacy. In the Villa Ervi the roof dominates the exterior form, merging house and garden with its gentle sweep. On the interior the main concept develops a strong relationship between the living areas, the terrace and the garden reaching down to the shoreline (Figure 108). Thus, from the outside the Villa Ervi is more enclosed and even more secretive than the Villa Mairea, while inside Ervi has extended Aalto's marriage of house and garden at Noormarkku and has made the spatial relationships more fluid (Figure 111). While the Villa Ervi has less symbolic content than the Villa Mairea it is undoubtedly a very livable house, the quintessence of the Finnish summer home and waterside garden in the modernist tradition.

In his winning design for the Malmi Funeral Chapel competition of 1951,[13] Aalto clearly opposed the direction established by Erik Bryggman in his Turku Funeral Chapel (Figure 29) and so eagerly followed by Bryggman's colleagues during the immediate postwar period. In the Malmi Funeral Chapel project Aalto set clear guidelines for functional clarity in a complex programme, which required three separate chapels capable of conducting crematory services at the same time. His unrealized design provides us with the absolute model of Aalto's use of a split axis in resolving functional dualities and the fact that it was not built has deprived us of a certain masterpiece. The Malmi Funeral Chapel project represents the perfection of Aalto's planning clarity and formal simplicity, while promising a strength and dignity that would have at least equalled if not surpassed Bryggman's Turku Chapel.

The headquarters building for the Finnish Sugar Company by Harmia and Baeckman was completed at the end of 1951,[14] shortly before Harmia's death aged 45 on 9 March, 1952. The Finnish Sugar Company Building reconfirmed the Harmia and Baeckman office's polite blend of tradition with some minimal modern concessions. It is a dignified, rather conventional and certainly unadventurous brick building, an example of industrial architecture brought into the city centre and becoming pompous in the process. More interesting are Jorma Järvi's Swimming Stadium[15] and Olli Pöyry's SPS Yacht Club for Helsinki,[16] both completed in 1952, which reasserted Finland's emphasis on recreation. Aalto also had two significant successes in 1952. In the Seinäjoki Church competition he was awarded the purchase prize because he placed the building outside the designated site, but eventually got the commission to build.[17] In the Rautatalo (Iron House) competition for the Finnish Iron Federation Headquarters he gained first prize over Aarne Ervi and Markus Tavio.[18] The Seinäjoki Church commission generated Aalto's involvement in planning the Seinäjoki Centre, while the Rautatalo success assured his first chance to build in the very centre of Helsinki, adjacent to Eliel Saarinen's 1921 Union Bank on Keskuskatu.

By far the most important events of 1952 in Finnish architecture, however, were the completion of two seminal Aalto buildings: Säynätsalo Town Hall[19] and the Muuratsalo Summer House, his own private retreat or 'experimental house'[20] – in fact a honeymoon cottage for Alvar and his new bride, Elissa Mäkiniemi, on an island across the lake from Säynätsalo (Figures 114, 146, 147).

The challenge presented by the design for Säynätsalo Town Hall was to create for the inhabitants of this forest village a building that, for them at least, was of comparable significance to that of the National Pensions Institute in Helsinki or the Helsinki Technical University at Otaniemi. The project therefore held several attractions for Aalto at this point in his career. It provided him with an

Figure 111
Aarne Ervi
Villa Ervi, Kuusisaari, Helsinki (1950): this is *the* 'house and garden' house, blurring distinctions. At his best and most unsophisticated Ervi came close to realizing Aalto's autonomous architecture.

Figure 112
Alvar Aalto
Town Hall, Säynätsalo (1949–52): the plan has an ingenious 'bottle and cork' layout, in which one side of the building is pulled away from the rest of the composition. This fragmentation collage technique began with Aalto's Munkkiniemi house and continued with the Villa Mairea and the New York World's Fair Pavilion.

opportunity to scale down his new urban imagery of the National Pensions Institute to the context of this forest village. It was his first opportunity, also, since the Ahlström housing for Kauttua of 1937–40, to relate his design so directly to nature. Such a context clearly held the key to significant shifts in Aalto's mode of architectural expression. Aalto was, of course, very familiar with the site from his planning studies for this village. The unexpected bonus of the Säynätsalo design was that it brought him into close contact with the young architect whom he had appointed as job architect for Säynätsalo, the striking Elissa Mäkiniemi, who became his second wife in 1952.

Säynätsalo is a rather rugged island in Lake Päijänne. At the time construction started on the town hall the village had a population of about 3000, all supported through employment with the Enso-Gutzeit Company. The building programme included local government offices, a Council Chamber, a community library and some staff flats and shops which, at a later stage, were intended to become additional offices for the municipality. The provision of a town hall for such a small community stresses the economic significance of Säynätsalo, which is quite disproportionate to its mere size and population.

The two-storey Säynätsalo Town Hall is set into the rising ground at the head of a triangular open space, exactly reversing the original proposal of Aalto's masterplan of 1943–45, in which the town hall was placed on the base of the triangle. Impacted into the sloping site, the building presents the dominant mass of the council chamber tower against a background of the forest (Figure 28). The ground floor of the block facing the open space is devoted to shops, with a formal granite staircase giving access to a courtyard at first-floor level. This courtyard is semiformal and almost domestic in scale and character. The courtyard contains a pool and fountain and a small paved area, within a domestic garden setting. It is approached under a pergola that bridges the space between the entrance to the council offices and that of the library (located over the shops) at the head of the formal, granite stairway (Figure 112).

The granite stair begins in the earth of the unpaved street below. Stepping onto its first tread we are already removed from the casual world of the forest village. As we proceed up the first flight the quiet dignity of another, more ordered world becomes powerfully apparent. At the first landing we are drawn in between the flanking walls, aware of being involved in an entrance of imposing but not forbidding order. The second flight, although in fact longer, seems much shorter as we become invited into the intimate enclosure of the pergola portico. Once under its shelter we are confronted not by a grand doorway but by the small garden landscape of the courtyard. This court is not at all a piazza but, as in the Villa Mairea, an open-air extension of the internal life of the town hall. The modest entry to the administrative area of the building is to the right, under the end of the pergola. The library entrance is tucked even more modestly and unobtrusively into the left-hand corner.

Once inside the entrance hall, with its low ceiling and warm brick floor, we feel as much at home as in any domestic interior. Straight ahead is a plain brick wall, broken by the opening that gives access to the circulation corridor for the offices. The glazed wall to our left faces north and looks through a trellis of vines onto the grass of the garden court. Ahead, through the narrow opening, we see the reflected sunlight from the corridor. To our right is the glazed entrance to the enquiry office, while tucked behind us and the entrance is the main staircase.

This stairway is another version of the form developed by Aalto in the theatre of the Southwestern Agricultural Co-operative Building at Turku (1927–28). We are enclosed in a 'tube' that carries us, with a simple pine handrail as our guide, up to the council chamber in two gentle flights. Both the stairway and the upper gallery passage are sparingly top-lit by a strip clerestory window that runs around the top of the second floor just below the slightly overhanging eaves. The square council

Figure 113
Alvar Aalto
Competition sketch of the Funeral Chapel for Lyngby, Denmark (1951): again the architect uses natural light for the exploration of plastic forms.

chamber provides a contrast by the subdued elegance of the seating, with a large wooden-louvred west window that, like the staircase, is reminiscent of medieval examples. Two fan-strutted pine roof trusses support the pine-boarded ceiling of the monopitch roof. While clearly modern and idiosyncratically characteristic of Aalto in form, these trusses and the roof they support recall structures familiar from great barns, an entirely suitable 'umbrella' for this assembly of councillors from an agricultural region (Figure 29).

Although there is a temptation to relate the courtyard plan of Säynätsalo Town Hall to classical courtyard precedents, there is clearly nothing classical about the disposition of elements around this informal open space. We have already observed that the effect of this court is not that of a piazza, although its form is certainly one of a piazza in miniature. It is not a pedestrian space, however, but a landscape element that spans between the formality of the entry stairs and the surrounding forest: its garden character is decidedly domestic, offering a bridge between architecture and nature. The dominant impressions of the architectural composition are twofold: the disjointed unity that characterizes the grouping of buildings on traditional farms in central Finland, as well as more than casual references to the massing and compositions Aalto would have seen in Willem Dudok's buildings when he visited Hilversum in 1928. Reminiscences of these Dutch buildings and particularly their De Stijl references are noticeable in the treatment of the exterior wall that approaches the council chamber, with its cantilevered upper storey; the horizontal slit window running just beneath the eaves; and the relationship of this lower wall to the tower of the council chamber.

There are elements in Aalto's so-called 'experimental house', the Muuratsalo Summer House, that recall Säynätsalo Town Hall, a natural transference considering that this honeymoon retreat grew out of the partnership of Alvar and Elissa on the town hall project. In particular, the dominant role of the courtyard in the plan and the use of the monopitch roof recall the town hall (Figure 114). The prevailing effect from within the courtyard, however, is one of geometrical modulation that is quite unknown in the rest of Aalto's work, although it is suggested by the planning of the Malmi Funeral Chapel project. The elaborate patterns that Aalto carried out in the brick floor of the court, which centres on a square, sunken hearth and in the brick-and-tile treatments on its enclosing walls, are very much dependent on the square and may relate to Aulis Blomstedt's 'cube theory'.[21] The notional enclosure sketched in Aalto's *Aitta Kumeli* design is replaced at Muuratsalo by an intimately detailed framework of walls that enclose the court on three of its sides (Figure 146). From another point of view, the treatment of the floor in the Muuratsalo courtyard can be seen as a more articulate expression of the floor patterning and composition of the ground floor in the Villa Mairea, the square formal court now replacing the landscaped court of the earlier design.

Further explanation of this decisively modular treatment of both floor and walls is that Aalto, whose own paintings are strictly notional and expressionist in character, may have sought here to systematize his architecture in painterly terms. His model here would have been the De Stijl movement, which was still extant when Aalto visited The Netherlands in 1928. De Stijl also later supplied a modular model for the modular exercises of Aulis Blomstedt. The use of raked brick joints is a characteristic of Dudok's work, with which Aalto would have also been familiar from Frank Lloyd Wright's houses. But the neoplastic use of brickwork at Muuratsalo suggests a direct inspiration from De Stijl and exhibits a remarkable richness and variety of effect within this disciplined framework. Only one wall is not treated in this way: the wall that looks out over Lake Päijänne has an open lattice screen that frames the view across the lake. This wall is left untreated, even unsurfaced, like an incomplete Italian church façade. This allows the view itself to become the treatment, recalling the idea of fresco, and particularly the painted walls of

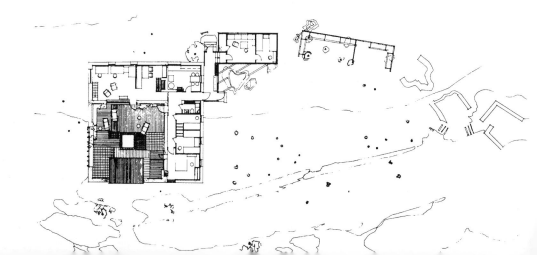

Figure 114
Alvar Aalto
Architect's own Summer House, Muuratsalo, near Jyvaskylä (1952–53): plan of the so-called 'Experimental House', showing main accommodation grouped around the courtyard with subsidiary elements freely climbing the slope behind.

Figure 115
Erkki Huttunen
SOKOS Building, Helsinki (1949–52): a commercial project, housing the celebrated Vaakuna Hotel and the SOKOS co-operative society department store. Its functionalist *parti*, with horizontally banded windows, and roof terraces, set on a two-storey transparent display podium, was the first truly modernist building in central downtown Helsinki (for which Sigurd Frosterus's Stockmann Department Store, 1918, provided a precedent).

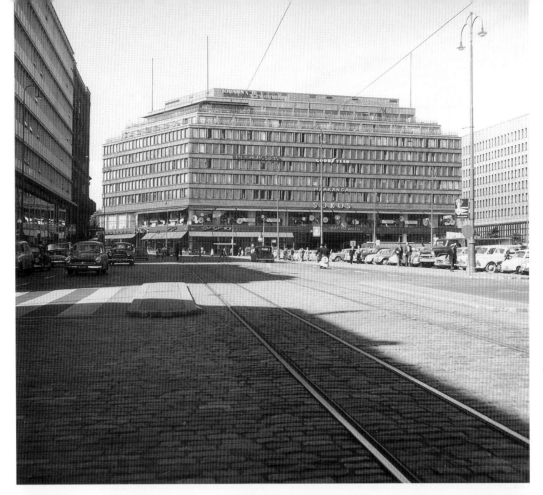

Figure 116
Yrjö Lindegren and Toivo Jäntti
Stadium for the 1952 Helsinki Olympic Games (1951–52): the revised external wall treatment shown here was added when the stadium was restored so that Finland could host the 1952 games, the original 1940 Helsinki Games having been cancelled following the outbreak of war.

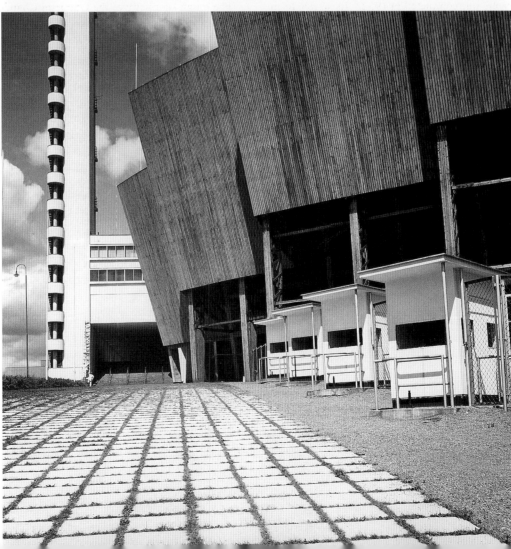

Pompeii, which depict a different world beyond. Through this 'window' there is a view of the natural 'garden' in the distance and through it, too, nature enters the more formal world of the courtyard; just as a spiritual world beyond the *casa* enters the Pompeian interior.

Although Aalto's highly articulated treatment of the Muuratsalo courtyard may have been influenced by Aulis Blomstedt's emphasis on modular coordinates in his paintings, as well as his buildings and theoretical sketches, Aalto's summer residence is more directly derivative of De Stijl sources and is also an exercise in refining his own unique modernism (Figure 147). Its white-painted external walls, the monopitch roof with pantile coping, the louvred windows and the loose scatter of outbuildings that ascend the granite escarpment from the back door, all these elements are combined in Aalto's new tradition. Contrasting elements are the house's *castelletto* defensive character and the Roman source of the courtyard house. From all these viewpoints this small house turns out to be every bit as complex as Säynätsalo Town Hall and just as experimental.

The building for the combined Industrial Centre and Palace Hotel, by Viljo Revell and Keijo Petäjä was completed in 1952.[22] Its simple form, lifted two storeys above the street on *pilotis* on the harbour façade, and its impeccable detailing make it one of the best advertisements for modernism in Helsinki. It dominates the harbour front on the market side (Figure 117) and its ingenious H-plan, with its asymmetrical 'bar' containing the vertical circulation, provides an efficient double-loaded corridor for the hotel rooms (Figure 118). With its construction, part of the centre of Helsinki was siphoned off from the areas previously dominated by Keskuskatu and Eliel Saarinen's Railway Station, Aleksanterinkatu, Engel's University and Senate Square. It was the beginning of a new subsidiary focus, which was later reinforced by Aalto's Enso-Gutzeit *palazzo* on the opposite side of the harbour (1959–62). The provision of a new hotel on this important harbour site greatly improved the public image of Helsinki for those arriving by sea from abroad. Within the hotel the spacious and exquisitely detailed Palace Grill Restaurant, with its fine views across the harbour, became a mecca for architects and designers (Figure 119). Unfortunately, the Palace Grill was replaced by a conventional Italian *trattoria* interior in the 1980s. All the original interiors for the Palace Hotel complex were designed by Olli Borg.

In 1954 an important competition provided a landmark in postwar Finnish architecture. This was for the Otaniemi Chapel on the campus of the Helsinki Technical University.[23] The winning design, by Erkki Pasanen and Kuoko Tiihonen, exhibited a strong influence from Bryggman's Turku Funeral Chapel, as did the entries of the other prize winners, Martikainen and Ypyä and Pentti Petäjä and Esko Hyvärinen. Indeed, only Heikki and Kaija Siren really broke new ground with a design that combines the clarity of Mies van der Rohe and the charm of Aalto's forest imagery. The winning design was not built and the Sirens were awarded the commission as recommended by the jury, although they received only the purchase prize as they broke the competition rules. The Sirens' chapel was completed in 1957.

The tough simplicity of the Otaniemi Chapel combines the best of Mies' classicism with the warmth of Aalto's more organic approach and might be described as the Finnish response to Le Corbusier's Notre Dame at Ronchamp in France. The chapel is an intense spiritual space, whose sanctuary is entered from a small, walled court within a woodland glade (Figure 142). This gentle introduction through a court that, like the Villa Mairea is both Finnish and Japanese in spirit, brings us into the simple, wedge-shaped box with its monopitch roof. In the tradition of Finnish eighteenth- and nineteenth-century country churches, this sanctuary is dominated by the carpenter's art. The Sirens' design allows the triangular, rough wooden trusses to fill the upper part of the building volume, directing our attention towards the glass wall of the east end. Against this

Figure 117

Viljo Revell and Keijo Petäjä
Palace Hotel and Industrial Centre, Grand Harbour, Helsinki (1952): although completed in the same year as the SOKOS Building, this is a much more advanced design in planning, construction and detail. Located across the harbour from the Russian Orthodox Uspensky Cathedral, it presented a new modern Finland to the visitor arriving by ship.

Figures 118 and 119
Viljo Revell and Keijo Petäjä
Palace Hotel, Helsinki (1949–52): the modified 'H' plan has double-loaded corridors that decrease in width, in response to dimishing traffic, from the central lift lobby – a finely adjusted interpretation of Corbusian circulation principles. The hotel's restaurant, the celebrated Palace Grill, was the meeting place of artists and architects for 35 years, from 1952 until the late 1980s. Its uncompromising modernity provided the appropriate cultural milieu for those who sought to escape the conservative world of old Helsinki.

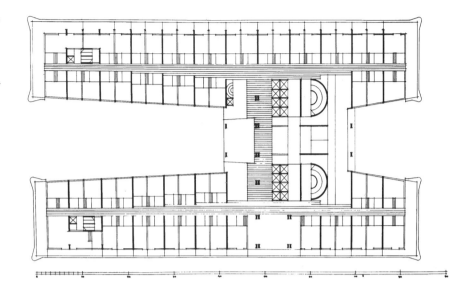

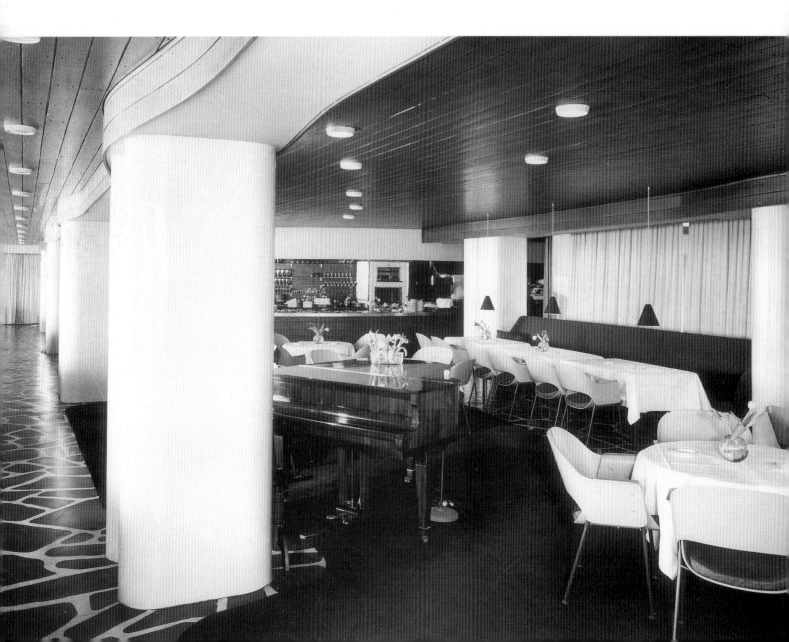

glass wall the skeletal steel altar and communion rails remove all effective barriers between the priest, congregation and forest beyond.

Visitors to the Otaniemi Chapel experience a poetic sequence of spaces, coming out of the trees into the courtyard with its floor of small stones, entering the powerful enclosure of the brick walls, being exposed then to the full revelation of the architectural idea in those taut, compelling trusses, then looking out again into the forest from which they have come (Figure 143). But in this progression we have passed from the world of nature through the world of ritual, so that the revelation of the forest is again transformed by humanity's enactment of symbolic space, by humanity's architecture. The Otaniemi Chapel is an architectural poem that stands with the best of Aalto. Indeed, the Sirens' student cafeteria for Otaniemi, Servin Mökki (1952),[24] is more interesting than Aalto's Enso-Gutzeit Employees' Club at Kallvik (completed in 1952), showing how well they could compete with the master in such small-scale exercises when they avoided the classicist mode.

Following the completion of the Palace Hotel, Viljo Revell went on to consolidate his position as one of the leaders of the younger generation with a number of other fine buildings in the early 1950s. Of these there are two important schools, both designed with Osmo Sipari. The more interesting is at Meilahti (1949–53)[25] with interiors by Olli Borg (Figure 120); and the other is the Kirkonkylä School at Tuusula (1950–53).[26] Both the Meilahti School plan and that for the Karjensivu Terrace Houses near Helsinki (1953–55; Figures 122, 123, 126), which include Revell's own home, demonstrate his ability to give an extra dimension to the conventional geometry of functionalism, a lesson surely learned while he was working in Aalto's office. Revell's talents were particularly suited to the design of industrial architecture, as we see from his elegant and sensitively detailed Kudeneule factory at Hanko (1953–55). The factory is the first example of Finnish industrial architecture to establish a new direction for modernism, following the

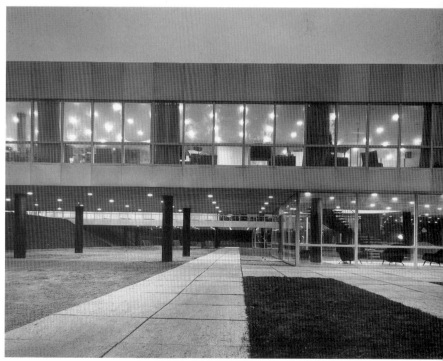

Figure 120
Viljo Revell and Osmo Sipari
Meilahti Secondary School, Helsinki (1949–53): this was one of the first postwar Finnish schools to experiment with a freer planning and educational environment.

Figure 121
Viljo Revell
Kudeneule Factory, Hanko (1953–55): long before Finland emerged to industrial supremacy in the mid-1960s, Revell here set the standard and style of the new Finnish industrialization.

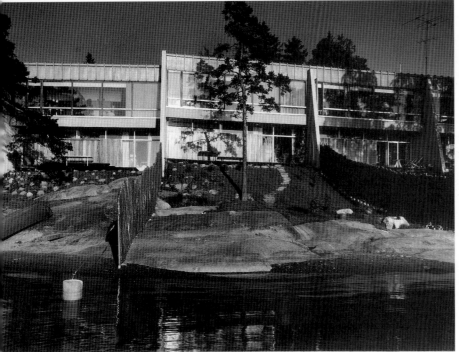

Figures 122, 123 and 126
Viljo Revell
Kärjensivu terraced housing, Helsinki (1955): a seashore development that, like Meilahti School, offers a gentle response to environment and function. The subtle variation in plan is given emphasis by changes in the topography. This design continues the experiment of Yrjö Lindegren's Snake House. Opposite, top right: a view from the living room of the architect's own unit across the adjacent sea.

models developed by Aalto in the 1930s and 1940s (Figure 121). It shows Revell as a master of simple form and his direct no-nonsense use of materials to achieve clarity of expression. Such clarity of detailing is only rivalled by the Sirens, particularly in the Otaniemi Chapel.

Revell's work, with its stress on industrial technique, such as in his welded steel details, provides a marked contrast to Aalto's persistent development of timber technology as demonstrated in the trusses for the Helsinki Technical University Sports Hall at Otaniemi (1949–54). The industrial precision of Revell and the Sirens provides another polarity which had no other adherents in the 1950s. Aalto had his followers, however, of whom Jorma Järvi, Cedercreutz and Jaatinen must be mentioned. Järvi's Kuulusaari High School (1953–55)[27] borrows a number of Aalto motifs in a competent but hardly coherent whole. Cedercreutz and Railio executed a variation of the Otaniemi Sports Hall in their Katajanokka Warehouse, Helsinki (1954–57),[28] while Jaatinen's Villa Jaatinen (1956) in Kuulusaari has much of Aalto's charm and spirit.

Meanwhile, Erik Bryggman's Honkanummi Funeral Chapel project for Puistola, Helsinki (1953; Figure 133),[29] reveals a complete deterioration into his romantic mode that can be traced back to details of the Turku Funeral Chapel. His private house in central Turku (1954)[30] conforms to the tradition of wooded classicism on the street side, while developing a more romantic free plan at the rear – a treatment certainly familiar to Bryggman from Frank Lloyd Wright. Also, Bryggman's Workers' Housing for Turku (1947)[31] has more consistency with his earlier work in its interpretation into wood construction of his preoccupation with *architettura minore*.

At the end of 1954 the result of the competition for Lauttasaari Church was announced.[32] This was won by Osmo Lappo, a professor at the Helsinki Technical University, Otaniemi, with Bertel Saarnio second and the newcomer Aarno Ruusuvuori, an influential professor at the Helsinki Technical

University (1959–66) and later Director of the Museum of Architecture, taking third prize. Keijo Petäjä continued to reassert his position by winning the purchase prize and, more importantly, the commission. The resulting Petäjä church for Lauttasaari is a highly formalized and rather clinical design, which adds little to the evolution of postwar ecclesiastical architecture in Finland.

The pattern of stimulating new work in Helsinki continued in 1955, however, with the completion of Aalto's Rautatalo (Iron House) (Figure 131) on Keskuskatu. Rautatalo develops Aalto's notion of an interior piazza – first used at the Pedagogical Institute (later University) of Jyväskylä (1950–57; Figure 125) and here combined with his concept of an atrium court for the revised National Pensions Institute (1952–56). The pristine and provocative Small Stage Theatre addition to the National Theatre in Helsinki by Heikki and Kaija Siren was also completed in 1955,[33] with its crisp geometry providing a sharp contrast to Aalto's Rautatalo nearby. Meanwhile Olof Hansson, Ervi's partner for the Helsinki Technical University Extension competition, completed a private residence of thoughtful design and elegant execution at Östersundom.[34]

Revell's work went from strength to strength during the 1950s. His Kaskenkaatajantie apartment terraces for Tapiola (1956–58) employ the tough-minded industrial detailing of his Kudeneule factory at Hanko, in a modest four-storey design that is powerful and elegant (Figure 138). In 1958 Revell achieved full international recognition when he won the competition for the Toronto City Hall with his partners Heikki Castren, Bengt Lundsten and Seppo Valjus. This revolutionary twin-tower design was, however, beyond the scale at which Revell could work successfully at that time and the finished building is disappointing. The unlinked towers are non-functional, as is the 'flying saucer' council chamber form, only part of which is used by the actual council chamber. Finland was nevertheless deprived of a major talent by Revell's untimely death in 1966.

Aarne Ervi followed his success with the University of Helsinki's Porthania Building (Figures 135, 136) by designing the Lohja School in 1955,[35] and went on to win the prestigious Tapiola Centre competition in 1956. He also prepared the masterplan for Tapiola[36] and was responsible for a number of major developments in this dormitory town for Helsinki, including the centre's tower and shopping court, cinema and some housing. His work always has a reliably high quality but is rarely exceptional in either concept or detail. The basic environment of Tapiola is, however, one of Ervi's major achievements. He was devoted to its development and wanted to establish the character of a modern, Finnish new town. In reality Tapiola is not a new town in the English sense but rather a suburban dormitory. His success in creating for Tapiola an identity of its own led to the invitation for him to become Professor of Town Planning at the Technical University of Stuttgart. Ervi declined, but recommended his assistant, Antero Markelin, who still occupies that chair at the time of writing. Later, Ervi was appointed City Planner of Helsinki and he abandoned his private practice of architecture to take up that appointment in 1968. His finest building in terms of space, structure, light and form is undoubtedly the Töölö Library, Helsinki, which shows him closely connected to the mainstream Finnish modernism of Aalto and Bryggman.

The year 1956 brought a variety of significant new developments. In the housing field two important projects exploited prefabricated elements: Mäntyriita by Viljo Revell,[37] and the Kontiontie scheme by Heikki and Kaija Siren.[38] Ervi's Library for Turku University was completed and demonstrates a competent translation of modernism into the urban context of a campus in the city centre. The importance of Aalto's Sports Hall for Otaniemi has already been noted.[39] In 1956 he was responsible for two related contributions: most significant was the simple but ingenious Finnish Pavilion for the Venice Biennale,[40] with its system of indirect natural lighting; his

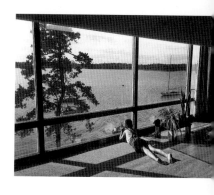

Figure 124 (bottom, left)
Alvar Aalto
National Pensions Institute, Helsinki (1948, 1952–56): the original design (with Aino) was for a site adjacent to the Parliament Building. This revised project, on a much more difficult site, offers the best evidence of Aalto's skills as an urbanist, a quality somewhat lost at the northern end of the Mannerheimintie.

Figure 125 (bottom, right)
Alvar Aalto
Pedagogical Institute (later University), Jyväskylä (1950–57): the foyer to the main auditorium was the largest public space in town, therefore it resembles a piazza. The tile column guards recall Erik Bryggman's use of them on the portico of the Turku Funeral Chapel.

glass-storage warehouse for the Iitala Factory at Karhula[41] is also of interest, as an industrial building type.

In 1956 Reima Pietilä made his first appearance on the scene by winning the competition for the Finnish Pavilion at the 1958 Brussels World's Fair. This was a highly original design of stepped timber forms, inspired by Aulis Blomstedt's theories (Figures 144, 145).[42] In addition Pietilä published a seminal first essay in *Arkkitehti*, entitled 'Transformations',[43] which is an important key to understanding his work of the 1950s and 1960s. Pietilä followed up the Brussels design with the publication of his influential modular stick studies in the following year.[44]

Finnish architecture was dominated in 1957 by the work of the Sirens. Not only was their exquisite Otaniemi Chapel (Figures 142, 143) published for the first time, but the Lahti Concert Hall[45] and the State School for Tapiola[46] were also completed. In 1958 their own home and office in Lauttasaari were finished. The competition for Lauritsalo Church was won by Jaakko Laapotti, his design presenting a novel section for a triangular plan.[47] In second place was Elja Airaksinen, whose project appears indebted to Pietilä's modular stick studies. Among other church designs of 1958 was Aarno Ruusu-vuori's interesting proposal for Hyvinkää.[48]

Aalto's work of the latter half of the 1950s is extremely diversified. His church for Vuoksenniska, Imatra, construction of which began in 1958, became his most significant contribution to ecclesiastical design (Figures 129, 130). Of Aalto's work completed in 1958, however, the most significant new development was in the field of housing. His apartments constructed in the Hansaviertel district of Berlin for the Interbau Exhibition, with their luxuriously deep balconies,[49] constitute his major work in housing design (Figure 134). Another significant building completed in 1958 was Woldemar Baeckman's addition to the Library at Turku (Swedish) University, which is a delicate and gentle example of self-effacing modernism.

Aalto reached his sixtieth birthday in 1958, the year in which the House of Culture in Helsinki was completed (Figures 127, 152). Indeed, it was an extremely busy year in the Aalto office, when a number of important new international projects were developed. Among these were the North Jutland Art Museum competition entry (with Jean-Louis Barüel), which received first prize, and competition entries for the Baghdad Art Museum, Iraq, the Kiruna Town Hall in Sweden and the Wolfsburg Cultural Centre, Germany. Most important, however, was probably the competition entry for the Essen Opera House, Germany.

Earlier we referred briefly to the Rautatalo (Iron House), the headquarters building for the Finnish Iron Federation, which occupies a central downtown site on Keskuskatu in Helsinki (Figure 131). It is located opposite the rear entrance of Frosterus's Stockmann Department Store, adjacent to Saarinen's Union Bank and only 50m from the Swedish Theatre at the intersection of Keskuskatu and Esplanadi. In the Rautatalo (1952–55), Aalto employed for the first time the elevational treatment he originally proposed for the office tower of the Forum Redivivum entries for the National Pensions Institute competition (1948).

Built on a cramped city site, the Rautatalo has a remarkably simple, basically L-shaped plan. Shops occupy the entire ground floor, with the exception of the access lobby and its staircase up to the *piano nobile*. The basement is also devoted to shopping, while the *piano nobile* accommodates shops and a café. Originally the Artek furniture and gift shop occupied the entire basement and the ground floor to the left of the entrance, with the Artek Gallery across from the café on the *piano nobile*. This upper space became a boutique in the late 1960s. This combination of furniture, design and fashion close to the intersection of two of Helsinki's principal downtown thoroughfares, Esplanadi and Aleksanterinkatu, created an important shopping focus, which Aalto exploited in the design of the *piano nobile*, creating a *piazzetta* at first-floor level that occupies almost a third of the building's area. Aalto justified this internal thoroughfare as a meeting

Figure 127
Alvar Aalto
House of Culture (Finnish Communist Party Headquarters), Helsinki (1955–58): another of Aalto's collaged plans, with the expressionist theatre volume held in position by the functional administrative elements.

Figure 128
Alvar Aalto
Architect's Studio at Munkkiniemi, Helsinki (1955): once again a collage of unlikely forms in the plan. Here the outdoor amphitheatre impacts into Aalto's own studio space.

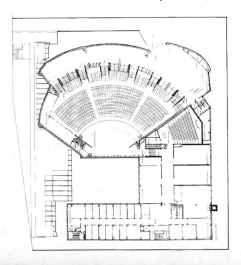
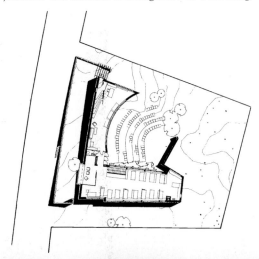

place for shoppers and intellectuals, taking advantage of its location between the Swedish Theatre and the Finnish National Theatre and the fact that it is only a quarter of a mile from Senate Square and the University of Helsinki.

Drinking coffee in Finland is a habit of great social significance, while the climate gives open-air cafés only a brief summer season. With his design of the Rautatalo's covered *piazzetta* and its open-plan café, Aalto sought to bring to central Helsinki the social advantages of the Mediterranean climate. In raising the office and commercial building to the level of a social and cultural statement he probably drew on the example of Lars Sonck's Stock Exchange (1916–18) in nearby Fabianinkatu. The Stock Exchange building was an essential part of Aalto's environmental memory, as he often met friends in its Adlon Bar. But much of the success of Aalto's Rautatalo atrium depends upon the intimacy of its small-scale adaptation of the Sonck model. During the day the interior court is naturally lit by 40 roof lenses of the type first used for the *Turun Sanomat* Building and then developed in the Viipuri Library. When daylight is not available (Helsinki enjoys only five to six hours of daylight in midwinter) light is provided by lamps suspended above the lenses on the roof.

The façade treatment of the Rautatalo had already been anticipated in the original Forum Redivivum designs for the National Pensions Institute (1948). It is based on a lightweight, metal framing system, which is copper-clad over cork insulation and fixed to the reinforced concrete building frame. Chronologically, the execution of Rautatalo parallels that of the National Pensions Institute and, whereas its façade system is distinctive for that period, it has various other details in common with the National Pensions Institute. These include the stacking door handles, used in pairs, which reflect the elaborate curvilinear designs of the national romantic period and also Bryggman's handles for his Turku Funeral Chapel. Their calculated bifurcation here is most certainly a post-functionalist statement.

In the Rautatalo, also, Aalto first made extensive use of marble: the parapet walls to the upper-level balconies in the atrium are faced with travertine, while the *piazzetta* floor and fountain are of white Carrara marble. Mixed with these handsome stone facings and familiar from his experiments at Muuratsalo, are deep-blue ceramic tiles from the Arabia Company Factory, which are used to give vertical emphasis on screen walls at either end of the atrium. Blue, white and buff tiles of this pattern are also used in the public areas of the National Pensions Institute. At the Rautatalo, the atrium feature of Säynätsalo Town Hall and Muuratsalo, already partially assimilated in the interview hall of the Pensions Institute, is successfully transferred to the very heart of the building, becoming the 'lungs' of the interior space. Shortly after the Rautatalo was opened Aalto applied the notion of the atrium once more to the balconies of the Hansaviertel flats in Berlin (Figure 134).

After the Pensions Institute and the plan for the campus of Helsinki Technical University at Otaniemi (1949–64), that for the University of Jyväskylä is probably the most cogent example of urban form in Aalto's work. In the best sense of the term this provincial university is a 'forest town', nestling into a thickly wooded hillside above Jyväskylä (Figure 150). In 1950 Aalto won the competition for the overall plan of the university, which was then the Pedagogical Institute; the first stage, including the auditorium block, was built between 1952 and 1957. In this block Aalto began to develop what became his favourite fan motif on a large scale by thrusting the wedge-shaped auditorium form hard against the rectilinear lecture theatre block. This gave the two elements a common party wall whose openings allow circulation between the two parts of the building and shared use of the cloakroom facilities at the junction.

Within the Jyväskylä auditorium building Aalto exploited two urban motifs that characterized his work of the 1950s and 1960s. First, the auditorium foyer at ground level has a stepped ceiling of acoustic-tile planes that reaches back to the glazed

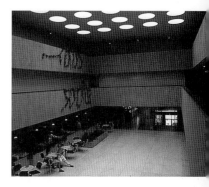

Figure 131 (top)
Alvar Aalto
Rautatalo ('Iron House', headquarters of the Finnish Iron Federation), Helsinki (1952–55): the first of Aalto's top-lit public atria, recalling the Sonck atrium for the Stock Exchange, it became a popular meeting place because of its central location and well-furnished café.

Figure 132 (above)
Architect unknown
Turret on house in Huvilakatu, Helsinki (c. 1905): the form and position of this detail are very similar to Aalto's use of the turret in the House of Culture.

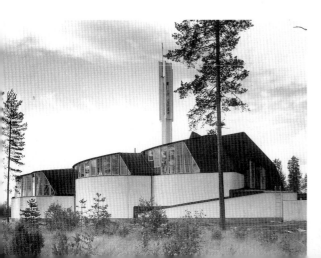

Figures 129 and 130 (left)
Alvar Aalto
Vuoksenniska Parish Church, near Imatra (1956–59): the bunker-like exterior is partly the result of a plan that allows three different sizes of nave with the use of sliding doors on the radii. Shortly after completion, a tornado destroyed 95% of the trees in the area. Aalto depended mainly on the double-window system to create complexity in the glazing pattern.

Figure 133
Erik Bryggman
Honkanummi Chapel, Puistola (1956): it is hard to imagine that the architect of the Turku Funeral Chapel could have produced this design 15 years later. Here Bryggman's wonderful control of the modernist language has gone, and his underlying romanticism has resurfaced.

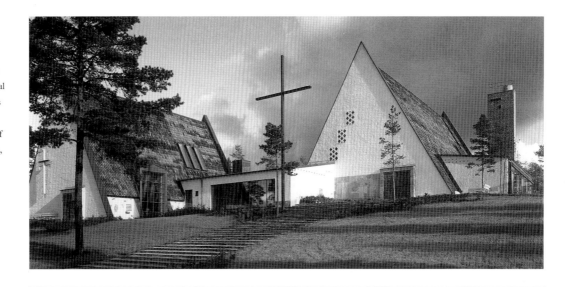

Figure 134
Alvar Aalto
Housing for the Interbau Exhibition, West Berlin (1957): the entry-level plan of Aalto's celebrated deep-balcony design for urban flats, where the balcony becomes a central feature of residential life.

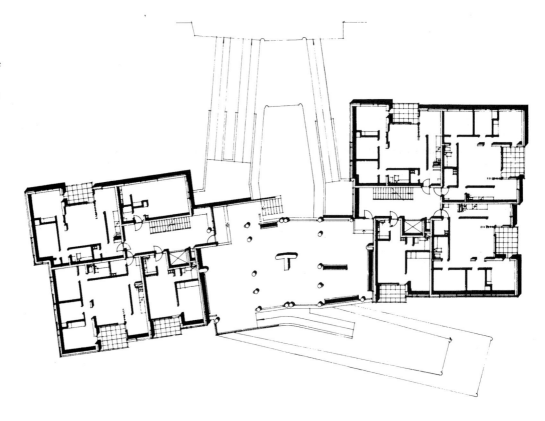

Figures 135 and 136
Aarne Ervi
Porthania Building, University of Helsinki, Helsinki (1955–57): a characteristically neutral Ervi design, where modernity fits quietly into a historic context, adjacent to Senate Square. The interior again has a minimalist treatment: in the heavily used entrance hall, the architecture is barely there.

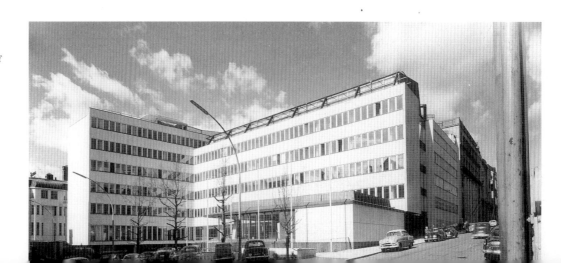

entry wall, which in turn frames the exterior landscape. With this blurring of the boundary between the exterior and the interior the foyer becomes, in a slightly disguised form, a further development of Aalto's idea of the interior court (Figure 125). Leading off this space is an internalized main street that gives access to the campus, which is a 'field' designed to accommodate outdoor track events. This street contains a monumental staircase, partially hidden behind a stepped wall, that leads to the lecture theatres, which are reached from three mezzanine landings. This stair recalls the experience of passing between the enclosing walls of an Italian hill town (Figure 152). Proceeding from one level to another we are enclosed, as at Säynätsalo Town Hall, which was being completed when the Jyväskylä stair was designed.

In 1955 Aalto began to design the headquarters building of the Finnish Communist Party, known as Kultuuritalo (House of Culture). In working out the highly expressionist, fortress-like contours of the auditorium massing, with its distinctive annular banding of the fan plan (Figure 127), he anticipated the organic plasticity of the Vuoksenniska Church, Imatra, on which he began work a year later in 1956 (Figures 129, 130). The House of Culture realizes a number of significant developments in Aalto's design language. Among his brick buildings, it follows the Baker Dormitory in abandoning the rectilinear or angular discipline in favour of curvilinear forms, an approach that was developed also in the revised design for the Otaniemi main auditorium block of the same year. In the interior of the Kultuuritalo auditorium Aalto continues to experiment with the structural column and the acoustical ceiling, both dominant themes in his interiors for the next decade. The columns, basically simple rectangles but with elegant fins that fan up towards the ceiling, recall his earlier interest in this splayed form, illustrated in the machine hall of the *Turun Sanomat* Building. The irregular cusping of the acoustic-tile ceiling onto the walls has many early Renaissance models, of which the Capella degli Scrovegni in Padua (recorded in Aalto's sketchbook of 1924) is a possible source. The specially made bull-nosed header bricks allow maximum freedom in the curved exterior brick surfaces and delicate modelling of the cantilevered projectionist's booth that thrusts out at eaves level, blurring the distinction between wall and roof (Figure 151); these seem to recall a national romantic window detail on Huvilakatu, Helsinki. Aalto never again achieved this impeccable quality of brickwork. The House of Culture therefore represents the ultimate refinement of these brick experiments begun at Säynätsalo and Muuratsalo. After its completion in 1958, Aalto turned to the use of marble and ceramic tile as the principal external cladding materials of his major buildings completed during the 1960s.

Following the completion of the Rautatalo in 1955 and the National Pensions Institute in 1956 (Figure 124, 148, 149), Aalto was not involved in the design of another office building until 1958, when he prepared the quite unremarkable design for the Baghdad Central Post Office in Iraq. But in 1959 came another important office commission for the Helsinki headquarters of the prestigious Enso-Gutzeit Company. This was located on the site originally used by Aalto for the first stage of his entry in the Parliament Building competition (1923) and was built between 1960 and 1962.

In the meantime, while the Hansaviertel Apartment Block was under construction in Berlin, Aalto received the commission in 1956 to design a house at Bazoches-sur-Guyonne, in the Ile de France, for the French art dealer and collector, Louis Carré. Aalto's Maison Carré continues his preoccupation with modularity, which began at Muuratsalo. As the brief required accommodating a substantial part of Monsieur and Madame Carré's collection of modern art in a structure that is primarily a residence, it also has parallels with his Studio R-S project (1954) to provide a combined house and residence for the Italian painter, Roberto Sambonnet.

In the Maison Carré the semipublic display areas are arranged side by side with the private

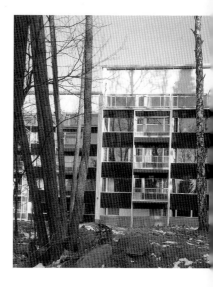

Figure 137
Kaija and Heikki Siren
Otalaakso Apartments, Otaniemi (1954–56): a new, high standard of finish in lighter materials for public housing.

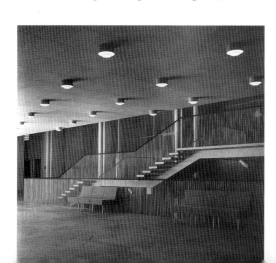

Figures 138 and 139
Viljo Revell
Housing at Kaskenkaatajantie, Tapiola (1956–58): the high point of Revell's panel façade treatments begun at the Kudeneule Factory (1955), this combination of *in situ* concrete frames with lightweight infills (including the revolutionary corrugated aluminium) achieves a highly refined and balanced result. The plan is constrained in its arrangement for optimum use of space.

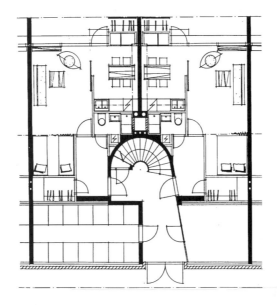
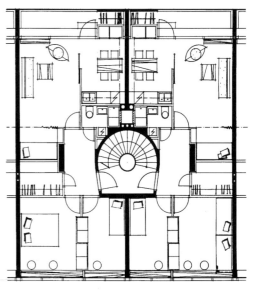

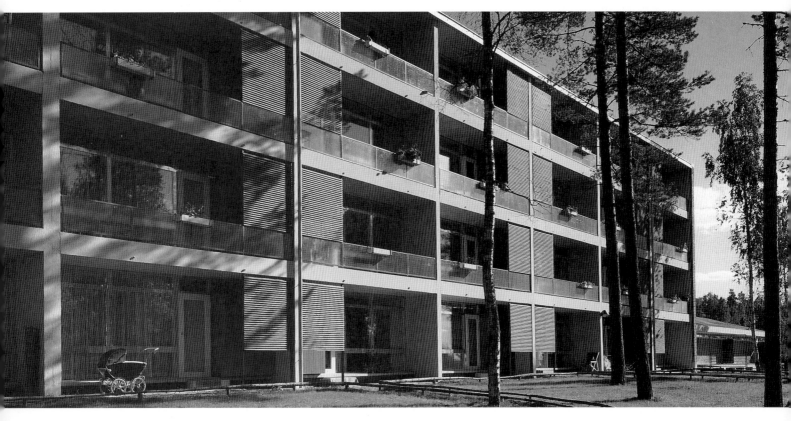

Finnish Architecture and the Modernist Tradition

parts of the villa. Aalto structured this 'privacy gradient' by designing a large entrance-hall-cum-gallery that leads directly into the major living and reception area, taking advantage of the natural downward slope of the wooded site (Figure 154). The transition between the entrance gallery and the reception room is achieved by means of a broad flight of steps. These lead down from the gallery hall, which is lit only by a clerestory over the entrance portico, towards the view across the gently rolling site revealed through the reception room window below.

Cell-like rooms, reminiscent of those in a wing at the Villa Mairea, lead off the gallery in an arrangement that echoes that of the Studio R-S project. At the front of the house these comprise Louis Carré's study and library immediately off the living area; the dining room, tucked behind the entry gallery, projects out to enclose the portico; and the adjacent kitchen, pantry and cook's dining area (with a staircase leading to the servants' quarters above). Along the back of the gallery are grouped three double bedrooms, each with its own bathroom, the master bedroom also having its own sauna *en suite*.

In the plan of the Maison Carré the square is once again the dominant theme, as shown by the shape of the study and two largest bedrooms. The result is a highly articulated interaction of solid and void which, consistently obeying the rectilinear discipline, is more coherent than the projected Studio R-S. The plan for the Maison Carré suggests a variation on a Frank Lloyd Wright theme: the two axes are at right angles to one another, while the planning elements that relate to those axes do so in a disjunctive way that denies the cruciform origin of the plan. Closer scrutiny, however, reveals another possible source. If we reconstruct the plan by adjusting the grouping of the two main bedrooms, the kitchen, reception room, dining room and study so that these elements conform to the crossed axes, we have a close approximation of the plan of a Palladian villa such as the Villa Malcontenta, which is a cruciform figure set within a rectangle. We might therefore suggest that the Maison Carré is a deconstructed Palladian idea. The simple deconstruction required changing only two design 'rules', by grid reflection along two perpendicular axes. How much of the fluid play upon themes of square (Carré) and cross(roads) (carrefour) was suggested by Carré's name? Such a Palladian disassembly may appear as an appropriate merger of the identities of patron and designer. That Aalto had such a Palladian model in mind is convincingly confirmed by the geometrical organization of the entry façade.

The main line of the monopitch roof recalls that of Muuratsalo, which has a Roman model for its plan. This main line also parallels the gentle upward slope of the site from the reception room and lower terrace over the entrance portico with its clerestory window to the gallery within. The wall plane beneath this shed roof is divided horizontally with the lower band faced in grey travertine, while the upper triangular slice is of white-painted brickwork. Within this plane the entry is deeply set back, with the clerestory above even further back from the travertine/brickwork plane. Also, a counterdirection is introduced in the façade by expressing the roof over the dining room and kitchen as a second monopitch, opposing the major one. This second roof line is stopped short of meeting the first roof by the cleavage cut into the façade by the deep-set portico and clerestory. Had they met, however, these two triangular segments of roof would have formed a triangular pediment over the entrance portico. In his characteristically disjunctive way Aalto frustrated this meeting, although the intention of this pediment motif is still tantalizingly there. The fact that the broken pediment is intentional is seemingly confirmed by the original sketch for this façade, which shows both roof lines parallel to each other, in complete agreement with the slope of the site. The decision to change the direction of the minor roof and create a discordant expectation on the entry façade, coupled with the deconstruction of the plan elements about the Palladian cruciform axes, reveals Aalto's great

Figures 140 and 141
Aulis Blomstedt
Annexe to Workers' Institute, Helsinki (completed in 1959): in contrast to Pietilä's Finnish Pavilion (Figures 144, 145) here his mentor stays clearly within orthodox modernist guidelines. The design for the theatre curtain reflects exactly the architect's De Stijl sympathies.

Figures 142 and 143 (below)
Kaija and Heikki Siren
Student Chapel, Helsinki
Technical University, Otaniemi
(1954–57): one of the most
celebrated modern Finnish
buildings, it is influenced by both
Alvar Aalto and Mies van der
Rohe, while the screened entry
court evokes Japanese traditional
architecture. In the interior, the
severe almost industrial, wooden
trusses carry the monopitch roof to
focus attention on the altar and,
beyond it, through the glass east
wall, the altarpiece – nature itself.

Figures 144 and 145 (opposite)
Reima Pietilä
Finnish Pavilion for the World's
Fair, Brussels (1956–58): the plan
shows Pietilä's expansion of
modular logic into a dynamic form.
In the third dimension the dynamic
form simulates a rhythmic dance
and Pietilä begins to demonstrate
new steps.

subtlety as a planner and form-maker.

On the garden side, however, the Maison Carré shows a conventional monopitch with the two small bathroom pavilions jutting out from the main bedrooms. But this white-painted garden elevation does not at all indicate an informal country house. Although the elevational geometry is informal enough in massing and detail, it is also crisply modern and the villa (viewed from the swimming pool at the lowest corner of the site) suggests the sharp contrast of built form with nature that provides the essential spirit of Palladio's villas in the Veneto.

Regardless of the villa's external form, however, the interior, with its stepped ceiling in the reception area rising up under the monopitch to meet the sharper inclination of the gallery vault, recalls Aalto's undulating ceiling for the lecture room at the Viipuri Library. This suggestion of acoustic functionalism, which in the Maison Carré is a purely mannerist gesture, was conceived in parallel with his design for the Vuoksenniska Church at Imatra (also begun in 1956). The re-emergence of the undulating ceiling in the Maison Carré and the Imatra church heralded another exciting period in Aalto's work, during which he abandoned the modular discipline of the rectangle in favour of a freeform, highly plastic approach to design.

In his design for the Enso-Gutzeit Headquarters, which he always referred to as the Enso-Gutzeit *palazzo* (1959–62), Aalto wanted to respond to the neoclassical discipline of Engel's buildings on the harbour front and Engel's Great Church on the hill behind Senate Square. To this end he prepared a panoramic elevation that spanned the harbour front, from the cathedral, past the town hall and the presidential palace up to and including, the Russian Orthodox Uspensky Cathedral. The Enso-Gutzeit Headquarters site is immediately below the Russian cathedral, almost at the harbour's edge. Aalto overlaid this panoramic elevation with a modular grid, which demonstrates the proportional relationship of the different buildings to the panorama as a whole.

The construction of new public housing remained important throughout the 1950s. Among the projects completed during the second half of the decade, two should be noted. These are the Kaskenkaatajantie Apartments by Viljo Revell in Tapiola (1956–58; Figures 138, 139),[50] and the Otalaakso Apartments by Kaija and Heikki Siren at Otaniemi, the latter notable in particular for the fine detailing of their balconies (1954–56; Figure 137).[51] We can observe Aalto's influence on the design of office buildings in the Kuparitalo (headquarters building for the Finnish Association of Copper Merchants) in Helsinki by Matti Lampen and Märta Blomstedt.[52]

Jukka Siren reached his seventieth birthday on 27 May 1959, but was no longer in active practice, although his son Heikki had by then clearly established himself as a leader of the postwar generation. The importance of Aulis Blomstedt's contribution to the continuation of mainline functionalist modernism in Finland is confirmed by the completion of his Helsinki Workers' Institute in 1959.[53] The streamlined detailing of elements inside and out, particularly the handling of ballustrades and staircase handrails and the further individualism of the theatre curtain, clearly demonstrate the persistence of De Stijl influence (Figures 140, 141). Among the younger architects who reinforced their position as potential leaders of the new generation is Timo Penttilä, who together with Kari Virtä won the competition for the combined Tampere Workers' Institute and State High School in 1959.[54]

Aalto's most significant development at the end of the decade was the design of a high-rise apartment block for the Neue Vahr district of Bremen, Germany (1958), which was already under construction by 1959 and completed in 1962. The Neue Vahr Apartments represent Aalto's most daring use of the fan plan, in which the fanning of the nine apartments on each floor is buttressed by the rectilinear spine containing the stairs, lifts and services. Although the balconies in this project do not have the significant depth of those in the Hansaviertel block in Berlin, they are nevertheless much larger than the German norm, particularly the

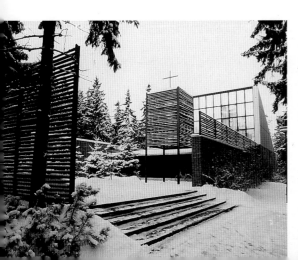
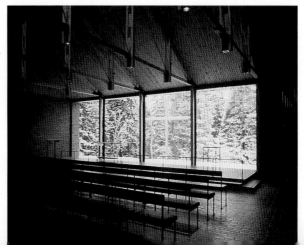

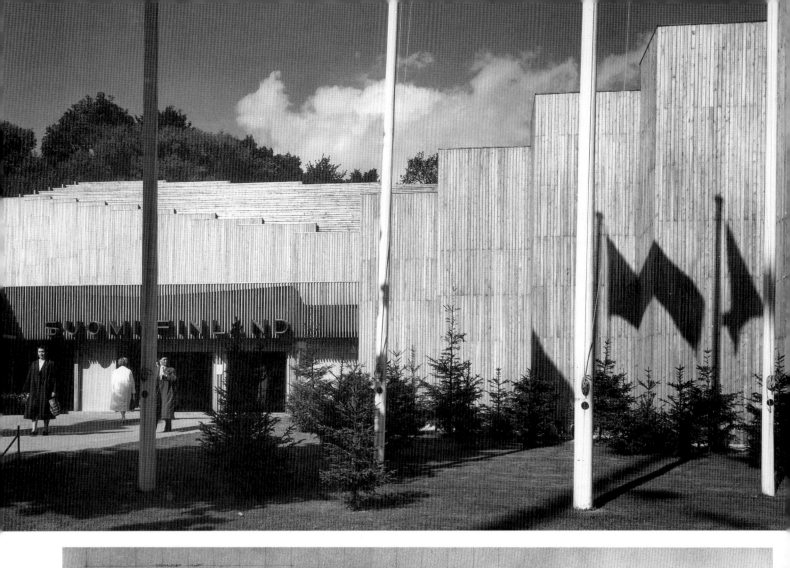
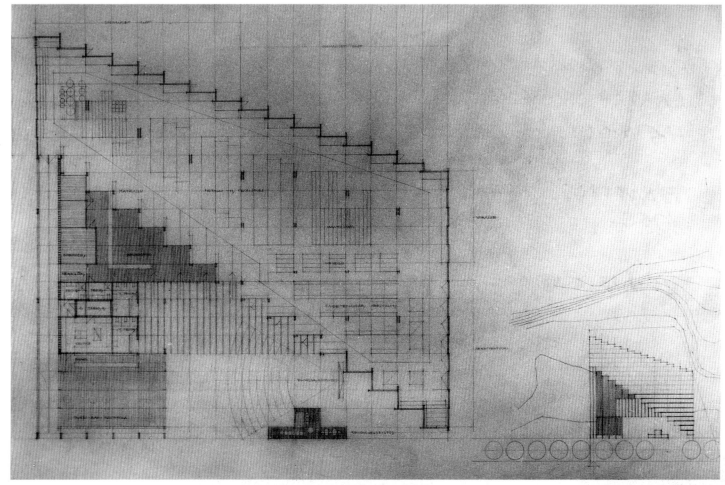

triangular ones at either end of the fan. Since the Neue Vahr Apartments are for single people and couples only there is, of course, less social pressure on the balcony as a family focus. The plastic quality of this 22-storey tower is certainly reinforced by the balcony slots and the whole achieves a bold sculptural character that realizes some ideals of the expressionism of the 1920s.

The revisiting of the expressionist terrain of the 1920s that we see in Aalto's Neue Vahr Apartments received its most positive reinforcement with the publication of the results of the competition for Kaleva Church at Tampere (1959). These results confirmed that the modernist church had been re-established following the neo-romanticism reawakened by Bryggman's Turku Funeral Chapel. The strength of this return to functionalist modernism in support of Aulis Blomstedt's position is seen in the third-prize designs of Toivo Korhonen and Jaakko Laapotti and Ahti Korhonen's second-prize design.

But the real disciple of Aulis Blomstedt, Reima Pietilä, submitted the winning project for Kaleva Church at Tampere, a design that did not follow the tenets of his functionalist teacher. Pietilä's Finnish Pavilion for the Brussels World's Fair was published at the end of 1958.[55] Of the Brussels Pavilion, Pietilä has said that he tried 'to make an architecture that is intellectual and natural at the same time'. Pietilä's Kaleva Church (completed in 1966), with its plan based upon the Christian symbolism of the fish rather than the cross, is certainly a highly intellectual design. It is also, however, a masterpiece of modern technology in its constructional technique, which allows the complex plan form to be realized easily by the use of rising shuttering. On the interior it is a highly atmospheric building, with a monumental sense of mystery that looks to examples of the great Finnish medieval churches.

What is clear from Pietilä's design for Kaleva Church is that a new force of great power and complexity has arrived on the Finnish architectural scene. The strength of Pietilä's protest against the conventions of functionalist modernism can be seen in his sketches. In his Brussels Pavilion, Pietilä had already shown his ability to extend modular design beyond its rectilinear constraints, making the intellectual become natural. Kaleva Church transcends the modular in search of a new vitality based on a fusion of diverse modern techniques and intentions, blending the memory of light, form and structure gleaned from precedent. The true expressionism of this design lies in its effort to be modern in spirit yet monumental in effect. Large functionalist churches often suffer from a certain monotony that derives from a combination of simple geometric forms with the repetition of barren surfaces. Pietilä's church attempts, in the tradition of medieval Finnish churches, to recreate a formal complexity of light and structure, which enriches the evolution of interior form and space. In Kaleva Church the marriage of constructional weight and a subtle choreography of natural light creates a great reflective silence.

References and notes

[1] The author first visited Finland as an undergraduate student in the summer of 1953, when he met Alvar and Elissa Aalto at Muuratsalo. During that summer he worked as an assistant in Rakennushallitus (The Finnish National Board of Public Building).

[2] *Arkkitehti*, 1950, No. 1, pp. 3–10.

[3] *Ibid.*, pp. 16–26.

[4] *Arkkitehti*, 1950, No. 3, pp. 33–40.

[5] *Ibid.*, pp. 47–52.

[6] *Arkkitehti*, 1950, No. 8–9, pp. 117–136.

[7] *Arkkitehti*, 1950, No. 5–6, pp. 74–82.

[8] *Arkkitehti*, 1950, No. 10–11, pp. 137–141.

[9] *Arkkitehti*, 1950, No. 12, pp. 164–168.

[10] *Arkkitehti*, 1951, No. 6–7, pp. 77–82.

[11] *Ibid.*, pp. 86–87.

[12] *Arkkitehti*, 1951, No. 11–12, pp. 145–164.

[13] *Arkkitehti*, 1951, No. 1, pp. 11–20.

[14] *Arkkitehti*, 1952, No. 1, pp. 17–21.

[15] *Arkkitehti*, 1952, No. 6–7, pp. 102–109.

[16] *Arkkitehti*, 1952, No. 8, pp. 129–134.

[17] *Arkkitehti*, 1952, No. 11–12, pp. 186–190.

[18] *Ibid.*, pp. 191–195.

[19] *Arkkitehti*, 1952, No. 9–10, pp. 150–158.

[20] *Ibid.*, pp. 159–163.

[21] *Arkkitehti*, 1954, No. 1, pp. 1–6.

[22] *Arkkitehti*, 1954, No. 3–4, pp. 33–55.

[23] *Arkkitehti*, 1954, No. 5, pp. 24–36.

[24] *Arkkitehti*, 1954, No. 6, pp. 89–92.

[25] *Arkkitehti*, 1954, No. 9, pp. 144–148.

[26] *Arkkitehti*, 1955, No. 11, pp. 179–183.

[27] *Ibid.*, pp. 168–173.

[28] *Arkkitehti*, 1958, No. 4, pp. 59–61.

[29] *Arkkitehti*, 1953, No. 7, pp. 114–115.

[30] *Arkkitehti*, 1953, No. 4–5, pp. 74–76.

[31] *Arkkitehti*, 1953, No. 3, pp. 34–39.

[32] *Arkkitehti*, 1954, No. 11, pp. 192–197.

[33] *Arkkitehti*, 1955, No. 6, pp. 81–91.

[34] *Arkkitehti*, 1955, No. 12, pp. 192–194.

[35] *Arkkitehti*, 1955, No. 11, pp. 174–178.

[36] *Arkkitehti*, 1956, No. 1–2, pp. 2–8 and 16.

[37] *Ibid.*, p. 20.

[38] *Ibid.*, pp. 22–25.

[39] *Arkkitehti*, 1956, No. 6–7, pp. 95–97.

[40] *Ibid.*, pp. 90–93.

[41] *Ibid.*, p. 94.

[42] *Arkkitehti*, 1956, No. 8, pp. 124–125.

[43] *Arkkitehti*, 1956, No. 6–7, p. 103.

[44] *Arkkitehti*, 1957, No. 4, pp. 73–74.

[45] *Arkkitehti*, 1957, No. 5, pp. 79–83.

[46] *Arkkitehti*, 1957, No. 6–7, pp. 94–100.

[47] *Arkkitehti*, 1958, No. 6–7, pp. 25–34.

[48] *Ibid.*, pp. 108–109.

[49] Of this solution, Aalto himself wrote: 'The conventional, small corridor-like balconies were here transformed into patios around which the rooms of the apartments were grouped. This grouping around the open-air room created an intimate, private atmosphere.' *Alvar Aalto: collected works*, Girsberger, Vol. I, 1963, p. 168.

[50] *Arkkitehti*, 1959, No. 1, pp. 10–12.

[51] *Ibid.*, pp. 13–18.

[52] *Arkkitehti*, 1959, No. 4–5, pp. 53–61.

[53] *Arkkitehti*, 1959, No. 9, pp. 129–141.

[54] *Arkkitehti*, 1959, No. 10–11, pp. 17–36.

[55] *Arkkitehti*, 1958, No. 9, pp. 154–159.

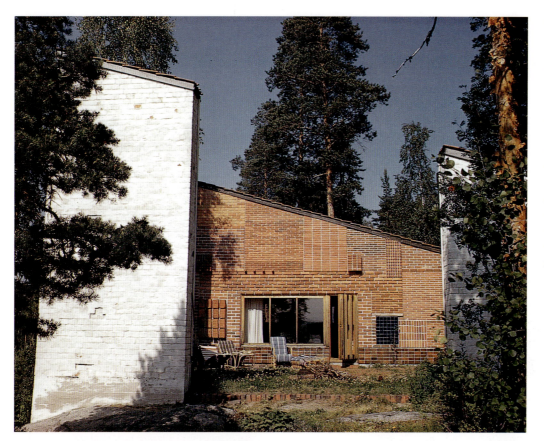

Figures 146 and 147
Alvar Aalto
Architect's own Summer House, Muuratsalo, near Jyvaskylä (1952–53): view into courtyard – the exterior brick walls are painted white, while the inner ones have De Stijl, Mondrian-like patterns of various bricks and tiles (left); interior view towards Aalto's suspended studio above (below, left). This study was taken at the author's first meeting with Alvar and Elissa Aalto, June 1953 (in the foreground are packages for lunch, just collected from Säynätsalo).

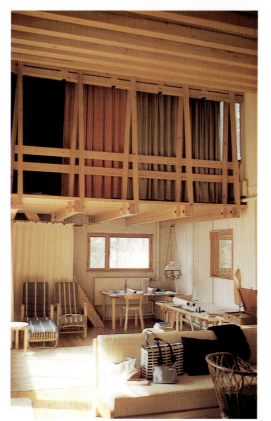

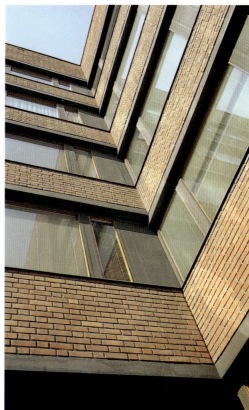

Figure 148
Alvar Aalto
National Pensions Institute, Helsinki (1952–56): in this building Aalto emphasizes the horizontal canon of modernism as in none of his other designs. Yet he is in such control of this device that he can manipulate internal junctions, as here, to show that the building is not simply functionalist but constructivist (in the sense of the *techne* being revealed in the fitting together of these horizontal planes).

Finnish Architecture and the Modernist Tradition

Figure 149
Alvar Aalto
National Pensions Institute, Helsinki (1952–56): just as we think we have pinpointed Aalto's source, he is off in another direction – perhaps more than one. This time we are certainly back in the Middle Ages with these main entrance doors (which open at street level, without step or threshold), while the adjacent seats suggest *quattrocento* Florence.

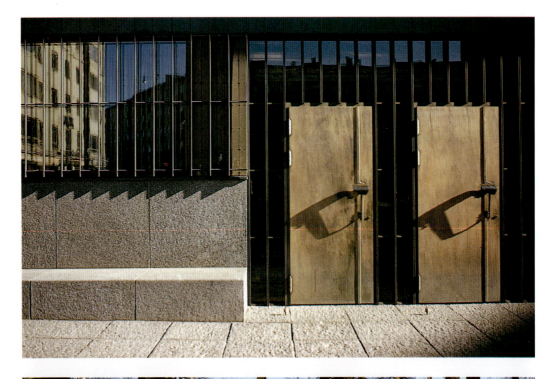

Figures 150 and 152
Alvar Aalto
Pedagogical Institute (later University), Jyväskylä (1950–57): of all Aalto's work this design corresponds most closely to Kirmo Mikkola's concept of 'the forest town' (right); the brick exterior walls are carried inside to line 'an urban street', while the walled stairs mount, as in an Italian hilltown, towards the lecture rooms above (opposite, bottom left).

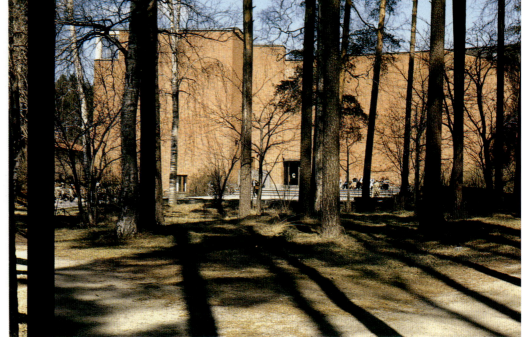

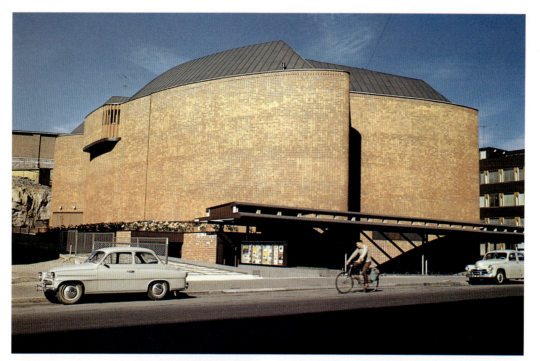

Figure 151
Alvar Aalto
House of Culture (Finnish Communist Party Headquarters), Helsinki (1955–58): the forceful curves of the theatre's brick exterior became symbolic of Aalto's work of the 1950s. Note the small turret at roof level that provides a ventilation gallery for the projectionist.

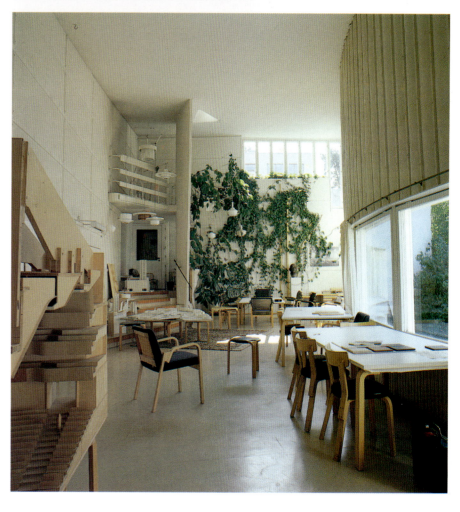

Figure 153 (right)
Alvar Aalto
Architect's Studio at Munkkiniemi, Helsinki (1955): interior view sharing the curved exterior wall that embraces the amphitheatre.

Finnish Architecture and the Modernist Tradition

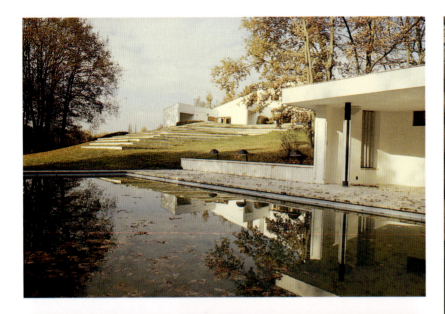

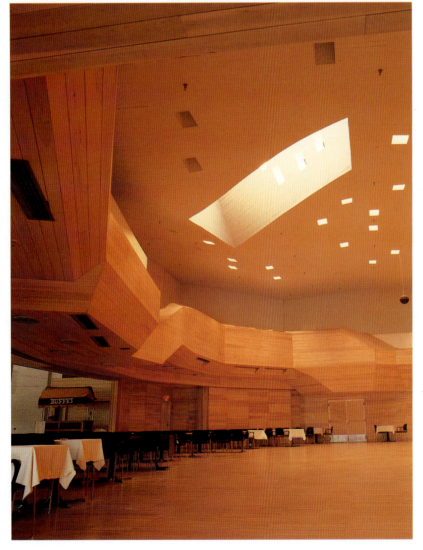

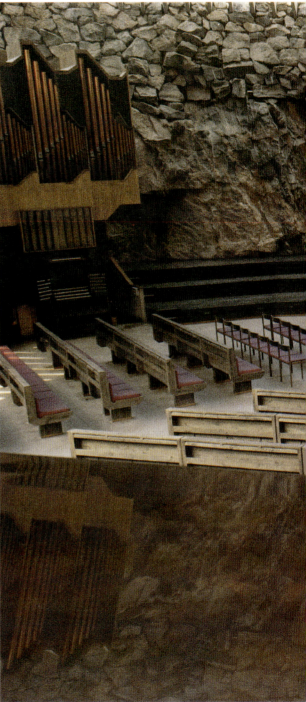

Finnish Architecture and the Modernist Tradition 128

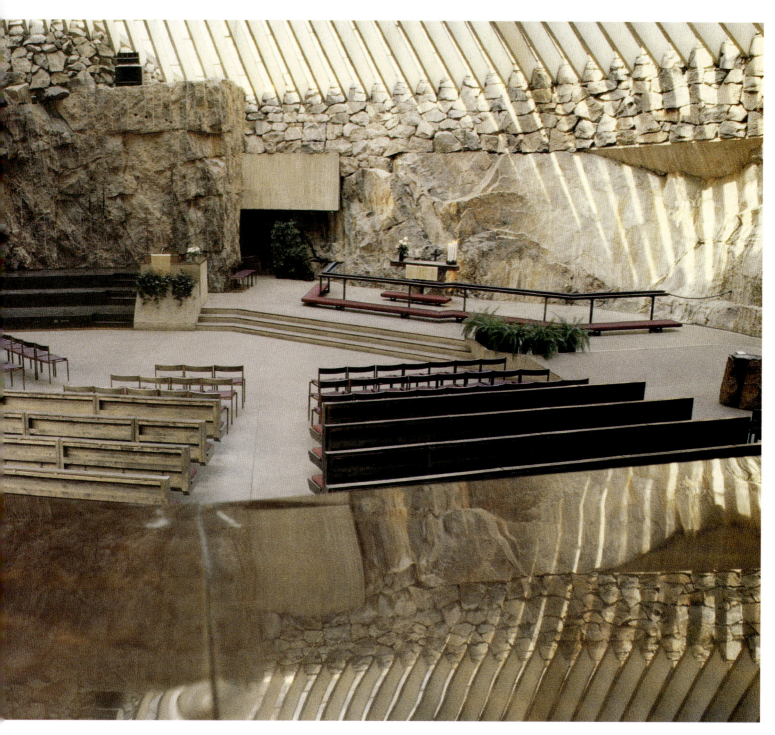

Figure 154 (opposite, top)
Alvar Aalto
Maison Louis Carré, Bazoches, Ile de France, France (1956–58): rear view, showing cubist massing within a triangular frame (the front elevation suggests a classical pediment). Note the rectilinear framing of the landscape, stepping down towards the pool, which is reminiscent of the sod steps at Säynätsalo Town Hall.

Figure 155 (opposite, bottom)
Reima Pietilä
Dipoli Student and Conference Centre, Otaniemi (1961–66): the interior of the main conference hall shows an impressive grandeur within this 'cave'.

Figure 156 (above)
Timo and Tuomo Suomalainen
Temppelikatu Church, Taivalahti, Helsinki (1961–69): subtle interior planning is finely detailed and illuminated, with the daylight streaming in between the rock-face of the periphery and the 'suspended' dome. The atmosphere is that of a well-lit catacomb.

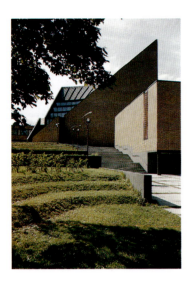

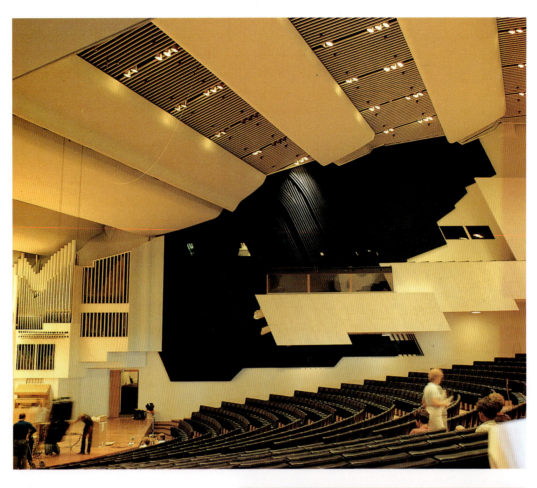

Figure 158
Alvar Aalto
Finlandia Concert Hall, Helsinki (1962–71): in the design of the Concert Hall interior, Aalto experimented with the acoustic forms he had proposed for the Essen Opera House.

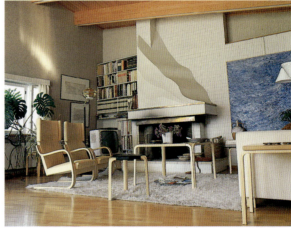

Figure 157
Alvar Aalto
Main Lecture Theatre Building, Helsinki Technical University, Otaniemi (1964): here Aalto completes the dual light-source experiment for lecture rooms begun in the Zagreb Hospital competition of 1930.

Figure 159
Alvar Aalto
Villa for Gorän Schildt, Tammisaari (1968–70): this house should not be compared with the Villa Mairea, but it has an airy elegance for its small size. Its details, particularly of the fireplace shown here, are memorable.

Figure 160
Reima Pietilä
Finnish President's Official Residence, Mäntyniemi, Helsinki (1983–93): in the interior the tree motif has been retained in the great folding doors of the public areas, providing an echo of Aalto's forest theme in the Villa Mairea.

Finnish Architecture and the Modernist Tradition

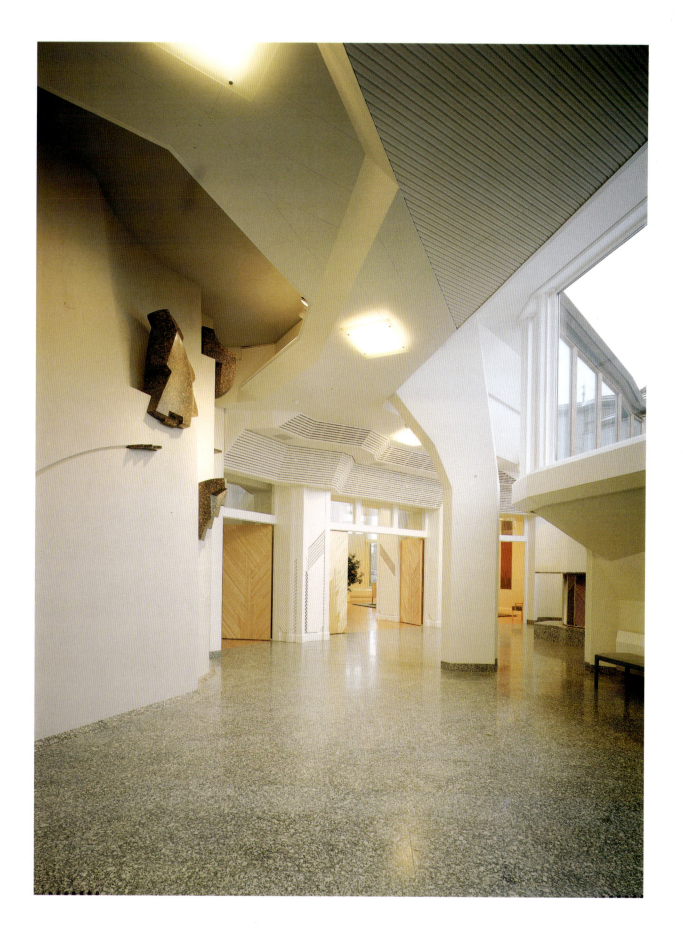

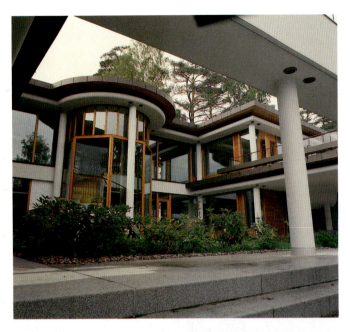

Figures 161 and 162
Timo Penttilä
Private Housing Development Hirviniemenranta, Kuusisaari, Helsinki (1980–82): surprisingly, Penttilä also took the lead at about the same time, although with a more obviously classical point of departure. The fireplace on the terrace makes reference, however, to Aalto's examples at the Villa Mairea and Villa Schildt.

Figure 163
Raili and Reima Pietilä
Ministry of Foreign Affairs, Sief Palace Area Buildings, Kuwait (1978–83): in this combination of environmental response (sun baffles), cultural adjustment (updating Islamic expression) and ecological expression (fountains inspired by the coral flowers of the reef below), Reima Pietilä was early in taking Finland into the erogenous zones of postmodernism.

Finnish Architecture and the Modernist Tradition

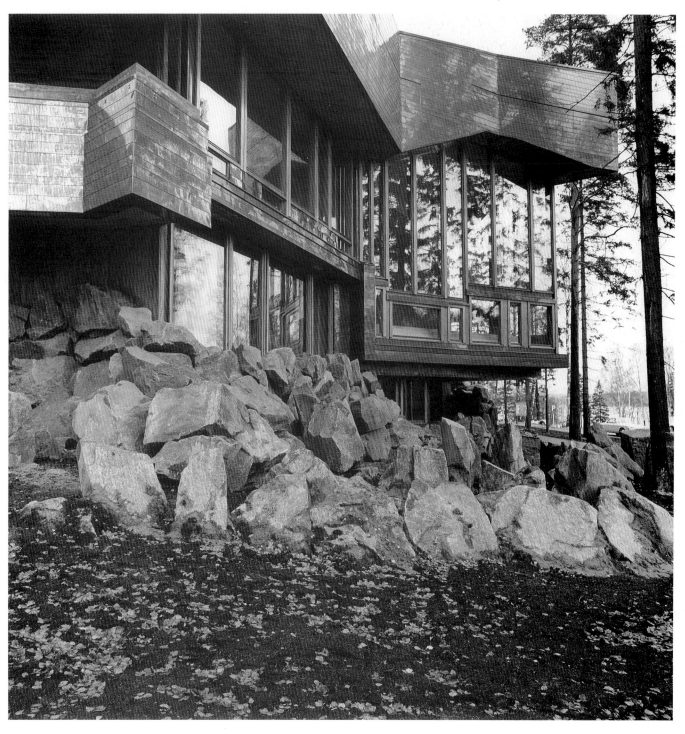

Figure 164
Reima Pietilä
Dipoli Student and Conference Centre, Otaniemi (1961–66): although Pietilä insisted that he 'normalized' the elevations for the competition drawings, the built version refers the module specifically to the rhythms of nature.

Figure 165
Viljo Revell
Sauna for H.F. Johnson, Wisconsin, USA (1961): although built entirely of wood, this design imparts through its modularity an industrialized, prefabricated appearance.

Figure 166
Kaija and Heikki Siren
Ympyrätalo office building, Helsinki (1960–68): in this extension of Helsinki's urban centre, the Sirens used a circular courtyard plan to echo the domed cylinder on the opposite corner.

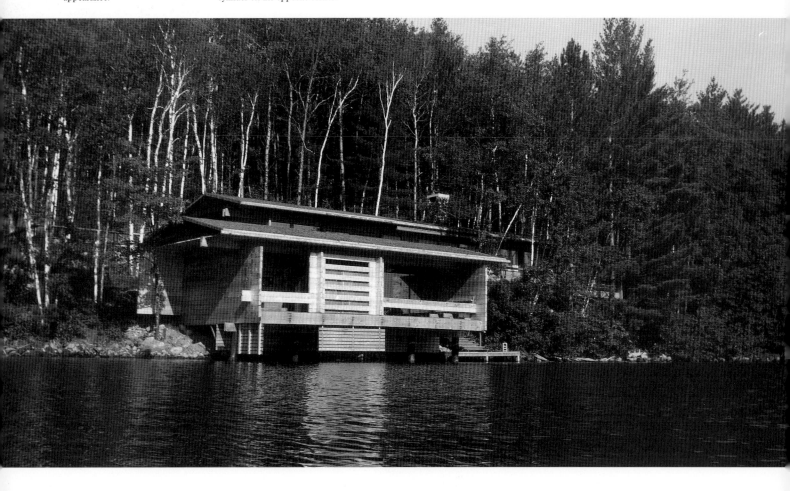

6 The 1960s: standardization *versus* architectural standards

During the greater part of the 1960s there was a distinct decline in the quality of much Finnish architecture. This corresponded with a period of industrial expansion and considerable economic growth in Finland. At the same time, Reima Pietilä, who was already 35 at the beginning of the decade, developed as a significant new figure. It is certainly an oversimplification to categorize the 1960s as a period of struggle between the values of an established modern Finnish architecture on the one hand and a reductionist mode of building measurement combined with so-called 'design methods' and rationalized production on the other. Nevertheless it is true that the broad sensitivity of Alvar Aalto's humanistic approach had a steadily diminishing impact and importance in his own country during the fourth decade of his practice as an architect.

During the 1960s, and not only in Finland of course, a new wave of rationalization sought to displace the values of architectural modernism with a disproportionate emphasis on technique. The tendency towards management methods lowered the quality of design practice and damaged the preparation of a new generation of practitioners in schools of architecture. We do well to bear this phenomenon in mind at the close of the twentieth century, as we appear to be witnessing yet another swing back to the pseudoscientism of the 1960s. In the wake of the often frivolous excesses of various interpretations of postmodernism and deconstruction, the reductionist empiricists are once again modifying both practice and education. It is clear from their corporate methods and management style that their purpose is to displace social and cultural values with an overdependence on technique and measurement.

Fortunately, architecture is too complex a discipline to be reduced to mere rationality by any witch doctors' spells and charms, certainly not those of rule and calculator. Nevertheless, we should remain aware of the continuing threat from these men of measurement. In the 1960s there seemed already to be something of a conspiracy between academic administrators, incompetent architects and sections of the building industry to make production technique the master of cultural expression rather than its servant. But at that time the conspirators had only primitive means in support of their efforts; more recently they have sought to attack architecture with sophisticated computational and other advanced techniques. History teaches us that, when things are well ordered in a culture, technique is the servant of its forms and expression. The illusion that technique can take over the role of master was rather convincingly discredited by our experiences in trying to rationalize architecture during the 1960s.[1]

There is no doubt that Reima Pietilä saw his role in this struggle as the opponent of the uniform, largely prefabricated and characteristically box-like architecture that was springing up all around him in Finland. He championed an architecture that was 'natural and intellectual at the same time',[2] through the development of forms that were liberated from an oversimplified view of modular coordination. He also succeeded in harnessing some of the most advanced techniques, for example in the construction of his Kaleva Church for Tampere (1959–66).

Pietilä's Suvikumpu Housing Development for Tapiola New Town (designed in 1962, first stage completed in 1969) is a truly remarkable blend of site planning, apartment design and creation of a

Figures 167 and 168
Aarne Ervi
Flats at Myllytie, Helsinki (1961): plans shows generous private apartments, with a variety of external wall stepping. The stepping and Ervi's simple tile-clad surfaces bring an elegant charm to this functionalist design, showing his skill in making modernism extremely livable.

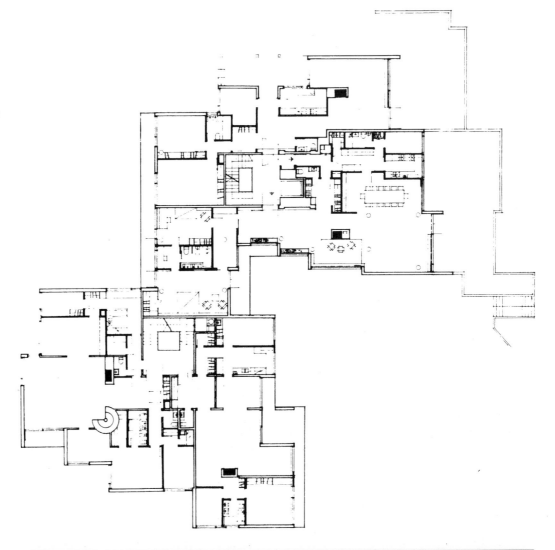

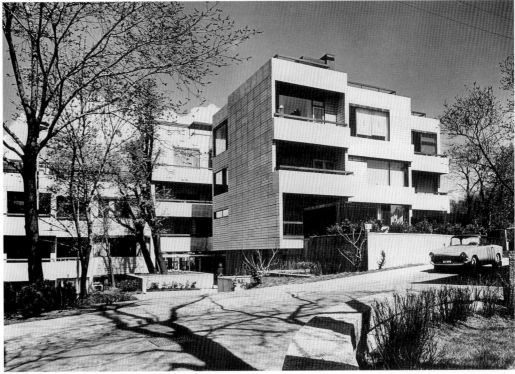

harmonious suburban environment. Suvikumpu demonstrates the virtue of rhythm-variety achieved through thoughtfully modulated repetition – as in the development section of a complex musical work. Pietilä's Dipoli Student and Conference Centre at Helsinki Technical University in Otaniemi (1961–66; Figures 155, 164, 169) is certainly the most muscular of his realized designs of the 1960s. But his seminal project for Malmi Church (1967; Figure 170) also reveals a robust individualism, confirming the mastery of constructive form shown earlier in his Finnish Pavilion at the 1958 World's Fair in Brussels. Pietilä's Malmi Church competition project represents a landmark in Finnish ecclesiastical design. It is therefore regrettable that this highly innovative building was not realized. All these achievements predicated the survival of a distinctive modern Finnish architecture in the tradition of Eliel Saarinen, Lars Sonck and Alvar Aalto, placing a considerable responsibility on Pietilä.

In his analysis of the attitudes of Tom Simons, a Finnish architectural graduate of the late 1960s, Pietilä highlighted a significant aspect of the decade's social, political and educational transitions in Finland. Simons gave a lecture on 'Architecture and Ideology' in 1971,[3] on which Pietilä commented:

'Simons follows the deterministic model of political thought. For him there are only two alternatives: the bourgeois and the socialist ideologies. There exists a fundamental and unsettled contradiction between them. This is black, that is white; this is right, that is wrong. For him architecture is part of this definitive choice: which path should we take? Tom Simons assumes that individualistic society is hostile to art and therefore to architecture. Collective society in the form of socialism, on the other hand, is still receptive to artistic and architectural views. In his view the task of architecture is well defined as part of the political establishment.'[4]

What is interesting about Simons' position in the context of the 1960s is its thoroughly reactionary character. He sees architecture removed from its broad cultural base and attached instead to the narrow confines of a political programme. This can only be the view of someone who is prepared to ignore a lot of cultural evidence. Such a viewpoint overlooks, for example, the historical interdependency of 'the state' and 'the individual' in the flowering of Renaissance art and architecture. It also ignores the significance of a distinction Ferdinand Tönnies made between *Gemeinschaft* (community) and *Gesellschaft* (society), which, a century after the publication of this pioneer sociologist's seminal work, has increasing relevance to our present condition.[5]

Socialists mistakenly believe that 'collective society' represents an aspect of *Gemeinschaft*, just as the architectural empiricists and rationalists mistake measurement and serial production for manifestations of *Gesellschaft*. Indeed, what Simons' *naïveté* reflects is the sort of presumptions made by religious moralists such as A.W.N. Pugin. This kind of *naïveté* is based on the notion that architectural form should derive from idealized concepts of social and cultural conformity rather than from the nature of society and culture as they actually exist. Pietilä's cultural lineage and therefore his architectural expression of social and cultural realities, prompted him to remark, 'All I have to teach are certain unlearnables.'[6]

Whether or not the work of Aalto and Pietilä formed the mainstream of architecture in Finland during the 1960s from the Finnish point of view, it certainly offers the main line of interest to the outsider. By the end of the 1950s Aalto, who was already 60, began to suffer fatigue and a consequent decline in the forcefulness of his designs. His project for Kiruna Town Hall, Sweden (1958) and his Wolfsburg Cultural Centre, West Germany (1958–63) do not have the strength and coherence of his Vuoksenniska Church, Imatra (1956–59) or his House of Culture in Helsinki for the Finnish Communist Party (1955–58). The two outstanding decades in Aalto's working life are undoubtedly

Figure 169
Reima Pietilä
Dipoli Student and Conference Centre, Otaniemi (1961–66): in his sectional sketches, Pietilä indicates something between geomorphic and zoomorphic sources.

Figure 170
Reima Pietilä
Project for Parish Church, Malmi (1967): the section and elevation of this unbuilt work clearly indicate the 'literal morphology' of 'rock'. This would have provided the culmination of ideas generated in the Dipoli centre. There is no further reference to the Malmi design until, in the President's Residence (1985–93), the underground cave reappears.

Finnish Architecture and the Modernist Tradition

the 1930s and the 1950s. During the 1960s and 1970s, with some notable exceptions, there is an observable slackening in his genius and energy. His projects for the Baghdad Art Museum in Iraq (1958) and for the Essen Opera House in Germany (1958–59), however, still show Aalto in his prime: they promised great strength in concept and overall massing. The Essen Opera House has certainly realized some of that promise, even though there were many delays and several reductions in size before the building was finally completed in 1988, three decades after its design and 12 years after Aalto's death.

Aalto's work of the 1960s was illuminated by the Mount Angel Benedictine College Library in Oregon, in the United States (1965–70), with its bold concept and impeccable detailing of structure and form (Figures 181, 182) and by such intriguing projects as those for the BP Headquarters Building in Hamburg, West Germany (1964), the Lehtinen Private Museum in Helsinki (1965) and the Siena Cultural Centre in Italy (1966).

On the whole, however, Aalto's work of the 1960s is generally diminished in effect by a new preoccupation with formalism. This formalism is already emerging in the design for the Enso-Gutzeit Headquarters in Helsinki (1959–62) and the Finlandia Concert Hall in Helsinki (1962–71; Figure 158). His Riola Church, near Bologna, Italy (original design 1966, completed posthumously 1976–78), although of striking form on the exterior is not as interesting in sectional construction as his project for the Altstetten Protestant Parish Centre, Zürich (1967). The Villa Erica project for a house near Turin, Italy (1967) should not be compared with his design for the Studio R-S, near Como, Italy (1954) in either its planning or formal dynamics. His highly successful North Jutland Art Museum at Aalborg, Denmark (with Jean-Louis Barüel), although not built until 1972–73, actually dates from 1958 when Aalto was still at the peak of his performance.

Nevertheless Aalto left us two promising projects from the 1970s: one for an apartment tower at Schönbühl, near Lucerne in Switzerland (1973); and an intriguing proposal for a Scandinavian–American Society Cultural Center in Wisconsin in the United States (1974). Otherwise Aalto's successful executed works of the 1960s are of small scale: the Villa Kokkonen, near Helsinki (1967–69), for a contemporary Finnish composer; and the Villa Schildt at Tammisaari (1968–70; Figure 159), for Göran Schildt, who became Aalto's official biographer in the 1980s.

Examination of the new rationalism of the 1960s reveals a complex issue. In his own work, Pietilä's adherence to Aulis Blomstedt's principles in the strictly modular design of the Brussels Pavilion shows evidence of his own particular kind of rationality. This form of rationalization recurs most obviously in Pietilä's Suvikumpu Housing for Tapiola and his Sief Palace Area Buildings (1978–83; Figure 163). But this is a humanized rationalism, in the spirit of Aalto's distinction between rationalization and standardization.[7]

The principle is demonstrated initially in the theme of the modular wooden form by Aulis Blomstedt and Heikki Koskelo, designed and constructed for the 'Architecture in Finland' exhibition held in Stockholm in 1960. This modular sculpture offers a parallel to Pietilä's own modular stick constructions of the late 1950s. In his Terrace Housing at Leppäkertuntie 41 at Tapiola (1962–64; Figure 180), Blomstedt apparently went back to the model of Aalto's Kauttua Housing (1937–40), although the simplified forms of the vertical supports and balustrades reflect rather a possible inspiration from Mies van der Rohe.

A comparison of Aarno Ruusuvuori's Tapiola Church (1962–64) with Pietilä's Kaleva Church (1959–66) for Tampere is instructive: it shows how Pietilä's rationalization of large-scale structure is immensely more spiritually evocative than the prefabricated unit system approach of Ruusuvuori's design. At Tampere we have a piece of architecture, while Tapiola Church demonstrates some of the limitations of the building block as an exercise in reductionist rationalization. Ruusuvuori had

Figures 171 and 172
Kaija and Heikki Siren
Replacement of Parish Church, Orivesi (1958–61): this bold, eye-shaped plan creates an intimate interior, with its short axis towards the altar. The gently curving wall provides a soft, non-competitive accompaniment to the original early nineteenth-century tower, which escaped destruction.

Finnish Architecture and the Modernist Tradition

been much more successful with his earlier Weilin and Göös Printing Works (1964–66; Figure 177), which did focus the logic of the design on structural technique: the entire construction was rationalized to provide four massive, circular concrete columns from which the entire roof is suspended, providing optimum flexibility of planning. The same kind of persuasive structural logic is evident also in Viljo Revell's proposal for the Peugeot Office Tower competition (1962).

Bengt Lundsten's Ship Passenger Terminal at Longnäs (1962) follows Ruusuvuori's approach for Weilin and Göös very closely: he suspends the entire bridge-like structure from two concrete portal frames. A similar method was used by C.-O. Lindqvist and Y. Sormunen in the superbly detailed steel and wood O/A Dance Parlour at Hanko (1965–66), in which the timber roof is suspended from steel columns. The industrial clarity of these designs, which are undeniably in the spirit of Viljo Revell's Kudeneule Factory at Hanko (1953–55), exemplify the quality of this form of rationalized Finnish architectural expression in the 1960s. There are two other fine examples of the rationalization of reinforced concrete construction: the Tampere Workers' Institute and High School (1962) by Timo Penttilä and Kari Virtä, and Woldemar Baeckman's Sibelius Museum in Turku (1966–68).

Penttilä, who was an assistant in Aarne Ervi's office in the late 1950s, shows that he is typically more adept than Ervi in picking up Aalto's clues about the deviation from the axiality of Cartesian coordinates. The entrance hall to the Tampere Workers' Institute and High School offers a dynamic example, in the Aalto manner of opening up an additional architectural entity by deviating a mere 5–10° from the rectilinear grid. Into this space Penttilä and Virtä have introduced a shaft of dramatic form, space and light. The effect is not at all like Aalto, although the design strategy undeniably suggests Aalto as the source of inspiration in its compact and neatly modular plan.

Baeckman's Sibelius Museum, on the other hand, in its compact and precisely modular plan appears just as clearly indebted to Aulis Blomstedt's mode of rationalization. Blomstedt was Sibelius's son-in-law. The *parti* stems from the arrangement of two adjacent 'courts', one precedent for which is Donato Bramante's Palazzo della Cancelleria in Rome (Figure 186). In Bramante's model, one 'court' becomes an actual *cortile*, while the other accommodates a church. In Baeckman's variation of this classical theme the concert hall replaces the church. While the ordering of the plan and the external elevations (Figure 188) in the Sibelius Museum show Baeckman faithfully following Blomstedt's precepts, it is significant that the structural supports for the roof of the concert hall certainly do not. Indeed, these four concrete columns supporting inverted pyramids that form a robust canopy over the audience are highly expressionist (Figure 187). Baeckman's gesture seems to suggest that the spirit of Sibelius cannot be contained within a rigid framework of right angles!

During the 1960s, a number of office buildings of a much lower design standard than the Sirens' Hakiniemi Centre, known as Ympyrätalo (1960–68; Figure 166) began to appear in Helsinki. Among those examples are the Säästökulma Building by Antero Pernaja, the Scandinavian Bank on Siltasaari by Riisto-Veikko Luukkonen and the Helsinki Telephone Headquarters by Kurt Simberg, all completed in 1960.[8] Against such a display of mediocrity, Aarne Ervi's Porthania Building for Helsinki University (1955–57) offers a refreshing contrast in both its concept and finesse of detail.[9] With a dramatic increase in the number of commercial office projects under construction the standard of design dropped correspondingly. In the work of a number of architects we can observe a consistent pattern; for example, Kurt Simberg's new headquarters buildings for the Wulff Company on Mannerheimintie (1965–67) maintains the tedium of his earlier Helsinki Telephone Office façade.

From their middle-of-the-road position, the Sirens dominated the Finnish architectural scene

Figure 173
Viejo Martikainen
Panakoski Church, Lieksa (1960–62): design and massing inspired by De Stijl and Aalto's Säynätsalo Town Hall.

Figure 174
Viljo Revell
Weekend house and sauna for H.F. Johnson, Wisconsin, USA (1961): Revell brings the simplicity and clarity of his other modular housing designs to the USA. Only the sauna was built.

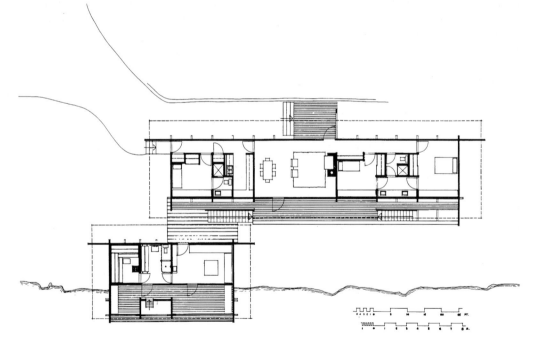

with the absolute clarity of their simple, formula designs. The Sirens could be counted on to maintain that certain standard, even if there were not many surprises in their repertoire. Their project for Espoo Church (1960) is a good example of this formulaic approach.[10] For exceptional work in the 1960s, we must turn to the work of Reima Pietilä, Timo Penttilä and, Aarno Ruusuvuori. Ruusuvuori in particular went on to maintain an authentic modernism by his poetic use of materials and sensitive, sophisticated detailing.

One universal manifestation of the 1960s, the shopping centre, also took root in Finland. Although this cultural phenomenon offers a very challenging architectural problem, it has yielded few interesting Finnish solutions. Even Pietilä's Hervanta Shopping Centre (completed in 1978), is one of his least successful designs. Among those that established the form in Finland in the early 1960s we should mention the Munkkivuori Shopping Centre by Antero Pernaja (1957–60) and those by Erkki Karvinen at Kuulusaari (1956–60) and Kannelmäki (1958–60).[11] Perhaps the most successful of all the Finnish shopping centre designs is another solution by Karvinen for the suburb of Puotila near Helsinki (1963–66), an imaginative plan that combines a rational layout with well-detailed expressionism and a thoughtful development of the exterior public areas. Karvinen's Puotila Shopping Centre combines the best features of architectural modernism in a solution that is pleasing to the user, with its airy and inviting sculptural concrete forms inspired by the work of Le Corbusier.

Jukka Siren died in 1961 at the age of 72.[12] Throughout his career he adhered to the classical principles that brought him his original success with the Parliament Building design for central Helsinki in the 1920s. Almost ten years older than Aalto, Siren maintained to the last a rigidity of formal design on which Aalto had already turned his back by 1927. Ironically, Aalto presented his Helsinki Plan in 1962 for the new city centre, focusing on the junction of Mannerheimintie with Töölö Bay at Siren's Parliament Building, shortly after Siren's death.[13]

Once Aalto had entered the Helsinki Central Post Office competition of 1934, he must have been acutely aware of the difficulties in trying to resolve this point of entry into the city. The fact is that the placing of the Parliament Building at this juncture in 1927 and the construction of the Central Post Office by Järvi and Lindroos, created an awkward elbow joint rather than a navel for downtown Helsinki. Given the location and extent of the railway yards adjacent to the Parliament Building and at the rear of the Post Office, it is almost impossible to resolve the spatial confusion at this point of the city without building over the railway tracks to create an adequate density of urban form.

Aalto's solution ignored that strategy, proposing instead to create a piazza as a replacement for Revell's Glass Palace (1933–36) next to Helsinki Bus Station. This proposal could never have succeeded in practice simply because the area adjacent to the Glass Palace is not a focus for the downtown area. Rather, since it houses the Helsinki Bus Station, it is a point of evacuation. Thus the problem remains one of making a coherent whole of the various 'holes' in the fabric of central Helsinki.

Finns are apt to joke about the fact that the Norwegian capital, Oslo, has only one main street, the Carl-Johan. But the Carl-Johan has the virtue of running from the royal palace to the Parliament, taking in both the university and the national theatre on the way. The Mannerheimintie in Helsinki, on the other hand, has neither a 'beginning' nor an 'end'. As a consequence, Siren's Parliament Building and Eliel Saarinen's National Museum are cast adrift at its mid-point in a suburban bay with Aalto's Finlandia Concert Hall and Congress Centre.

Aalto's production of large private residences ended with the completion in 1958 of the Maison Carré, the private villa of Louis Carré at Bazoches in the Ile de France. These larger homes actually number only two, since the Villa Sambonet and

Figure 175
Kurt Moberg
Swedish Student Centre, Otaniemi (1962–66): although the wedge- or fish-shaped plan seems inspired by Pietilä, the *béton brut* interiors are in marked contrast to those of the Dipoli Centre.

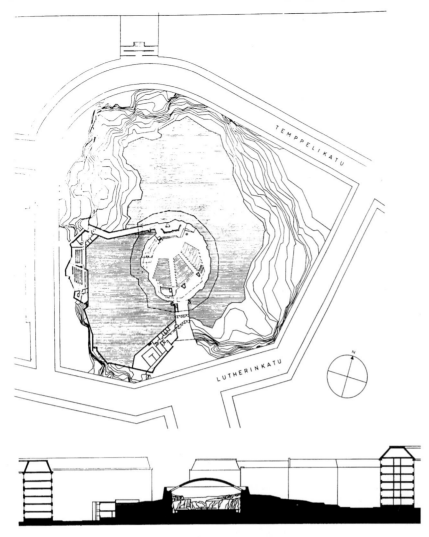

Villa Erica were not built, and both the Villa Kokkonen and Villa Schildt are on a much smaller scale. The focus of house design in Finland in general moved in the 1960s towards smaller dwellings and apartments. There was also an increasing emphasis on prefabrication and modular co-ordination in housing design and production.

Perhaps the last significant example of Aalto's influence on residential design is to be seen in the work of his former assistant, Aarne Ervi, whose skilful composition of the apartment complex at Myllytie 3, Helsinki (1959–61), complements the Villa Ervi as the architect's best example of multiple housing (Figures 167, 168). Ervi's Myllytie Apartments stand in strong contrast to the work and ideas of Kirmo Mikkola and Juhani Pallasmaa, reflected in Pallasmaa's article on 'Building and technique' in the June 1967 issue of *Arkkitehti*,[14] and demonstrated in the modular prefabricated design of the Villa Relander at Muurame (1966) by Mikkola and Pallasmaa. These two architects produced several designs for modular wooden houses in the mid-1960s[15] and were at the centre of a new movement that focused again on the standardization originally spearheaded by Aalto in the 1940s. Others closely followed the lead of Mikkola and Pallasmaa, notably Vainio and Lehtinen, whose As-you-wish Modular Housing for Espoo (1966–68) is self-explanatory as well as being one of the best examples of this mode.

Figure 176
Timo and Tuomo Suomalainen
Temppelikatu Church, Taivalahti, Helsinki (1961–69): a highly successful solution to a difficult siting problem, the *parti* already suggested by Pauli Blomstedt's entry in the original competition of 1933.

Figure 177
Aarno Ruusuvuori
Weilin & Göös Printing Works, Tapiola (1964–66): here a rationalist structure – only four giant columns supporting the roof – offers free planning of the factory floor.

The spirit of modular prefabrication was certainly in the air in Finland, as it was elsewhere in both Eastern and Western Europe in the 1960s and Mikko Pulkinen's own summer cottage (completed in 1967) is a delightful solution in this form of construction. Another follower of Mikkola and Pallasmaa, Eero Valjakka, produced a noteworthy, though less intriguing, semi-detached house at Pakila (1966–68). Meanwhile Aarno Ruusuvuori showed his mastery of modular co-ordination and refinement of detail in his own Marikylä Summer House and Sauna (1963–68) at Bökars (Figures 193, 194, 196).[16]

Kristian Gullichsen, son of Maire and Harry

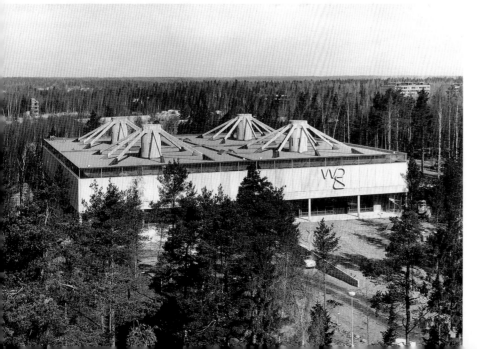

Gullichsen and a very thoughtful architect, also aligned himself briefly with the modular prefabrication movement. Gullichsen and Pallasmaa collaborated at the end of the decade to produce the Moduli Summer House System (1969–70), another example of the Finnish summer-cottage genre in which Aalto had been so actively involved at the beginning of his career. In their Moduli design, Gullichsen and Pallasmaa take the notion of modular prefabrication in the assembly of wooden houses to its ultimate point of refinement. With Moduli they demonstrated that standardization at the hand of Finnish architects, and as originally envisaged by Aalto, can be a truly sophisticated mode of expression (Figure 195).

Emulating another of Aalto's powerful contributions to the body of modern architecture, Timo Penttilä has produced outstanding work in the realm of industrial architecture with his designs for power stations. The most notable of these is the Hanasaari Power Plant for Helsinki; this was begun in 1965, although the first phase was not completed until 1972, with the second stage added between 1973 and 1976. Penttilä adopts Aalto's simple formulation of the basic building masses, clarifying this strategy by leaning towards a Miesian character in the detailing. The result provides a totally convincing example of industrial architecture at a scale that dwarfs the developments of the surrounding suburbs. Penttilä's power stations build on the models of his former employer, Aarne Ervi, and resemble cathedrals in the modern landscape.

Penttilä, who vies with Pietilä in the originality and power of his contributions to Finnish architecture of the 1960s, made his most significant contribution so far with the Helsinki Municipal Theatre (1964–67). This is a complex structure with two stages and it is set in parkland adjacent to Aalto's Finlandia Concert Hall and Congress Centre (1962–75; Figure 158) on the edge of Töölö Bay. Its distinguishing feature, or rather lack of it, is its total exterior modesty and self-effacement in the parkland landscape. On the interior, the stepped and terraced access galleries build their own landscape around the two auditoria, creating a lively dialogue between the natural terrain outside and its constructed counterpart within the architecture.

Penttilä eschewed Aalto's later preference for marble on public buildings, returning instead to the master's earlier use of tiled surfaces. The result is both underplayed and entrancing. Penttilä's exploration of this unique city-centre site combines bravura in the plan with a poetic finesse in the massing and detail (Figures 189–191). Curiously, it is one of the buildings least remembered by visitors, who tend to recall Aalto's more pretentious and monumental Finlandia complex next door, frequently confusing the two. Indeed, Aalto is often mentioned as the architect of the Helsinki Municipal Theatre, just as he was credited with the design of the Helsinki Olympic Stadium in one London newspaper obituary.

Another architect who contributed interesting and forceful solutions in the field of industrial architecture also emerged in the 1960s. Matti K. Mäkinen began to make his mark as the chief architect to the Valio Company, Finland's giant milk conglomerate which has a virtual monopoly on milk and fruit juice products. The Kuivamaito Oy (Dried Milk Company) Offices and Plant, designed by Mäkinen with Aila Sääksvuori and built in two stages in 1966–67 and 1967–68, already reveal the architect's flair for making bold, formal statements with simple, elemental means. In the case of the Kuivamaito complex the structural form is exaggerated in the sections revealed on the end elevations, suggesting the repetition and continuity of the production line.

Aarno Ruusuvuori, who had a distinguished career not only in architectural practice but also as a university professor and as a long-term director of the Museum of Finnish Architecture, made a truly significant contribution to postwar Finnish architecture. In addition, among his works in the field of historic preservation are: the restoration of Hämeenlinna Church (1962–64), which has a thoughtful modern organ and choir gallery inserted into the neoclassical original; the pristine

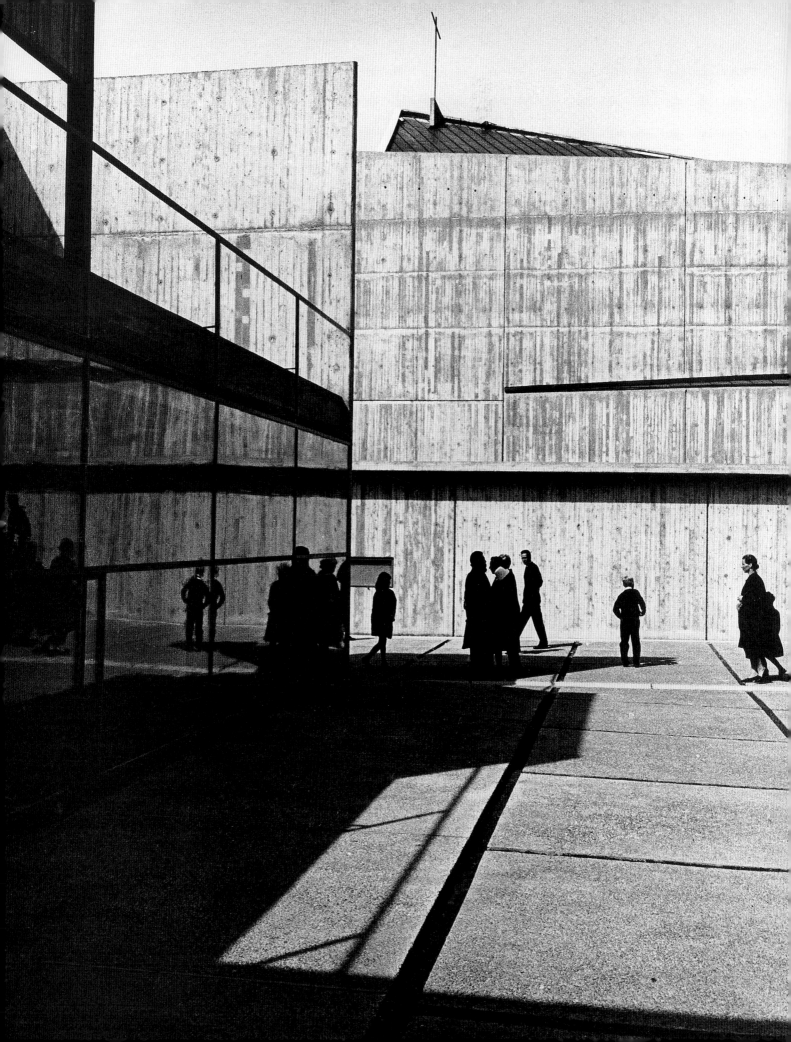

refurbishment of Sonck's Private Bank and its conversion into the Helsinki City Exhibition Gallery (1968); and more recently his restoration and extension of the Helsinki City Hall (1970–88). Ruusuvuori, who died in 1992, was one of the most intelligent and versatile of Finland's postwar architects, combining a powerfully resistant architectural modernism with a scholarly understanding of modern architecture's role in the continuation of historical traditions.

Viljo Revell, Keijo Petäjä's partner on the Palace Hotel, died suddenly in the spring of 1966 and *Arkkitehti* reviewed his major projects in the May–June issue.[17] These included not only the Toronto City Hall (Figure 183) but also the Didrichsen Gallery at Kuusisaari and the KOP Bank Building in Lahti, as well as the Johnson Sauna on Lake Owen in Wisconsin in the United States (1961).

The Johnson Sauna was designed as part of a lakeside residence for the Johnson family, but the larger wing planned for the upper part of the lakeshore above the sauna, which was to have contained a large living/dining room, three bedrooms and two bathrooms, was never built (Figure 174). A single flight of stairs linked the upper residential wing to the parallel sauna building below. What is interesting about this design is the fact that it is clearly modular from the constructional point of view, yet this is not apparent from the external appearance of the completed sauna (Figure 165). The wooden construction is rationalized, yet the effect is one of spaciousness and breadth rather than that of a repeated unit. While the formal ordering is modern, this logic is clearly backed up by a classical system of proportional construction. This explains the success of a large-scale domestic sauna in relation to the lakeshore. It also accounts for the entirely unsentimental use of wooden construction in this totally modern design.

Revell's work was always thoughtful, confining invention to clearly delineated notions about the scope of an architectural problem. His buildings somehow resemble an anatomy lesson, in which the bones and organs are carefully displayed for scrutiny by the inquisitive student. Everything is always clearly visible and apparent in a Revell design: the relationship of the different parts is self-evident. It is possible to dissect his work, to pull it apart, in precisely the reverse order to that in which the architect has put it together. Revell's rationalism was extremely anatomical; when we look at it we observe the spare, muscular structure of the body of modern architecture, clothing the conceptual skeleton.

A comparison of Revell and Ervi reveals the tough-mindedness of the former and the more fanciful digressions of the latter. There is more to be learned from Revell because his logic and discipline are taut and balanced. If we dissect a Heikki Siren building it yields little subcutaneous substance, while a Revell building surrenders its bare bones. The differing approaches of the Sirens and Revell seem to meet in the design of the Sirens' Otaniemi Chapel, the interior of which might well have been detailed by Revell. At the other extreme, if we examine the Oulu City Theatre, the competition for which was won by Marjatta and Martti Jaatinen in 1967, we might expect to find some Siren muscle beneath the skin. In fact the Oulu City Theatre is a typical 1960s skin building, an illusion of the body of architecture with no real material beneath the surface. This 'skin without body' notion is, however, appropriately applied by Martti Jaatinen to his design for the Lintulahti Camping Shelter (1967–68). Here we have a Miesian framework, perhaps borrowed from Philip Johnson's house at New Canaan, Connecticut, United States (completed in 1949) clad in a transparent envelope that permits the interior space to mingle confusedly with the external natural setting of the camp site.

A review of significant Finnish church designs of the 1960s must begin with Orivesi Church (1958–61) by the Sirens. This is interesting because it subverts a classical form into an eye-shaped plan that is generated by two ellipses (Figure 171). The new church, which replaces the destroyed wooden original, presents a starkly

Figure 180
Aulis Blomstedt
Terrace Houses, Leppäkertuntie 4, Tapiola (1962–64): reminiscent of Aalto's housing at Sunila, this terrace identifies, too, with all mainline European modernism of the 1920s and 1930s.

Figures 178 and 179 (left and below)
Aarno Ruusuvuori
Parish Church, Huutoniemi (1964): subtle shaping of the church space within an overall rectangle gives this otherwise down-to-earth solution its refinement. The concrete walls are unrelieved except by marks of the formwork. This design shows Ruusuvuori at his most uncompromisingly modern.

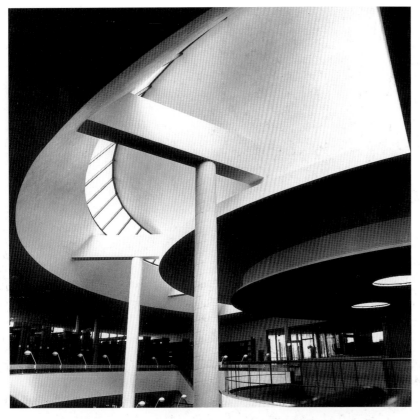

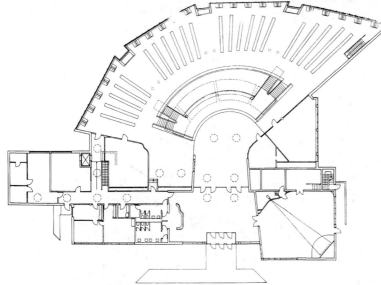

Figures 181 and 182
Alvar Aalto
Library for Mount Angel Benedictine College, Oregon, USA (1965–70): the Abbot believed that Aalto was the only architect qualified to design the library for his college. Aalto responded to the challenge by producing the most perfect example of his library projects. The interior has both a ritual and ethereal splendour.

modern form in its combination of sharp angles and broad, sweeping curves. This hard, clear form, cut into by peripherally placed vertical and horizontal windows that emphasize the intersection of the building's masses, offers a distinct contrast to the only vestige of the original Orivesi Church – the early nineteenth-century, four-tiered, onion-domed bell-tower that stands at the entrance to the churchyard (Figure 172). As a successful blend of modern architectural forms with historical ones, the Sirens' Orivesi design bears comparison with Pietilä's replacement for Engel's original parish church at Lieksa, in eastern Finland (1979–82). In that case, however, Pietilä's design has more resonances in its interior relationship of the new building form to the original campanile, which survived the fire of 1979 that destroyed the original church.

Aalto's church and parish centre for Detmerode, a suburb of Wolfsburg, West Germany (1965–68) was published side by side with his Riola Church design in 1968.[18] The form of the Riola Church is the more developed of the two; it suggests that it would create a dramatic landmark in a valley near Bologna, Italy, as it hugs the riverbank, which was confirmed when the main building was completed ten years later. Unfortunately, the Detmerode site did not offer similar potential for an architectural dialogue and the composition of the building has to stand on its own merits. Although the exterior form of Aalto's Detmerode Church has affinities with that of his Vuoksenniska Church in Imatra, it is much simpler and less forceful in its massing. There is no doubt that Aalto experienced considerable difficulty in the composition of building masses on suburban sites. This weakness is apparent in most examples of his work that do not have the compact agglomeration of forms that distinguish, for example, Säynätsalo Town Hall and the Malmi Funeral Chapel project. The organization and effect of the Detmerode Church and Parish Centre suffers from problems similar to those evidenced by the Seinäjoki Church (1952–60) and Town Hall (1960–65) where the loose relationship of building masses fails to

Finnish Architecture and the Modernist Tradition

achieve strength and formal unity.

There is a clear link between Aalto's designs for auditoria and churches, corresponding directly with his concept of architectural functionalism. What is surprising, however, is the almost complete lack of connection between Aalto's strong sense of ritual in his designs for the Malmi Funeral Chapel and Lyngby Funeral Chapel and Cemetery Masterplan (1951–52), the Maison Carré (Figure 154) and Studio R-S and the five designs for churches produced in his mature period. This period spans more than a decade, beginning with the design of the Vuoksenniska Church, Imatra (1956) and ending with the Altstetten Protestant Parish Centre project (1967). The Riola Church design of 1966 was not built until after Aalto's death: it was completed, with the exception of the campanile, in 1978. Of these church designs from the mature period, the most obviously functional – a simple wedge shape – was for the Wolfsburg suburb of Detmerode. The plan of the Detmerode design is based on Aalto's original design for the Lahti Church, with which he won the competition in 1950. In 1970 the Lahti Church design was substantially modified before construction commenced, although the basic wedge form was retained. One modification was the inclusion of an attached campanile in a more elaborate style than Aalto's 1950s' designs for this feature, for example that at Seinäjoki. It was at Detmerode (built 1965–68) that he first worked out this form of belfry. The structure is basically a skeleton of vertical concrete planks to which subsidiary fins are added at the bell enclosure.

Aalto's first major church design of his mature period was the commission for the Vuoksenniska parish of Imatra, eastern Finland. Built between 1957 and 1959 the church follows the plastic expressionism originated by Aalto in his House of Culture, Helsinki (1955–58; Figure 151). The asymmetrical plan of the auditorium for the House of Culture is transformed in the Imatra church into a three-part shell form on the long axis. This clustering effect allows the building to accommodate three different sizes of congregation. One-third or two-thirds of the nave may be closed off by the sliding walls, which are housed in boxes set in the functional accommodation ranged behind the left-hand side of the church, and in the curved shells on the right. The ceiling is also shaped in three distinct shells, corresponding to the plan, developing an undulating form from altar to rear wall that recalls Aalto's innovatory design for the Viipuri lecture-room ceiling.

The Imatra design provides the most convincing evidence of Aalto's ability to fuse a plastic plan shape with the fluid form of the section. The exterior form represents the interior complexity in a strange combination of functionalist and expressionist references that make up an autonomous whole. From the outside it resembles a bunker or gun-emplacement, while the faceted and finned detached campanile anticipates the Detmerode model by almost a decade. On the inside Aalto's exquisite detailing of the transitions between the three compartments of the church, developing fine fan-like sculptural forms that are perforated by air vents, demonstrates a total coherence of modern construction in the resolution of complex geometries that is unequalled in Aalto's mature expression. Aalto's exploitation of the double-shell concept, first hinted at in the lanterns of the National Pensions Institute (1952–56) and considerably developed in the auditorium of the House of Culture, achieves perfection in the Vuoksenniska Church. This design is more than an interweaving of plan and section: it shows Aalto giving to architecture the elegant jointing of his furniture, providing the church with the complexity and intimacy that is characteristic of his best domestic examples.

Aalto's skill in grouping his neoclassical solutions of the 1920s, such as his Töölö Church and Viinikka Church designs, or his late functionalist work, of which the Paimio Sanatorium is perhaps the best example, is not matched in his designs after the 1950s when he abandons his tight-packing or spinal arrangements of the overall plan. The architectural forms of the Sirens' Orivesi Church

Figure 183
Viljo Revell
City Hall, Toronto, Canada (1958–66): a bold design that is conceptually strong (twin towers overlooking a central, council chamber, 'eye') but functionally weak. The fact that the towers are not connected is disastrous in communications terms, and the council chamber 'eye' is a poor fit of room to purpose.

Figures 184 and 185
Erkki Elomaa
Parish Church, Järvenpää (1965–67): De Stijl/cubist masses generate a busy, muscular interaction of forms. The interior shows *beton brut* in Aarno Ruusuvuori's manner. It suggests in its simplicity an early Christian subterranean hide-away.

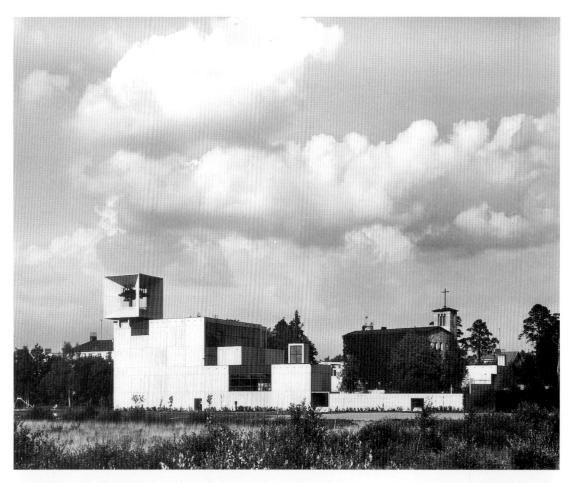

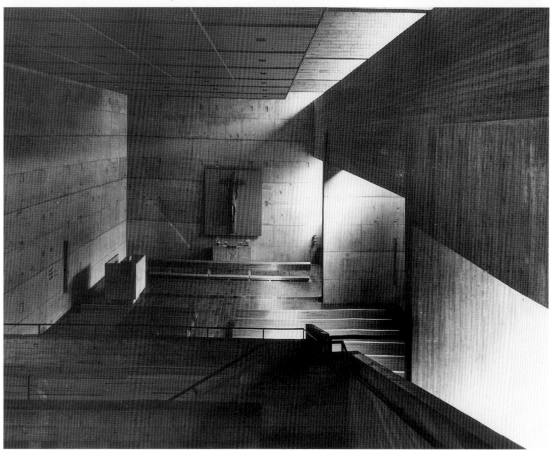

(Figures 171, 172) and Aalto's Detmerode Church have to respond to the same contextual problem: isolation from other buildings. While the Sirens' solution at Orivesi, with the support of the old belltower, establishes its existence in the graveyard, Aalto's Detmerode design fails to make its mark in the Wolfsburg suburb.

If we are looking for that suburban sense of place in Aalto's later work, the unbuilt Altstetten Protestant Parish Centre in Zürich offers the best evidence. Church design, inseparably linked with 'sense of place', has a social and cultural role in both city and suburb. In some settings, Aalto could focus on the benefits of close-packing, as he did in both the University of Jyväskylä Sports Institute (1964–70) and in his project for the Siena Cultural Centre, Italy, which promised the same dynamism as his Mount Angel Benedictine College Library (Figures 181, 182). But, ironically enough, with the exception of two unbuilt projects, those for Malmi Funeral Chapel and the Altstetten Parish Centre, Aalto never realized the design potential of the close-packing strategy in his church designs.

There are distinct similarities between the design for the Riola Church and Parish Centre, near Bologna, commissioned in 1966 and the church and parish centre project for the Altstetten district of Zürich of 1967. However, the geometry of these designs owes nothing to the mastery Aalto exhibited at Imatra; rather it has its origins in modernism's interest in the forms of industrial sheds. It is disappointing that the path which led from Muurame (1926–29) to Imatra should have gone on to the anticlimax provided by the Riola and Altstetten designs. In one sense his church designs provide the alpha and omega of Aalto's career, with the high point in the Vuoksenniska Church.

It is regrettable that the design for Altstetten was not built, as it is the more interesting of these two final church designs. In the Altstetten project there is a close correlation between the site planning and the overall building form. The formal approach by a flight of steps is framed by a parapet wall and the campanile and the massing of the church that runs west–east at the upper level is tightly orchestrated with that of the parish hall which runs east–west at the lower level. Located on either side of a 'street' the relationship of these two elements recalls the compact urban forms of both the National Pensions Institute and Säynätsalo Town Hall. There is a backward glance, also, in this design to Viinikka Church project for Tampere (1927), with its reference to an Italian hilltop piazza. The soft undulations proposed for the Altstetten roof line and the overall coherence of the massing, including the sympathetic cut-off of the campanile walls to an angle at their top, promised a more effective result than we see at Riola.

Veijo Martikainen demonstrates the virtues of Aalto's close-packing of forms in his Panakoski Church (1960–62). This design has the clarity of Aalto's earlier experiments in 'carving' and 'modelling'. Indeed, it borrows substantially from the form and massing of Aalto's Säynätsalo Town Hall. Although a design of the early 1960s its rationale reflects back also to De Stijl concepts (Figure 173). While the ideas and work of Aalto and Blomstedt may appear, on first acquaintance, worlds apart, they certainly seem to meet here in Martikainen's Panakoski Church. The essential bridge between the different design positions of Aalto and Blomstedt is to be found in the importance of natural lighting and its value as an element of the body of architecture. Blomstedt's basic preoccupations were within formal relationships and proportions, which derive directly from De Stijl concerns, while the element of natural light is of considerable importance in the organization of his façade patterns. The exploitation of natural lighting is central to the realization of an Aalto concept.

Blomstedt's attitude to natural light may be traced to his master, Le Corbusier, who changed his approach only in his last religious buildings – the French pilgrimage church of Notre Dame at Ronchamp (1950–54) and monastery of La Tourette (1957–60). At La Tourette, Le Corbusier successfully borrowed Aalto's use of roof lenses. In his Panakoski Church, Martikainen in turn

Figures 186–188
Woldemar Baeckman
Sibelius Museum, Turku (1966–68): the double-court plan of Bramante's Cancelleria in Rome here has the church displaced by a concert hall that has only four columns to support the roof (avoiding internal obstruction). The neutral, panelled concrete structure on a stone plinth slips easily into the park in the shadow of Turku cathedral. The interior of the concert hall shows the successful intimacy of the space.

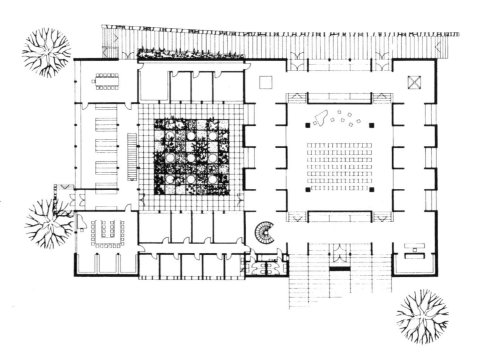

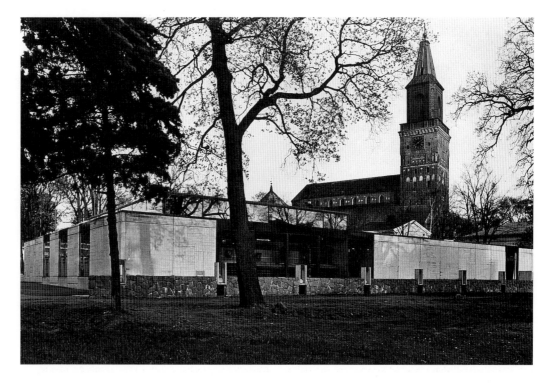

Finnish Architecture and the Modernist Tradition

borrows Aalto's window screens from Säynätsalo and Muuratsalo (Figure 146), although the overall form has more traces of Blomstedt's cool following of De Stijl than Aalto's warmer Säynätsalo variations on De Stijl themes.

There is perhaps a need to investigate the combined influences of Blomstedt and Aalto on Finnish architecture, since a pure Aalto influence is difficult both to convey and observe. For example, we shall see later how Juha Leiviskä's church designs reflect Aalto's use of natural light, while at the same time following a De Stijl inspiration in their geometric configuration that may be traced to Blomstedt's influence. In fact, to use Pietilä's terms, Leiviskä's architecture clearly strives to be 'natural and intellectual at the same time'.

The other interesting church designs of the 1960s constitute a very substantial 'body of architecture', in most cases by use of reinforced concrete for construction and expression. Although there may be modular constituents in their geometry, they are in no way conceived as prefabricated clones. Their materiality, the substance of their architecture, is in all cases more significant than the technique. Above all they tell us that, in spite of the new wave of rationalization, an adherence to the constructive and formal principles of modernism survives at least in the design of Finnish churches.

First we should mention Osmo Sipari's Kemi Funeral Chapel (1958–60). This design takes a clear stand against the romantic tendencies in Finnish church design that may be traced back to Erik Bryggman. The chapel's simple, hard geometric forms restore the idea of a distinctive modernist expression that is independent of traditional memories of construction and detail. Basically a wedge in section, with the axis of the chapel set against the slope of the monopitch roof, this form is intersected on both axes by low walls. One of these low walls directs us to the entry under the high, louvred window on the side wall of the nave; while the other links the chapel transversely with the surrounding graveyard. White-painted concrete and white-painted brick are the basic materials, with the pews consisting of concrete frames supporting wooden seats and backs. The floor of the nave is tiled, while the raised podium is made of granite slabs. The long lines of the external walls combined with the low mass presented by the wedge-shaped chapel provide a sharp contrast to the vertical patterns of the trees in the surrounding woodland.

Erkki Elomaa's Järvenpää Church (1965–67) is a larger and more complex structure. This design is realized by means of concrete elements that have a distinctive pattern built into the formwork on the interior. Although the exterior is rather box-like, the interior form of the church uses structural divisions, natural light and a choir gallery to achieve a lively pattern of dramatic contrasts within its simple framework (Figures 184, 185). Its siting is unfortunate – again the problem of making a sense of place in a suburban setting – and the loudspeaker-like belfry is not well integrated into the overall design either by scale or position. Nevertheless, its interior alone makes a substantial contribution to maintaining the line of Finnish modernism in the 1960s.

Much more coherent and successful in balance of material weight and mass is Pekka Pitkänen's Holy Cross Funeral Chapel (1964–67). This crematorium complex, located not far from Bryggman's Funeral Chapel in the Turku Cemetery, is a superbly articulated exercise in the ordering of pathways, space and masses. It possesses an essential solemnity and dignity in the heaviness of its architectural elements, which demonstrate the classic canon of modernism. Set in a beautiful and tranquil landscape, one much flatter than that surrounding Bryggman's chapel, the contrast of Pitkänen's weighty horizontal masses with the embracing pine trees, juniper bushes and immaculate lawns establishes the memorial sense of these buildings (Figure 192). Because the whole is carefully divided up into a number of related parts, the scale is never overpowering. Each building element is neatly and precisely joined to the next. It is as though modernism itself has become 'autonomous'. There is no overt demonstration of

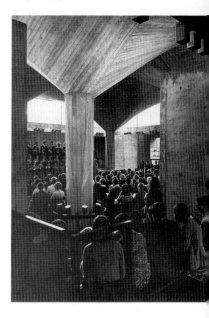

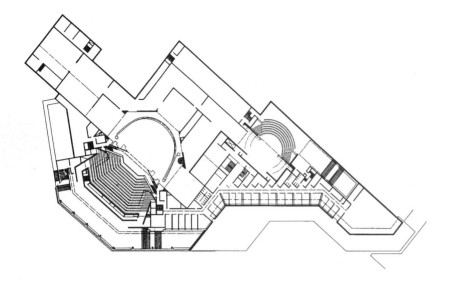

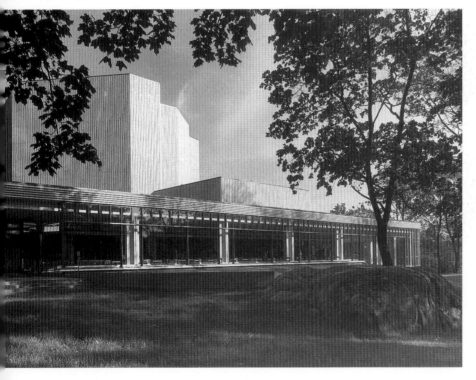

dexterity, only evidence of a self-effacing but total competence in handling forms, masses and junctions.

Pitkänen's whole design, taking full advantage of a lengthy approach from the parking lot at a lower level, slowly introduces the mourner or visitor to the measured seriousness that belongs to ritual architecture. The Holy Cross Funeral Chapel comes gradually into sight, reaching out with its approach canopy, reassuring us of the solemnity of this place, where life and death meet symbolically in a woodland garden. Yet there is nothing romantic about any of Pitkänen's architectural gestures. He simply takes his materials – concrete, stone, light and nature – and orders them with an appropriate dignity. The fact that he has found this dignity within the canon of architectural modernism is especially significant, for it shows that our memory of solemnity and dignity depend as much upon weight, mass and the use of light, as it does on some pictorial or graphic effect. After the excesses of nostalgic imagery that characterized the 1970s and early 1980s, it was refreshing to visit Pitkänen's chapel again in the summer of 1987. The unrepentant modernism to which Ruusuvuori was dedicated is brought to fruition in Holy Cross Chapel.

I have left consideration of Timo and Tuomo Suomalainen's successful resolution of the Temppelikatu site until last. In addition to its reference to Pauli Blomstedt's project for the original Taivallahti Church (1933) – a reference that has been persistently denied by the Suomalainen brothers[19] – there are other important architectural issues embodied in the creation of this church.

There can be little doubt that, in addition to their probable reference to Pauli Blomstedt's design of 1933, the Suomalainens were also intrigued by Pietilä's 1961 proposal for the Dipoli Student and Conference Centre when they prepared their Temppelikatu Church competition project later that same year.[20] Pietilä's proposal for the construction of the Dipoli building at Otaniemi included the process of actually blasting part of the building out of the natural granite of the site

Figures 189–191

Timo Penttilä

Municipal Theatre, Helsinki (1964–67): the ingenious plan accommodates the large and small stages by a simple cranking of the supporting accommodation. The monumental masses of the stage tower are kept at a distance by lower subsidiary accommodation, retaining the informality of the park setting. Generous interior spaces, especially those for circulation, create a grandeur of place and occasion.

Finnish Architecture and the Modernist Tradition

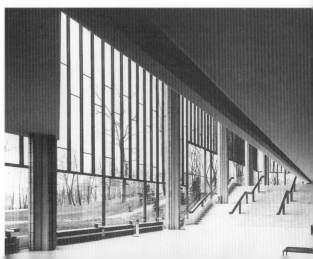

(Figure 164). This meant that the Dipoli building was designed to have a natural subterranean form for some of its interior spaces. Also, Pietilä planned for as little interference with the natural granite of the site as possible. In other words, by blasting into the rock he intended to leave the base form of the granite intact. Unfortunately, this did not work in practice, because the blasting process fragmented the rock bed and Pietilä had no alternative but to reassemble remaining fragments around the base of the Dipoli building.

The Suomalainens, too, were determined to blast and drill into the Temppelikatu rock, while leaving much of it intact (Figure 176). Fortunately, they were successful in their attempt, which was perhaps of even greater importance in an underground church with its implied memory of the Roman catacombs. Indeed, the Suomalainens' success in doing what failed at Otaniemi achieves a further connection with Pietilä's notion of making an architecture that is 'natural and intellectual at the same time'. The Temppelikatu Church (completed in 1969) preserves a natural element as an essential part of the body of architecture. To this it adds an intellectual dimension of the traditional, domed Christian worship space. Just as Pitkänen's Holy Cross Chapel offers a modernist bridge between life and death, so the Suomalainens' Temppelikatu Church creates, with modern technology, a bridge between the traditions of Christian pre-architecture and Christian architecture by means of nature, creating a rock-sheltered crypt-cum-nave.

The Temppelikatu Church has a further significant dimension that spans between tradition and modernism and that is once again the element of light. As we have already observed, Pauli Blomstedt seemed oblivious of light considerations in his 1933 design, in much the same way that Aulis Blomstedt often ignored the light dimension in his interiors. It is therefore a considerable achievement that the underground Temppelikatu Church is one of the best-lit churches in Finland. Perhaps there was a confusion in Pauli Blomstedt's mind as to whether

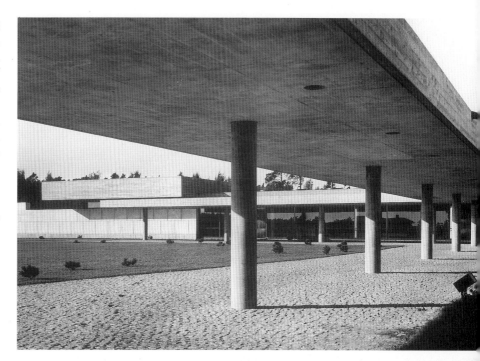

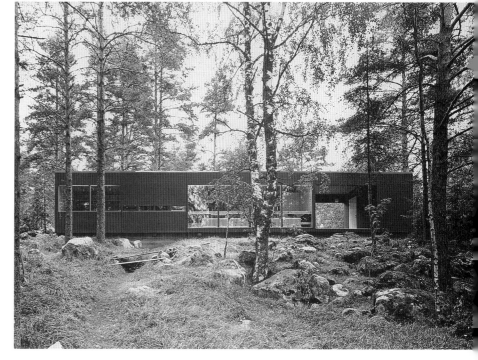

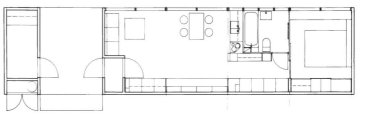

Figure 192 (top, right)
Pekka Pitkänen
Funeral Chapel of the Holy Cross, Turku (1967): located in the same cemetery as Erik Bryggman's chapel, Pitkänen's building offers the contrast of dignity within the restraint of pure, modernist mass and detail.

Figures 193 and 194
Aarno Ruusuvuori
Experimental House for Marimekko, Bökars (1967): within a simple, rectilinear plan, a basic summer or temporary house is provided. The modular units give simple prefabricated components for this elegant design.

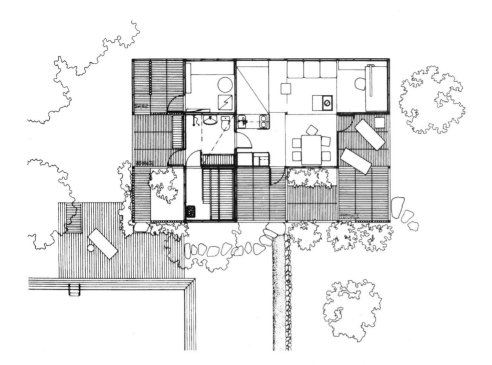

Figure 195
Kristian Gullichsen and Juhani Pallasmaa
Moduli, an industrially produced holiday-house system (1969): a larger, more elaborate version of Ruusuvuori's earlier design.

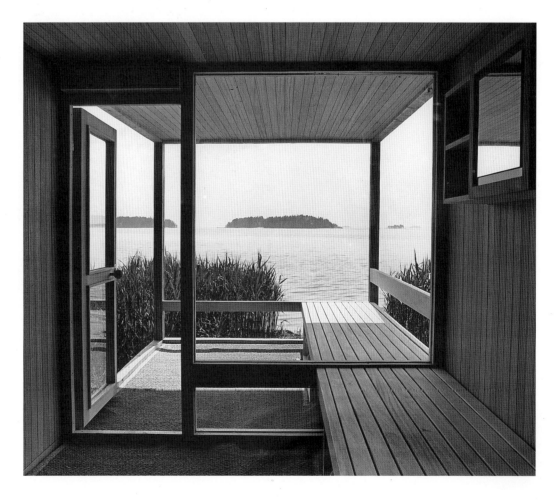

Finnish Architecture and the Modernist Tradition

his 1933 proposal should be classical or modern. Since he proposed a conventional classical dome he may well have thought it incorrect to combine this with the advantages of modern technology in introducing natural light through the dome to the church interior. In the Orivesi Church, completed in 1961, the Sirens used slit windows at the junctions of the masses both to admit daylight and emphasize the building form. This is precisely the strategy adopted by the Suomalainens in supporting a smaller central dome over the congregation by means of an outer ring of concrete ribs with clear glass between. There is no question about the authority and originality of the Suomalainens' design for the Temppelikatu Church; but it is equally important to stress how much architectural form draws on precedent for its invention.

There is something astonishing and almost incredible about the interior of the Temppelikatu Church, for in it we seem to experience the impossible (Figure 156). Here we are, in an underground church, which our memory of medieval crypts tells us should be dank and dark. Yet it is actually bathed in sunlight; the level of natural lighting allows us to perceive every detail of rock and architecture. This must truly be the 'church built on the rock'. Also, it appears to be bathed in an eternal light. The detailing, especially the use of copper for the interior of the dome and the balcony wall coping, provides a vibrant richness that emanates directly from forms and materials. Our 'memories' of catacomb and dome are sufficient to complement the architects' recreation of the body of the church; additional props and visual reminders are not necessary. This is a universal church in the tradition of catacomb and dome. It is not especially Lutheran, it could just as well be Catholic. Although it is interesting to speculate on the sources of this design, the significant thing is that the architects pulled them together into a coherent whole. We are unlikely to see a repetition of its form and splendour, which, as in Bryggman's Turku Funeral Chapel, successfully integrate the romantic tradition into the framework of modernism.

A further reference to Reima Pietilä's influence is appropriate here. In 1962, a year after the Dipoli Student and Conference Centre competition, Pietilä was a member of the architectural jury for another Otaniemi competition, this time for the design of the Swedish-speaking Students' Centre at the Helsinki Technical University (Figure 175). This aimed to provide a smaller, parallel facility to Dipoli, which accommodates the Finnish-speaking majority of the student body. Kurt Moberg's winning design has a plan in the form of an elongated, broken wedge. It is a curious anomaly in Finnish architecture of the early 1960s. In some ways it seems to derive inspiration from Pietilä's Kaleva Church (for which the competition was in 1959) or more particularly Dipoli itself (competition, 1961); it is also found in some Aalto designs of the mid-1960s, especially the projects for the Lehtinen Private Museum (1965) and the Siena Cultural Centre (1966). Moberg's building, completed in 1966, however, is of conventional *béton brut*, the dynamism of the plan being somewhat diluted by building technology that has a typically flat 1960s' expression.

Figure 196
Aarno Ruusuvuori
Marisauna (1968): a prefabricated sauna extension for the Bökars or other summer houses.

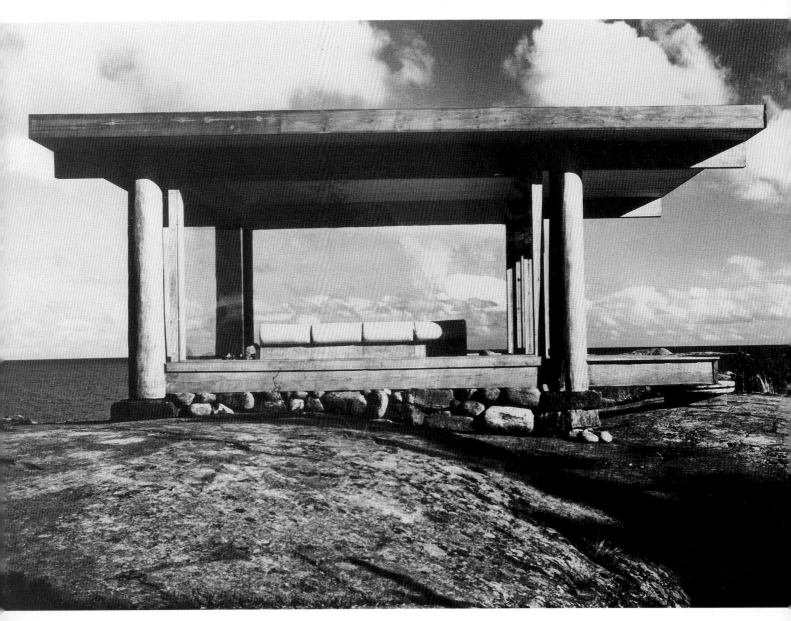

Figure 197 (above)
Kaija and Heikki Siren
Pavilion at the Villa Siren, Lingonsö (1969): a complete contrast to Figures 190–193 in the approach to the recreational 'villa', with a handcrafted temple-like design that has Japanese sources.

Figure 198 (opposite)
Alvar Aalto
Academic Bookshop, Helsinki (1962–69): here Aalto achieved the ultimate form and expression of his top-lit atrium *parti* inspired by Lars Sonck's Stock Exchange, which is only a few streets away.

References and notes

[1] For a detailed analysis of the two conflicting 'worlds' of sensory experience and measurement, see William Barrett, *The Illusion of Technique*, William Kimber, 1979.
[2] Malcolm Quantrill, *Reima Pietilä: architecture, context and modernism*, Rizzoli, 1985, p. 28.
[3] At the seminar on 'Finnish architecture and urban planning' arranged by the Association of Finnish Architects (SAFA) in Helsinki, August–September 1971.
[4] From a paper delivered by Reima Pietilä at the Team X Meeting, Cornell University 1972. Quoted in *Reima Pietilä: one man's odyssey in search of Finnish architecture*, Building Books, 1988, ed. Malcolm Quantrill.
[5] Ferdinand Tönnies, *Gemeinschaft und Gesellschaft*, 1887: English edition published as *Community and Society*, 1957, trans. and ed. Charles P. Loomis.
[6] Malcolm Quantrill, *Reima Pietilä*, 1985, p. 211.
[7] 'The architect's relationship to standardization should be like that of the poet's to the dictionary.' (Alvar Aalto). Quoted by Nils Erik Wickberg in *Finnish Architecture*, Otava, 1962 (Finnish edition 1959).
[8] *Arkkitehti*, 1960, No. 2, pp. 29–44.
[9] *Arkkitehti*, 1960, No. 1, pp. 20–28.
[10] *Arkkitehti*, 1960, No. 3, pp. 74–76.
[11] *Arkkitehti*, 1960, No. 12, pp. 181–201.
[12] *Arkkitehti*, 1961, No. 1, pp. 10–12.
[13] *Arkkitehti*, 1961, No. 2, pp. 34–44.
[14] *Arkkitehti*, 1967, No. 6, pp. 31–40.
[15] *Arkkitehti*, 1966, No. 3, pp. 42–46.
[16] *Arkkitehti*, 1966, No. 7-8, pp. 116–117.
[17] *Arkkitehti*, 1966, No. 5–6, pp. 71–94.
[18] *Arkkitehti*, 1968, No. 2, pp. 23–61.
[19] In discussion with the author at their office on 14 May 1987.
[20] *Arkkitehti*, 1961, No. 4–5, pp. 13–24.

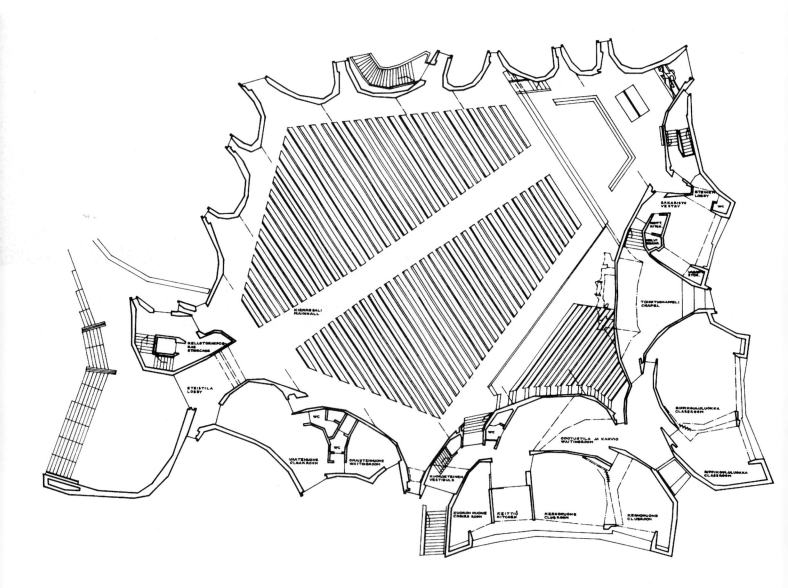

7 Reima Pietilä: form follows approach

The work of Reima Pietilä spans from the mid-1950s to 1993. His first building to receive wide attention was the Finnish Pavilion at the 1958 Brussels World's Fair, which was staged just at the point when Alvar Aalto's work began to show a decline in vigour. Pietilä's design ideas bridge across from the theories of Aulis Blomstedt to some of Aalto's attitudes to architecture, but the body of his entire work is uniquely his own. Both in theory and construction, his interests have embraced notions from the abstract to the tectonic, from philosophy to the form of language, literature and art.[1]

Pietilä's buildings, like those of Aalto, are distinctive; while his influence, also like that of Aalto, is small. He has been overshadowed by Aalto for half his career, yet his work of the 1960s made a vital and significant contribution to modern Finnish architecture. His ideas and his precocious ability to create provocative designs, placed him in direct opposition to the new rationalism of the 1960s. His work, like Aalto's, is easily recognizable and his entries to competitions could therefore be readily singled out by the jury. His idiosyncratic designs have frequently excited the envy and anger of his professional colleagues. His early and continuous flow of successes with the Brussels Pavilion, Kaleva Church in Tampere (competition 1959, completed 1966), Dipoli Centre (competition 1961, completed 1966), Suvikumpu Housing for Tapiola (competition 1962, constructed 1967–69), the Finnish Embassy for New Delhi (competition 1963, constructed 1980–85) and the Malmi Church design (competition 1967), all generated a determined resistance to his talents among many of his colleagues.

Finland is a small country with a population of little more than five million. By the mid-1960s, the Finnish architectural profession had lived in the shadow of Aalto's achievements for four decades. Pietilä clearly represented the threat of a similar domination by another outstanding performer. Following the completion of both Kaleva Church (Figures 199, 200) and the Dipoli Centre (Figure 155) in 1966, Pietilä got the commission to build the Suvikumpu Housing for Tapiola in 1967 (Figure 202). Although he had two small commissions for the Sarestö Gallery (1971–72) and the sauna for Hvittträsk (1973–75), he was otherwise without work in his own country from the completion of Suvikumpu Housing in 1969 until the 1975 commission for the Hervanta Congregational, Leisure and Shopping Centre for a Tampere suburb. In the interim period he worked on the report for 'The City of Kuwait: a future concept' from 1970 until the project for the Sief Palace Area Buildings was commissioned in 1973 (Figure 163). Construction on both the Hervanta Centre and the Kuwait buildings began in 1978, after almost a decade without involvement in a major building project. Although Pietilä's work of the late 1970s and 1980s shows a revival of his old vitality, there is no question that a hiatus of almost ten years adversely affected the architect's health, energy and creative force.

Pietilä has explained the Brussels Pavilion in the following terms:

'My Brussels idea had to do with spatial modulation. It came, of course, from Blomstedt. *It was an idea for making Finnish architecture natural and intellectual at the same time...* The modular structuralism of the Brussels Pavilion shows how one operates artistically with this system. As an exhibition building, this type of anti-functional function-

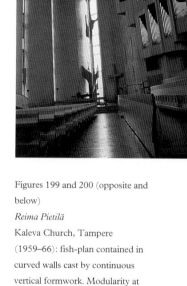

Figures 199 and 200 (opposite and below)
Reima Pietilä
Kaleva Church, Tampere (1959–66): fish-plan contained in curved walls cast by continuous vertical formwork. Modularity at work with a seemingly random form. The interior reveals the remarkable thing is the sense of 'churchness', of a mystery suspended in light, achieved not by the roof or vaulting, but entirely by Pietilä's choreographed walls.

Figure 201 (above)
Reima Pietilä
City Library, Tampere (1978–83): interior of the entrance hall, with the gallery beneath the dome.

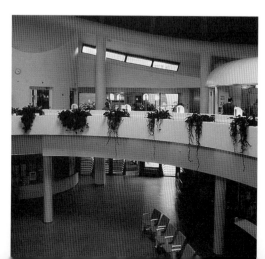

alism is all right. The space is mono-functional and its wooden skirt consists of stepped compositions of pyramidal elements. The idea was to demonstrate the artistic option of the new structuralist concept that Blomstedt was pioneering.'[2]

There are possible references in the Brussels Pavilion to Aalto's Sports Hall for the Helsinki Technical University at Otaniemi (1949–54), of which Pietilä's pavilion might be viewed as a more specifically modular interpretation. As already noted, Aalto's plans do sometimes have a modular preoccupation. His Otaniemi design is, however, fundamentally a structural concept in response to a volume of large span. In contrast, Pietilä's plan for the Brussels Pavilion embodies the geometry of a more complex three-dimensional exploration. Whereas Aalto's Otaniemi Sports Hall concentrates its structural dynamic in the interior space (just as he had stressed the formal dynamic of the interior in his Finnish Pavilion for the New York World's Fair of 1938–39),[3] Pietilä's Brussels Pavilion reveals, by its cohesive ordering of the modular skin, the exterior form as the true mould for the interior volume. The rigid portal frames of Aalto's sports hall are transformed by Pietilä into significant contributions to the evolution of modern architecture. Pietilä begins with a modular idea, but goes on to free the interior space from the constraints of a standard functionalist plan by making it dance. Although Pietilä's Brussels Pavilion might have some superficial affinities with Aalto's Otaniemi Sports Hall, we shall see from closer examination that Pietilä's whole conceptual design derives more from his own experimental modular exercises than from Aalto's structural solution.

Pietilä's systematic approach to formal explorations was on view in his 'Morphology and Urbanism' exhibition at the Pinx Gallery, Helsinki (1960). This exhibition included his semimodular stick studies of 1957–59, which are strongly influenced by Aulis Blomstedt's ideas and later found expression in both the Suvikumpu Housing at Tapiola and the Finnish Embassy in New Delhi (Figure 204). The other exhibits by Pietilä comprised more organic studies of urban configurations, which anticipate the cellular 'fish' design envelope of Kaleva Church, as well as the freeform sculpted concepts for Malmi Church and the Monte Carlo Centre project (1969).

Kaleva Church, Tampere, demonstrates a marked departure from the cool detachment of Aalto's church interiors that often suggest neoclassical influences. Of course, the Kaleva design was immediately preceded by Aalto's most personal and distinctive church, that for Vuoksenniska (1956–59), in which he had most perfectly achieved his concept of 'interweaving of the section and the plan shape' and 'unity of horizontal and vertical construction'[4]. Because of Aalto's Vuoksenniska design the Lutheran Church in Finland was already prepared for the acceptance of a plastic free-form plan.

Pietilä's Kaleva Church plan, derived from the Christian fish symbol, generates a daring interior space, with the single-volume nave capturing a powerful, medieval sense of monumentality (Figure 199). This can be understood as the architect's response to the competition specification of 'a monumental project' intended to provide the religious focus for 30 000 people in East Tampere. The apparent massiveness of the 'piers' derives from the convex form of the external walls on the interior. In contrast, that massiveness is broken and denied by the persistent play of light from many vertical slit windows, a light that ripples across the wall surfaces (Figure 200). In fact Pietilä described his design objective in this way:

'I tried to achieve a visual weightlessness by using rhythmic and light kinetics of broken line chains in constantly evolving series. It is similar to the rapid sequences in organ music. Kaleva Church actually fights against the traditional idea of wall heaviness.'[5]

The sculptural monumentality of the interior space is modulated by the simple form of the concrete

pulpit and canopy, where fine detailing gives an insight into the lively character for this material that Pietilä had intended for the exterior. While the wooden sculpture placed against the east window dominates the interior from the moment of entry, this 'Broken Reed' (as it was christened by the original minister, Paavo Viljanen) reduces the off-centre Lutheran cross to a subservient role. Even the design of the organ case, combined with its prominent location as an extension of the choir ramp on the south wall, makes it more dominant than the cross. The organ case resembles the wing of some great angel, protectively spread out to shelter the choir. The church has a pervasive liveliness throughout its interior space; Pietilä has transformed the rhythmical freedom he introduced into the Brussels Pavilion, generating in Kaleva Church a dance of joy within a framework of appropriate solemnity.

Kaleva Church was a watershed in Pietilä's development. It shows that the time he devoted to the systematic study of form began to pay dividends in his second full-scale architectural realization. In this single leap, from the springboard of the Brussels Pavilion, he removed himself from the constraints of Blomstedt's influence. Just as Aalto connected himself with the mainstream of European functionalist architecture with the *Turun Sanomat* Building and Paimio Sanatorium, so Pietilä, with Kaleva Church, placed himself close to the centre of the European expressionist tradition, measuring up at once to the standards established by Antoni Gaudí, Rudolf Steiner, Erich Mendelsohn and Hans Scharoun.

Also, following the example of Aalto – who had retreated from internationalism after Viipuri Library and evolved his own highly idiosyncratic Finnish expression – Pietilä set out to evolve a new architectural language which, although springing from the Finnish *genius loci*, seeks to make appropriate connections with other cultures. We shall observe Pietilä constantly in search of those external reference points in other cultures, yet the essentially Finnish centre of his own design integrity

Figure 202
Reima Pietilä
Suvikumpu Housing, Tapiola (1962–69): one of Pietilä's most successful and popular designs, this housing for the garden suburb of Tapiola blends with, and reflects, its environment.

always remains firm.

If Kaleva Church is disappointing from the outside this is mainly because Pietilä was required by his clients to clad the fresh, boarded texture of the concrete original with a monotonous tile finish, a sort of decency veil! Kaleva Church can be seen to conform to the tendencies of the 1960s only in the sense that this poorly scaled cladding is characteristic of much Finnish architecture of that decade.

Pietilä's Dipoli Student and Conference Centre at Otaniemi, which replaced Thomé and Lindahl's old Poli Students' Clubhouse (1901–1903) on Lönnrotinkatu in Helsinki, is perhaps difficult to grasp in the context of the Brussels Pavilion and Kaleva Church. But the concept of the Dipoli Centre is a straightforward one: it is not at all connected to an image of city or urbanity, but rather to forest and nature. Dipoli is about 'a sense of belonging', a connection and relationship between building and place. After the thoughtful control of the Kaleva wall system, however, Dipoli tends to shock the visitor by its apparent lack of balance. It appears that there is a plethora of ideas bursting out of the structure, perhaps prompting Louis Kahn's protest: 'I don't want to go in there. That's not architecture.'[6] Pietilä offered his own explanation for this phenomenon:

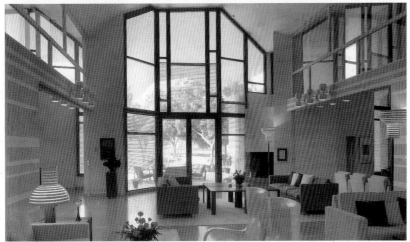

'As in Beckett's novels, there are no exposed trenchmarks of balance. The concept of a traditional balance of composition is redundant in the design aesthetics of Dipoli... after the hill top was blasted the broken heaps of rock gave an initial image which one could follow with the slow, crawling motion of structure. The reptilian metaphoric image; the silhouetted *dinosaurus* accentuating the rhythmic consistency of retardation.'[7]

The overall concept of Dipoli is in the grip of a strong plan form. Its strength derives from a hard 'core' of basic functions from which the other elements of the building probe into the terrain. Such a marriage of a firm baseline with the exploratory character of major functions is, of course, familiar

Figure 203
Reima Pietilä
Brander Café, Tampere (1963): once again modularity at work within a ceiling that seems to be positively musical in its orchestrations.

Figure 204
Reima Pietilä
Finnish Embassy, New Delhi (1963, 1980–85): the famous 'lost design' that was excavated from the Ministry of Foreign Affairs archives 17 years after the original competition. The main reception area of the Ambassador's residence. (See also Figure 205.)

Finnish Architecture and the Modernist Tradition

to us from Aalto's planning after the Villa Mairea (1937–39).⁸ In the Dipoli design the hard core consists of non-social and subsidiary functions at ground-floor level. These functions are gathered tightly into an approximate square, divided diagonally by the students' foyer, which cuts right through the centre of the plan to the lecture theatre/cinema and separates out the cloakrooms in the process. Above, on the principal floor, the main hall together with the principal foyer, bar and restaurant areas form three 'hands' that stretch out irregularly to the south and west from the subservient body of regular spaces. At the lower level those irregular spaces form the students' main entrance, restaurant and bar; they give a free-flowing character to this 'cellar' interior. Shifts of axis combined with persistent irregularity in the shaping of these spaces give the key to Pietilä's concept for this student social centre in the Otaniemi forest.

The exterior of Dipoli projects an image of a giant granite outcrop, complementing the grotto-like interior of the lower floor. Pietilä's use of varied horizontal divisions in the Dipoli fenestration is part of a complex reasoning behind the façade as a whole. On the one hand, this organization is clearly modular, producing a semiconventional segmentation of the entire wall area. More than that, however, it sets out to 'dissolve' the window wall so that it becomes an apatetic membrane between internal and external space. For Pietilä the Dipoli context is forest, of which the building is just a part. In this context the external wall is not a barrier in the normal architectural sense, but a skin that adapts the building to fit its natural environment, to give the structure the appearance of belonging. The artificiality of the large area of glazing is therefore systematically broken down by use of modular subdivisions, echoing the fragmentary patterns in nature. The heavy wooden window frames in turn emulate the forest forms. Thus, the glazed areas literally reflect the surrounding natural environment and the architect's intention to create an apatetic skin, which allows the building to adapt to nature.

More than any other Finnish building completed since Helsinki Railway Station (1914) and the National Museum (1916), Dipoli bridges the gap between the solid bourgeois comforts of national romanticism and the bizarre excitements of modern life. Dipoli has the vigorous 1960s vitality of the Beatles; it is every bit as earthy and muscular as the original Poli Students' Clubhouse. In designing Dipoli Pietilä was limbering up for even more complex exercises in space and form.⁹

The housing for the Suvikumpu district of Tapiola, designed in 1962 and built between 1967 and 1969 (with the Suvituuli Extension and Flower Shop added in 1981–82), is a mixed development of 162 units, which are principally apartments. Originally intended to accommodate 400 people, it now has a few more than 500 in its extended form. On a site embracing a steep, wooded hillside with considerable variety of contour, Pietilä created a basically linear layout for the multistorey terraces of housing (Figure 202). In addition, there is a small group of terraced houses set apart in an almost flat clearing on the site's southern edge. Crossing the main hump of the contours adjacent to the hilltop itself, the stepped layout descends to hug a ridge form on the far boundary.

The Suvikumpu Housing design is Pietilä's most recognizably modular work since the Brussels Pavilion. The strategy is generated by the planning of units, which is carefully articulated to avoid monotony of massing and surface. However, the modular idea at Suvikumpu works against the conventional, repetitive treatment associated with modular design. The apartment units are linked in long, staggered lines that form terraces of varying height across the site. This variety of building form is then developed in the detailed elevations in which an elaborate patchwork of small surface areas imitates the complex structure and *chiaroscuro* of this beautiful wooded site.

Pietilä's concept for Suvikumpu, like that of Dipoli, is a marriage of building with surroundings; its success depends upon setting up a system of sympathetic harmonies to reflect the shifts in the patterns, light and textures of the surrounding

forest. Within this system he builds up rhythms, achieving a harmonic complexity in the repeated window elements. These window forms shift in turn in response to the articulation of plan and mass. For example, the long blocks have a variety of height and planar treatment, built up into a lively mixture of contrasts achieved by combining stucco, green-painted concrete (horizontally ribbed to suggest wooden elements) and horizontal timber boarding, which is mainly used for fascias.

Extending the vocabulary of window modulations Pietilä developed for Dipoli, the Suvikumpu design generates a pattern of fenestration that gains unity through variations in the repetition – an approach the architect used again in the outer 'skins' of both the Sief Palace Area Buildings and the Hervanta Centre. This idea of skin is not at all the conventional one associated with the thin skins used in industrial cladding. As Pietilä explained: 'The sculptural work with wall opening and profiled openings outline an artistic method. They are trying to create an optical fiction of wall depth that is not otherwise possible in this type of sandwich.'[10]

The breaking down of a building's external surface, the fragmentation of a rational whole into an interpretive, transforming skin, may be traced back to Aalto's work of the 1930s beginning with his own house at Munkkiniemi (1934–36; Figure 146). One characteristic of this interpretive or apatetic skin is that the windows are no longer punched through the façade as a series of regular holes but rather 'eat' into the overall building form, breaking down the primary masses in the process. This erosion effect, combined with the stepping of the terraces, is one of the most satisfying features of Suvikumpu: it successfully avoids the monotony normally associated with mass housing, giving the units within the complex as a whole something of the individuality of the trees they overlook.[11] As already noted, this seeking for individuality within collective housing was one of Aalto's objectives.

In March 1980 the project for the Finnish Embassy in New Delhi was resurrected by the Ministry of Foreign Affairs, giving Pietilä the opportunity to realize in the 1980s one of his most subtle compositions of the 1960s (Figures 204, 205). The architects, Pietilä with his wife and partner Raili Paatelainen, won first prize in the competition held in 1963 and the building was eventually completed in 1985. The original drawings reveal affinities with both the Kaleva Church and Dipoli Centre: in its profiling, the section of the New Delhi Embassy project is reminiscent of the Kaleva plan, as well as the original sketches for the Dipoli section. The original plan for the embassy exhibited a strong axiality, with two long elements made up of tube-like sections – one containing the consular offices, residences for the ambassador, Finnish staff and the sauna; the other housing the Indian staff and ancillary accommodation. These two main elements were linked by a free-form entrance area that combined the visitors' reception and chancellory with an exhibition space. The planning within the two long elements followed a highly modular pattern, with the residential or office units linked *en échelon*. The resulting form had little in common with an axial composition in its treatment of the peripheral units adjoining these main elements, the apparent sliding apart of the two elements and the varied undulations of section in these two single-storey wings.

The revised design separates the Indian staff apartments from the main structure, although provision is made to link them at a later stage by extending the office accommodation. Also, in the revision the ambassador's residence became closer to the reception and exhibition area, while the extended Finnish staff apartment wing includes a sauna and technical centre.

A generous site, combined with the problem of security within its periphery, promoted this spread-out, single-storey concept, in effect an aggregation of bungalows or pavilions. Separate pavilions are also good for ventilation. But otherwise the planning and formal solution does not look to local precedent. Pietilä described his overall concept as 'a Finnish island, floating in the midst of the Indian sub-Continent'.[12]

Figure 205
Reima Pietilä
Finnish Embassy, New Delhi
(1963, 1980–85): plans, sections and elevations.

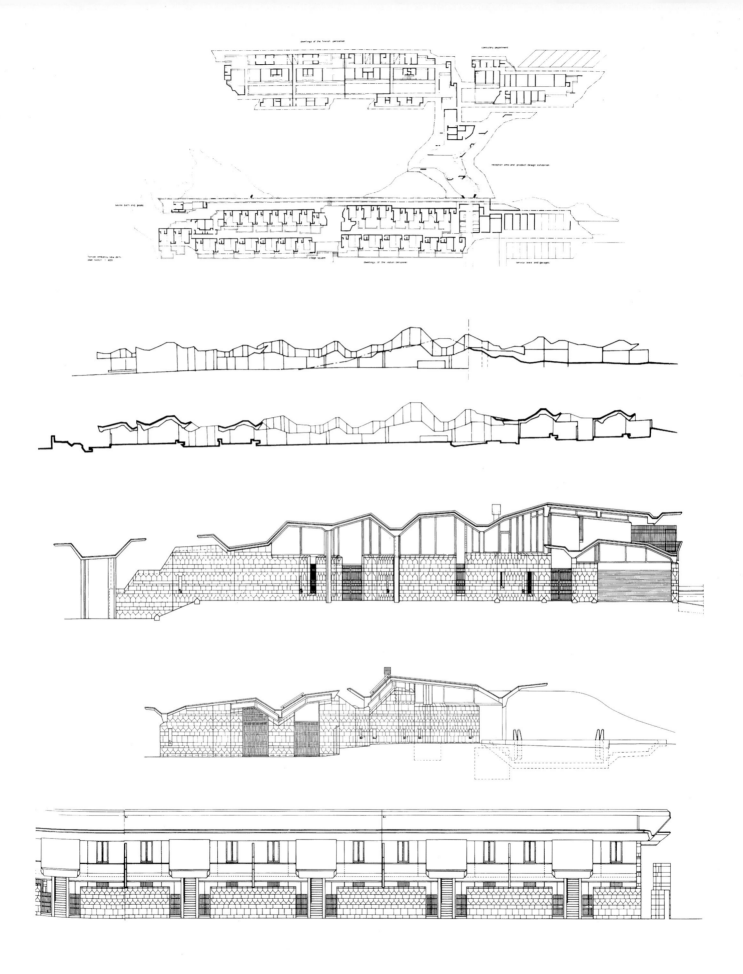

Reima Pietilä: form follows approach

The apparent sliding of the two main elements in the New Delhi Embassy suggests a connection with a similar sense of friction found in Pietilä's modular stick constructions of the late 1950s. They seem to share the same intention to build up a coherent whole from the rhythmical and proportional relationship of the constituent parts. Within the regularizing discipline of the plan form, the differing functional spaces are given various and subtly distinctive delineation by the changing profile of the undulating roof line. The roof itself is plucked up, as in a series of linenfolds, to accommodate the different functions arranged beneath it. Rather as Buckminster Fuller praised Jell-o as the most universal food 'because you can suspend just about anything in it', so Pietilä's New Delhi roof line is adjusted to assimilate the differing functional spaces it spans.[13]

In both the Brussels Pavilion and Dipoli Centre the plans and sections have matching formal characteristics. The stepped volume of the Brussels structure, however, converts the modular stick exercises into monolithic space and form; while the Dipoli volume clearly distinguishes between the sculptural form of the enclosing walls and that of the roof. The Malmi Church competition project (1967) resolves this distinction by integrating the plastic plan and section into a monolithic whole. A pattern of enclosing walls that characterizes both Kaleva Church and Dipoli has been superseded in the Malmi Church design, which proposed a plastic continuum of walls and ceiling. This dissolving of walls and roof has precedent in both Eliel Saarinen's Villa Winter project (1909) and the 'interweaving [of] the section and plan shape, with the complete unity of horizontal and vertical construction' that Aalto achieved in his Vuoksenniska Church (1956–59). Pietilä gave two explanations for the Malmi Church concept, one provocative and the other philosophical.

'Our cat came to rest on the drawing board and lay across the drawing before me. It visually terrorized me into accepting the form language of its own physiognomy for my free form sketch. Missukka was a domestic Finnish cat, grey and striped transversely in a darker grey. "Well," I said to her, "I accept your shape because otherwise I cannot make this competition."'... Malmi also has another precedent in its idea: our Finnish word *Siirtolohkare*, meaning a boulder that stands isolated by glacial ice. There are many examples of these rocks scattered around Finland, the result of a glacial dislocation from their original "mother rock". Malmi Church could be taken to express our "human dislocation" metaphorically.'[14]

Both these explanations, however, conform to Pietilä's deep conviction that a design notion may be generated by almost any stimuli or precedents, which need not be architectural.

For the sloping suburban site of Malmi Church, near Helsinki, he proposed a bold faceted rock-like mass that owes more to Dipoli than Kaleva Church. Aalto's Vuoksenniska Church has two shells or skins, each with a different form, but its external image is more military than organic. In contrast, as with Dipoli, Pietilä set out in his Malmi Church project to achieve a marriage of building and site, to create a close relationship between architecture and nature, to make the church a 'member' of the landscape, contriving to construct a ubietous whole. The Malmi concept is therefore essentially geomorphic, with the church and its dependent chapel and conference room clinging dramatically to the edge of the escarpment.

As in the Dipoli design, the supporting accommodation at Malmi is grouped as an anchor for the more expressive forms that thrust out as the rock-like mass of the church. Although this may suggest that Pietilä was influenced here by Rudolf Steiner, the Malmi concept is quite distinct from both the anthroposophic ideals of Steiner and the plastic expressionism of Erich Mendelsohn. Pietilä's intention was to echo natural structures, to use an architectural metaphor for rock formations, to develop what he calls a 'literal morphology'. The interior studies for Malmi convey a cave-like

character, suggesting perhaps a primeval, pre-Christian religious space. Pietilä's Malmi design, with its variation on the literal morphology of the Dipoli rock theme, would have provided an interesting contrast to the Suomalainens' Temppelikatu Church. It may well have been an atmospheric rival, too, for Le Corbusier's Notre Dame du Haut pilgrimage church at Ronchamp.

The jury awarded Pietilä only the purchase prize in the Malmi Church competition, but recommended that he should be given the commission to build the church. Unfortunately, it was unfairly ruled too expensive to construct and judged by a fellow competitor to be technically impossible to construct.[15] Although the Malmi Church project reveals Pietilä in a more constrained vein than his Dipoli design, its concept rebels more against conventional ideas about church forms than Kaleva Church. Malmi represents the high point of his designs of the 1960s; the geomorphic ideas that originated in Dipoli culminated in the Malmi project. It shows that the true dynamic of a Pietilä plan is its grip on architectural space, its capacity to reach up and embrace the entire interior form. Malmi promised to extend the functional programme into an architecture that stimulates an emotional response, promoting human involvement and interaction with its sense of form and place.

Work on the construction of the Suvikumpu Housing also began in 1967. Its completion in 1969 brought built commissions in the Pietilä *œuvre* to a standstill. Fortunately, just as work ran out in 1969, the architect was invited to participate in the limited competition for the Monte Carlo Recreational Centre.

The Monte Carlo project does not depend upon geomorphic imagery. Its characteristic is much more zoomorphic: it even includes moving parts, establishing a new emphasis in Pietilä's formal expression. This zoomorphic emphasis asserted itself again in his 'fighting cock' design, with which he won the Tampere City Library competition in 1979. Although at first sight the Monte Carlo

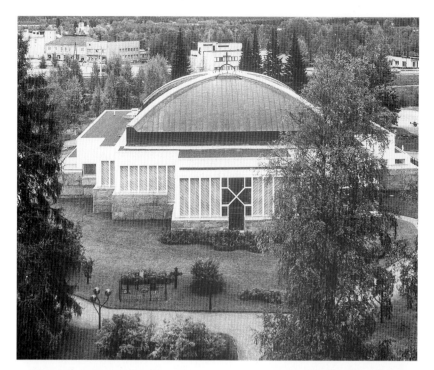

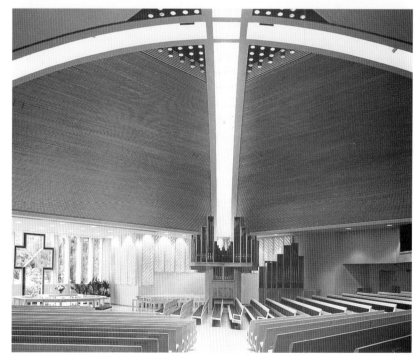

Figures 206 and 207
Reima Pietilä
Parish Church, Lieksa (1979–82): only the campanile was left from Carl Ludwig Engel's original building (1838) after a fire in 1979. Pietilä's imaginative design is based on the outline of the original foundations, and has a shallow dome built in four sections with glazed ribs between. The interior, shows the relationship of the dome to the organ and the cross-shaped window beyond the altar, which frames Engel's campanile beyond. (See also Figure 208.)

project may appear as a fundamental shift in overall intentions, it is abundantly clear from the original sketches, competition drawings and model for this project that Pietilä was returning to the 'live' architecture of Dipoli. Later, in his Oulu lectures,[16] Pietilä spelled out his method for mapping future architectural imageries in a technique he called 'horoscopes' and the Monte Carlo project can be seen as a horoscope for some of his work of the 1980s, certainly for the Tampere City Library (Figure 201). The Monte Carlo programme, with its dramatic waterside site that mixes both land and sea in the building's functions, was rich with suggestions that correspond closely to Pietilä's intentions as revealed in the Dipoli and Malmi Church designs.

The element of water in the scheme and the fact that in such a location architecture is potentially a hybrid generated by visible land masses on the one hand and those exotic ectoskeletal marine creatures on the other, made Monte Carlo a perfect exercise for Pietilä. The powerfully organic plasticity of the design draws on that complex process uniquely associated with the marine life cycle, the transformations achieved by a combination of erosion and accretion. Geological forms are eroded in sea water while, at the same time, marine creatures attach themselves to those decaying surfaces and, in the process, build up new contours and configurations. In the Monte Carlo design the imagery is decidedly crustaceous and also a direct reflection of the wearing down and building up that occurs in nature.

Pietilä's Monte Carlo project is not simply the emulation of some marine form or creature, however; it is a complex encrustation of the shoreline, offering a future architecture that had few parallels in 1969. Its absence from Arthur Drexler's *Transformations in Modern Architecture* (1979) is therefore conspicuous.[17] Given its established origins in the Dipoli Centre and its development in the Malmi Church project (where Pietilä proposed for the first time the construction of natural metaphors), the Monte Carlo project appears to offer an extension of Frank Lloyd Wright's organic marriage of architecture to nature. In both plan and section the Monte Carlo project embraces the notions of natural movement and growth, capturing them as though calcified at a particular moment in time, yet suggesting an ageless continuity familiar to us in the carapace of crab and lobster. Moving antennae, designed to wave on the skyline in the process of activating the environmental systems, link our memory of primeval sea creatures with the imagery of high technology.

It is a measure of the high regard with which Pietilä was held outside Finland that, within a year of the Monte Carlo design, he was once again involved in a limited international competition. This was for the reconstruction and development of Old Kuwait. The others invited were the British architects Alison and Peter Smithson and Candilis, Belgioso and Peressutti. Although no commissions were given following the review of submissions in June 1970, each team was asked to prepare demonstration projects for a different part of the Old Town area. The Pietiläs' task was to complete the central waterfront, including three ministry buildings and their relationship to the whole environment. As a result, the Pietiläs were commissioned to design these three buildings (1973–83), when the project became finalized as the Sief Palace Area Buildings (SPAB). One of these buildings was an extension to the Old Sief Palace – actually built only in 1960–63 in an eclectic Arabic style to the designs of the British architects Pearce, Hubbard and Partners – which contained the Emir's Audience Hall and the Diwan for administration. The contract for the new work was not signed until 1973 and stipulated that the Sief Palace extension was to 'follow' the style of the original building.

The Islamic context – the complex details of its architectural language, the nuances of its expression, deriving from an inseparable blend of pattern and calligraphy with architectural form, this illusory framework posed a most appropriate problem in cultural interpretation for Pietilä, suspended as he was between unrealized projects of the 1960s and his horoscopes for the 1980s. The SPAB project

was 'real' in the context of the Arabian Gulf climate and Islamic tradition although this tradition was certainly not part of the environmental memory of the Kuwaitis and there was an additional problem posed by having to work within the somewhat fanciful Islamic expression of the Pearce, Hubbard and Partners' Old Sief Palace.

Another important aspect of the SPAB project was the need to create an urban scale and character, which scarcely existed in Kuwait in 1970. The notional basis for the Pietiläs' solution was largely dictated by the nature and location of the site, adjacent to the Old Sief Palace and stretching along the edge of the Arabian Gulf. Although the Pietiläs surveyed the old two-storey merchant houses and the traditional kasbah housing that remained at that time, in this context an Islamic tradition was more of a mirage than a presence: the notion of such a tradition had to be reinvented in order to become a reality.

In much Islamic architecture the abstract and vegetal patterning combine with often elaborate calligraphic inscriptions to build up surface texture and effect. Pietilä's treatment of the exterior of the Sief Palace Extension achieves a similar effect but by substantially different means. He resorts to breaking down the regular forms of the external envelope through the repetition of irregular and unconventional window openings. The transition from the quasi-Islamic style of the original palace to the new work and the transformation from generalized Islamic design precepts into the new Kuwaiti expression is a subtle process in Pietilä's hands. As he explained:

'I do not apply calligraphic models appearing in historical Islamic architecture. Instead I use the kinetic rhythms of people and the rhythmic inspiration I get when hearing Arab folk music... I do not use anarchic irregularities in this Kuwaitian design but rhythmically melodic chains that are not symmetric but balanced due to their forward motion in the way a dancer links movement choreographically.'[18]

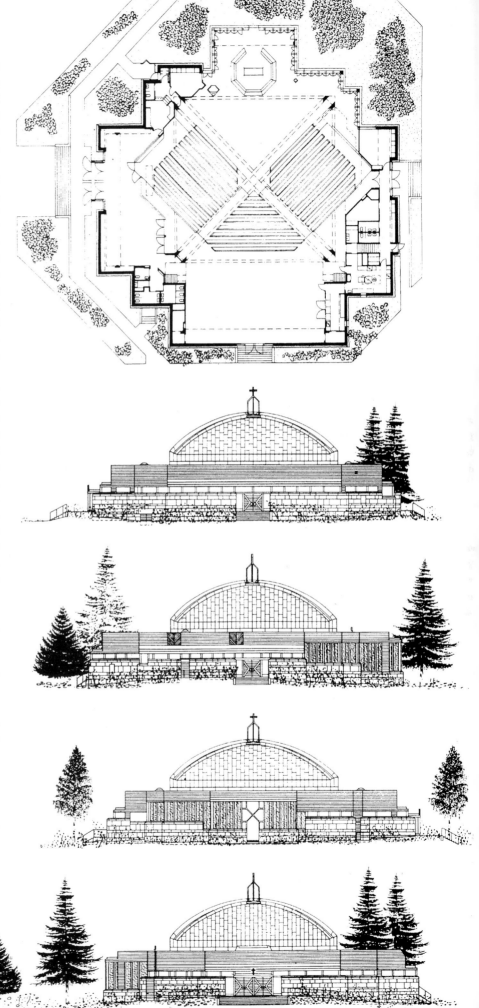

Figure 208
Reima Pietilä
Parish Church, Lieksa (1979–82):
plan and elevations. (See also
Figures 206 and 207.)

There are basically two stages or levels in this process. First of all, in the Sief Palace Extension Pietilä places an additional outer skin[19] across the front and back of the pavilion. This outer skin takes on the essential characteristics of the Old Sief Palace in terms of regular openings, arch shape and so on. It forms an arcade on either side of the building, creating the essential architectural depth for an elegant covered walkway behind which the Audience Hall and Diwan are contained within a completely enclosed volume. These arcades also protect the inner volume from direct solar radiation. The inner volume has relatively small window openings, grouped in pairs under a double-arch form of lintel, with simple lattice teak *mishrabia*[20] screening the windows on the outside. It is clear, in the form and treatment of these windows, that Pietilä is beginning to break with the 'tradition' that he still follows academically in the outer skin of the arcade. Again, although the tiling surrounds to the windows of the inner wall appear to follow the model set by the tiling of the old palace, they do so more in colour than in spirit, for Pietilä's tile patterns are abstract in a modern rather than a traditional way.

If the Sief Palace Extension appears to adopt the style of the old palace, this is only in the character and cadence of the outer skin. Meanwhile, behind the screen of this outer arcade, subtle shifts of emphasis are already taking place as the architect explores the possibilities of what we might call a transformational syntax, which he then uses for the new building complex containing the Council of Ministers and the Ministry of Foreign Affairs (Figure 163).

In this second stage Pietilä seems to seek both a modular key and a geometrical pattern language in identifying appropriate architectural terms with which to give expression to these new buildings. He uses the double-skin strategy of the Sief Palace Extension again in conceiving the shapes of openings for the outer and inner skins, taking care not to copy Islamic arch forms as the architects of the old palace had done. His aim is to embody the spirit and rhythm of Islamic work but not its actual forms. He wants to transform the ancient spirit into modern terms, to achieve a cultural symbiosis of old and new construction, forms and effects. The forms of the windows, openings and baffles he invents may be strange to Western eyes, but this strangeness is certainly evocative of the Arab preoccupation with geometric puzzles. These unfamiliar shapes, which appear random at first sight, are both formally and rhythmically part of a highly articulated 'choreography'. Also, the puzzling complexity of this articulation is reminiscent of Islamic architectural games.[21]

Architecture with an additional outer skin has an in-built threshold or 'valve', which modifies the transition between the external environment and the inner world of the building itself. Pietilä's architecture is never transparent: it generates complex experiences by building up layers of form, space and structure. This process of layering is fundamental to the concept of his Sief Palace Area Buildings. For example, boundary walls and those parts of buildings that do not merit an outer skin sprout precast-concrete fins instead. These fins are stepped in section and faceted on the sides. The shadows they cast across the pale local brickwork produce changing patterns throughout the day that relieve the monotony of those sun-bleached surfaces. The way these batteries of fins 'harness' the sun is quite traditional to the Gulf region, generating 'solar patterns' in the architecture with an expressive energy of shadows that counteracts the oppressive and persistent sun.

In establishing the interior character of this design where plan and section interweave, Pietilä rightly eschews use of the dome, which traditionally has sacred connotations in Islamic architecture. Normally the dome denotes a large, important space associated with a religious or ceremonial congregation, or a religious memorial. Instead, Pietilä punctures the roof line with lanterns, which is functionally correct since the lantern traditionally belongs to a covered, internal court. In Islamic architecture the lantern, although now much

neglected, is a major functional element. Whereas the wind-catcher is purely concerned with ventilation, the lantern serves to introduce light and air into the interior spaces of densely compact building volumes.

We have seen in the Kaleva Church, Dipoli Centre and Malmi Church project how Pietilä's expressive imagery can transcend the building programme. The Suvikumpu Housing design revealed how he could use a rational system to break down, in an apparently random way, the conventional image of mass housing, producing a more intimate human scale. With the invaluable experience of the Suvikumpu Housing in transforming the abstraction of a theoretical modular approach into an alternative architectural language, he was able to approach the complex problems of form and imagery for the Sief Palace Area Buildings in an equally logical way.

Although Aalto prepared projects for both an art museum in Baghdad, Iraq (1958) and another art museum in Shiraz, Iran (1970), he never built anything outside the Western world. Kaija and Heikki Siren designed and built the new Finnish Embassy in Riyadh, Saudi Arabia but this, together with Timo Pentillä's winning project for the Bahrain Cultural Centre (1975), are merely cases of expatriate classical versions of Western modernism in the Arab world. In comparison, Pietilä's experience in designing and building the Sief Palace Area Buildings and the New Delhi Embassy gave him an almost unique opportunity among Finnish architects to develop an architectural language for non-Western cultures, to make a transcultural statement.

In marked contrast to the problems posed by the Sief Palace Area Buildings there are two essentially wooden Pietilä structures of Finnish typology: the Säresto Gallery at Kittilä, Lapland (1971–72) and the Hvitträsk Sauna (1973–75) built for public use at Eliel Saarinen's former home and now museum. Neither is really typical of Pietilä, but they continue the exploration in traditional log construction that was undertaken successively by Lars Sonck, Eliel

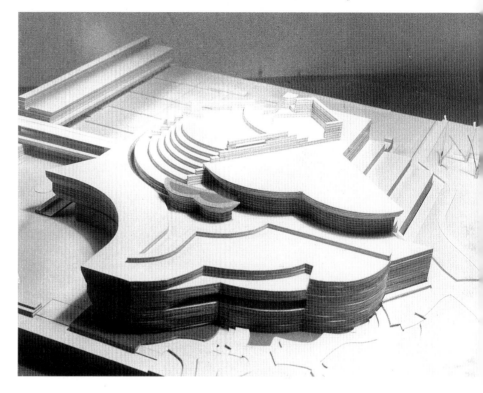

Figure 209
Reima Pietilä
Project for Cultural Centre, Tapiola (1980): a bold, constructivist approach, this promised to be one of Pietilä's most interesting buildings.

Saarinen, Aulis Blomstedt, Aarne Ervi and the Sirens, among others.

The Säresto Gallery, designed with the Finnish painter, Reidar Särestöniemi, conforms in principle to lapped-log construction as revived and developed in the national romantic period by Gallén-Kallela, Sonck and Saarinen.[22] It is basically modular in the articulation of its rectilinear plan form. But even in this interpretation of traditional construction, Pietilä's wit shines through. His combination of the traditional handmade exterior with a flat roof presents a traditional form as though it were a large-scale version of a prefabricated cottage. The image of the national romantic painter, Akseli Gallén-Kallela, has been brought up-to-date to fit that of Särestöniemi. In fact, the gallery was entirely built by carpenters from the village of Kaukonen with the aid of a motor-driven saw, the only machine tool available to them in remote Lapland.

In spite of the modular spirit of the plan and the squaring-off of the building volume with a flat roof, the gallery is no more a uniform box than any other true log cabin. The idea of a rationalized, industrial container is denied at the corners of the building, where the painter insisted on keeping the cantilevered ends of the lapped logs where they ran over the junctions in construction. Although basically a 'log cabin', the building harmonizes with the client, the 'exaggerated' log detailing reflecting the painter's untamed, somewhat 'hairy' spirit.

The Hvitträsk Sauna presents, in contrast, the immaculate refinement of detail associated with the national romantic period. In midwinter 1979–80 the author was enjoying a sauna with Keijo Petäjä and Reima Pietilä (both sadly sinced deceased) at Hvitträsk, when a skier who had crossed the frozen body of water appeared on the porch. He took off his skis, entered the sitting area and greeted us. Then he began to inspect the woodwork, feeling and tapping it with a craftsman's special pride in his technical knowledge. He announced: 'You can tell this is genuine Saarinen. It's obvious in the details.' After a brief pause, Pietilä answered him, thoughtfully: 'Oh, you're quite right. Saarinen certainly drew it. I was just holding the pencil.'

Pietilä won the competition for Tampere City Library at the end of 1978. In its design we can observe not only a return to the zoomorphic imagery of the Monte Carlo Centre but also to the fundamental modernism of the Dipoli Centre. From the design for Kaleva Church onwards Pietilä's projects are as easy to identify in competitions as are Aalto's from the late 1930s, but perhaps none so unmistakably as his entry for this library. Pietilä said that the formal origins of this design came from two distinct sources: the image of the male woodgrouse ruffling his plumage in a mating call; and the tightly wound mollusc shell. These two notions merge,[23] with the bird's form dominating the overall shape of the plan while in the third dimension the shell takes over as the dominant formal and structural idea. With such an idiosyncratic marriage of generating formal ideas the Tampere City Library design could hardly be from any other hand.

In considering the apparent irrationality of these sources it is perhaps helpful to recall the evolution of Finnish library design between the late 1920s and the late 1970s. This basic lineage was very much in the hands of Aalto after the final design for Viipuri, through those at Seinäjoki and Rovaniemi, to that for Mount Angel Benedictine College in Oregon. Aalto's basic concept for the internal character of his libraries was relatively constant, with a top-lit court containing a sunken reading area being the most persistent feature. The plan forms of Aalto's libraries did change in his later works, however, becoming progressively freer after Seinäjoki, with the fan shape, particularly in the Mount Angel design, becoming one of Aalto's more successful exercises in plasticity. Aalto argued the origin of his stepped interiors in terms of the terracing of mountain landscapes. However, the exteriors of these later libraries scarcely express their internal arrangements except, in a minor way, through the shifting planes generated by the fan-shaped plans.

Pietilä's Tampere City Library is clearly a return to the plastic forms he first explored in the geomorphism of the Malmi Church project (1967) and went on to assert in the zoomorphism of the Monte Carlo Centre project (1969). The Tampere design, however, has a formality of both plan and section that is not present in the Mediterranean project a decade earlier; its centralized form capped by a dome is more selfconsciously civic than the rambling pleasure palace he proposed for Monte Carlo. Although the shell form embodied in Pietilä's Tampere plan has similarities to the fan arrangement of Aalto's later library designs, in the third dimension Pietilä's library is indisputably a shell.

In describing his progression towards a design solution Pietilä referred to a cohesive coalition of notion, image and idea (or architectural concept).[24] Pietilä allowed the image to be derived from any source: no stimulus to formal thinking was excluded at this stage of the design process. He listed 'function', 'nature', 'culture' and 'abstraction' among the possible sources of architectural imagery, thus embracing all modernist sources (function and abstraction) as well as the organic (nature, context and culture). The Tampere City Library has its roots in natural forms. While these may appear abstract as a notion, the abstracted natural references are skilfully interpreted, transformed and absorbed into an architectural whole.

The site for the Tampere City Library (built 1983–86) is a prominent one in the centre of the city. Tampere has always been up-to-date in its architecture, with its superb wooden church by Carlo Bassi (1824), Lars Sonck's Cathedral (1902–07) and the functionalist railway station of the 1930s, each a vigorous expression of its time. Pietilä's library design is also a symbol of its time in its freedom from any obvious stylistic influence. Commissioning Pietilä to build both Kaleva Church and the city library confirms the continuing importance of modern architecture in Finland's industrial capital. Over two decades, beginning with the Kaleva Church competition (1959), continuing with the Hervanta Centre, and finally with the library, Tampere adopted Pietilä, following a pattern of patronage that links Carlo Bassi with Turku, Carl Ludwig Engel with Helsinki and Alvar Aalto with Jyväskylä. Tampere has always had its own bustling, competitive image of modernity and Pietilä's work is now part of that expression. Not surprisingly, the provocative forms of the library have made it an attraction for visitors to Tampere and it has become one of the most frequented buildings in Finland. Its open plan and light, airy interior have also made it extremely popular with the library staff and users of the building. Indeed, the general public has been much less intimidated by Pietilä's design than have architectural critics.[25]

Pietilä spoke of the library as a 'spaceship' and this otherworldliness is certainly evident on approaching the building. There is something about its external form that suggests 'alien' and 'extraterrestrial'. Its strange copper cap seems to crouch too close to the earth for architectural comfort, as though a giant vehicle from outer space had squatted upon and crushed an earlier building. Beneath the alien invader the surviving podium and balustrades of Finnish granite seemingly protest in a national romantic voice against this forced landing of a more radical, outlandish culture.

Once inside the 'alien ship', however, one feels strangely at home. In the entrance hall, under a dome that is more like a hat worn at a rakish angle than a classical lid, we immediately sense Pietilä's invitation to participate in and enjoy this building (Figure 201). Within the spacecraft's spacious interior, under that saucy blue dome, beneath the vaulted galleries of the bookstacks, 'the concept of traditional balance of composition is redundant' (as Pietilä said of the Dipoli Centre). We instantly sense that this is no mere architecture of containment, but the complex score of a 'Symphonie Fantastique'. Like the Berlioz work, this building liberates the human spirit. It is an exuberant composition of energies that bursts upon the senses, opening up the mind to travel in this larger-than-life vehicle of the imagination.

On the eve of the New Year 1979, the parish church of Lieksa in eastern Finland caught fire as a result of a fault in the electrical wiring. The old wooden church, designed by Carl Ludwig Engel and built in 1838, was destroyed by the blaze. In the large garden on the bank of the Lieksa River that forms the churchyard, all that remained of Engel's design was the detached campanile thrusting up from the graveyard. The competition held soon after the destruction sought to replace the powerful mass of Engel's church, which had a Greek-cross plan and an exterior based on the intersection of four Greek temples. Such a challenge was unique in the evolution of modern Finnish architecture. Initially, in approaching this problem, Pietilä's inclination was to be uncompromisingly modern. After he had listened to the parishioners recalling memories of the original church, however, he felt himself gripped by the formal power of Engel's legacy in Finland and he rejected his early sketches, resolving 'to be modern appropriately'.[26]

Pietilä decided to accept the outline of Engel's granite foundations as the basis for his new plan. The building programme, which was completed in 1982, took the opportunity to bring the use of the church up-to-date. The social and cultural gatherings that take place today in Lutheran churches require more flexibility in the use of space than parishioners demanded of Engel's design. Also, it was decided that Lieksa should become a broadcasting centre for relaying church services by television to local hospitals. The traditional narthex or porch room therefore became in Pietilä's design a sort of parish house, while the church itself had to accommodate the monitoring booth for television broadcasts. This meant that the sense of enclosure afforded by Engel's original design was dissolved by the increased movement needed between fixed architectural spaces on the one hand and the mobile television cameras on the other. Pietilä responded to these new challenges by providing an elegant structure in which the freedom of access and movement afforded by the plan is paralleled by the penetration of light into the interior of the church. He broke down the barriers between the interior space, the surrounding landscape and the sky.

Externally the new church fits into the landscape like a garden pavilion: it is less bulky than Engel's original mass and, with its low profile, it nestles comfortably into the churchyard. Nevertheless, its crisp white-painted exterior resting upon the rugged granite podium sets it apart with a quiet dignity, like a classical temple in a romantic landscape (Figure 206). Even the squatness of the dome reinforces this impression, following the interior form without resorting to a more dominant outer shell. The Lieksa dome is merely a cap that gently moulds the skyline rather than dominating it. In the overall composition, Engel's campanile still reigns supreme, while Pietilä's quiet pavilion pays homage at a respectful distance.

The supremacy of the surviving campanile is also felt in the body of the church, from where it is visible through the cross-shaped window behind the altar. In this way the old and new are visually linked during the celebration of the Mass (Figure 207). By its simplicity and clarity, emulating the restraint of the original, Pietilä's interior offers a 'framework of interpretation' rather than a personal statement by the architect. Thus, the exterior and interior are characterized by a distinctly modest presence in the archaeological shadow of the neo-classical master. If the outside of the church harmonizes with its surroundings by echoing traditional forms and construction, however, the interior is uncompromisingly modern.

The crossed double arches that span the entire interior volume and form the 'dome' spring from twin column shafts that have no precedent in any previous period. They are decidedly twentieth-century and, like Aalto's double columns for the Vuoksenniska Church or those for the House of Culture, they seem to owe a debt to Robert Maillart's handling of reinforced-concrete structures.[27] Interestingly, these apparent borrowings from Maillart, making refined variations on some of the

Swiss engineer's details, have cropped up not only in Aalto's work (beginning with the columns in the printing press hall of the *Turun Sanomat* Building) but have also characterized the work of other Scandinavian architects such as Gunnar Asplund and Jørn Utzon. In Lieksa Church, Pietilä carries Maillart's structural thinking to a new level of modernism. By skilful transformation of arch to dome he not only gives the interior space a modern form, but by finesse of detail in the edges and junctions he also succeeds in incorporating a classical quality into its material expression. It is this quality that Pietilä suggests when he speaks of Lieksa Church as being 'somewhere between *then* and *now*, between Engel and me'.[28]

Between the crossed double arches the sky is visible through a clear, transparent plastic skylight. This 'high-tech' detail permits a cross of sky to be framed within the dome. The representation of the heavens so often found painted onto the surface of the neoclassical dome is transformed here, by thoroughly modern means, into a glimpse of the natural heavens. In Kaleva Church the symbolic cross was set on one side by Pietilä and replaced by the 'spirit of the cross', Christ himself, as the Broken Reed. At Lieksa the cross-motif is restored but not as a piece of liturgical furnishing: it is integrated into the architectural form. Both in the cross-shaped window that frames the Engel bell tower and the skylight in the dome we find the building elements themselves fusing the architectural entity with 'pictorial' images.

The technique of filtering daylight by means of wooden screens, recalling the effects of sunlight piercing through the canopy of the forest, is one that Aalto made very much his own. His use of it on the ground floor of the Villa Mairea and in the council chamber of Säynätsalo Town Hall gives us two of the more memorable experiences in modern architecture. At Lieksa, the movable screens across the windows on the east wall provide a third such memory. These slotted elements, the perforations of which are cut at an angle in sympathy with the branch patterns of the surrounding trees, have a

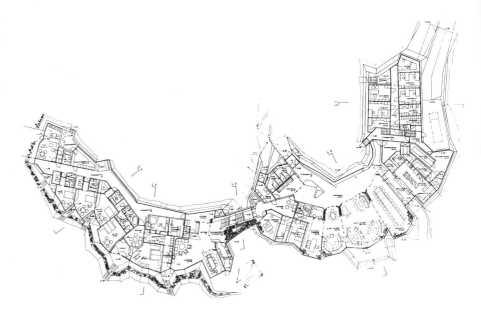

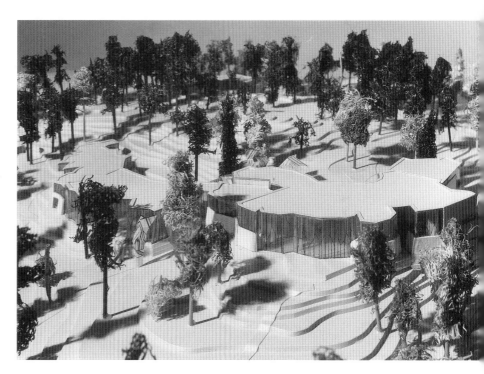

Figures 210 and 211
Reima Pietilä
Finnish President's Official Residence, Mäntyniemi, Helsinki (1983–93): plan derived from the form of a mermaid washed up on the seashore; only the rear office wing approaches a regular form and layout. The original competition model, showing the intention of incorporating three motifs in the exterior glazing. This was ruled out by the size restrictions on armour-plated glass and the tree motif now only occurs on the internal dividing doors.

delicate almost lace-like quality against the morning sun. As with *mishrabia* shutters, Pietilä's screens at Lieksa transform a functional element into an elaboration of the architectural character.[29]

Until recently Finnish presidents always lived in a private villa on loan to the state, an existing house that was not specifically designed as an offical state residence. It is significant, then, that the competition held in the autumn of 1983 for the design of the President's Residence was open to all architects registered in Finland.

In discussing the future of architecture, Pietilä spoke of two premises: that formed between 1900 and the 1920s and that worked out in the 1980s. He chose, however, in his winning design for the President's Residence, to return to his premises of the 1960s. This gave him a superb opportunity to explore again the architectural metaphors that had their origin in the Dipoli Centre and reached their optimum potential in the Malmi Church project. The upheaval of Finnish granite is the site base from which his President's Residence grows; but in this new design the granite shield is not the whole form as in Dipoli, nor are the cave and cavern interiors of Dipoli and Malmi appropriate to a president's residence. Instead, in his so-called Mica Moraine design, the natural rock escarpment is embellished by a jewelled necklace that flows naturally across the body of the site (Figures 210, 211). The metaphor for this precious symbol of the Finnish state is the crystalline structure of ice and its memory in the Finnish winter landscape. Pietilä's design is no Finnish White House, no homage to Palladio, nor acknowledgement of Engel's position in Finland's architectural hierarchy; instead it speaks of the informality of nature and of its natural metaphor (Figure 160).

The competition results for the President's Residence revealed that most of the other competitors were either unable or unwilling to address the problem in terms worked out in the 1980s. Almost all the entries selected for prizes, purchase or honorable mention look back to an earlier period of modernism, not to the exciting experiments of the 1920s, however, but to the more stereotyped projects of the 1930s that were rejected by Aalto as early as 1935. The second purchase-prize project, by Kristian Gullichsen and his colleagues, characterizes this reactionary tendency in a design that attempts to bring urbanity to the rocky seashore, but not at all in the spirit of Aalto's superb model at Säynätsalo. Only Marja-Riitta Norri's first purchase scheme seeks once more the pre-functionalist roots of modernism.

In one of his humorous sketches, Pietilä characterized contemporary Finnish architects as a group crowded into the bows of 'The Ark of Architecture' in order to get a good view of the way ahead, leaving nobody to man the rudder and thus steer the craft. Unfortunately, the general standard of entries in the President's Residence competition rather confirmed this situation. But perhaps the greatest disappointment was that so many entries ignored the prevailing character and real nature of the rocky shoreline at Mäntyniemi. Instead of a Finnish sensibility to environment and occasion, what prevailed was a slick approach to elemental composition such as might be found in almost any country.

Early in his career, Aalto demonstrated his interest in, and commitment to, the nature of the site, the uniqueness of place and a building's identity with that place. Even in the Töölö Church design of 1927, when he was only 29, Aalto sought this contextual dimension that was missing from the work of his contemporaries and had certainly not been part of his education. Aalto's Töölö Church took its inspiration from the Italian hill towns and, appropriately, his landscape motif was also taken from the terracing of the Tuscan hillsides. In drawing upon his environmental memory of another place, Aalto sought to link it to the Töölö site in achieving a coherent whole.

This concept of place, of the marriage of building to site to create a new place, is precisely what was missing from the often sophisticated schematics of the majority of projects entered in the competition for the Finnish President's Residence in

Figure 212
Aarne Ervi
Töölö Branch Library, City of Helsinki (1970): Ervi's command of a precise but inviting modernism was never better. In the Töölö Library he reveals everything he learned from Aalto in the 1930s, particulary from the Viipuri Library.

1983. Only Pietilä's design truly explored the rocky terrain, proposing a solution that is redolent of Finnish nature and climate, 'speaking' a Finnish poetry whose imagery and metaphor have not been diluted by fashion or adherence to popular views of rationalization.

Although he was elected a member of the Finnish Academy in 1982 at the age of 59, and worked up until his death in 1993, Pietilä never became an establishment figure. His work is far too provocative to engage universal acclaim. Each commission was hard won. His struggle for recognition taught him to evolve strategies for overcoming immediate 'realities' when those appeared to threaten the progress of his ideas. As he said:

'My ideas do not progress: they move around like clouds over the archipelago of the architectural ideas of modernism. There I have my favourite island, where I can disembark and explore... I am an intellectual agent accounting for myself, risking myself. Life is exotic as such: too many commissions overload life and do not increase the real excitement at all.'[30]

References and notes

[1] See Malcolm Quantrill, 'Breaking the culture of silence: or the case of Reima Pietilä', *The Structurist*, October, 1994.

[2] Malcolm Quantrill, *Reima Pietilä: architecture, context and modernism*, 1985, p. 28.

[3] *Ibid.*, pp. 28–30.

[4] Alvar Aalto, 'Zwischen Humanismus und Materialismus.' Lecture to the Austrian Institute of Architects, Vienna, 1955.

[5] *Ibid.*, p. 33.

[6] Reported to the author by Professor Osmo Lappo, June 1985.

[7] Malcolm Quantrill, *Reima Pietilä*, 1985, p. 50.

[8] Malcolm Quantrill, *Alvar Aalto: a critical study*, 1983, pp. 83–90.

[9] Malcolm Quantrill, *Reima Pietilä*, 1985, pp. 49–64.

[10] *Ibid.*, p. 66. In correspondence with the author, June 1983.

[11] *Ibid.*, pp. 65–72.

[12] *Ibid.*, p. 74. In conversation with the author, Helsinki, January 1978.

[13] *Ibid.*, p. 77.

[14] *Ibid.*, p. 82. In conversation with the author, Helsinki, August 1983.

[15] *Ibid.*, p. 189. 'Olof Hansson (a member of the Malmi competition jury) later said he was sorry I didn't win the competition. But technically we could not receive the First Prize because I had enlarged the entrance hall for an after-service coffee space, thus exceeding the space restrictions on the competition brief ... We only got the Fourth Prize, but the Jury recommended that we should have the commission. Instead the winner became the paid employee of the congregation and was asked to assess the cost of our project. He told them it was very expensive if not impossible to build.' Reima Pietilä in correspondence with the author, 1983.

[16] *Ibid.*, p. 173. In correspondence with the author, May 1983.

[17] Arthur Drexler, *Transformations in Modern Architecture*, Museum of Modern Art, New York, 1979.

[18] *Ibid.*, p. 107. In correspondence with the author, June 1983.

[19] *Ibid.*, p. 110.

[20] *Mishrabia*: the enclosed balconies of Arab houses that give privacy while allowing a view into the courtyard or street below; or the intricate screens that enclose such balconies or windows.

[21] Archibald Walls, *'Symmetry and Asymmetry in a Cairo mimbar'*, Art International, Vol XXV.

[22] Malcolm Quantrill, *Alvar Aalto*, 1983, pp. 8–10.

[23] Malcolm Quantrill, *Reima Pietilä*, 1985, p. 170.

[24] *Ibid.*

[25] The library is so popular with the staff working in the building that they commissioned a commemorative winter sweater bearing the 'Metso' bird design from the Finnish Crafts Association.

[26] Malcolm Quantrill, *Reima Pietilä*, 1985, p. 149.

[27] 'The structure is a concrete bridge, with slender beams and thin cylindrical vaults... my structures professor was Paavo Simula, who showed us the thin, monolithic structures of Maillart... And our engineer, Mr. Vahanen, was in Simula's office for some time; so there is a link in a way.' (Reima Pietilä in correspondence with the author, June 1983).

[28] Malcolm Quantrill, *Reima Pietilä*, 1985, p. 152.

[29] *Ibid.*, p. 156.

[30] *Ibid.*, p. 90. In correspondence with the author, June 1983.

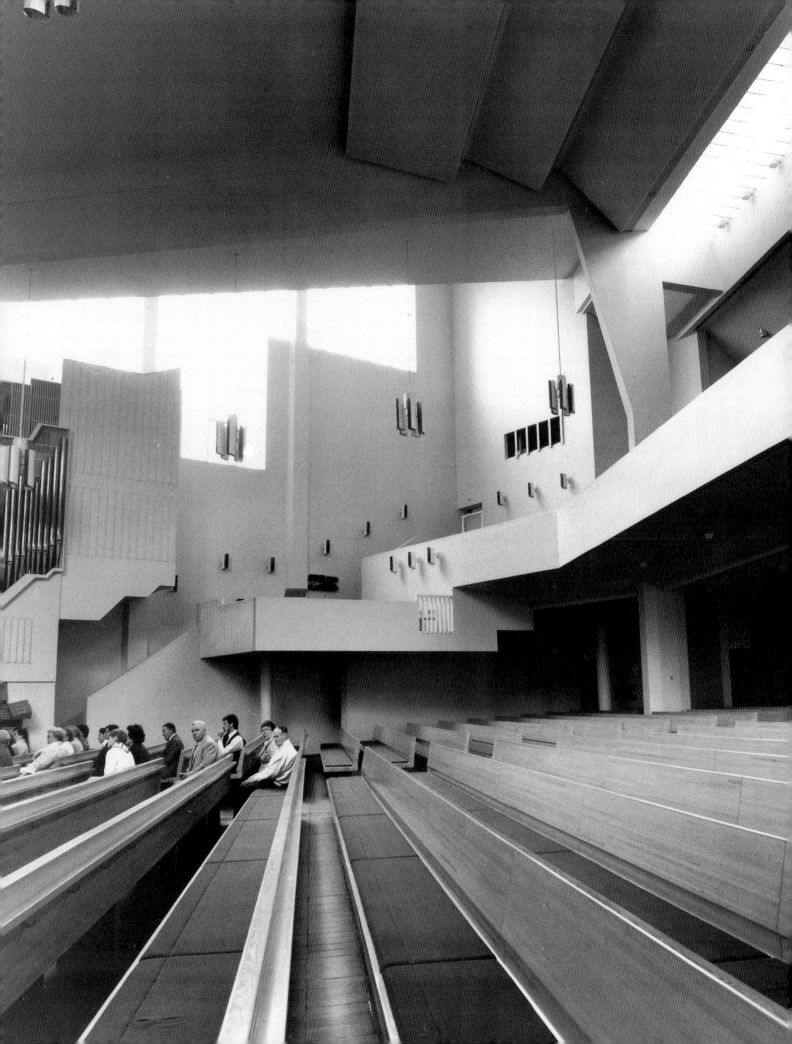

8 After Aalto: form and formalism in the 1970s and 1980s

This book originated in an article, published in *Architectural Design* in 1979,[1] which posed the question of its title: 'Après Aalto, une nouvelle vague?' In the article I asked if, after the dominance of modern Finnish architecture by Alvar Aalto for almost half a century from 1927 until his death at 78 in 1976, there appeared to be a new wave (Finnish: *aalto*) emerging that would assure the continuing international reputation of Finnish building design? Bearing in mind that work of high quality by other Finnish architects had gone largely unrecognized because of Aalto's long-established pre-eminence, I reflected on whether or not a subsequent generation of talent could be identified whose architecture should command attention and respect. In reviewing those prospects at the end of the 1970s, the article discussed the immediate legacy of Aalto's two assistants during the 1930s, Aarne Ervi and Viljo Revell, and then focused on some of the work of Reima Pietilä, Timo and Tuomo Suomalainen, Timo Penttilä, Keijo Petäjä, Gullichsen, Kairamo, Vormala, Helin and Siitonen and Matti K. Mäkinen. The article served to bring my British colleagues up-to-date, as there had been no comprehensive exhibition of Finnish work in the UK since the 1950s. Regrettably, the important retrospective exhibition held in Turin at the end of 1973 and the beginning of 1974 came no closer to London than The Hague.

The question remains in the 1990s: is there a new wave of Finnish architecture? The answer is certainly in the affirmative. In spite of the disappointing standard of conceptual design revealed by the President's Residence competition in the 1984 exhibition at the Museum of Finnish Architecture, there is plenty of evidence of vitality and variety in the work designed and completed since the 1970s.

Of those architects whose work was reviewed in 'Après Aalto, une nouvelle vague?', only that of Pietilä, Gullichsen, Kairamo, Vormala, Helin and Siitonen and Mäkinen belonged to the 1970s, and all four practices remained at the centre of the Finnish stage during the 1980s. In addition, Kirmo Mikkola, Juhani Pallasmaa, Kaija and Heikki Siren, Aarno Ruusuvuori and Pekka Pitkänen continued to produce interesting and significant projects. Other architects emerged or continued to establish varying reputations with their work of the 1970s and 1980s. These include: Juha Leiviskä, Kari Järvinen and Timo Airas, Arto Siipinen, Huhtiniemi and Söderholm, Eero Valjakka, Jaakko Laapotti, Osmo Lappo, Söderlund and Valovirta, Kauria and Turtola, Osmo Mikkonen, Kari Virtä, Erik Kråkström, Erik and Gunnel Adlercreutz, Nurmela/Raimoranta/Tasa, Simo and Käpy Paavilainen, Heikki Taskinen and Louekari and Viljanen. This is quite an extensive list and we shall now examine the trends and virtues that its principal figures represent.

We completed our review of the 1960s by discussing Pietilä's apparent influence on the design of Temppelikatu Church and the Swedish-speaking Students' Centre at Otaniemi. Those two buildings were as untypical of Finnish work of the 1960s as Pietilä's own designs. Finnish rationalism, particularly as shown by the serious endeavours of Mikkola, Pallasmaa, Gullichsen and Ruusuvuori, had a much stronger following, which generated a substantial body of high-quality work in the 1970s. The very *raison d'être* of this form of architecture gave it a strong industrial bias and it is logical therefore that some of its best manifestations are to be seen in the area of industrial buildings. Among the outstanding examples are the Sinebrykoff Brewery

Figure 213
Alvar and Elissa Aalto
Church, Lahti (1950, 1970–79): Aalto originally won the competition for this church in 1950 but did not return with a final design until 1970; the building was completed after his death by his widow, Elissa Aalto. The interior of this brick church is spacious and airy, but at the same time rather impersonal and mechanical (in the manner of the Riola Church).

Figure 214
Woldemar Baeckman
Sinebrykoff Brewery, Helsinki (1970): Baeckman is an extremely versatile architect, and here gives an early example of Miesian influence in Finnish architecture over the past quarter century.

Figure 215
Kristian Gullichsen
La Petite Maison, annexe to the Villa Grasse, Grasse, France (1972): an extremely skilful exercise in 'autonomous architecture', a rare, under-played Gullichsen work. In this old French olive grove it's a case of 'now you see it now you don't'.

Figure 216
Kaija and Heikki Siren
Co-operative Bank for Kotka Region, Kotka (1970–71): here we find the Sirens working with brick in the Miesian manner, a favourite approach with these architects.

in Helsinki by Woldemar Baeckman (1968–70; Figure 214); the Marimekko Factory in Helsinki by Erkki Kairamo and Reijo Lahtinen (1972–74); and the New Varkaus Paper Mill for the Ahlström Company by Gullichsen, Kairamo, Vormala (1974–77).[2] It should be noted, too, that before joining Gullichsen and Vormala in partnership in 1973, Erkki Kairamo had designed an elegant Miesian housing terrace at Honkatie, Espoo (1970–72), as well as the new Marimekko factory.

The Marimekko Factory and the New Varkaus Paper Mill for the Ahlström Company are the quintessence of new Finnish industrial architecture. The mill is on a historic industrial site: contributors to its planning and layout included Valter Thomé (1921), Karl Lindahl (1923) and Bertel Jung (1927), while the grinding plant and old paper mill were designed by Valter and Ivar Thomé (1922). It was in the 1940s that Alvar Aalto designed his well-known conveyor and silo building, adjacent to the old saw mill. Unfortunately, these Aalto contributions were lost when the saw mill was demolished and the old paper mill was extended in the 1960s.

One of the principal problems that Gullichsen, Kairamo, Vormala had to resolve in siting the hot-grinding unit, newsprint mill and warehouse was the sheer size of this new complex. The total length is almost half a kilometre and, with the exception of the warehouse, these buildings are about 24 m high. Furthermore, although the site is located in the centre of Varkaus, it was felt desirable not to disguise the industrial character but to reveal the paper-making process as the *raison d'être* of the town. In the solution, therefore, the technical and constructional requirements of the process, together with the provisions associated with fire precautions and safety work, are clearly visible in the external appearance of the buildings (Figure 224).

The impression of length was effectively reduced by providing a view through the complex from the town square to Huruslahti Bay, between the mill and the warehouse. The break also serves as a fire precaution. Moreover, careful refinement of the exterior details has given this huge building an extraordinary elegance. The giant structure never appears ponderous. Instead, the large glass areas and the ribbed-steel panelling seem held in dynamic tension, an impression aided by spiral stairs and linking catwalks. The result is an almost playful lightness in the exterior masses. This is carried through to the interior spaces as well, where the main objective of creating an agreeable working environment has been brilliantly achieved. The interior sense of light and transparency is created by extensive use of large glass panels. Considerable thought was also given to the elimination of noise and vibration: the control rooms and offices are built on vibration absorbers, while the welfare facilities at the side of the mill are isolated from the main framework by an expansion joint.

The use of colour is restrained throughout, with dark grey, black or blue predominating, contrasted by silver-painted stairways and the panel details, while the exposed concrete was left unpainted. Machinery is generally pale grey and the brilliant colours of standard warning signs and piping trace sharply contrasting lines, which thread through the great machine halls. The confident handling of elements and detailing throughout the plant demonstrates a remarkable maturity from these young architects.

Three other outstanding examples of this industrial rationalism are to be found in: the Casa Academica commercial building in Helsinki by Huhtiniemi and Söderholm (1972–75); the Baghdad Conference Palace, Iraq, by Kaija and Heikki Siren (1978–82); and the Murikka Training Centre for Metalworkers by Pekka Helin and Tuomo Siitonen (1974–77).[3] The Casa Academica is a precise, prefabricated, metal container on a concrete frame, entered at the lower level, with a first-floor balcony running all round the building, suspended on braced hangers from the double-storey cantilevered offices above. An important part of the precision of the Casa Academica design is the elegance of detail and good proportions

Figure 217
Kristian Gullichsen and Juhani Pallasmaa
Summer-Module '73 at the Villa Mairea – a temporary exhibition structure (1973): the task was to blend with, not compete against, Aalto's masterpiece.

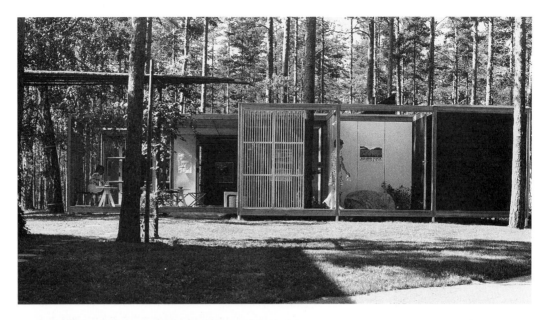

Figures 218 and 219
Kaija and Heikki Siren
Bruckner Haus Concert Hall, Linz, Austria (1969–74): it is difficult to match a large modern building mass with the delicate baroque profile of the city's silhouette. The segmental form reduces the apparent weight. The interior forms a striking contrast with Alvar Aalto's Finlandia Hall. Aalto often spoke of the 'need for charm': and the Finlandia Concert Hall has that quality. Although predominantly of wood, the Bruckner Haus is more regularized and mechanical in effect than Aalto's concert hall.

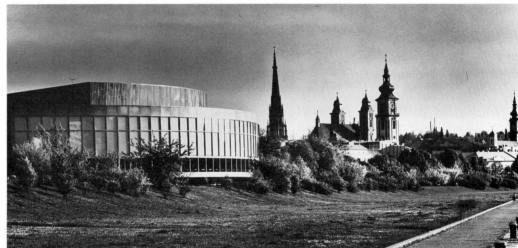

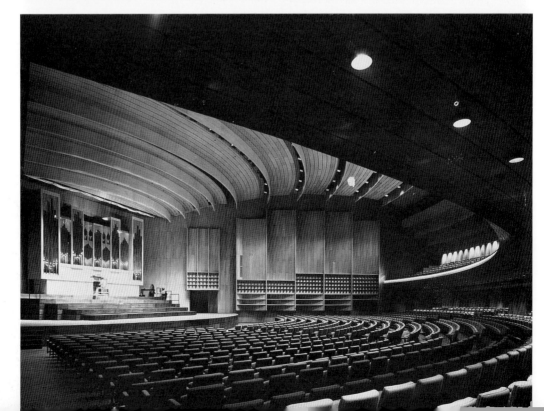

throughout. The Sirens used prefabricated-concrete elements to achieve a high standard of construction and finish in their Baghdad Conference Palace, which has all the clarity of plan and massing we have come to expect from the classical approach of this architectural practice to modern building design.

The Murikka Training Centre for the Finnish Metalworkers' Union is located at Teisko, near Tampere, on the shore of Lake Näsijärvi. It is a highly functional building, which provides residential courses for the union's members. The site is extremely beautiful, stretching down to the rocky shoreline (Figure 229). For the architects two things were of paramount importance: a careful relationship between the delicate quality of the site and its natural surroundings and a sense of close identity with the building users, the metalworkers. The building therefore has a low profile within the landscape, with its volume distributed in small-scale masses. In addition, these individual pavilions are literally conceived as metal 'containers' with the main glazed areas concentrated within particular features, such as the circulation and recreation areas (Figure 230).

The Murikka Training Centre consists of a number of quite distinct building units, while the principal building containing the training office, dining facilities and some of the leisure provisions is arranged as four similar cells, each for 24 students. Joint facilities, auditorium and library are located in a central spine that runs through this complex, with the dining and leisure rooms at the west end overlooking the lake. The residential accommodation is also arranged in four cells, cranked around a courtyard adjoining the main building: each cell has 24 bedrooms with communal lounge and kitchen. The sports building is intended for use by local residents and those attending courses at the centre: it includes a basketball court and a swimming pool. The service building includes the heating plant, transformers, workshop and garage. There is also a lakeside sauna bath. Separate housing facilities accommodate the residential staff.

The building units on the site are clustered in a tight formation with the principal building, residential units and sports centre grouped around a main court. A variety of enclosure and semi-enclosure is achieved in the overall grouping of buildings on the undulating site, with a lot of interplay between the formal character of the layout and the natural landscape elements. The repetitive building components, with their horizontally ribbed panels, are arranged to achieve a character and scale reminiscent of Finnish farmhouse vernacular. Certainly, there are strong similarities between the disposition and interrelationship of building elements in the Murikka design and those of Finnish traditional farm structures. The separate pavilions are an example of this, imparting a small scale that offers subtle relationships with the terrain, courtyards and overall horizontal emphasis.

Although Murikka is in one sense an expressionist building, the fact that its expression of 'metal box' is skilfully fitted to the terrain reduces the harshness that might have resulted from such an overt demonstration of metalwork technique. The building complements the site with its delicacy of detailing. An interplay between the artificial and natural features, balancing opacity with transparency, allows Murikka to be substantial yet, at the same time, barely there. A combination of variations in assembly of the kit-of-parts, linked with artfully contrived vistas through the site, produce an effective industrial alternative to the traditional forms and character of log construction. Murikka is a superb demonstration of artifice in modern Finnish architecture.

The Laiho, Pitkänen (Pekka) and Raunio partnership's design for the extension to the Parliament Building (1972–78)[4] precedes and parallels the Murikka centre, adopting a similar pressed-metal panel aesthetic, but the effect of the Helin and Siitonen design is more convincing. This is partly to do with the interplay of built form and site in the Murikka design, where nature has such an important role in the composition of the whole. Also the

Figure 220

Kaija and Heikki Siren
Utsjoki Restaurant, Kuruizawa, Japan (1972–1974): a double-take on Japanese Finnish architecture, with a decided obeissance to Lars Sonck, also.

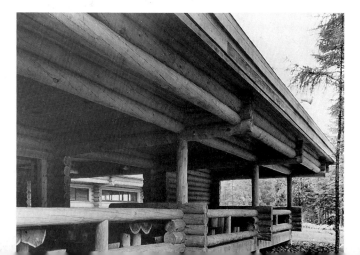

Parliament Extension lacks the fine sense of scale achieved in the same genre by Huhtiniemi and Söderholm in their Casa Academica. The Laiho, Pitkänen and Raunio design for the Parliament Extension attempts to solve an extremely difficult problem. Jukka Siren's Parliament Building, the true monument of Finnish 1920s classicism, is something of a national shrine. Their architectural solution, therefore, sets out to achieve a number of objectives.

First and foremost, the architects felt obliged to adopt a neoclassical *parti*, creating a semicircular court at the rear of the Parliament Building (Figure 238). They also believed it was essential to play down their own contribution to what would become the comprehensive new Parliament complex. This second decision was in part to do with the subservient role of the extension, in the sense that it contains only 'slave' bureaucratic accommodation. But the formal consequence of the linked decisions to follow a neoclassical *parti* and adopt the slave-quarters' model is the creation of too much obvious disparity between the old and new (Figure 239). Even the stable block in the classical *parti* has its own monumentality (see Andrea Palladio and Claude-Nicolas Ledoux). Perhaps what was needed was more *bravura*, some positive formal competition for Siren's turgid Parliament Building box? Given his approach to the Lieksa Church design, it is interesting to speculate what Pietilä might have made of this neoclassical jigsaw? As a piece of functionalism, however, the interior of the Parliament Extension is an outstanding success, which is consistent with expectations of Pekka Pitkänen's work (Figure 240).

There are other intriguing, if less successful, examples of this industrial rationalism that should be mentioned. The first of these is the Kotka Co-operative Bank by the Sirens (1970–71; Figure 216), which like their 1959 extension to Jan Eklund's Finlayson Factory in Tampere (completed in 1928) follows the Tampere tradition, much emulated by the functionalists of the 1930s, of industrial *techne* or constructional logic and expression. The Sirens' Kotka Bank, in its subtle tension between the semicircular piers and the flat spandrels between the windows, suggests the kind of surface tautness of an Aalto façade. Kirmo Mikkola's Artists' Studios at Oulunkylä (1975–76) have the surface tension of a Japanese *shoji* screen. The very antithesis of Pietilä's fiction of wall thickness, these studios contrive to present a paper-thin external 'sandwich'. On the interior, the spatial ordering of the Mikkola units is equally 'thin'. The industrial rationale is appropriately applied to the Herttoniemi Station on the Helsinki subway system (1974–77) by Oy Kaupunkisuunnittelu Ab/Jaakko Ylinen and Jarmo Maunula, where the thinness of the constructional motifs suggests the temporary support structures of a building site. At Herttoniemi we appear to be waiting for the architecture, like a train, to arrive (Figure 227).

Jaakko Laapotti is a professor at the Technical University in Otaniemi. His significant contribution to the extension of rationalism in the 1970s is also in the classical mould. Like the Sirens (and in this case Jukka and Heikki are referred to), Laapotti's work has to be classified as academic. The Hotel Rosendahl in Tampere (1975–77) by Laapotti and Martti Kukkonen is, in every sense, the ultimate rationalization of the tourist hotel (Figure 231).

There is a basic, functional, difference between a tourist hotel and a traditional hotel. One goes to stay in the traditional hotel and enjoy its amenities. The traditional hotel has a timeless quality precisely because one goes there to spend time: its indulgence is to suspend the guest between the past and the future. A tourist hotel, on the other hand, makes a fetish out of time, hurrying transient visitors hither and thither, making them ever aware that they are paying by the minute, although the freedom of an hour (or two) eludes them. For metalworkers who are looking for a busman's holiday, the Hotel Rosendahl provides the perfect ride. If they observe in the industrial trusses a memory of the factory they have just left, they can also find (in the cellar restaurant below) an echo of the cave,

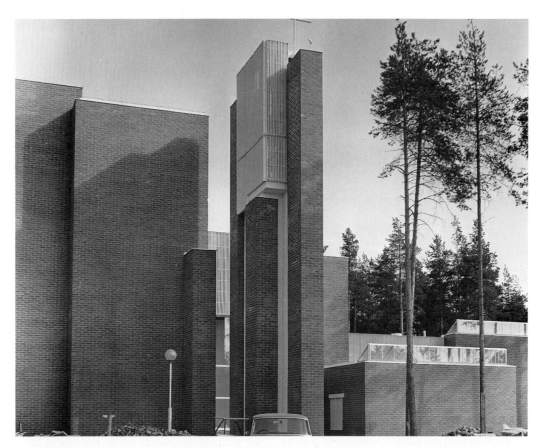

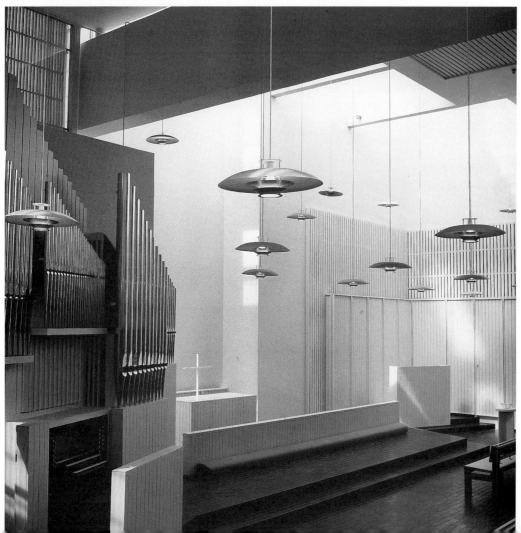

Figures 221 and 222
Juha Leiviskä
St Thomas's Church, Oulu (1970–75): Leiviskä's first major work, which established him immediately as an important architect. This design, with its distinct references to De Stijl design confirmed Pietilä's view that one of the best ways forward was by returning to the unused ideas of early modernism. The interior shows that within a puritanical, Protestant tradition Leiviskä has inserted two mysteries from other Christian denominations: the fleeting, dissolving focus of daylight; and the lamps that divide and unify Byzantine space in the Greek religious stasis.

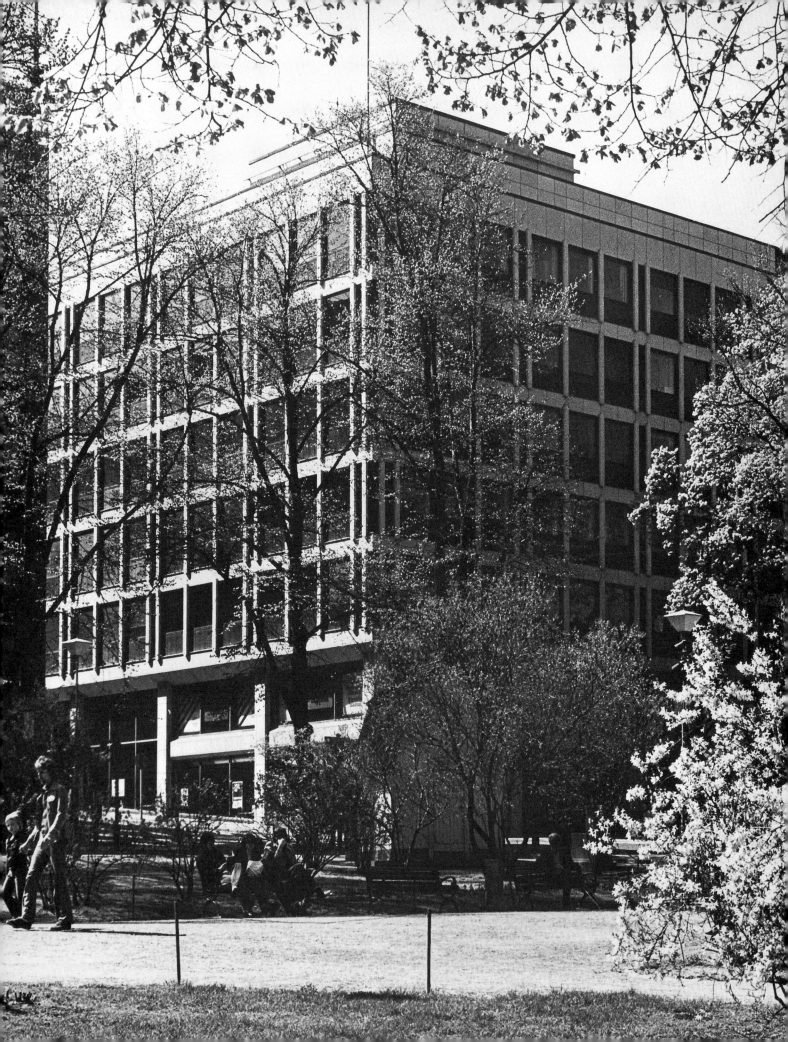

Temppelikatu Church, or the Grand Canyon (Figure 232).

The limitations of Laapotti's rationalism are not confined to his approach to tourism. They also impinge upon his attitudes to culture as a whole. His architecture seems to make little distinction between time, place and occasion. If we have difficulty relaxing in the Hotel Rosendahl, there may be similar difficulties in gaining a spiritual experience in Laapotti's Kuovala Church (1976–78; Figure 233).[5]

There is a difference, not only culturally, but in terms of space–time experience, between a factory, hotel and church. Gullichsen can distinguish between a factory, as he did with Kairamo and Vormala at Varkaus and a convincing church. The Malmi Church eventually built in 1983 to Gullichsen's design (on a different site from Pietilä's original scheme), although not in any way a substitute for Pietilä's design, is a thoughtful piece of church architecture, a sturdy brick structure that possesses great dignity.

If Finnish architects have to compete with Aalto's Vuoksenniska Church, Sirens' Otaniemi Chapel and Pietilä's Lieksa Church design they face high standards in making a memorable statement. But a church is a church, after all, just as a factory is a factory. And for all their technical skill, which is admirable, for all their refined achievement of the architectural object in the best sense of Heidegger's *das Ding*, Laapotti's buildings do not make these cultural distinctions.

This is not the error of Laapotti, since he merely borrowed his universal rationalism from Mies van der Rohe, the Bauhaus, or from Viljo Revell. And the reasoning, the rationalization behind this is that industrial technology provides the modern equivalent of the classical language of architecture. But we know that the Tower of the Winds does not resemble a temple, any more than the basilica form apes the Colosseum. In their understanding of the classical tradition, both Schinkel and Engel could distinguish between museum and landmark, between church and observatory. The history of modern Finnish architecture also emphasizes these distinctions. When Aalto blurred the distinction between internal and external space, or between architecture and nature, he did not confuse the fundamental social and ritual patterns of humanity's behaviour as represented by built form.

At the formative stage of his career, Professor Matti K. Mäkinen was in the fortunate position of not having to make these distinctions. As Chief Architect of the Valio Company his task was to express the hard industrial reality of milk production. Then from 1985 to 1994, as Director General of the National Board of Finnish Building (Rakennushallitus), he oversaw the more complex problem of the image of public buildings in Finland.

The sheer magnitude of the Valio Headquarters Building in Helsinki (1975–78) places it in a category of its own in the realm of Finnish commercial architecture. Mäkinen's design (together with Kaarina Löfström) for this five-pavilion project is an astonishing achievement, because it realizes the commercial potential that Finland first gave glimpses of as an emerging nation in the 1930s. This commercial representation is more complex than that of the Gullichsen, Kairamo, Vormala buildings for Varkaus and its design sources are correspondingly more diverse. It nevertheless represents an exercise in industrial rationalization that is very much akin to that of Varkaus.

The Valio complex is designed to bring together the central administration of the company, previously scattered throughout Helsinki. Eight office plan types were considered: the one selected has a substantial dependence upon open-plan arrangements (Figure 234). Originally it was intended that 75% of the staff should work in open-plan offices. In the completed building the balance of accommodation has been adjusted slightly in favour of individual rooms. The building form responds to three main factors: town-planning constraints; the need to conserve energy; and the working environment for the staff. The cube-like form of the buildings was adopted to provide a minimum surface area to the external shell.

Figure 224
Kristian Gullischen, Erkki Kairamo amnd Timo Vormala Ahlström Paper Mill, Varkaus (1974–77): external detail of plant assembly.

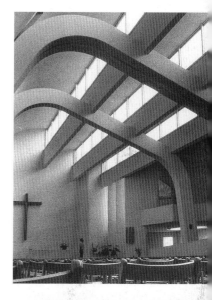

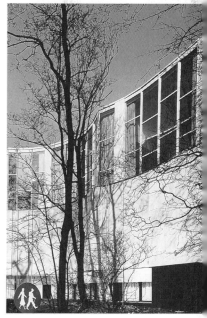

Figure 223 (left)
Keijo Petäjä
Office Building, Etaläesplanadi, Helsinki (1975–77): Petäjä's well-known exercise in proportional ratios, designed to fit into a sensitive area of classical Helsinki.

Figure 225 (centre, right)
Alvar Aalto
Riola Parish Church, near Bologna, Italy (1966, 1976–78): a commissioned design that was completed after Alvar's death by Elissa. Like Lahti Church, the interior is industrial and unrefined.

Figure 226 (bottom, right)
Alvar Aalto
Congress Extension to Finlandia Hall, Helsinki (completed in 1975): the plan and the rhythm of the walls seem more like Reima Pietilä's Kaleva Church than a characteristic Aalto form.

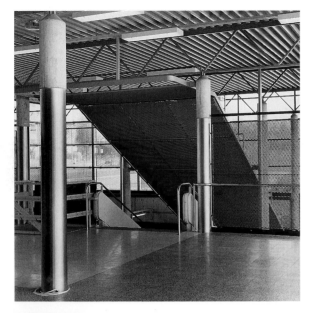
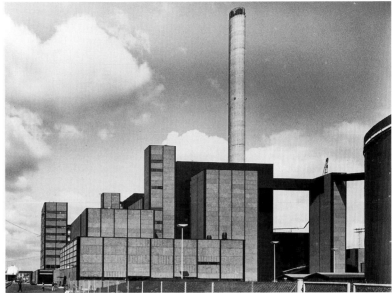
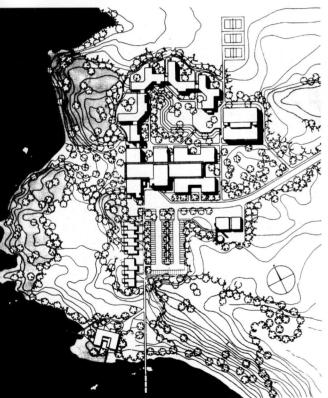
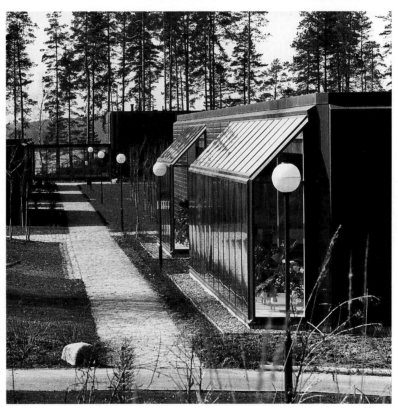

Figure 227 (top, left)
Jarmo Maunula and Jaakko Ylinen
Herttoniemi Station, Helsinki underground system, Helsinki (1974–77): the aesthetic of this design seems to reject permanence: instead of monumentality, which was inappropriate for this suburban line, a cosy amalgam of hands-on, temporary materials and uses gives the form.

Figure 228 (top, right)
Timo Penttilä and Heikki Saarela
Hanasaari Power Station, Helsinki (1971–76): in the tradition of the great Aarne Ervi power stations, Penttilä (an assistant in Ervi's office in the late 1950s) here achieves a new clarity of materials and monumentality of form.

Figures 229 and 230 (bottom, left and right)
Pekka Helin and Tuomo Siitonen
Murikka Metalworkers' Union Training Centre, Tampere (1974–77): the site plan gives no idea of the formal subtlety and ingenious fit of materials to landscape. These simple 'metal boxes' are absorbed perfectly into the terrain.

The comprehensive development plan for the Valio Headquarters Building provides four pavilions, but so far only two have been completed (Figure 235). Their external character is bold and uncompromising, with tile-cladding and metal windows. The corners of the pavilions are rounded off, which makes the overall building outline seem continuous and unified. The air-conditioning system makes a direct contribution to the expression of the building. This is concentrated in centrally located machine rooms, and the fresh air is blown into the open-plan offices through hollow columns. The air is then extracted through ducts that run along the façades and is returned to the machine room for heat recovery and recycling (Figure 237). These anodized-aluminium external ducts grip the pavilions, pulling them together, with only the glazed rounded corners and the vertical circulation elements left free of this network of tubes. Juhani Pallasmaa has suggested that the exterior ductwork has strong associations with dairy machinery. Certainly, the character of the Valio complex is emphatically mechanistic, reflecting recent international trends. The work of the Austrian architect Gustav Peichl, in particular, springs to mind. There are other references to earlier precedents in, for example, the rounding of window sills on the ground floor (a reflection of the corner treatment of the pavilions) that suggest German expressionism, echoing the themes of Erich Mendelsohn, Bruno Taut and Hans Scharoun.

In fact the whole design appears to be poised somewhere between the 1930s and the future. The exterior has a predominance of metallic parts, exuding a certain muscularity with decidedly utopian overtones. Inside, however, there is a sense of quiet security in the working areas, giving a comfortable and often homely feeling (Figure 236). Certainly, the new Valio Headquarters Building established Mäkinen as a force to be reckoned with in new Finnish architecture. The scheme definitely represents a new industrial urbanism in both scale and character.

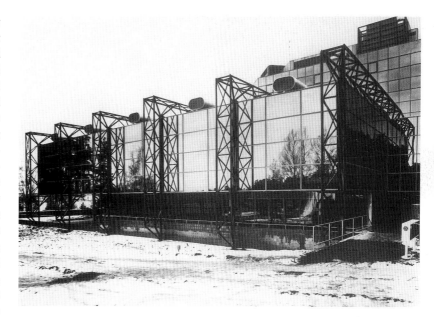

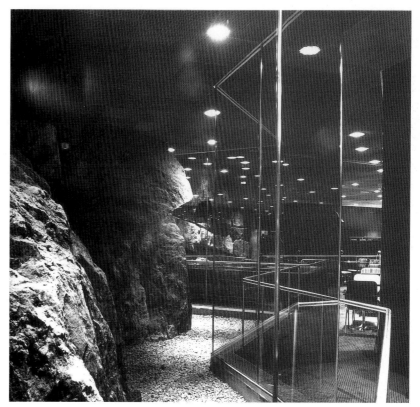

Figures 231 and 232
Jaakko Laapotti
Rosendahl Hotel, Tampere (1975–77): Laapotti's harsh industrial forms may be suitable for processing the tourist. There is some relief inside when the native rock is displayed as a reminder of our earlier cave-dwelling days. It offers a complete contrast to Aulis Blomstedt's Valhalla on Suomenlinna.

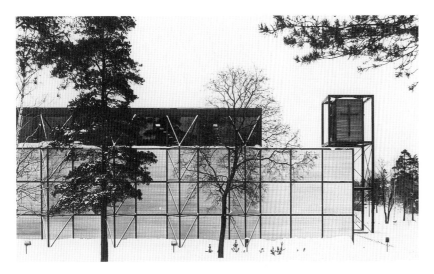

Figure 233
Jaakko and Kaarina Laapotti
Kuovala Church (1976–78): when the industrial imagery of the Rosendahl Hotel is repeated in this church design the minimalism tends more toward the commercial than the spiritual. Laapotti represents a sort of Finnish internationalism that naturally finds it difficult to be at home with itself.

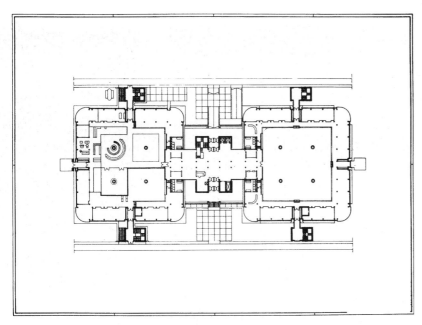

Figures 234–237
Matti K. Mäkinen and Karina Löfström
Valio (dairy products company) Headquarters Building, Helsinki (1975–78): only two of the four planned pavilions have been built and the appearance of the formal whole is modified by site levels (plan, above). Opposite: The industrial imagery is complex and rich. Each pavilion has four giant columns (from which, basically, all the accommodation is suspended), shown clearly here in the interior. The buildings are robustly detailed, both inside and out, as seen in the ducting on the exterior and in the ultimate form (if such a thing is possible) of the 'industrialized' sauna.

A similarly strong urban form is achieved by Timo Penttilä in his comparable but smaller headquarters building for the Finnish Sugar Company at Tapiola (1978–80). But Penttilä's urbanity is much more aloof and classical, bringing an elegant dignity to the extension to Aarne Ervi's original Tapiola Centre. The Finnish Sugar Company offices are finely detailed and proportioned. Appropriately, the extension is tile-covered in a way that recalls Ervi's treatment of external surfaces. Ervi designed both the masterplan and the original Tapiola Centre in 1959–60. Penttilä is a master of restraint and, like Heikki and Kaija Siren, he brings a taut perfection to the external surfaces of his buildings.

Although Penttilä won first prize in the competition for the Bahrain Cultural Centre (1975), this project was not built. The plan is ingeniously compact, yet provides a rather free configuration within the rectangular envelope. In its modern assembly of classical forms it promised an interesting contrast to the more predictable work of Kaija and Heikki Siren.

Olof Hansson, a collaborator with Ervi on the original competition for the Porthania Building at Helsinki University, produced a very sensitive design for the Tammisaari Library together with Pekka Manner, which was completed in 1978. It has a wonderful sense of reserve, achieving a modest and unpretentious scale in a conservation area of great charm and delicacy. The equally sensitive interiors are by Osmo Helenius.[6]

While he was still working on the construction of the Hervanta Centre outside Tampere in 1979, Pietilä won the competition for the Tampere City Library. Interestingly, the rational attitudes that had weighed against his ideas at the close of the 1960s were not at all evident in the jury's selection of this design. Under the heading of 'Feasibility', the jury report stated:

'Judging feasibility did not only involve identifying the simplest and cheapest possible physical and technical plan... Feasibility here was made to

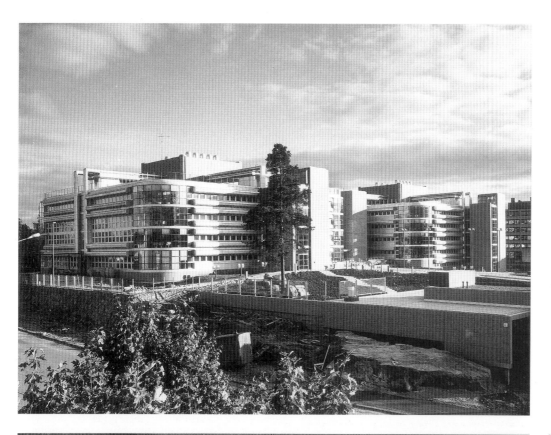

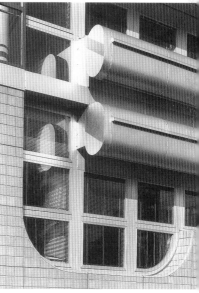

After Aalto: form and formalism in the 1970s and 1980s

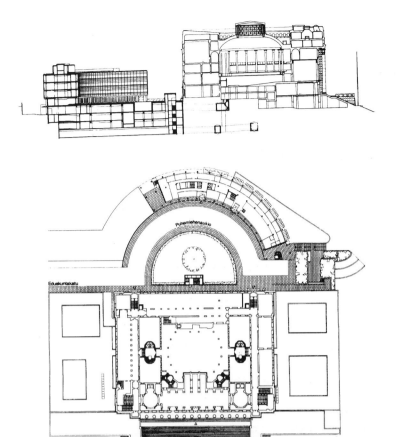

include at least satisfactory spatial and functioning constructions *and a style that communicates the building in a friendly and expressive way* [author's italics]...'[7]

From this point of view it has to be observed that most of the entries failed to qualify. Indeed, the only other 'friendly and expressive' design was judged to be Juhani Pallasmaa's entry, which was awarded the purchase prize.

The 1970s ended with the construction of a number of other buildings of note, for example, Keijo Petäjä's office building at Eteläesplanadi 20, Helsinki (1973–75).[8] Petäjä's work, at its best, has a tough-minded, disciplined clarity combined with the cool classical sense found in the Sirens' designs. This office building reveals his attention to the co-ordination of the module into the design and architectural expression. The many studies for the elevations, which front onto the linear Esplanadi Park and therefore form part of one of the principal neoclassical streets in Helsinki, show how Petäjä retreated from elaborate faceting and other efforts to compensate for the jointing characteristics of prefabricated components, settling finally for a simple classical formula (Figure 223). A two-storey recessed podium of shops and offices is surmounted by a further five storeys of office accommodation. In the upper portion, the bays established below are divided into three, plus a smaller unit corresponding to the columns below, giving an ABBBA rhythm on both façades and a spacing gap at the corner junction. This solution provides a thoughtful marriage of classical intentions with prefabricated means. It was Petäjä's favourite work from his own hand. Always a meticulous man, he brought this quality to his architecture.[9] He was very actively engaged in practice and professional life right up until he died following a bicycle accident in 1988 at the age of 68.

In the area of industrial building two further contributions of interest and merit were added in 1977: the Loviisi Power Plant by Erik Kråkström; and the Waste-Incinerator Plant for Turku by

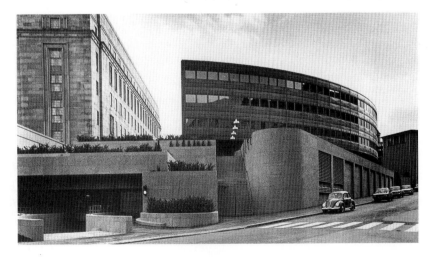

Figures 238–240 (above and opposite)
Pitkänen, Laiho and Raunio Administrative Extension to the Parliament Building, Helsinki (1972–78): although the form may seem obvious – a semicircle added to a classical rectangle – this is an ingenious plan and *parti*. The interior spaces are remarkably effective and well lit. What is problematic is the aesthetic of a metal container in this context: not that metal is inappropriate as such, but the pressed can-like servant form makes too much of its servitude.

Finnish Architecture and the Modernist Tradition

Pekka Pitkänen. While in the housing field, Simo Järvinen and Eero Valjakka brought some of the industrialized building ideas of Juhani Pallasmaa and Kristian Gullichsen to public housing in their development at Kannelmäki, Helsinki (1977).

The competition for the new Helsinki Opera House was also held in 1977, generating considerable optimism for this new cultural image in the capital.[10] It was won by the team of Eero Hyvämäki, Jukka Karhunen and Risto Parkkinen. The second purchase prize went to Juha Leiviskä assisted by Kari Järvinen and Simo Paavilainen. An Aalto-esque design by Ålander, Packalén and Korsström shared third prize with the entry by Krogius, V.-P. Tugminen, Björnstedt and Pettersson. Opened at the end of 1993, the new opera house is located close to Penttilä's City Theatre in the park between Mannerheimintie and Töölö Bay. Its form refers extensively to high-style 1930s modernist public buildings, such as those of the Dutch master Willem Dudok, in both its cubist masses and the prevailing transparency of its public spaces.

In 1978 a provocative competition was held for the Helsinki East Centre Landmark, in which the problem of making a modern Finnish tower was explored once again. By far the most successful design was by Erkki Kairamo, Timo Vormala and Aulikki Tiusanen. This solution was eventually built, although the finished result does not match expectations the project originally raised for a dynamic neo-constructivist monument.[11]

In 1978, Kairamo and Vormala, together with Gullichsen, also entered the most imaginative design in the Forum Site competition for the corner site adjacent to the *Hufstadsbladet* newspaper office on Mannerheimintie. Their design was the sole entry to contain a genuine *galleria* approach, but was awarded only second prize.[12]

The *Helsingin Sanomat* Building at Vantaa, near Helsinki, was completed in 1979. This design by Kalle Vartola is in the best tradition of Finnish industrial architecture, while, in contrast, the IBM Building in Munkkiniemi by Osmo Lappo and Johani Westerholm, also finished in 1979, offers what is almost certainly the ultimate Finnish exercise in the Miesian vein.[13]

Arguably, in spite of a lack of detailed refinement in its overall execution, the most memorable Finnish building of the 1970s is the new grandstand for the Lahti Sports Centre,[14] completed in 1977 together with the 50 m and 70 m ski jumps for the 1978 World Championships in Nordic skiing. The bold panel column construction and cantilevered facilities are not complemented by the infill accommodation, which is inconsistent in form, detail and scale with the overall engineering concept. As a result this solution by Esko Koivisto, Pekka Salminen and Juhani Siivola falls short of the high standards established by both Penttilä and Ruusuvuori. Nevertheless, the Lahti Sports Centre demonstrates a continuation of the structural tradition of Finnish modernism pioneered in the 1930s in the *Turun Sanomat* Building by Aalto and echoed in the Tampere Railway Station design. Together with Eliel Saarinen's Lahti Town Hall and Aalto's Church of the Holy Cross it has placed Lahti securely on the map of modern architecture in Finland.

Upon entering the 1980s, however, there is less certainty about the origins and intentions of the new Finnish architecture. There are exceptions, notably at the beginning of the decade in the work of Aarno Ruusuvuori and Matti K. Mäkinen, both architects offering superb evidence of the continuing tradition of Finnish industrial architecture. Ruusuvuori's contribution is the Parate Printing Works at Myllypuro (1978–80),[15] while Mäkinen completed two buildings of note in 1980, namely, the Valio (Central Finland) Dairy at Seppälänkangas, Jyväskylä,[16] and the Osuuskunta Butter Factory (with Antti Katajamäki).[17]

The general picture during the 1980s, however, was one of confusion, with more certainty about international sources and influences than the maintenance of earlier national attitudes and the continuance of the Finnish tradition of modernism. The overall effect, consequently, was to diminish the impact and importance of Finnish architecture and

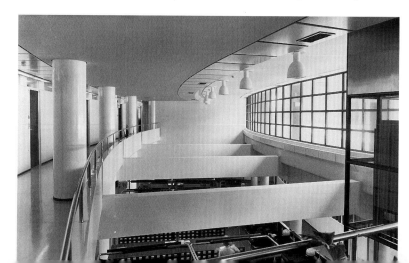

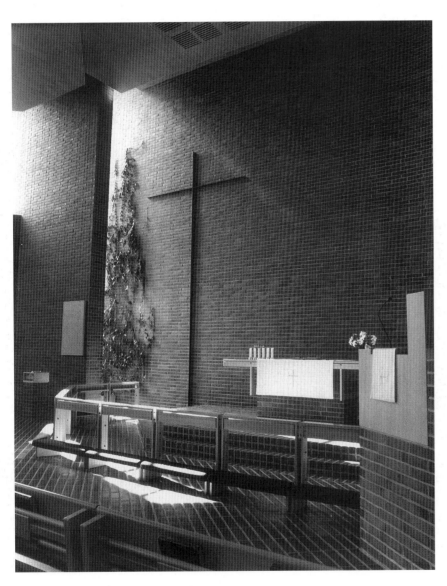

Figure 241

Pekka Pitkänen

St Henry's Church, Turku (1977–80): a fine brick church, especially the interior that equals Kristian Gullichsen's Malmi Church, demonstrating the success of this material over hard plaster (compare with Aalto's late examples at Riola and Lahti).

move it from its hard-earned central position, reducing it in part to the status of a province of international postmodernism. This is not, of course, totally the case since there remained some significant and productive pockets of resistance. The struggle may perhaps be characterized by contrasting the work of two architectural offices of relatively recent provenance. In this conflict of new Finnish architectural expression, the work of Matti Nurmela, Kari Raimoranta and Jyrki Tasa stands for the more eclectic international polarity, while that of Kari Järvinen and Timo Airas represents new insights into the continuing tradition of Finnish modernism.

Two buildings with a social emphasis by these architects attracted attention when they were completed in 1980: the Länsi-Säkylä Day Home and Church Club, at Iso-Vimma, Säkylä by Järvinen and Airas;[17] and Karviaismäki Daycare Centre and Local School for Malmi, near Helsinki, by Nurmela/Raimoranta/Tasa.[18] More significant in terms of Finnish architectural ideas, however, is a design of 1980 by Järvinen and Airas, for the Siiskonen House at Mikkeli (completed in 1985);[19] this once again works on the precedent of the Finnish farmhouse group that provided the basis for some of the Aalto transformations. The Siiskonen House, however, appears to come even closer to Aalto's notion of 'an autonomous architecture' than Aalto himself actually achieved, with the architect seemingly acting only as a constructive onlooker (Figures 260–262).

It is interesting to compare Aalto's Church of the Holy Cross, Lahti (competition design 1950, completed 1979) with Bishop Henry's Church in Turku by Pekka Pitkänen (1977–80).[20] Both have red-brick exteriors; and both are rather formal, even forbidding, from the outside. In the case of Aalto's Lahti Church there is a conscious urban gesture. Lahti is built across a valley: its main street, the Aleksanterinkatu (named after Tsar Alexander), follows the valley floor. Eliel Saarinen's Lahti Town Hall (completed in 1921) has a commanding position on the southern heights of the city,

Finnish Architecture and the Modernist Tradition

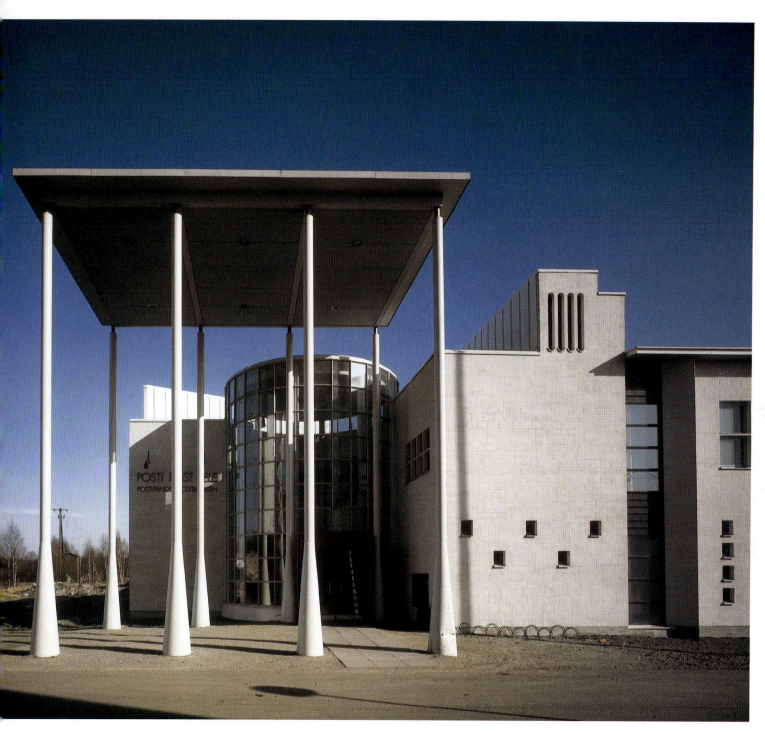

Figure 242
Nurmela/Raimoranta/Tasa
Post Office, Malmi (1983–84): here the partnership's postmodern classical intentions are quite clear: cylindrical entrance (grand scale); grand columns (on a low-fat diet). Inversion of principles: that's the rule.

Finnish Architecture and the Modernist Tradition

Figure 243
Kari Järvinen and Timo Airas
Housing at Sofianlehdonkatu, Helsinki (1987–89): this project represents a change of approach, with the planar references now much less derivative of autonomous regionalism, and much more connected to De Stijl sources (especially Gerrit Rietveld's Schröder House in Utrecht), which in this urban context is very fitting.

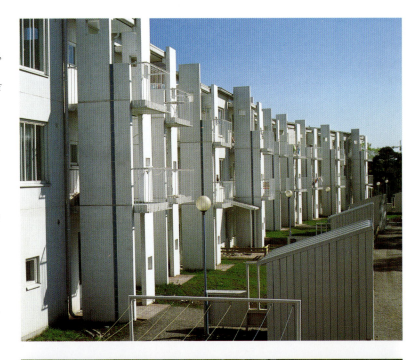

Figure 244
Nurmela/Raimoranta/Tasa
Library at Kuhmo (1982–84): The postmodern impacting of forms and destruction of conventional order is at work here. The effect of this design strategy can be clearly seen in the interior, where the main book stack meets an elliptical feature.

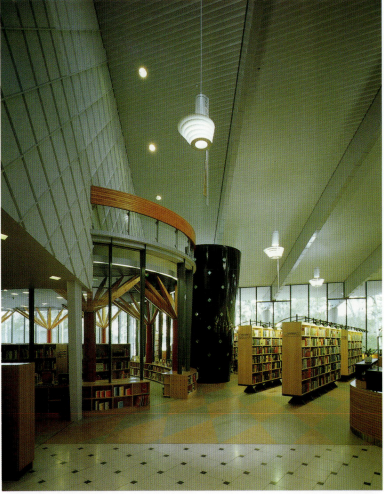

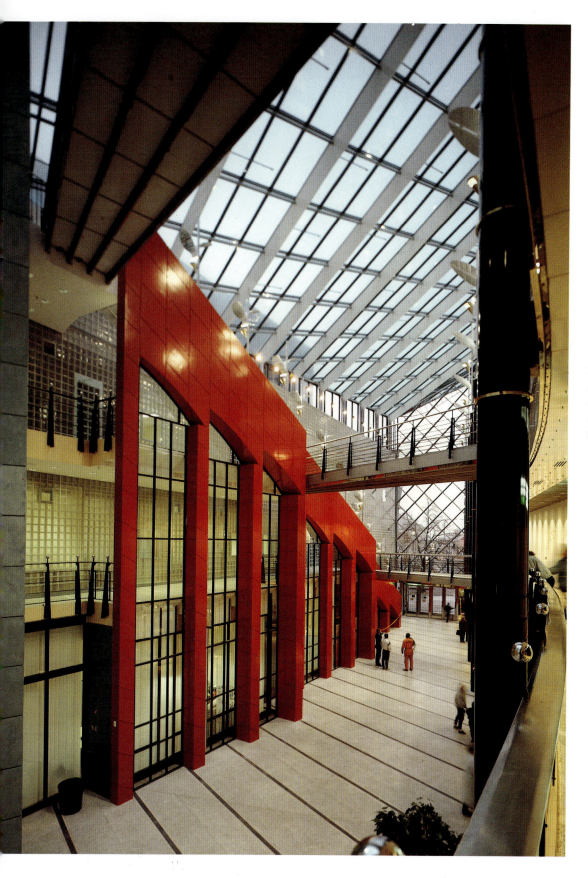

Figure 245
Nurmela/Raimoranta/Tasa
Commercial Centre, Pori
(1987–89): interior. (See also
Figures 271 and 272.)

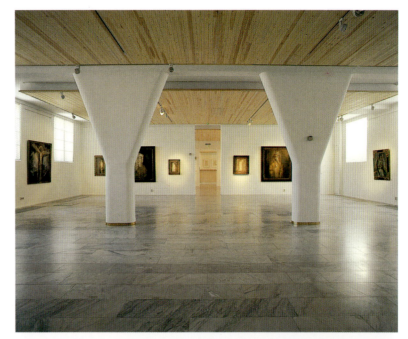

Figure 246
Juhani Pallasmaa
Art Gallery, Rovaniemi (1989): this conversion of industrial premises has all of Pallasmaa's established trademarks. There is a refined minimalism of form and detail that he learned from Aarno Ruusuvuori.

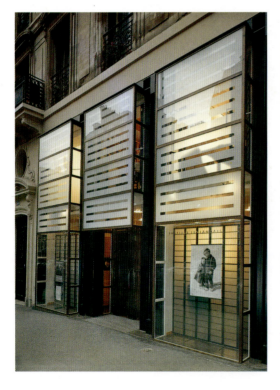

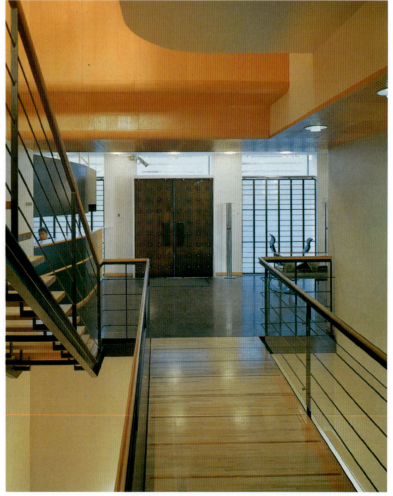

Figures 247 and 248
Juhani Pallasmaa
The Finnish Institute, Paris (1992): for description see Figures 273 and 274.

Figure 249
Heikkinen and Komonen
European Film School, Denmark (1989–93): in the meeting hall/cafeteria interior the treatment by Heikkinen and Komonen recalls the 1930s work of Pauli Blomstedt, particularly his Kotka Savings Bank (1935).

Figure 250
Pekka Helin and Tuomo Siitonen
UNIC (Computers) Ltd, Helsinki (1989–91): if this brick and stone-clad building seems familiar, it may be because the architects admit they were inspired by Eliel Saarinen and particularly Hvitträsk. But this is no eclectic patchwork: both the delineation and the details have the spirit of the old master.

Figure 251
Pekka Helin and Tuomo Siitonen
Sibelius Quarter, Residential Building, Boräs, Sweden (1989–93): a bold and successful try at that old student dream, the *Wohnhügel* (Living Hill) – see the work of Peter Faller and Hermann Schröder (Stuttgart in the 1960s), complete with sod roof (*à la* Aalto at the Villa Mairea) and an attractive courtyard built in for daylight relief. For the Swedes to learn from the Finns at last is very reassuring.

Figure 252
Pekka Helin and Tuomo Siitonen
The North Karelian Provincial Library, Joensuu (1988–92): the rear view has an extraordinary muscularity of form and structure, while the interior (p. 229) is classic Helin and Siitonen: total simplicity and clarity of form, construction and detailing. Whether inside UKK, UNIC or here at Joensuu, the same high quality prevails and impresses.

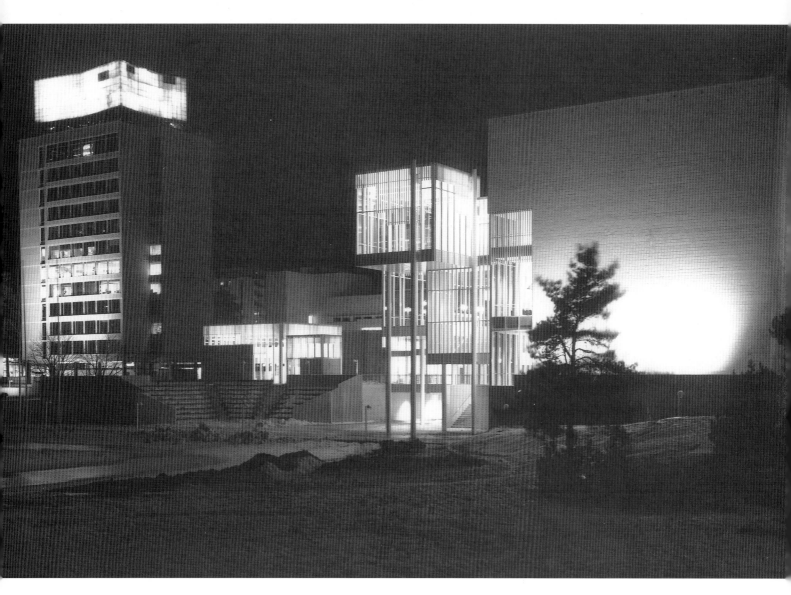

Figure 253
Arto Sipinen
Cultural centre for Tapiola (1985–89): this represents the developed expression of an architect who began as a devotee of Mies van der Rohe, but since Raisio Town Hall (1977–81) has moved towards a stilted, polite modernism that now has little in common with Miesian ethics. At Tapiola, where his Cultural Centre engages in flambuoyant combat with Aarne Ervi's Centre Tower, true architectural charm is tested. In his attempts to be free of the Finnish time-warp, Sipinen seems to have perfected some sort of corporate functionalism for public buildings. The Centre's concert hall, however, has more of the architect's earlier strength. (For interior, see p. 212)

Figure 254
Kirmo Mikkola
Studio Laurema, Espoo (1980–82): this fragmentary and seemingly incomplete object represents Mikkola's brilliant driving force in Finnish architecture, which was tragically and prematurely spent.

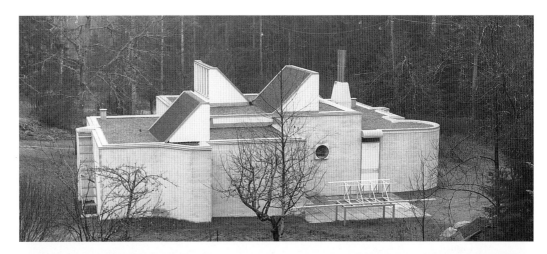

Figure 255
Juha Leiviskä
Kirkkonummi Parish Centre (1980–83): typical of Leiviska's long, drawn-out De Stijl plans.

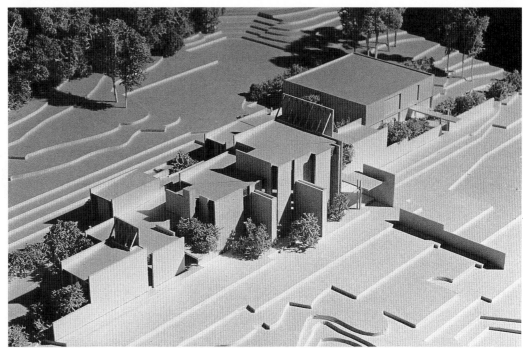

Figure 256
Aarno Ruusuvuori
Prefabricated Summer House (1978): by playing with the roof pitches the architect turns this carefully regulated modular design into a remarkable free expression of summer living.

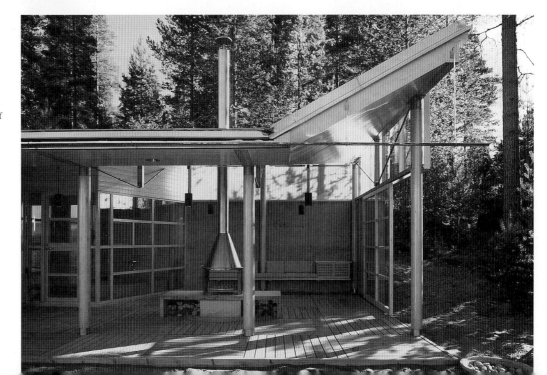

while the Church of the Holy Cross is located on the northern slopes of the valley, above the other side of Aleksanterinkatu. The two buildings represent opposing polarities in the urban fabric of Lahti. They do not actually face each other – the Saarinen Town Hall is approached from a small park to its east – but Aalto's Church of the Holy Cross certainly addresses the Saarinen building across the valley. This appears to explain the formality of the Aalto design: it responds decidedly to the axis established by the earlier master's building.

Bishop Henry's Church, on the other hand, is in a remote, suburban area of Turku. Although there is quite a satisfying religious space within its brick envelope (Figure 241), the exterior form of the church does not establish that sense of place Pitkänen achieved with his earlier Holy Cross Funeral Chapel in Turku. Both the Lahti and the Turku churches seem to be out of step with their own time. In the case of the Aalto design, this project of 1950 is understandably frozen in time. But Bishop Henry's Church seems lost in the architectural landscape of Turku. Having strayed from the monumental clarity of Pitkänen's Holy Cross design it presents a confusion in direction between Bryggman and Aalto. These untimely churches serve to remind us why it is that Reima Pietilä and Heikki Siren were so good at producing authentic Finnish religious architecture: in their different ways both Pietilä's and Siren's work reveals an understanding of the fusion between primitive rituals and their classicized formality within the Protestant puritan tradition. Although Aalto's Vuoksenniska Church is a finely tuned architectural entity, it is not a religious space in the sense that Siren's Otaniemi Chapel or Pietilä's Lieksa Church are and Pietilä's Malmi Church project promised to be.

1981 saw the emergence of a new phenomenon in Finnish architecture. It took the form of an attempt by some of Pietilä's former students[21] from Oulu University to emulate his irrational design strategies and therefore attracted the label of 'Oulun Koulu', or 'the Oulu School'. The formal characteristics of work by the Oulu School affect a

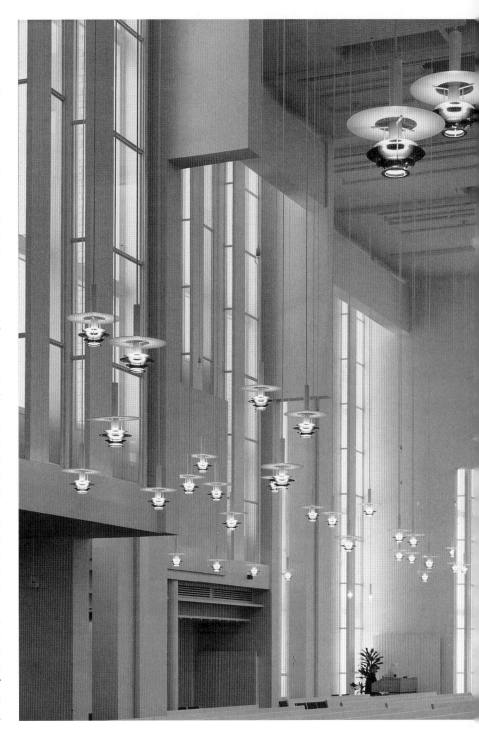

Figure 257
Juha Leiviskä
Myyrmäki Church, near Helsinki (1980–84): this example is stretched out, on a narrow site by a railway line. It is probably his most successful church, particularly in the quality of its interior form and lighting.

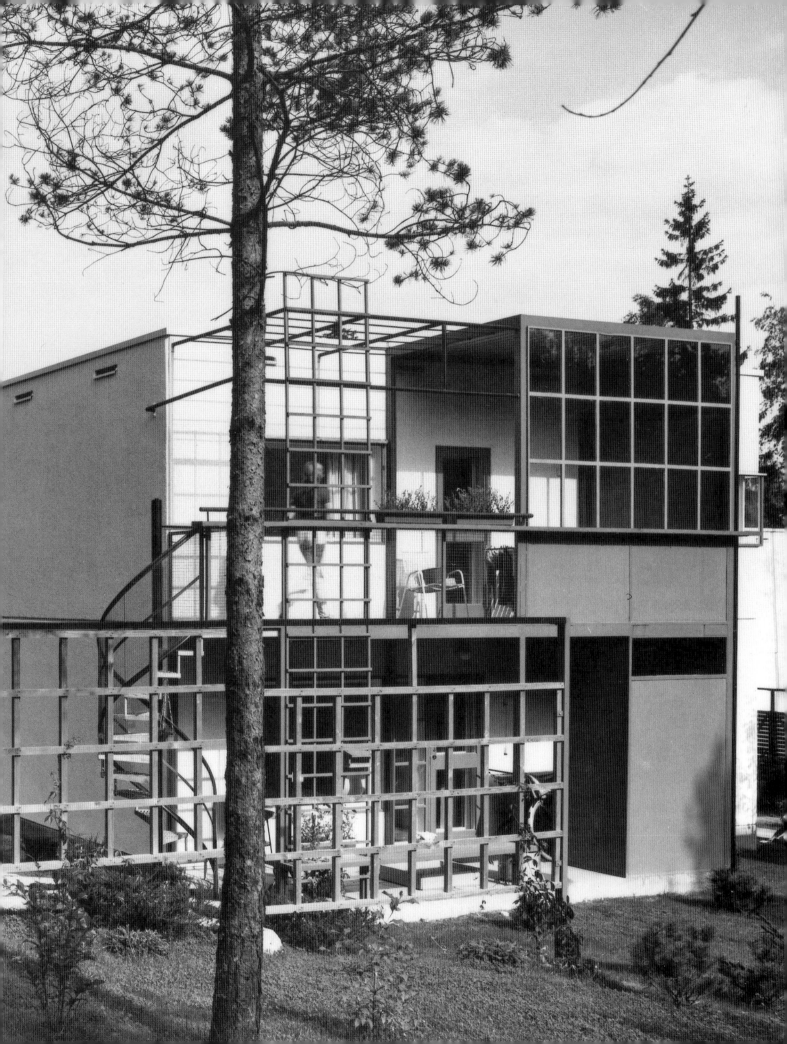

provincial modesty; the work is also characterized by a certain clumsiness of gesture that speaks the language of suburbia. Perhaps it is an indication of the architectural uncertainty of the 1980s that the Oulu School attracted so much attention. Compared with the work of the Oulu School, even the confused imagery of Pietilä's Hervanta Centre has a distinct clarity. In fact the school convincingly confirms Pietilä's assertion that all he is teaching are 'certain unlearnables'. Nevertheless, several of these modest works, by their extraordinary notoriety, became part of the architectural scene in the early 1980s. These include: the Oulunsalo Town Hall (1980–92) by Kari Niskasaari, Kalle Villanen, Ilpo Välsänen and Jorma Öhman; the Villa Ikla III project by Asko Jääskeläinen; Madekosken-ala-este by Heikki Taskinen (1980); the remodelling of the Salonkallio House by Osmo Jaatinen; the Day House Maxmo by Kalle Viljanen (completed in 1980); and the semidetached houses at Espoo by Mauri Tommila (1979–82).

The work of the Oulu School may be somewhat clumsy and suburban but it nevertheless has a vitality of its own. This stems from its achievement of a character and effect that are somewhere between Aalto's Seinäjoki or Pietilä's Hervanta Centre and the 'autonomous architecture' that Aalto sometimes advocated. Certainly, compared with the results of the Oulu School, Arto Sipinen's Raisio Town Hall (1977–81) lacks youthful vitality, seeming somewhat flat and second-hand in its imagery. The overall character of the Raisio building, but particularly its interior, represents an indecisively eclectic view of Finnish modernism; as though, for example, Aalto's ideas had been filtered not through Ervi and Penttilä but through the secondary apparatus of Jorma Järvi.

Simo Paavilainen is a bright architect of the younger generation, who has not yet found his true *métier*. He is an ardent acolyte of Finnish classicism in the 1920s.[22] An articulate analyst of the post-Robert Venturi climate in Finnish architecture, Paavilainen's designs are often appropriately inarticulate in their eclecticism, but he did enter a fine,

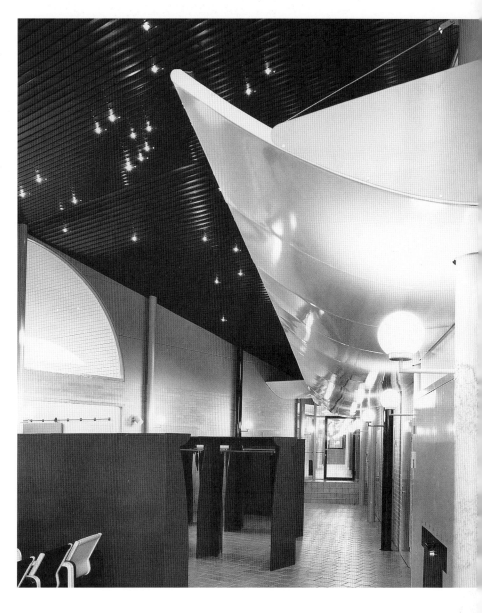

Figure 258
Erkki Kairamo, Juhani Maunala and Aulikki Tiusanen
Housing at Liinasaarenkuja, Westend, Espoo (1982): as with Leiviskä's work, an excellent case for the continuation of classic modernist influence from the 1920s and 1930s, only here is more evidence that 'Finland seems to be in a time warp'.

Figure 259
Käpy and Simo Paavilainen
New Parish Centre, Paimio (1982–85): Käpy Paavilainen is the daughter of Keijo Petäjä. This couple has consistently produced interesting solutions in recent years (including a second prize in the 1989 competition for the Institute for the Study of Health and Fitness in Tampere). At their best they are crisply and thoughtfully inventive.

Figures 260–262
Kari Järvinen and Timo Airas
Siiskonen House, Mikkeli (1985): the split axes of the plan stem from Alvar Aalto, although increased irregularity and particularization belongs more to the national romantic tradition. The expression, however, swings back to Aalto's 'autonomous architecture', which rides here again in the wilds of Mikkeli. This autonomous, barn-yard quality runs right through the house, reminding us of where Finland has been, of her rightful place in time's warp and weft.

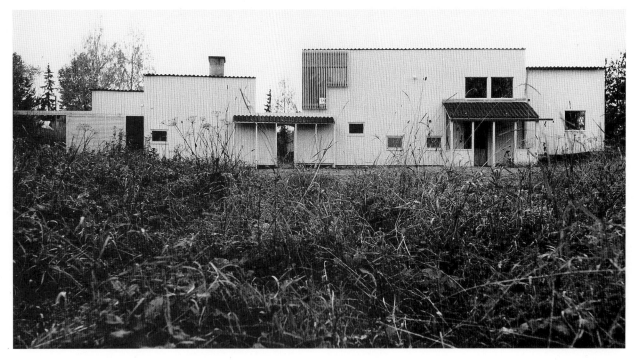

functionalist design for the UKK Centre, Tampere, competition (1981). In this project for a health institute named in honour of the late Finnish President, Urho Kekkonen, Paavilainen deservedly shared first prize with two pairs of entrants, Pekka Helin and Tuomo Siitonen and Antti Laiho and Jan Söderlund.[23] Helin and Siitonen won the commission and their design, an elegantly refined example of late modernism, was completed in 1984. The UKK Centre is certainly one of the landmarks of modern Finnish architecture in the 1980s, with great clarity of structure and form in its interior spaces.

The partnership of Helin and Siitonen represents one of the major forces in Finnish architecture of the 1970s and 1980s. Their work has an essential precision of form and detail, particularly in interior volumes. If we recall Lars Sonck's Stock Exchange atrium and Aalto's various transformations of this precedent in the National Pensions Institute atrium, Rautatalo *piazzetta* and the atrium of the Academic Bookshop, we can see the tradition to which Helin and Siitonen conform in their own use of natural light. Their UKK Centre is a particularly cogent example of the realization of internal structural clarity, the celebration of the building's skeleton, derived from the nineteenth-century precedent of introducing industrial lighting techniques, a characteristic of railway stations, libraries and art galleries that was the hallmark of work by such disparate personalities as William Cubitt, Henri Labrouste and Karl Friedrich Schinkel. Perhaps a closer inspiration for the work of Helin and Siitonen, however, is Gunnar Asplund's extension to the Gothenburg Town Hall (completed in 1937). The freedom and clarity of structural forms in the UKK Centre certainly echo those of Aalto in the National Pensions Institute and Vuoksenniska Church, but the spatial composition within which they exist suggests the broader canvas of Asplund's Gothenburg design.

In any case, the thoughtful work of Helin and Siitonen persistently recurs in Finnish architecture of the 1980s, in their Torpparinmäki Housing Project (1982),[24] for example, which restates the case for revisiting modernism and getting it right the second time. It is fashionable to argue that 'the people' really prefer faceless suburbia to a sense of place framed in the modernist idiom,[25] but in Finland there has always been popular support for the light and airy modernist conceptions characterized by such work as the Torpparinmäki Housing and, of course, Pietilä's Suvikumpu Housing at Tapiola.

Timo Penttilä's exclusive development of private apartments by the seashore on Hirviniemenranta, Kuusisaari (1980–82), reveals signs of post-modern classicism that is, frankly, surprising from this established modernist.[26] The scheme is well detailed, but is overly fastidious in its classical formality, with mannerist implications that are inconsistent with Penttilä's previously forceful and clear designs (Figures 161, 162). It could be said that Penttilä enters the debate of the 1980s with this building, but in doing so appears to have compromised his formerly clear position. This may be a result of his partnership at that time with Heikki Saarela, although Penttilä and Saarela were also jointly responsible for Hanasaari Power Station (1971–76; Figure 228).

The Paavola Old People's Home (1982) by Lauri Louekari and Kaarlo Viljanen provides an appropriate contrast to the somewhat pretentious Hirviniemenranta development, emulating a modest Finnish farmhouse that seems eminently appropriate for Finns retiring from the countryside.[27]

Other noteworthy work completed in 1982 includes: the Kuovala-Talo by Erkki Valovirta, which has a semifree plan form in the Aalto mode;[28] the AMF Building at Kivenlahti, Espoo, in the form of an amphitheatre by Heikki Koskelo and Simo Järvinen;[29] and the housing development at Liinasaarenkuja 3-5, Westend, Espoo (1982) by Erkki Kairamo, Juhani Maunala and Aulikki Tiusanen,[30] which offers evidence of a new modesty of approach in housing (Figure 258), in the mode established, for example, by Bryggman's Kaarina house.[31]

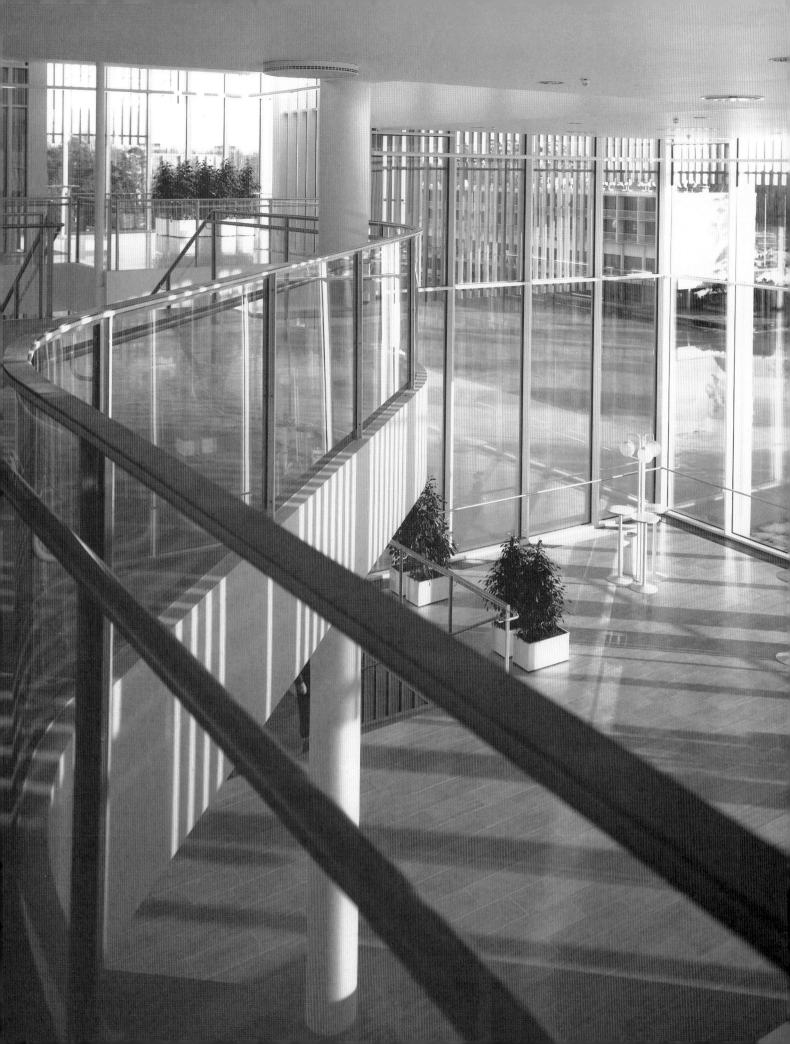

Already we can see, at the beginning of the 1980s, a return to the Finnish sense of delicate forms and refinement of detail, as evidenced in particular by the work of such offices as Helin and Siitonen and Nurmela/Raimoranta/Tasa. This stands in strong contrast to the general international production of bland, large-scale masses that are boringly repetitive. The competition entry by Nurmela/Raimoranta/Tasa for the Kuhmo Central Library (1982–84),[32] with its intriguing plan form, is a good example of this new sensitivity: significantly, too, they received first prize (Figures 244 and 270).

In an article published in 1985 entitled 'The place of man: time, memory and place in architectural experience', Juhani Pallasmaa wrote:

'Now that the art of building is sinking under the payload of practical demands, Bachelard's phenomenological 'Pure scrutiny' or 'scrutiny of being' (see *The Poetics of Space*, 1958) once again pinpoints the heart of architectural experience. The increasing anonymity of building in the industrialized world and its detachment from the human being force one to ponder the interaction between the human mind, culture and building. As building seems to be increasing human alienation, rather than offering a sense of home, there is good cause for analysing the basic experiences that relate to buildings through thought and language.'[33]

This sentiment seems to reflect precisely the new climate in Finnish architecture of the 1980s, a climate for which Reima Pietilä fought so tenaciously throughout the 1960s. It is evident also in Kristian Gullichsen's Malmi Church, which exploits once more, although on a larger scale, the fine spirit of Finnish brickwork and carpentry so successfully revived by the Sirens in the Otaniemi Chapel.

In February 1981, *Arkkitehti* published a discussion between Risto Iivonen, Juha Leiviskä and Marja-Riitta Norri, entitled 'Instruments of light',[34] which focused attention on the talents of Juha Leiviskä. His work, mostly concentrated so far in

Figure 263
Arto Sipinen
Cultural centre for Tapiola (1985–89): for description, see p. 205.

Figures 264–266
Kari Järvinen and Timo Airas
School for Suna (1987): this very direct design translates the autonomous regionalism of the Siiskonen House into the nature of a public building but, more importantly, a learning environment. Attention is given to durable, no-nonsense detailing, particularly with the natural daylighting – always important in near-Arctic Finland – and here stunningly successful.

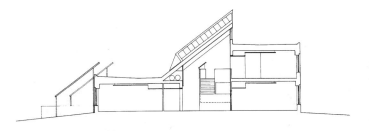

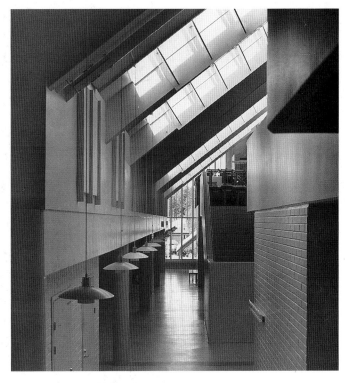

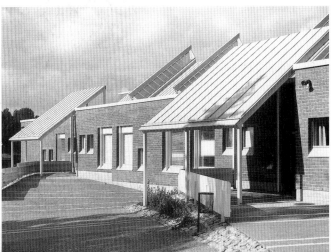

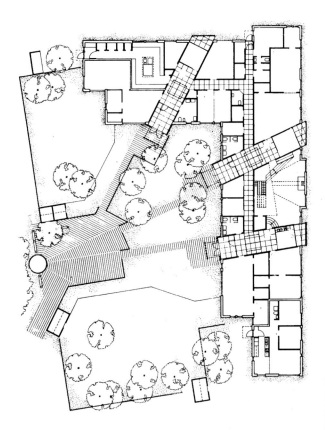

Figures 267 and 268
Nurmela/Raimoranta/Tasa
Lippajärvi Daycare Centre (1983): in this very sympathetic early design, the partnership set out to achieve a friendly, domestic scale. Clearly ordered by a series of angled counter axes, its apparently simple form is obviously the product of much careful thought. This result is in marked contrast to the firm's later work.

church design, shows another transformation of Aalto's heritage in the harnessing of natural light within buildings. The Kirkkonummi Parish Church and Centre (1980–83) is a typical example of Leiviskä's delicate layering of screens and light fixtures within the church interior, to achieve a haunting luminosity that is at once spiritual and 'natural' (Figure 255).[35] His success as an architect, following in Aalto's footsteps, is to interfere as little as possible with the relationship between the basic constructional form of a building and our perception of that form. He certainly adheres to the techniques of filtering and directing light perfected by Aalto; just as his formal approach derives from De Stijl models and the modular ideas of Aulis Blomstedt and Pietilä. The promise of his early design for St Thomas's Church, Oulu (1970–75; Figures 221, 222) was certainly fulfilled in the 1980s.

We can understand Leiviskä's buildings within an established tradition of modern Finnish architecture, a tradition that links Finnish culture with selected aspects of modernism, and as an evolution of forms rooted in the Finnish sensitivity to materials, form, space and light. Leiviskä's churches use these 'instruments' to construct a vibrant and sensitive architecture, creating a geometry of feeling to which we can respond. We can readily analyse these forms and spaces, identifying specific sources in Aalto and De Stijl. In particular, Leiviskä's debt to Aalto in his manipulation of natural light is evident, but the resulting 'atmosphere' of Leiviskä's buildings remains elusive and unique. Although there is a quite determined similarity running throughout his various designs, a formal theme that transforms De Stijl intentions into a more subtle, humanized geometry, and one can also detect classical patterns of repetition and variation in his work, Leiviskä's formula – like that of classical music – is not at all boring. His variations and repetitions are within the 'tradition' of Pietilä's Suvikumpu Housing at Tapiola. Or, as Leiviskä himself might say, within the tradition established by the variations in Haydn's late string quartets.

Figure 269

Aarno Ruusuvuori

Remodelling and Extension, City Hall, Helsinki (1970–88): from the street these alterations are necessarily invisible, and only an aerial view reveals the internal courtyard changes. But once inside the building, Ruusuvuori's immaculate command of the classic modernist idiom asserts itself with a broad but accommodating confidence. It is impossible to imagine post-1950s' Finnish architecture without the special gifts and contributions of Ruusuvuori.

If we come to expect a certain treatment or effect of light or surface in a Leiviskä design it is with the same eager anticipation generated by an Aalto interior. In the same way that we can identify an Aalto or Pietilä design, we easily spot the Leiviskä hallmark. Leiviskä's work is a welcome addition to new Finnish architecture of the post-Aalto period and, interestingly, it corresponds with Pietilä's first premise for the future of architecture, 'that formed between 1900 and the 1920s'. In that connection, also there appears to be a direct link between Leiviskä's church interiors and Frank Lloyd Wright's Unity Temple (completed in 1906).

Juha Leiviskä's commission to design the new German Embassy in Helsinki (1986–93) was won in competition. It provided him with an opportunity to vary his formal themes in response to a different set of functional requirements. Also, because the exterior of an embassy is an announcement of national identity, the external composition and massing suggests a different approach from Leiviskä's normally self-effacing planar treatment. The German Embassy site offers a beautiful and challenging context for these further transformations of Leiviskä's use of the modern tradition.

In 1982 not only was Pietilä's Lieksa Church completed, but the Suvituuli additions to the Suvikumpu Housing at Tapiola were also finished, including a delightful corner flower shop.[36] The continuation of this 1960s project, together with the consolidation of Leiviskä's position, clearly demonstrated a re-examination of 1920s' modernist ideals. This tendency was confirmed by two housing developments completed in 1983. The first of these is the Asunto-Oy Hiiralankaari scheme at Westend, Espoo by Erkki Kairamo (Gullichsen, Kairamo, Vormala),[37] while the other is one of Jaakko Laapotti's most successful designs, the housing for Asunto-Oy Haukitanner at Espoo.[38]

In contrast, 1983 also brought the completion of two buildings by Heikki Taskinen, a member of the Oulu School: the Oulunsalo Upper

Finnish Architecture and the Modernist Tradition

Comprehensive School;[39] and the Madekoski Lower Comprehensive School.[40] The design of the Madekoski School exhibits a number of postmodern influences interestingly combined with clear references to the work of Aalto and Erik Bryggman.

In the area of theatre design, 1983 again brought two striking contrasts. The Jyväskylä City Theatre, which has its origins in Alvar and Elissa Aalto's proposals for the Jyväskylä Administrative and Cultural Centre of 1964 and 1970, was completed by Elissa Aalto with interiors by Pirkko Söderman.[41] In Lahti the new City Theatre by Pekka Salminen was also finished.[42] The Aalto theatre has no surprises: it seems fair to regard this posthumous work as a formula reproduction of his intentions as expressed in earlier buildings. Salminen's Lahti City Theatre, on the other hand, is a vigorous example of Finnish industrial expression in the mode established by Viljo Revell, Aarno Ruusuvuori, Gullichsen, Kairamo, Vormala and Jaakko Laapotti. Compared with the tired imagery of the Jyväskylä City Theatre, the Lahti building seems to reflect that city flexing its technological muscle power.

The Valio Headquarters Building (Figures 234–237) continued into the 1980s the high standard of the company's commissions established under the direction of Matti K. Mäkinen during the previous decade. Among its most significant buildings is the Valio/Maikkula Plant at Oulu (completed in 1984),[43] a determinedly modernist design, with a lighter approach to detailing than was characteristic of Mäkinen, producing a sense of freshness in the finished buildings.

In 1984 Helin and Siitonen won first prize in the competition for the headquarters building of a new Finnish industrial technology giant, the Nokia Company, on a site at Keilalahti just outside Helsinki.[44] Their project has an extremely well integrated plan with great clarity in the composition of the pavilions. This design is comparable in scale to Mäkinen's Valio Headquarters Building. Its strongest influence, however, appears to have been the planning and formalism of Louis Kahn's 'interpretive' modernism. The Helin and Siitonen Daycare Centre, also completed in 1984, reveals in contrast the strong influence of Aalto's design strategies.[45]

Significantly, *Arkkitehti* carried not only Pallasmaa's essay 'The place of man' in 1985, but also an extensive review of Christian Norberg-Schulz's book *Dwelling and Existence*.[46] In reviewing the buildings completed that year, however, evidence of a 'geometry of feeling' and the creation of 'a sense of place' is not overwhelmingly present. Neither Simo Paavilainen's Paimio New Parish Centre (completed in 1985; Figure 259)[47] nor his Ala-Malmi Square[48] proposal offer either of these qualities. The Paimio Parish Centre does have an almost whimsical delicacy, not unlike some of the romantic classicism to which the architect is so attached. Also, the Malmi Post Office by Nurmela/Raimoranta/Tasa (1983–84) attempts to develop a rather precious formality for this modest suburb, losing a sense of place to an overly conscious use of classical imagery, when a robust reference to *archittetura minore* might have been more appropriate (Figure 245).

The Main Building for Joensuu University (1982–85) by Jan Söderlund, Erkki Valovirta and Risto Marila is much more successful.[49] Although it derives its inspiration from Aalto, in particular from the Main (auditorium) Building at Jyväskylä University (1952–57), this building is not at all a tired replay of exhausted Aalto themes. The plan is compact and clean, while the massing and fenestration are refreshing in the variety they achieve using simple, restrained means. This is one of the outstanding Finnish brick buildings of recent years and bears comparison with Aalto's best brick architecture of the 1950s. A lesser work, but still a very competent example of Finnish brick expression is the Tampere Workers' Theatre (completed in 1985) by Marjatta and Martti Jaatinen.[50] This is a bulky building, with its sometimes awkward massing exaggerated by over-zealous detailing, but it is well-anchored to the street and makes a forceful contribution to the urbanity of Tampere.

Figure 270

Nurmela/Raimoranta/Tasa Library at Kuhmo (1982–84): the plan is a curious amalgam of an Aalto *parti*, where a regular ordered baseline is established to carry more expressive elements, and an array of such forms that have nothing in common with either Aalto or the history of modernism. (For interior, see p.198.)

Figures 271 and 272
Nurmela/Raimoranta/Tasa
Commercial Centre, Pori (1987–89): this is already post-postmodern classical, and on now to the derisive destruction of modernism (including art deco, of course, if it happens to get in the way). Not much time warped here, although everything else certainly is. (See also p. 199.)

Another mainly brick building of note is Kuusankoski House, the adventurous cultural centre for the small industrial town of Kuusankoski (population 23 000) by Bronow and Maunula.[51] Like the work of Arto Sipinen it clearly takes some of its inspiration from Aalto, but the Kuusankoski House is a much more articulate transformation of Aalto's forms (as at Jyväskylä University and Helsinki Technical University in Otaniemi) than Sipinen's Raisio Town Hall. Sipinen's 1985 design for the Tapiola Cultural Centre adjacent to Aarne Ervi's Tapiola Central Tower is, however, a much more considered building, with strong references in its external massing to those premises worked out during the De Stijl period of the 1920s. This elegant and well-detailed centre, adjacent to the town lake and fountains, was completed in 1989 (Figures 253, 263).

The University of Oulu Botanical Gardens and Greenhouses by Kari Virtä and Matti Rotko were completed in 1983.[52] Their design is thoroughly rooted in the nineteenth-century greenhouse tradition, with updated technology. The gardens lie on the shore of Lake Kuivasjärvi at the north end of the Linnanmaa campus and, although primarily intended for teaching and research purposes, are open to the public. The greenhouses are pyramid-shaped, so plants of differing heights may be grown without overshadowing one another. Construction is steel, mainly covered with a plastic material, which allows light through but whose cellular structure obviates the necessity for blinds. Heat, humidity and ventilation are regulated automatically throughout, with the pyramids divided into sections by climatic zone, each with its own temperature and humidity control. This design is a brilliant anticipation of Emilio Ambasz's San Antonio Botanical Gardens (completed in 1988).

Again echoing Pietilä's premises worked out between 1900 and the 1920s, we turn once more to Juha Leiviskä, whose Myyrmäki Church and Parish Centre was completed in 1984.[53] The long narrow site lies below the local railway station and embankment. It is also the only piece of parkland in the centre of the Louhela suburb. By concentrating the building and access in a long narrow complex that hugs the embankment, most of the site has been retained as a park. The complex is identified by a wall that rises gradually south towards the church and belfry, an arrangement that challenges the dominance of the railway station; it also stimulates a dialogue between church, station and surroundings. The principal rooms open onto the park.

An ingeniously simple plan form generates Leiviskä's architecture at Myyrmäki. Every aspect of space and detail stem from this plan idea. All possible variations of daylight conditions are exploited. The rooms appear quite different at various times of the day and in each season, changing dramatically with sun or cloud. A shimmering, continuously changing veil of light was the objective, engendering a dynamic of large and small, high and low, light and shade variations suggested, says Leiviskä, by the contrasts between a Mozart string quartet and the opening of Bach's B Minor Mass. The long, high wall parallel to the railway is the backdrop for the altar, giving a church plan that is short and wide. This makes it acoustically good for speech and excellent for music. All the rhythms of plan and formal composition seem musical in their inspiration. The result is a scintillating study in form, material and light (Figure 257).

Kristian Gullichsen's description of the Pieksämäki Cultural Centre project,[54] designed by Kristian Gullichsen, Timo Vormala, Eeva Kilpiö and Kimmo Friman (1985), is interesting as a marked contrast to Leiviskä's approach:

'Pieksämäki has all the features of an urban centre that has developed around a railway junction. The townscape is horizontal and loosely built, like many other country centres. The landscape lacks any topographical accents. The beautiful lake, with its shallow shores opening up from the heart of the town, underlines the peaceful horizontal line of the setting. The plan for the cultural centre used this setting as its basis…

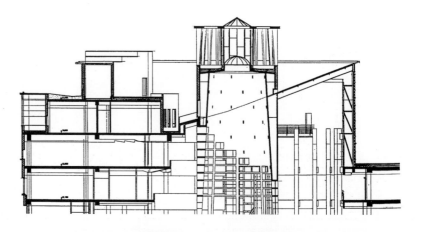

The centre is arranged like a farmhouse: in the middle is the hall, flanked by a kitchen/living room and a bedroom. Its manor house style has imposing motifs borrowed from the treasure chest of classical tradition along its 'public' side and a veranda on the side facing the park that is inviting and sociable. The long tripartite street side embodies a train metaphor in the Pieksämäki spirit, though there are also motifs from the Renaissance palace, together with a forecourt. The axis of its symmetry, imperfect like a flounder's, ends with a blazing open fire, the symbol of hospitality…

The long east wall acts as a boundary between the urban space and the landscape; through its entrances the building converses with the landscape. At the north end of the wall there is a watchtower with a moat looking out towards the lake. The tower contains a children's story room and adult reading corner.'[55]

There is something absolutely authentic about Leiviskä's transformations of the premises 'formed between 1900 and the 1920s'. We see and understand their relationship with the interventions that modernism has made in the historical process; his contribution to the evolution of the new 'tradition' is crystal clear. If, on the other hand, we take Gullichsen's account of the Pieksämäki design as an explanation of how Finnish architects were working things out in the 1980s, then there are difficulties with the coherence of the narrative.

Of course, as Pietilä observed, the spectrum of design sources is open-ended and unlimited. What he does not mention, but it seems clearly inferred in his own narratives, is the fact that simple nostalgia cannot either reconstruct the past or construct the future. It is clearly possible to reconstruct modernism, advancing its tradition as Leiviskä does by his precise use of the modernist De Stijl precedent.[56] Gullichsen's selection of precedents, however, suggests a more open tracing of historicism than applied in the confused eclecticism of early twentieth-century Finnish work. In working things out as we approach another *fin de siècle* it seems imperative to have strategies other than a packaged nostalgia of pre-modernist forms and values.[57]

References and notes

[1] Malcolm Quantrill, 'Après Aalto une nouvelle vague?', *Architectural Design*, Vol. 49, No. 12, 1979.
[2] *Arkkitehti*, 1977, No. 6, pp. 14–19.
[3] *Arkkitehti*, 1977, No. 8, pp. 16–27.
[4] *Arkkitehti*, 1978, No. 7, pp. 18–27.
[5] *Arkkitehti*, 1978, No. 1, pp. 42–45.
[6] *Arkkitehti*, 1979, No. 1, pp. 24–30
[7] *Arkkitehti*, 1979, No. 4, pp. 30–36.
[8] *Arkkitehti*, 1977, No. 5, pp. 24–28.
[9] Malcolm Quantrill, *Reima Pietilä: one man's odyssey in search of Finnish architecture*, Building Books, 1988, pp. 56 and 61.
[10] *Arkkitehti*, 1978, No. 1, pp. 51–61.
[11] *Arkkitehti*, 1978, No. 4, pp. 37–41.
[12] *Arkkitehti*, 1978, No. 5–6, pp. 20–36.
[13] *Arkkitehti*, 1979, No. 2, pp. 22–27.
[14] *Arkkitehti*, 1979, No. 5–6, pp. 44–53.
[15] *Arkkitehti*, 1980, No. 3, pp. 30–33.
[16] *Ibid.*, pp. 34–39.
[17] *Ibid.*, pp. 40–45.
[18] *Arkkitehti*, 1980, No. 7, pp. 22–25.
[19] *Ibid.*, pp. 26–31.
[20] *Ibid.*, pp. 42–45.
[21] *Arkkitehti*, 1980, No. 8, pp. 18–21.
[22] *Arkkitehti*, 1981, No. 1, pp. 40–43.
[23] *Ibid.*, pp. 27–31. Simo Paavilainen, 'Martti Välikangas ja 1920-luvun klassismi Käpylässä'.
[24] *Arkkitehti*, 1981, No. 5, pp. 42–50.
[25] J. Bishop, *The Best of both Worlds: public and professional views of a new town*, Bristol University, 1986.
[26] *Arkkitehti*, 1981, No. 6–7, pp. 48–53.
[27] *Arkkitehti*, 1982, No. 2, pp. 48–53.
[28] *Arkkitehti*, 1982, No. 3, pp. 36–39.
[29] *Arkkitehti*, 1982, No. 7, pp. 26–33.
[30] *Arkkitehti*, 1982, No. 8, pp. 24–31.
[31] *Ibid.*, pp. 32–39.
[32] *Ibid.*, pp. 60–61.
[33] *Arkkitehti*, 1984: competition supplement.
[34] *Arkkitehti*, 1983, No. 1, pp. 26–34.
[35] *Arkkitehti*, 1981, No. 2, pp. 64–65.
[36] *Arkkitehti*, 1983, No. 4, pp. 40–43.
[37] *Arkkitehti*, 1983, No. 8, pp. 52–57.
[38] *Ibid.*, pp. 58–63.
[39] *Ibid.*, pp. 64–66.
[40] *Arkkitehti*, 1983, No. 7, pp. 56–61.
[41] *Ibid.*, pp. 62–65.
[42] *Arkkitehti*, 1983, No. 5–6, pp. 46–53.
[43] *Ibid.*, pp. 54–64.
[44] *Arkkitehti*, 1984, No. 1, pp. 72–77.
[45] *Ibid.*, pp. 80–86.
[46] *Arkkitehti*, 1984, No. 8, pp. 62–67.
[47] *Arkkitehti*, 1985, No. 1, pp. 22–27.
[48] *Arkkitehti*, 1985, No. 4, pp. 30–38.
[49] *Arkkitehti*, 1985, No. 3, pp. 60–62.
[50] *Arkkitehti*, 1985, No. 8, pp. 20–29.
[51] *Ibid.*, pp. 58–65.
[52] *Ibid.*, pp. 46–57.
[53] *Ibid.*, pp. 30–33.
[54] *Ibid.*, pp. 36–45.
[55] *Ibid.*, pp. 66–67.
[56] *Ibid.*, p. 79.
[57] See Kenneth Frampton, Karsten Harries, Christian Norberg-Schulz *et al.*, contributions to the inaugural CASA international symposium on 'Constancy and change in architecture', held at Texas A&M University, 12-14 April 1989, published as *Constancy and Change in Architecture* (Texas A&M University Press, October 1991, eds. Malcolm Quantrill and Bruce Webb).

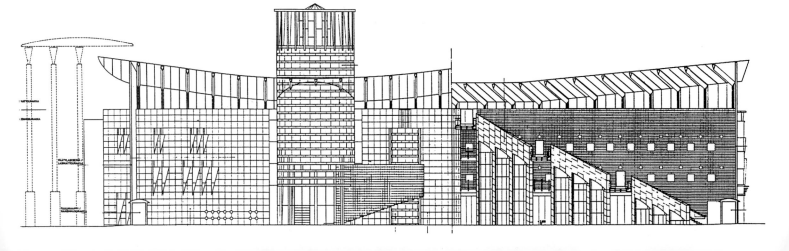

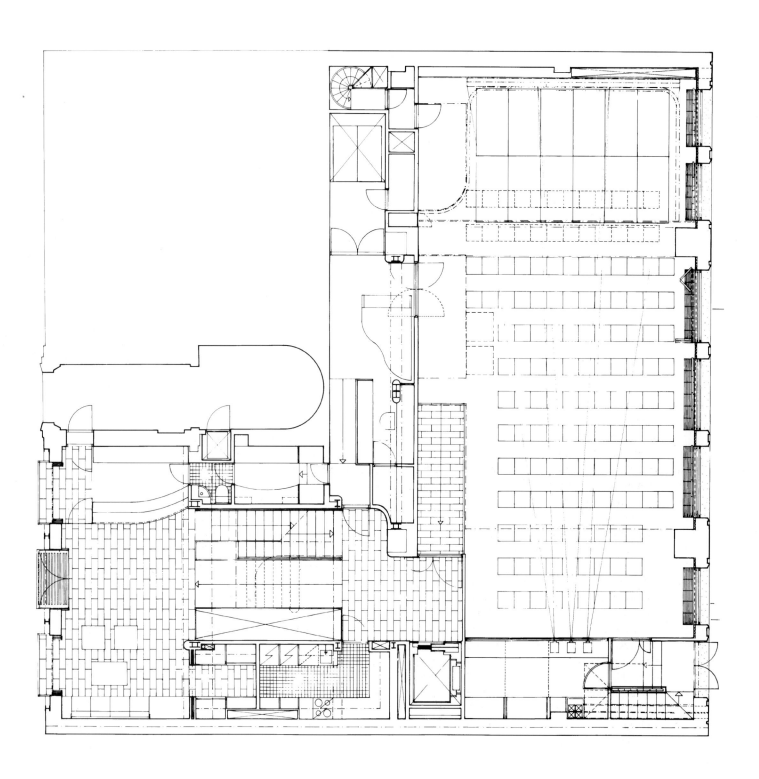

9 Fin de siècle

I set out to trace and describe a particular phenomenon in this study, Finnish architecture in the twentieth century, and to identify its peculiarities. In this I have leaned heavily on my previous explorations of the work of Alvar Aalto and Reima Pietilä.[1] But, importantly, I have stressed also the contributions made throughout the century by other significant architects, notably Lars Sonck, Eliel Saarinen, Erik Bryggman, Pauli Blomstedt, Oiva Kallio, Hilding Ekelund, Aarne Ervi, Viljo Revell, Heikki and Kaija Siren, Aarno Ruusuvuori, Pekka Pitkänen, Mikko Heikkinen and Markku Komonen, Erkki Kairamo, Kristian Gullichsen, Juha Leiviskä, and Pekka Helin and Tuomo Siitonen.

After four decades of contact with modern Finnish architecture, the architecture that is cradled in the century between the 1890s and 1990s, I still vividly recall my first meeting with Alvar and Elissa Aalto at Muuratsalo in 1953. On that first visit to Säynätsalo and Muuratsalo, I was surprised to find that Aalto's version of modernism in the 1950s had an element of familiarity about it. I was neither sufficiently knowledgeable nor experienced as a young student to make the connections between Aalto's new buildings and those of the Dutch architect, Willem Dudok, which I had seen in Hilversum five years earlier. Nevertheless, I must have sensed intuitively that the brick tradition within which Aalto was working in central Finland stretched back across the entire Baltic region and through Denmark, Germany and The Netherlands to connect with my own roots and the art of brickwork as practised in my native Norfolk. One might say that I was caught up then, in 1953, in the web of a mystery, only I was unaware at the time of the mysterious phenomenon of Finnish architecture in which I had become entangled.

Essentially, this web of mystery about modern Finnish architecture inhabited the forest landscape – where I had first experienced it – and only impinged infrequently on the scattered traces of urban form to be found in Helsinki, Turku, Tampere and Jyväskylä. Also being a forest web of mystery, strung from tree to tree, it contains its own primeval silence. Can this silence be broken, some words be uttered to offer clues about the hidden meanings in the forest undertow? Not according to Berthold Brecht, who pronounced that 'The Finns are silent in two languages'. Did this mean that we were to be left without answers to our questions: 'What is unique about Finnish architecture?' and 'What constitutes its Finnishness?' Certainly, Aalto was virtually silent on these issues, offering only a few poetic nuances and some semitechnical directives. Pietilä, on the other hand, dared to break the culture of Finnish silence and became the most talkative architect since Le Corbusier.

In the final analysis, however, Pietilä's buildings – the Brussels Pavilion, Kaleva Church, Dipoli Student and Conference Centre, Suvikumpu Housing, New Delhi Embassy – and projects such as the Malmi Church, are more persuasive. Not that the text, the jottings, the seemingly endless garrulity are unhelpful. But it's like sifting the forest floor for clues about its mystery. So, in the end, Pietilä fits as perfectly as any protagonist into our *fin de siècle* scenario, for he is in John Irwin's terms a 'mystery towards a solution' rather than the other way about. This inversion of the rational process, an 'inverse rationality', also places Pietilä (at least partially) in the terrain of postmodernity and that may very well be the reason most postmodernists have been so vehemently opposed to both his work and his ideas.

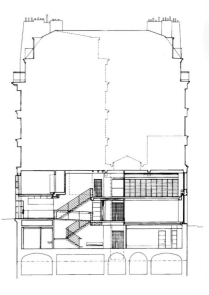

Figures 273 and 274
Juhani Pallasmaa
The Finnish Institute, Paris (1992): an elegant plan and a slice of Finland fitted deftly into an existing building frame. There are echoes here of Alvar Aalto in the use of wood, the Japanese influence etc. Although precisely tailored and taut, this does not owe a debt to Mies van der Rohe; rather it reminds one of the best of Viljo Revell.

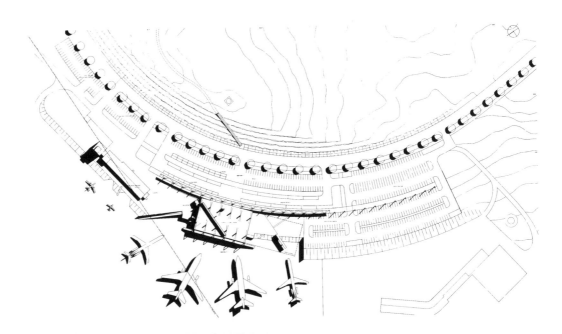

Reima Pietilä came close to being a great architect: the interior space of Kaleva Church at Tampere (Figure 200) and of the President's Residence at Mäntyniemi (Figure 160) speak of that greatness; the exterior form of the Dipoli Centre confirms it; and the interior quality of Lieksa Church supports his case. His buildings are always provocative, raising issues about the relationship of architecture with nature and with culture that many did not want raised. In terms of built works he was silenced for almost a decade, but no one could stop his mind working or his tongue wagging wittily. Two of his most poignant statements of the 1980s focused on the profession – 'In the Ark of Architecture, all the architects are crowded into the prow of the ship so they can see where they are going. Meanwhile, there is nobody in the stern to take care of the steering!'; and on the future – 'From this point on (the mid-80s) architecture can take two different directions. Either it can look back to those unused revolutionary sources of the 20s; or it can develop out of today's resources – out of our own time.'[32]

As we have seen, Pietilä turned back in his final building – the President's Residence at Mäntyniemi – not to the 1920s of De Stijl and constructivism but to his own imagery of the 1960s, of the Dipoli Centre and Malmi Church. But his fellow Finnish architects have been fairly faithful to his prescription, either seeking inspiration in the ideas of the 1920s or mining the more immediate resources of our own epoch.

We are still too much enclosed in the 1990s to have the necessary perspective for a true assessment of what current developments imply. All we can do is take a sampling of the more interesting work going on and let that stand as a banner while we approach another *fin de siècle*. Thus, the small group of architects whose work is highlighted in this study represent the conceptual quality and an essentially Finnish attention to detailing of the built product.

For the first gesture, we turn to Kristian Gullichsen of Gullichsen, Kairamo, Vormala and his taut, elegant extension to Frosterus's Stockmann Department Store (1985–89). For almost half a century, from about 1912 until the mid-1950s, Frosterus himself worked on proposals to extend his original building over the entire Mannerheimintie block. In addition, Aalto designed a number of unbuilt projects for the Stockmann extension between 1955 and 1966. Both Frosterus and Aalto chose to demolish the eclectic, Flemish-style, nineteenth-century Argos Building on the corner of Mannerheimintie and Esplanadi, one of the most prominent intersections in Helsinki's downtown area. Subsequently, the Argos Building attracted the attention of conservationists with the result that very few competitors in the first stage of the Stockmann Extension competition (1984) chose to destroy this nineteenth-century landmark (formerly the headquarters of the architectural supply company, Wulff). All six competitors chosen for the second stage of the competition preserved the Argos Building in their original entries. Gullichsen's glass façade to Keskuskatu complements Frosterus's weighty brickwork by recalling the glass dreams of the 1920s and 1930s while his constructivist tower at the corner makes clear the challenge embodied in his surface harmonics.

For the rest, a word or two has to suffice, leaving the work to speak for itself or convey its purpose through a material silence of immateriality. So, the new Finnish Embassy in Washington (1989–94) by Mikko Heikkinen and Markku Komonen blows clean as a whistle through the ghosts and shadows of the neoclassical American capital. Juhani Pallasmaa's Finnish Institute in Paris (completed in 1992; Figures 247, 248, 273, 274) revives again the French revolution in the architecture of the 1920s and 1930s, carrying the Finnish flag into the affray as Aalto had done in 1937 with his 'Le bois en marche' pavilion for the Paris World's Fair. And at home, Pekka Helin and Tuomo Siitonen began this revolution all over again with a building focused on change – the Centre for Changing Exhibitions. Scheduled for completion in the mid-1990s,

Figures 275 and 276
Heikkinen and Komonen
Airport for Rovaniemi (1988–92): both the clarity of planning, and the bold, straightforward detailing of the interior are characteristic of the experienced intelligence of this partnership. Markku Komonen was formerly head of the exhibitions department at the Museum of Finnish Architecture, where he was clearly a close observer of the world at large.

Figures 277 and 278
Heikkinen and Komonen
European Film School, Denmark (1989–93): all the elements in the composition of this project are basically rectangles. Some are curved to fit into the radial wing: these and the main pavilion are impacted by elements of square or rectangular plan. The outdoor amphitheatre is an exception, being almost a quadrant of a circle. The progress of these elements across the site generates a choreographed, kinetic effect. The central hall of the school (combined with the cafeteria) is interesting in that its formal discipline recalls the 1930s work of Pauli Blomstedt.

the Centre stresses *techne* as technology as building – as did their earlier Murikka Metalworkers' Training Centre.

Possibly the boldest export of Finnishness, of Finnish imagery, indeed a veritable 'literal morphology' (to use Pietilä's term) of rock-rift landscape, was the Monarch group's Finnish Pavilion for the 1992 Seville World's Fair. This is an incredibly bold yet simple design, which converted the giant cleft between rockfaces that was its inspiration into two shells – one of wood like a ship's hull and the other a steel-framed box to which the first is 'moored'.

Why does Scott Poole, in *The New Finnish Architecture* (1992) comment: 'Oddly enough, it was Reima Pietilä's Pavilion for the Brussels World's Fair in 1958 that displayed the rational and constructive approach that was to dominate architectural thinking for over a generation in Finland.'?[3]

What, in fact, is odd is that, with the exception of one other incomplete reference to Pietilä's explanation of the origins of his Malmi Church project (1967), Poole ignores Pietilä's important oppositional theory and practice in the over-rationalized 1960s and does not illustrate Pietilä's work at all. Poole's quotation from Pietilä includes only the first half of Pietilä's narrative describing the genesis of the Malmi design, referring to the arrival of the Pietiläs' cat, Missukka, on the architect's drawing board, causing him to accept 'the form language of its own physiognomy for my free form sketch...', drawing 'a pencil line around the shape of the cat's body; fixing its configuration on my plan.' Having drawn the unwary traveller, too, off the track, Pietilä significantly went on to say:

'Malmi also has another precedent in its idea – 'Siirtolohkare', a boulder standing isolated by glacial ice. There are many examples of such rocks scattered around Finland, the result of a glacial dislocation from their original 'mother rock'. Malmi Church could express this human dislocation metaphorically.[4]

So, it was not so much a question of 'oddly enough' but more one of 'not surprisingly' that Pietilä's Brussels Pavilion provided the rationale and the constructive force behind a whole decade of Finnish work. After all, Pietilä himself expained that: 'My Brussels idea... came from Blomstedt. It was an idea for making Finnish architecture natural and intellectual at the same time.'[5]

That was the triumph of Pietilä's Brussels Pavilion. It really did promise, and even fulfilled the promise, of a new spirit and new mould for modernism. Sadly, exhibition pavilions are ephemeral structures, they are with us only briefly and then often forgotten. Oddly enough, as Poole would have it, some are more often forgotten than others. It is certainly interesting that we still recall quite coherently both Aalto's 1937 Finnish Pavilion for the Paris World's Fair and his 1939 design for New York. The reason for this is quite simple. We are repeatedly bombarded with images of these two pavilions in books and other publications, whereas, although Poole refers to Pietilä's Brussels Pavilion in his text for the Monarch group's 1992 Seville Pavilion, he does not illustrate Pietilä's design. Perhaps this is what he means when he calls his introductory essay for *The New Finnish Architecture*, 'The construction of silence'.

Let us examine here Poole's use of misquotation, or rather quotation misapplied. For, in relating the idea of the Brussels Pavilion to Monarch's Seville Pavilion, while ignoring the glacial isolation of the *Siirtolohkare* – the rock dislocated from its mother – Poole seems to miss the whole point of the connection between Pietilä and the Monarch design.

In the 1980s a group of Professor Pietilä's former students at the University of Oulu bravely decided to follow the difficult and slippery path of their master. The resulting work of the Oulu School offered only a rough approximation of his design strategies. The reason for this, it appears, is that these former students sought their inspiration from the work itself rather than from Pietilä's commentary – the text. It is all to easy to misread

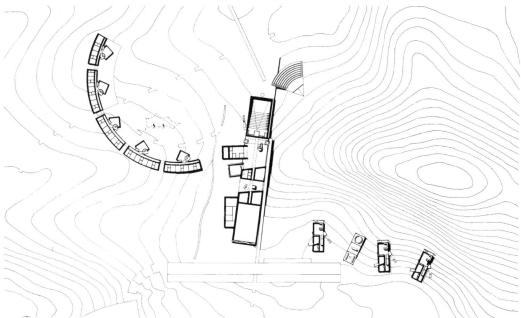

Fin de siècle

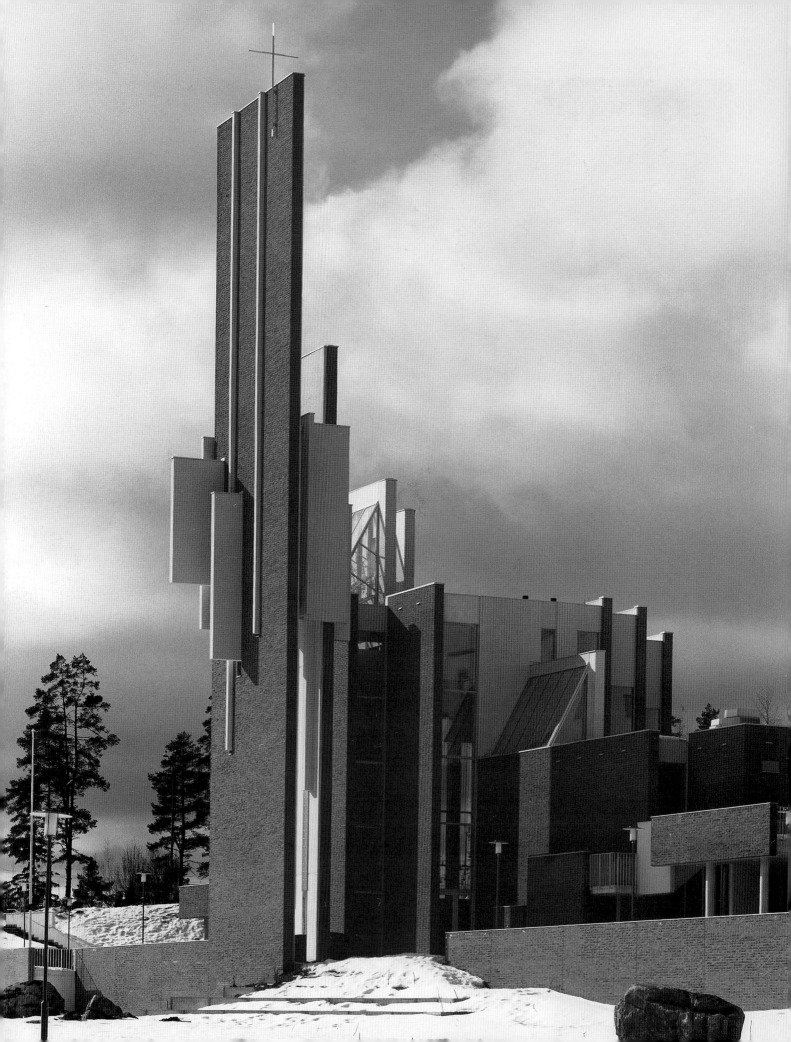

Figures 279–282
Juha Leiviskä
Männistö Parish Church and Centre, Kuopio (1986–92) and Germany Embassy, Helsinki (1986–93): Leiviskä seems to have achieved what he has been working for over two decades, namely the ultimate refinement of De Stijl ideas for contemporary use in a variety of functions. In Männistö Church this now includes a tower within the language, and an even more delicate balance of natural light. The German Embassy seeks a monumental complexity on the outside while, within, the repetition of Rietveldian planes characteristic of Leiviskä's churches are replaced by the seemingly endless overlapping of a Mondrianesque grid.

Fin de siècle

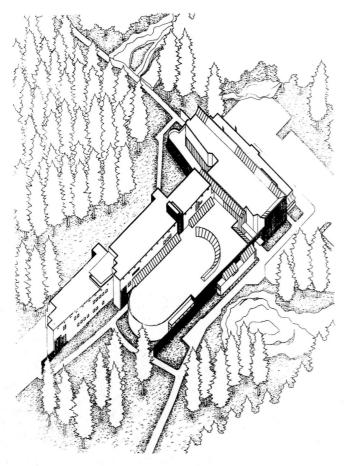

Figure 283
Pekka Helin and Tuomo Siitonen
The UKK (Urhu Kekkonen) Institute for the Study of Health and Fitness, Tampere (1980–84): aerial isometric view. The institute combines a generous and welcoming arrival area with an indoor track, lecture theatre, diagnostic and administrative accommodation. The facility is named after Kekkonen, who was President of Finland for two strenuous decades during the 1950s to the 1970s.

Figure 284
Pekka Helin and Tuomo Siitonen
The North Karelian Provincial Library (1988–92): interior. (See also p. 204).

Pietilä's garrulity, his affectionate *bonhomie* and skip over the real meat of his narrative. In this way, Poole seized upon Pietilä's cat, a warm and friendly creature, and left the hard facts of a rock orphaned in the landscape to one side.

Enter, once again, another great teacher of the post-Second World War period, one of Pietilä's own teachers, Professor Aulis Blomstedt, who said with the apparently preternatural wisdom of a Finn: 'Architecture is rather like an ice-berg. What we see amounts only to about ten per cent, while the rest remains invisible and submerged.'[6]

Pietilä was fond of repeating Blomstedt's maxim, perhaps in the knowledge that only 10% of what he did or said was learnable. In any case, the Monarch group, five young men – Juha Kaakko, Juha Jääskelainen, Petri Rouhianen, Matti Sanaksenaho and Jarl Tirkkonen – who were all students at the Helsinki University of Technology in Otaniemi at the time of the competition for the Seville World's Fair Pavilion, seemed to understand the *Siirtolohkare* metaphor.

It seems perfectly obvious from their first sketches that Monarch took this metaphor of 'a rock dislocated from its mother' as a serious point of departure. Oddly enough, as Poole might say, because Jääskelainen worked in the office of Juhani Pallasmaa and Tirkkonen with Gullichsen, Kairamo, Vormala in the period 1988–89.

As the century closes, Pietilä's predictions appear to be rather accurately confirmed. For example, as the 'iceberg' influence of Aulis Blomstedt resurfaces and the work of Kristian Gullichsen, Helin and Siitonen, Heikkinen and Komonen and Juha Leiviskä provides ample evidence of liveliness and 'infinite variability' (Aalto) of this modernist tradition. In spite of occasional lapses, Gullichsen has been a very constant force in this direction, while Juha Leiviskä has continued to refine and perfect his reinterpretation of De Stijl particularly in his German Embassy for Helsinki (1986–93; Figures 280, 281) and his new church in Kuopio (1986–92; Figures 279, 282). Not much opportunity has been taken to connect new work in

Finland in the 1990s with the prevailing dissonance and disjuncture of deconstruction. Perhaps it is the prevalence of the Finnish classical tradition beneath the surface that underpins the iceberg's cool and brilliant yet stern visage.

For a number of reasons, both cultural and political, much of Pietilä's work has remained suppressed beneath the surface. The brilliant Brussels Pavilion was only a short-lived memory; Kaleva Church was covered with lavatory tiles (a sort of reverse graffiti); the Dipoli Centre was constructionally only a partial success; Suvikumpu Housing, New Delhi Embassy and Lieksa Church confirm his early promise; while the extraordinary Malmi Church was ruled *hor de concours!* It is therefore significant to see what happens when one of his ideas does re-emerge and becomes manifest, when the origins of Malmi Church pop up in, of all places, Seville. Furthermore, the Finnish President's Residence at Mäntyniemi, which was constructed virtually underground, will remain concealed from the public for some time yet.

For the moment it must suffice to report that at Mäntyniemi, Pietilä achieved an even more remarkable interior than in Kaleva Church or New Delhi Embassy, with strong hints of what the Malmi Church project had promised. The light quality in particular is quite wonderful.[7] The Finnish president and his wife announced in the spring of 1994 that they hope soon to open their official home to the public while they are out of Helsinki during the summer months. So, it may not be too long before these underground secrets become more common knowledge.

References and notes

[1] Malcolm Quantrill, *Alvar Aalto: a critical study*, Secker & Warburg; Schocken, 1983.

Malcolm Quantrill, *Reima Pietilä: architecture, context and modernism*, Rizzoli, 1985.

Malcolm Quantrill, *Reima Pietilä: one man's odyssey in search of Finnish architecture*, Building Books, 1988.

[2] Malcolm Quantrill, *Reima Pietilä: architecture, context and modernism*, 1985, pp. 159–197

[3] Scott Poole, *The New Finnish Architecture*, Rizzoli, 1992, pp. 214–218.

[4] Malcolm Quantrill, *Reima Pietilä: architecture, context and modernism*, 1985, p. 82.

[5] *Ibid.*, p. 28

[6] Quoted by Reima Pietilä, in correspondence with the author, May 1984.

[7] The idea of the 'storytelling' landscape door, invented for the Hervanta Parish Centre, Tampere, in the late-1970s achieves its full potential in the great folding doors of the public areas in the President's Residence.

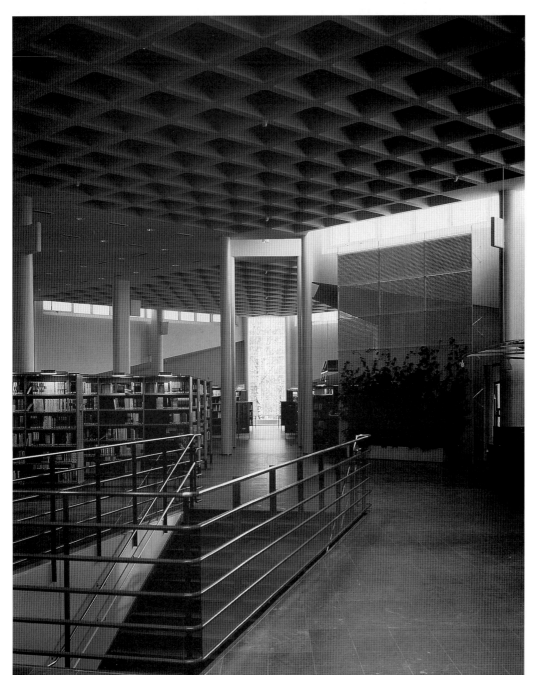

Fin de siècle

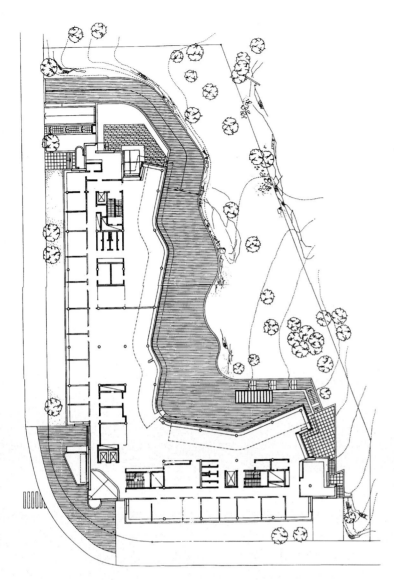

Figures 285 and 286
Jan Söderlund and Eero Eskelinen Corporate Headquarters for the Aspo Group, Helsinki (1989–93): this building represents the quintessence of the present state of play in Finnish architecture. Its plan form may be traced back to Aalto's Baker Dormitory for MIT (1946–47) and Yrjö Lindegren's equally famous Snake House block of flats (1949–51) – itself a homage to Aalto. But there the Aspo Group building's Finnish connections end. Whereas in his earlier buildings for Joensuu University, Söderlund adhered to Aalto's general ideas about brick massing and detail, the Söderlund and Eskelinen Aspo Group Headquarters looks towards internationalism and particularly to the refinement of an industrial expression made possible by the techniques of 'high-tech'. It may be argued that this approach has Finnish roots in Revell's Kudeneule Factory for Hanko (1955) and in the Sirens' Otalaakso Apartments at Otaniemi (1954–56), but the true sources for the Aspo building are to be found in the work of the Norman Foster office and international 'high-tech' practices that have emerged since the mid-1960s. It was in the 1960s, of course, that Reima Pietilä began his the campaign to resist mass production and other international tendencies.

Ironically, within months of Pietilä's death in August 1993, the American architect Steven Holl won the *international* competition for the Finnish Museum of Modern Art, to be built in Helsinki. Just at that point in history when difference has come into focus as the characteristic of distinction and identity, the Finns, who celebrated more than half a century of national, cultural difference based on ethnic origins and language (in the wake of Finland's independence of 1917), are embracing the Americanization of their ways of thinking and doing. This Americanization of Finnish architecture was no more inevitable than the Frenchifying of American academic debates: both are consequences not of cultural distillation, but of the pollution generated by an over-productive academic industry during the second half of the twentieth century.

Finnish Architecture and the Modernist Tradition

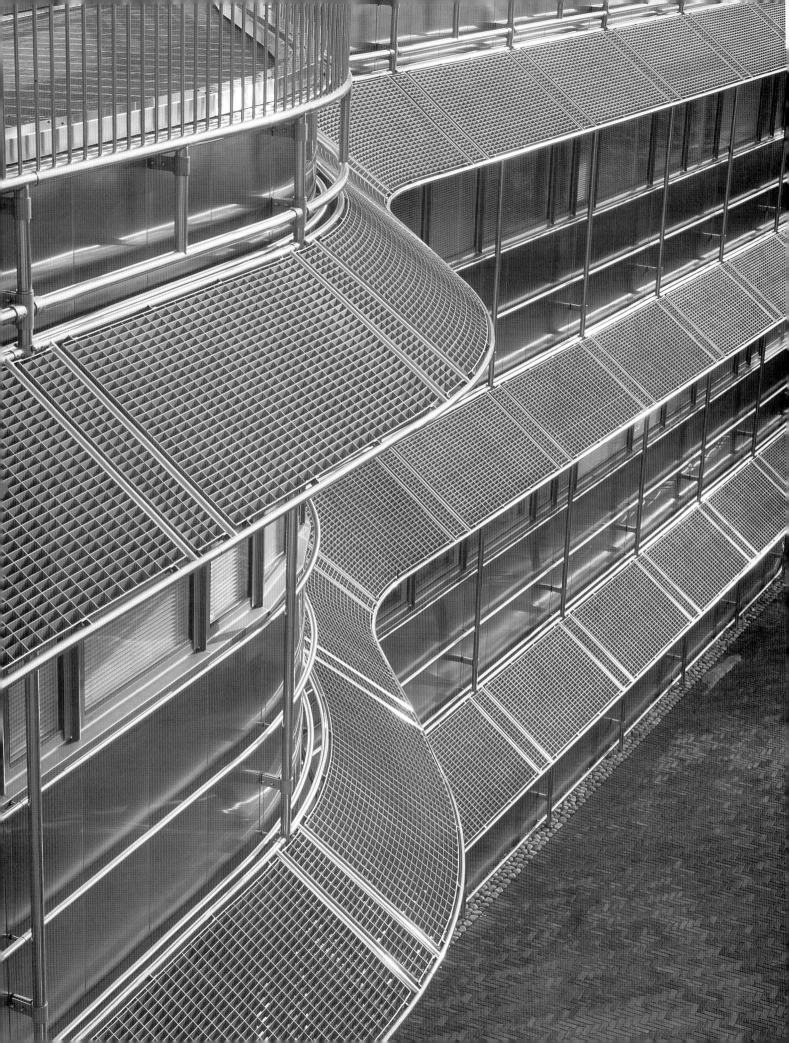

Selected bibliography

Books, exhibitions, catalogues etc.

Alvar Aalto versus the Modern Movement, 1979 Alvar Aalto Symposium, Alvar Aalto Museum, Jyväskylä, 1981.

Ålander, K., *Rakennustaide*, Werner Soderström Oy, Porvoo-Helsinki, 1954.

Banham, R., *Age of the Masters, A Personal View of Modern Architecture*, Harper and Row, New York, 1975.

Benevolo, L., *History of Modern Architecture*, MIT Press, Cambridge, Mass., 1971.

Borras, M.L. and Jaatinen, M., *Arquitectura Finlandesa in Otaniemi: Alvar Aalto, Heikki Siren, Reima Pietilä*, Ediciones Polygrafia, Barcelona, 1968.

Connah, R., *Writing Architecture*, MIT Press, Cambridge, Mass., 1990.

Dobbins, H., 'The achievement of Finnish Architecture: Social Responsibility and Architectural Integrity', in *Perspecta No.8*, pp. 3–36 (a portfolio of works by six Finnish architects).

Dodi, L., Ponti, G., and Rogers, E.N., *Profilo di Alvar Aalto*, Pubblicazione del Politecnico, Milan, 1964.

Doflores, G., *Artificio e natura*, Einaudi, Turin, 1968.

Donnely, C.M., *Architecture in the Scandinavian Countries*, MIT Press, Cambridge, Mass., 1992.

Drew, P., *Third Generation: The Changing Meaning of Architecture*, Praeger, New York, 1972.

Fleig, K. (ed.), *Alvar Aalto: Collected Works*, Vol. 1, Girsberger, Zürich, 1963; Vols 2 and 3, Artemis, Zürich, 10971 and 1978.

Giedion, S., *Aino and Alvar Aalto*, Kunstgewerbe Museum, Zürich, 1948.

Giedion, S., *A Decade of New Architecture*, Girsberger, Zürich, 1951.

Giedion, S., *Space, Time and Architecture*, 5th edn, pp. 618–67, 'Alvar Aalto: Irrationality and Standardization', Harvard University Press, Cambridge, Mass., 1967.

Groak, S., Heinonen, R.L. and Porphyrios, D., *Alvar Aalto*, Architectural Monographs No. 4, Academy Editions, London, 1978.

Grunigen, B. von, *Mobel aus Holz und Stahl: Alvar Aalto–Mies van der Rohe*, Gewerbemuseum, Basel, 1957.

Gutheim, F., *Alvar Aalto*, Braziller, New York, 1960.

Hausen, Mikkola, Amberg, Valto, *Eliel Saarinen: Projects 1886–1923*, Otava, Helsinki, 1990.

Helander, V. and Rista, S., *Modern Architecture in Finland*, Werner Soderstrom, Helsinki, 1987.

Hitchcock, H-R., *Architecture of the Nineteenth and Twentieth Centuries*, Penguin Books, London, 1958.

Hoesli, B. (ed.), *Alvar Aalto Synopsis: Painting, Architecture, Sculpture*, Birkhauser Verlag, Basel, 1970.

Hofmann, N. and Kultermann, U., *Baukunst unserer Zeit*, Beukhard, Essen, 1969.

Hollatz, J.W., *Das Neue Essen Opernhaus*, Beukhard, Essen, 1964.

Institut für Städtebau, Technische Universität, Stuttgart, *Städtebau in Finnland*, Stuttgart, 1966.

Jacobus, J., *Twentieth Century Architecture: The Middle Years, 1940–1965*, Praeger, New York, 1966.

Jencks, C., *Modern Movements in Architecture* (Chapter 5: 'Alvar Aalto and the Means of Architectural Communication', pp. 167–83), Anchor Press/Doubleday, New York, 1973.

Joedicke, J., *A History of Modern Architecture*, Praeger, New York, 1959.

Joedicke J., *Architecture since 1945: Sources and Directions*, Praeger, New York, 1969.

Kivinen, P., *Tampereen Jugend*, Otava, Helsinki, 1982.

Kultermann, U., *Der Schlüssel zur Arkitektur von Heute*, Econ, Wein-Düsseldorf, 1963.

Mairea Foundation, *Alvar Aalto as artist*, exhibition at the Villa Mairea, catalogue (text by Göran Schildt), 1982.

Moorhouse, Carapetian, Ahtola-Moorhouse, *Helsinki Jugendstil Architecture*, Otava, Helsinki, 1987.

Mosso, L., *L'opera di Alvar Aalto–Catalogo della Mostra*, Edizioni Communita, Milan, 1965.

Mosso, L., 'Note storico critiche sull'architettura finlandese' (Introduzione a: *Esempe di pianificazione edilizia in Finlandia*), Edizioni de Communita, Milan, 1960.

Museum of Finnish Architecture, *Suomi rakenta – Finland Bygger* ['Finland Builds'], Helsinki, 1953.

Museum of Finnish Architecture, *Guide to Helsinki Architecture*, Otava, Helsinki, 1963 (revised editions 1969 and 1989).

Museum of Finnish Architecture, *An Architectural Present: Seven Approaches*, Helsinki, 1990.

Museum of Modern Art, *Alvar Aalto, Architecture and Furniture*, New York, 1938 (exhibition catalogue).

Museum of Modern Art, *Alvar Aalto, Architecture and Furniture*, New York, 1966 (exhibition catalogue).

Neuenschwander, E. and Neuenschwander, C., *Finnish Architecture and Alvar Aalto*, Praeger, New York, 1954.

Norberg-Schulz, C., *Meaning in Western Architecture*, pp. 389–90, 398–9, 400, 416, Praeger, New York, 1975.

Paullson, T., *Scandinavian Architecture*, Leonard Hill, London, 1958.

Poole, S., *The New Finnish Architecture*, Rizzoli International, New York, 1992.

Quantrill, M., *Alvar Aalto: a critical study*, Secker and Warburg, London, 1983 (revised paperback edn, New Amsterdam Books, New York, 1989).

Quantrill, M., *Reima Pietilä: Architecture, context and modernism*, Rizzoli International, New York, 1985.

Quantrill, M., *The Environmental Memory: Man and Architecture in the Landscape of Ideas*, Schocken Books, New York, 1987.

Quantrill, M., *Reima Pietilä: One Man's Odyssey in Search of Finnish Architecture*, Rakennuskirja, Helsinki, 1988.

Richards, J.M., *A Guide to Finnish Architecture*, Hugh Evelyn, London, 1956.

Richards, J.M., *800 Years of Finnish Architecture*, David and Charles, Newton Abbot, 1978.

Ringbom, S., *Stone, Style and Truth: Natural Stone in Nordic Architecture, 1880–1910*, Otava, Helsinki, 1987.

Ruusuvuori, A., *Omakotikirja, liusia pientaloja*, Helsinki, 1961.

Salokorpi, A., *Modern Architecture in Finland*, Praeger, New York, 1970.

Sanderson, W. (ed.), *International Handbook of Contemporary Developments in Architecture*, Greenwood Press, Connecticut, 1981.

Scully, V., *Modern Architecture: The Architecture of Democracy*, Braziller, New York (revised edn), 1974.

Sharp, D., *Sources of Modern Architecture*, Architectural Association Paper No. 2, Lund Humphries, London, 1972.

Smith, J.B., *The Golden Age of Finnish Art*, Finnish Ministry of Education, Helsinki, 1975.

Suhonen, P., *Neue Arkitektur in Finland*, Tammi, Helsinki, 1967.

Wickberg, N.E., *Byggnadskonst i Finland*, Werner Söderström, Helsinki, 1959 (English edn published by Otava, Helsinki, 1962).

Zahle, E., *Scandinavian Domestic Design*, Methuen, London, 1963 (for the Museum of Industrial Art, Copenhagen).

Articles

Acanthus, Vol. 1, pp. 7–53. 'Alvar Aalto's Library', Simo Paavilainen, in 'Viipuri Library - The 1927 Competition Entry'; Kristina Nivari, 'Viipuri Library From Paper to Final Building'; Sergei Kravchenko, 'Viipuri Library Ruined?', Museum of Finnish Architecture, Helsinki, 1990.

Aalto, A., 'Problemi de Architettura', *Quaderni ACI*, November 1956.

Aalto, A., 'Zwischen Humanismus und Materialismus', *Baukunst und Werkform*. No. 6, 1956, pp. 298–300.

Connah, R., 'Letter from the Suburb of Suburbs', *ANY (Architecture New York)*, March–April 1994.

Heinonen, R.L., 'The Beginnings of Functionalism in Finland', *Arkitekten-Arkitehti*, No. 11–12, 1966, pp. 162–70.

Hitchcock, H-R., 'Aalto versus Aalto: The Other Finland', *Perspecta* (Yale University) Nos 9 and 10, 1965, pp. 132–66.

Mikkola, K., 'Aalto the Thinker', *Arkitekten-Arkitehti*, No. 7–8, 1976.

Quantrill, M., 'Reima Pietilä on Design Knowledge: a Notional Appraisal', *Architectural Association Quarterly*, January 1978.

Quantrill, M., 'Alvar Aalto and Post-rationalism in Finnish Architecture', *Architectural Association Quarterly*, December 1978.

Quantrill, M., 'Après Aalto Une Nouvelle Vague?', *Architectural Design*, February 1980.

Quantrill, M., 'Alvar Aalto: Prophet of Ubiety' (text of lecture given at the Royal Institute of British Architects, 15 February 1983), *RIBA Transactions*, Vol. 2, No. 1, May 1983.

Quantrill, M., 'Reima Pietila: Form Follows Approach', *Places*, Vol. 2, No. 1, Cambridge, Mass., 1985.

Quantrill, M., 'Rhetorical Questions and Architectural Answers' (in Recent Work by Reima Pietila), *Architecture & Urbanism*, Tokyo, January 1988.

Quantrill, M., 'Lateral-Mindedness *versus* Literal-Mindedness in Aalto's Use of History', *Architecture & Urbanism*, Tokyo, March 1989.

Quantrill, M., 'Juha Leiviska and the Continuity of Finnish Modernism', *Architecture & Urbanism*, Tokyo, July 1991.

Sharp, D., 'Aalto and his Influence', *Architecture and Building*, December 1957, pp. 476–9.

Standertskjöld, E., 'Alvar Aalto and Standardization', and 'Alvar Aalto's Standard Drawings 1929–1932', *Acanthus*, Vol. 2, pp, 74–111, Museum of Finnish Architecture, Helsinki, 1992.

Acknowledgements

There are many to whom I must express gratitude for the inception, development and completion of this project. First of all, I must thank my original Finnish publisher, Professor Heikki Reenpää, who, as Chairman of Otava Oy, Helsinki, generously supported the concept of this history of twentieth-century Finnish architecture. It was Heikki Reenpää who facilitated the funds necessary for me to carry out the basic research in the Museum of Finnish Architecture during the summers of 1985, 1987 and 1988. Having given me the benefit of both moral and material support over almost four years, Heikki Reenpää was deprived of the satisfaction of seeing this book published by Otava.

Several Finnish companies, both commerical and industrial, gave their support to facilitate my stay in Finland at various times during the period 1985–88. Regrettably, I no longer have the names of these organizations, but I should like to thank those anonymous donors for the very real and positive way they made my research in Finland possible through Heikki Reenpää's thoughtful initiative.

Without the active interest, also, of the Finnish Ministry of Foreign Affairs my work would have been much more difficult. Tom Södermann, now Finnish Ambassador to Iceland, continued his enthusiastic support of my explorations in modern Finnish architecture. Many of his colleagues in the ministry, including Marja Kallo, Marja Liislahti, Maija Lahteenmäki, and Messrs Lassi Lehtinen and Tatu Tuohikorpi, were very helpful along the way. In particular, Ritva Scott and Pirkko-Liisa O'Rourke, who were Cultural Counsellors in Finland's Washington Embassy in the period 1983–93, went out of their way to assist me.

Many of my architect colleagues in Finland have generously supplied me with illustrations from their archives. They are too numerous all to be mentioned here, but I should like to record my particular gratitude to: Elissa Aalto (1922–1994), Pekka Helin and Tuomo Siitonen, Juha Leiviska, Juhani Pallasmaa, Reima and Raili Pietilä, Pekka Pitkänen, and Aarno and Anna Ruusuvuori. I have also had access to the photographic records of my

American colleague, Gerald Moorhead of Houston, for which I am grateful.

My own investigations of Finnish architecture ovefour decades have built up a substantial collection of photographic material, particularly of Aalto and Pietilä schemes, but ranging over the whole period c. 1890–1990. It would not have been possible to undertake this study, however, without the generous, expert and thoughtful help of my friends at Rakennustaiteenmuseo (The Museum of Finnish Architecture). Over the past few years I have appreciated my dialogue with the present Director, Marja-Riitta Norri. Even more significant, however, has been the courteous and efficient assistance I have had from the museum's Photographic Archives Department, particularly from the Head of Archives, Timo Heinanen, and the Curator of Archives, Elina Standerd-Skjöld, and I am grateful to both of them.

When this project was set in motion, in 1985, Professor David Woodcock, as Head of the Department of Architecture at Texas A&M University, gave me every possible help and support for my work; and this continued while he remained department head, that is until 1988. In addition, my Japanese collaborator and editor of *Architecture and Urbanism* (Tokyo) has always been an enthusiastic supporter of this book. Although unable to place it in his own house, he has been generous in helping replace lost and stolen photographic material, making it possible to complete my labours with another publisher.

Many other colleagues and friends have helped me bring this project to fruition. Over the years there have been various different titles for this study of Finnish architecture in the twentieth century. *Finnish Architecture and the Modernist Tradition* most accurately expresses the underlying framework of the book. I had the opportunity to discuss some of my ideas with Professor Timo Penttilä when I was with him at his home in Farnedella, near Siena, in 1987. Professor Juhani Pallasmaa, Pekka Helin and Tuomo Siitonen, academician Reima Pietilä, Simo Paavilainen, Aarno Ruusuvuori, Arto Siipinen, Mikko Heikkinen and Markku Komonen, and Juha Leiviskä all gave generously of their time and views.

Living in Finland to engage in research is recognized as being an expensive undertaking. It was so in the 1970s, and it continued to be during the 1980s. Even with generous research support from Otava and Professor Reenpää's commercial and industrial colleagues, which took care of travel and basic living costs, it would not have been possible to make the number of excursions to Finland I found necessary without additional provisions, and these were fortunately forthcoming. On two occasions, for example, the Finnish Foreign Ministry provided me with air tickets. Otava Oy allowed me extensive use of the company guest apartment in Helsinki and its guest house at Keuruu, near Jyväskylä. Significantly, too, at a period when her husband was not in the best of health, Raili Pietilä generously extended the hospitality of their Helsinki apartment to me 'any time'. I stayed with the Pietiläs quite often in the late 1980s, enjoying the benefit of Reima Pietilä's company during those last years, and my thanks are due to Raili Pietilä for that privilege. During these years, too, I got to know Roger Connah better. He was Pietilä's amanuensis, who had been so very helpful in assembling my Pietilä book, and during this project we went regularly to the sauna at the Hesperia Hotel, where we engaged in dialogues on the state of the art.

During the lengthy procedure of editing the illustrations down to the present number – approximately half of my original collection – I had the invaluable aid of my graduate student Bentley Tibbs, and my former secretary Francelle Harris unflinchingly retyped all the captions.

Finally, I must thank my family for all its understanding and forbearance over the past nine years. My wife, Esther, and my daughters, Francesca and Alexandra, learned that irregularities in meal times and organization of life in general could be blamed not on me personally but on a rare and totally consuming disease known as 'Finnish architecture in the twentieth century'.

Malcolm Quantrill

Illustration acknowledgements

The author and publishers would like to thank the following individuals and organizations for permission to reproduce material. We have made every effort to contact and acknowledge copyright holders, but if any errors have been made we would be happy to correct them at a later printing.

Photographers
Apollo 61
M. Burkle 206, 207
Arno de la Chapelle 280, 281
Patrick Degommier 215, 217
J. Elby 97
Aarne Ervi Foreword, 111, 117, 136, 167
Foto Ltd 94
Kari Hakli 14, 16, 44, 82, 226
Heikki Havas 32, 33, 95, 102, 110, 115, 116, 121, 123, 126, 133, 137, 139, 141, 144, 183
H. Iffland 41, 65, 72, 73, 75, 81, 90
O. Ingervo 140
Martti I. Jaatinen 164, 190
Arto Jousi 214
Pertti Kaarsalo 233
Oiva Kallio 35
J. Kamumen 269
Rauno Karhu 64
Arto Kiviniemi 253, 263
Jouko Könönen 191
Ola Laiho 239, 242, 244, 268
Esa Laurema 254
Titta Lumio 251
Ari-Jukka Martikainen 173
Gerald Moorhead 10, 19–21, 27, 76, 142, 143
Osami Murai 220
Voitto Niemela 160
A. Pietinen 105, 119, 145, 172, 180, 197
Harald Raebiger 223
O.J. Erwin Reichman 218, 219
Simo Rista 40, 175, 184, 185, 188, 193, 196, 224, 227, 231, 232, 257, 258
A. Roos 78, 88, 135
Matti Saanio 178
Arvo Salminen 192
Ezra Stoller 100
Jussi Tiainen 235–7, 249, 259, 276, 277, 279, 282
O. Troberg 168
Sakari Viika 255
P.-O. Welin 52, 53, 55, 240
A. Wickberg 87
Iiro Ylismaa 216

Individuals and organizations
Timo Airas 222, 243, 260, 261, 262, 264–6
Heikkinen-Komonen 249, 275–8
Helin & Siitonen 229, 230, 250, 251, 252, 283, 284
Juha Leiviskä 221, 257, 279, 280, 281, 282
Selim A. Lindqvist 9
Museum of Finnish Architecture 5–7, 11–18, 32–7, 40–55, 57, 58, 61–9, 71–5, 78–80, 82, 83, 87–92, 94–123, 126–9, 133–41, 165, 168, 171–3, 175, 176, 180, 182–92, 195, 197, 214–220, 222–4, 226–8, 231–4, 236–40, 254, 258
Nurmela/Raimoranta/Tasa 242, 244, 245, 267, 268, 270–2
Käpy and Simo Paavilainen 259
Juhani Pallasmaa 246–8, 273, 274
Raini and Reima Pietilä Architects 144, 145, 160, 164, 169, 170, 199, 204–8, 210, 211
Viljo Revell 121, 126
Aarno Ruusuvuori 177–9, 193, 194, 196, 256, 269
Eliel Saarinen 15, 17
Arto Sipinen 263
Siren Architects, Helsinki 18, 216
Jan Söderlund and Eero Eskelinen 285, 286

Index

Page numbers appearing in **bold** refer to illustrations (for building name and architect). Notes at the end of each chapter are denoted by suffix 'n' followed by the note number, e.g. 20n[7] is note 7 on page 20. Abbreviations: [H] indicates Helsinki, [Tm] Tampere, and [Tk] Turku.

Aalto, Aino **28**, 51, **86**, **89**, 101, 103
Aalto, Alvar 1, 2–3, 18, 46–53, 62–7, 71–85, 116–19, 121–2
 architectural philosophy 89–90
 church designs and restoration work 3, **46**, 47, **47**, **49**, 51–3
 and Erik Bryggman 57–9
 examples of early work **21–3**, **34**, **44**, **46–7**, **49**, **52**, **57–8**, **65–6**, **68**, **72**, **76–7**
 fan-plan motif 3, **22**, 73, 92, 100, 117, 124
 furniture design **52**, **68**, 72–3, 74, 92
 influences upon him 1, **3**, 5–6, 10, 11, 15, 16, 39, 48–9, 51, 64, 67, 100, 109, 119, 221
 later work 3, **130**, 137, 139, 148–9, 151, **159**, **180–1**, **189**
 middle-period designs [1940s/1950s] **26–8**, **86**, **89–91**, **107–9**, **115–18**, **125–8**
 and standardization 90, 92
 and USA 88, 89, 90, 92
Aalto, Elissa 3, 105, 108, 109, **180–1**, 217
Åberg, Urho 17, 18, 43
Academic Bookshop [H] 16, **158–9**
Adlon Hotel and Bar [H] **15**, 16
Ahlström company housing [Kauttua] 74, 78–9, 92
Ahlström industrial commissions 92, 93, 95–6, 183
Ahola, Pentti 105
Airas, Timo 196, **198**, **210**, **213**
Aitta competition designs 64, 73, 77
Alavus church 17
ALKO Headquarters [H] 74
ALKO Salmisaari warehouse [H] 75
Altstetten Protestant Parish Centre [Zürich, Switzerland] 3, 139, 149, 151
Americanization 230
Andersson, Henrik 35
Antwerp World's Fair Finnish Pavilion **60**, 61
Arabia Company ceramics factory 99
Argos Building [H] 223
Arkitekten–Arkkitehti 16, 17, 18, 41, 51, 87, 98, 99, 116, 144, 147, 213, 217
 editors 6, 16, 43
 first published 3
Art nouveau **7**, 15
Artek Company 72, 73
Artek Company Exhibition Building [Hedemora, Sweden] **86**, **89**, 98
Asplund, Gunnar 39, 45, 46, 57, 62, 87, 211
Aspo Group Corporate Headquarters [H] **230**
Atrium Apartments [Tk] **42**, **50**, 53–4, 57, 59
Aulanko Hotel [Hämeenlinna] 76–7, **80**
Aurejärvi Church [Kuru] 18

Baeckman, Woldemar 87, 88, 92, 97, 99, **101**, 105, 107, 141, **152**, **182**, 183
Baghdad Art Museum [Iraq] 116, 139
Baghdad Central Post Office [Iraq] 119
Baghdad Conference Palace [Iraq] 183, 185
Bahrain Cultural Centre 173, 192
Baker Dormitory [Cambridge, USA] 90, **91**, 92, 100–1
Barüel Jean-Louis 116, 139
Bassi, Carlo **1**, 20n[4], 37, 175
Bensow Office Building [H] **84–5**, 88
Bio-Rex cinema [H] **69**, 76
Bishop Henry's Church [Tk] 196, **196**, 207
Blomstedt, Aulis 2, 20n[7], **92**, 98, 99, 101, **121**, 122, 139, 141, **147**, 151, 155, 228
Blomstedt, Märta 76, **80**, 87, 122
Blomstedt, P.E. (Pauli) 32, **40**, **66**, **67**, 68–9, **70**, 71, **79**, 87, 155
Borg, Elsi 39, 98
Borg, Kaarlo 17, 18, 41
Brander Café [Tm] **164**
Bruckner Haus Concert Hall [Linz, Austria] **184**
Brussels World's Fair Finnish Pavilion 116, **122–3**, 124, 161–2, 224, 229
Bryggman, Erik 18, 39, 51, 53–5, 61, 87, 88, 96–8, 99, 114
 and Alvar Aalto 57–9
 examples of designs **24–6**, **42–4**, **48**, **50**, **57**, **60**, **70**, **82**, **94**, **118**

Casa Academica commercial building 183
Centre for Changing Exhibitions 223–4
Chicago Tribune Tower 17, 18

Church buildings
 modern designs 21, **46**, **47**, **49**, **67**, **71**, **75**, **79**, **117**, **138**, **129**, **140**, **144**, **146–7**, **160–1**, **169**, **171**, **180–1**, **187**, **189**, **196**, **206–7**, **226–7**
 restoration work 3, 47, 145
 traditional materials used 1
Cinema Palace [H] 17
Co-operative Bank [H] 17
Co-operative Building [Tk] 57, 59, 62–3, 72, 81

De Stijl influences 109, **121**, 122, **142**, **150**, 151, 153, **198**, **206**, 215, 218, 219, **227**, 228
Detmerode [Germany] Church and Parish Centre 148, 149, 151
Dipoli Student and Conference Centre [Otaniemi] **128–9**, **133**, 137, **138**, 154–5, 161, 164–5, 223, 229
Dutch influences 100, 109, 122

Eerikäinen, Eero 99, 105
Eira District Hospital [H] **4**, 6, 12, 15
Ekelund, Hilding 18, 19, 39, 43, 45–6, 51, 53, 59, 87, 88
Eklund, Jarl 18, **71**, 75, 87
Elomaa, Erkki **150**, 153
Engel, Carl Ludwig **1**, 20n[5], 37, 47, 176
English influences 3, 29, 41
Enso-Gutzeit Headquarters [H] 18, 103, 119, 122, 139
Entrances, treatment of 15–16, 20n[38], 102
Erottaja air-raid shelter [H] 93
Ervi, Aarne 76, 87, 95, 98, 101, 105, 107, 115, 141, 144
 examples of designs **104–5**, **107**, **118**, **136**, **178–9**
Eskelinen, Eero **230**
Essen Opera House [Germany] 2–3, 116, 139
Etaläesplanadi office building [H] **188–9**, 194
European Film School [Denmark] **201**, **224–5**
Expressionism 2, 12, 124, 191

Fazer Office Building 32
Finlandia Concert Hall and Congress Centre [H] 3, **130**, 139, 143, 145, **189**
Finnish Bank [Tk] 17
Finnish Museum of Modern Art [H] 230
Finnish National Museum [H] 10–11
Finnish Parliament Building [H] 18–19, **19**, 30, 45, 47–8, 61–2, **63**
Finnish President's Official Residence [H] **130–1**, **177**, 178–9, 223, 229

Finnish Sugar Company headquarters buildings [H] 107, [Tapiola] 192
Flodin, Otto **70**, 75
Forum Redivivum designs 101–3, 116, 117
Forum Site [H] 195
Friman, Kimmo 218
Frosterus, Sigurd **4**, **9**, **10**, 11, 16, 17
Functionalism 57–86

Gallén-Kallela, Akseli 5, 10, 174
German Embassy [H] 216, **227**, 228
German influences 35, 37, 191
Gesellius, Herman 3, **4**, 6, 9, 12, 16
Glass Palace [H] **69**, 76
Granberg, Marjanne 87
Gullichsen, Harry 72, 73, 81, 82, 93
Gullichsen, Kristian 144–5, **156**, 178, **182**, 189, 195, 218–19, 223, 228
Gullichsen, Maire 72, 73, 81, 82

Haarla Residence [Tm] **36**, 43
Hahl, Nils Gustav 73
HAKA (Social Democratic Building Society) high-rise housing 87, 92
Hakiniemi Centre [H] 141
Hämeenlinna Church 145
Hanasaari Power Station [H] 145, **190**, 211
Hansaviertel apartments [Berlin, Germany] 116, 117, **118**
Hansson, Olof 105, 115, 179n[15], 192
Harmia, Hugo 87, 88, 92, 97, 99, **101**, 105, 107
Heikkinen, Mikko **201**, **222**, 223, **224–5**
Heinola Sports Institute 59
Helin, Pekka 183, **190**, **202–4**, 211, 217, 223, **228–9**
Helsingfors Magasins department store [H] 16, 17
Helsingin Sanomat Building [H] 195
Helsinki Central Post Office 75–6, 83, 143
Helsinki Children's Clinic 99
Helsinki City Hall Extension **215**
Helsinki Commercial High School 88, **101**, 105
Helsinki East Centre Landmark 195
Helsinki [Lutheran] Cathedral **1**
Helsinki Municipal Theatre 145, **154**
Helsinki Opera House 195
Helsinki Passenger Terminal 103
Helsinki Port customs warehouses **73**
Helsinki Railway Station **4**, 11, 17
Helsinki residential building **85**
Helsinki State School Building 6
Helsinki Stock Exchange 12, **15**, 16

Helsinki Technical University [Otaniemi]
 Main Lecture Theatre Building **130**
 Sports Hall 114, 116, 162
 Student Chapel 111, 113, **122**, 147
Helsinki Telephone Exchange 12, **13**, 15, 16
Helsinki University Library Extension 74, 83, 88
Helsinki Workers' Institute **121**, 122
Herttoniemi Station [H] 186, **190**
Hervanta Shopping Centre [Tm] 29, 143, 161, 166
Hirviniemenranta Apartments [H] **132**, 211
Holl, Steven 230
Holy Cross Funeral Chapel [Tk] 153–4, **155**, 207
Honkanummi Funeral Chapel [Puistola] 114, **118**
Hospits Betel hotel [Tk] **45**, **48**, **50**, 53, 54, 59
House of Culture [H] 2, 3, 10, 20n[38], 116, **116**, 119, **127**, 137, 149
Huhtiniemi 183
Huttunen, Erkki **71**, **75**, 76, 87, 99, **110**
Huutoniemi Parish Church **146–7**
Hvitträsk House and Studio [H] 6, 9–11, **13**
Hvitträsk Sauna [H] 173, 174
Hyvämäki, Eero 195

Independence [of Finland], effect on architecture 19, 37
Interbau Exhibition apartments [Berlin, Germany] 116, 117, **118**
International style 2, 77

Jääskelainen, Juha 228
Jaatinen, Marjatta and Martti 147, 217
Jämsä Parish Church **46**, 51
Jäntti, Toivo 87, **110**
Järvenpää Parish Church **150**, 153
Järvi, Jorma 75, 105, 143
Järvinen, Kari 196, **198**, **210**, **213**
Järvinen, Simo 211
Jensen-Klint, P.V. 35
Joensuu University Main Building 217
Johnson weekend house and sauna [Wisconsin, USA] **134**, **142**, 147
Jung, Bertel 183
Juslen, Gösta 32
Jyväskylä City Theatre 217
Jyväskylä National Guard Headquarters 30
Jyväskylä Pedagogical Institute [later University] **115**, 117, 119, **126–7**
Jyväskylä Railway Workers' Apartments 49
Jyväskylä Workers' Club 22, 30, **34**, 49–51, 77

Kaakko, Juha 228
Kairamo, Erkki 183, **189**, 195, **208–9**, 211

Kajana Primary School 17
Kaleva Church [Tm] 124, 139, **160–1**, 161, 162–3, 223, 229
Kalevela House project [H] 17, **17**
Kallio, Kaunio S. **9**, 17, 37, 39
Kallio, Oiva 17, 18, **33**, **34**, 41, 43, 59, **60**, 61
Kannonkoski Parish Church 69, 71, **79**, 87
Käpylä [H] suburban housing 29, 30, **31**, 32–3
Karelian building construction 5, 9
Karhunen, Juka 195
Karjensivu terraced housing [H] 113–14, *114*, 115
Karviaismäki Daycare Centre and Local School [Malmi] 196
Karvinen, Erkki 143
Kaskenkaatajantie apartments [Tapiola] 115, **120**, 122
Kemi Funeral Chapel 153
Kestikartano Restaurant [H] 98
Kilpiö, Eeva 218
Kinopalatsi Cinema [Tk] 61, **70**
Kirkkonummi Parish Church and Centre **206**, 215
Kiruna Town Hall [Sweden] 116, 137
Koivisto, Esko 195
Kokemäki River Valley masterplan 93
Kokko, Nillo **69**, 76
Komonen, Markku **201**, **222–3**, 223, **224–5**
Konsoli design 64
Korhonen, Ahti 124
Korhonen, Otto 72, 92
Korhonen, Toivo 124
Korvenkontio, Marjatta 87
Koskelo, Heikki 211
Kotka Co-operative Bank **182**, 186
Kotka Savings Bank **70**, 71
Kotka Town Hall 61, **66**, 68
Kouvala Church 189, **192**
Kråkström, Erik 194
Kudeneule factory [Hanko] **113**, 114
Kuhlefelt-Ekelund, Eva 39, 87
Kuhmo Central Library **198**, 213, **216–17**
Kuivamaito Oy Offices and Plant 145
Kukkonen, Martti 186
Kultuuritalo, *see* House of Culture
Kumeli design 64, 109
Kuusankoski House/Cultural Centre 218

Laapotti, Jaakko 124, 186, 189, **191**, **192**
Laapotti, Kaarina **192**
Lahti Church 3, 53, 105, 149, **180–1**, 196, 207
Lahti City Theatre 217
Lahti Sports Centre 195
Lahti Town Hall 17, 196, 207

Lahtinen, Reijo 183
Laiho, Antti 185–6, **194–5**, 211
Lampen, Matti 76, **80**, 122
Landtdaghus (Local Government Headquarters) [H] 16
Länsi-Säkylä Day Home and Church Club [Iso-Vimma] 196
Lappo, Osmo 115
Lapua Agricultural Fair pavilion 89
Lauritsalo Church 116
Lauttasaari Church 115
Leiviskä, Juha 153, **187**, **206**, **207**, 213, 215–16, 218, **226–7**, 228
Leppäkertuntie terraced housing [Tapiola] 139, **147**
Library designs **56**, **66**, **148**, **161**, **174**, **198**
 see also Helsinki University...; Kuhmo...; Tampere...; Turku University...; Viipuri...Library
Lieksa Parish Church 148, **169**, **171**, 176–8, 223, 229
Liinasaarenkuja housing [Espoo] **209**, 211
Lindahl, Karl 6, 183
Lindegren, Yrjö 87, 99, 101, 105, **106**, 110
Lindgren, Armas 3, **4**, 6, 10–11, 12, 16, 19
Lindqvist, Selim **8**, 16
Lindroos, Erik 75, 99, 143
Linnasalmi, Erkki 99
Lintulahti Camping Shelter 147
Lippajärvi Daycare Centre **214–15**
Löfström, Kaarina 189, **192–3**
Lönn, Wivi 88
Louekari, Lauri 211
Lundsten, Bengt 141
Lyngby Funeral Chapel [Denmark] **108**, 149

Madekoski Lower Comprehensive School 217
Maillart, Robert 176–7, 179n[27]
Maison Carré [Bazoches, France] 119, 121–2, **128–9**, 143, 149
Mäkelänkatu [H] public housing **39**, 43, 68
Mäkinen, Matti K. 145, 189, 191, **192–3**, 195, 217
Malmi Funeral Chapel 107, 149
Malmi Parish Church 137, **138**, 161, 168–9, 179n[15], 189, 224, 229
Malmi Post Office **197**, 217
Manner, Pekka 192
Männistö Parish Church and Centre [Kuopio] **226–7**, 228
Marikylä Summer House and Sauna [Bökars] 144, **155**, **156–7**
Marila, Risto 217

Marimekko Factory [H] 183
Marimekko summer house [Bökars] **155**
Marisauna sauna extension [Bökars] **156–7**
Markelin, Antero 115
Martikainen, Viejo **142**, 151
Martikainen-Ypyä, Märta 87, 88
Maunala, Juhani **209**, 211
Maunula, Jarmo 186, **190**, 218
Meilahti Church [H] 97–8
Meilahti Secondary School [H] **113**
Merikoski Power Station 93
Mica Moraine design 178
Mikkola, Kirmo 144, 186, **206**
Moberg, Kurt **143**, 157
Moduli Summer House System 145, **156**
Monarch Group 224, 228
Monte Carlo Recreational Centre 169–70
Moscow Finnish Embassy 74, 79
Mount Angel Benedictine College [Oregon, USA] 11, 139, **148**
Munkkiniemi House and Studio [H] 71, 74, 77–8, 79, 102, **127**, 166
Murikka Metalworkers' Union Training Centre [Tm] 183, 185, **190**
Muurame Parish Church 3, **21**, 30, **49**, 52–3, 72
Muuratsalo Summer House 2, 20n[9], 107, 109, **109**, 111, **125**
Myllytie Apartments [H] **136**, 144
Myyrmäki Church and Parish Centre [H] **207**, 218

Nakkila Parish Church **71**, **75**, 76
National Pensions Institute [H] 2, 20n[38], 101–3, 105, **115**, 117, **125–6**
National romanticism 2, 3, 5, 12, 17
Neoclassicism 1, 17, 37
 reaction to 1–2
Neoconstructivism 195
Neue Vahr Apartments [Bremen, Germany] 124
New Delhi [Finnish] Embassy 161, **164**, 166, 167, 168, 229
New York World's Fair Finnish Pavilion 2, **72**, 74, 83, 85, 88
Nokia Company headquarters building [Keilalahti] 217
Norri, Marja-Riitta 178
North Jutland Art Museum [Aalborg, Denmark] 116, 139
North Karelian Provincial Library [Joensuu] 204, **228–9**
Northern Joint Stock Bank [H] 11
Nurmela, Matti 196, **197–9**, 213, **214–15**, **216–17**, **218–19**

Nyström, Gustaf 17, 37
Olympic Stadium and Village [H] 87, 88, 105, **110**
Orivesi Parish Church **140**, 147, 151
Oslo Student Association Building 61
Östberg, Ragnar 17, 18, 19, 46
Otalaakso apartments [Otaniemi] **119**, 122
Otaniemi Sports Hall 114, 116, 162
Otaniemi Student Chapel 111, 113, **122**, 147
Oulu City Theatre 147
Oulu River project 93
Oulu school [of architecture] 207–8, 217, 224
Oulu University Botanical Gardens and Greenhouses 218
Oulunkylä Artists' Studios 186

Paalanen, Martti 76, **79**, 87
Paatela, Jussi 18, 19, **36**, 43, 98
Paatela, Toivo 18, 19, 43, 87
Paatela, Veli 98
Paatelainen (Pietilä), Raili 166
Paavilainen, Käpy **209**
Paavilainen, Simo 30, 33, 43, 209, **209**, 211, 217
Paavola Old People's Home 211
Paimio Parish Centre **209**, 217
Paimio Sanatotorium 2, 30, **44**, **52**, 54, 57, 59, **68**, 72, 73, 149
Pakkinen, Risto 195
Palace Hotel and Industrial Centre [H] 100, 111, **111**, **112**
Pallasmaa, Juhani 33, 144, 145, **156**, 191, 194, **200**, 213, **220–1**, 223
Panakoski Church [Lieksa] **142**, 151
Paris Finnish Institute **200**, **220–1**, 223
Paris World's Fair Finnish Pavilion 6, 10, 74, 79, 81, 102
Parliament Building [H] 18–19, **19**, 30, 45, 47–8, 61–2, **63**, 102, 143
 extension 185–6, **194–5**
Penttilä, Timo 122, **132**, 141, 145, **154**, 173, **190**, 192, 211
People's Restaurant [H] 68
Petäjä, Keijo 100, 105, 111, **111**, **112**, 115, **188–9**, 194
Petäjä, Marja 105
Petersen, Carl 39, 41
Pieksämäki Cultural Centre 218–19
Pietilä, Reima 2, 116, 124, 135, 137, 139, 148, 154–5, 157, 161–79, 192, 221, 223, 224, 228, 229
 examples of designs **122–3**, **128–30**, **132–3**, **138**, **160–1**, **163–4**, **166–7**, **169**, **171**, **173**, **177**
 suppression of work 161, 169, 179n[15], 229

Pitkänen, Pekka 153–4, **155**, **194–5**, 195, 196, **196**, 207
Pohja Insurance Building [H] 59, **60**, 61
Pohjanhovi hotel [Rovaniemi] 71
Pohjola Insurance Co Headquarters [H] 6, 46
Poli/Sampos Polytechnic Student House [H] 5–6, 164, 165
Poole, Scott 224, 228
Pori Commercial Centre **199**, **218–19**
Porthania Building [H] 105, **118**, 141
Postmodernism **197**, 217, **218**
Pöyry, Marja 87
Prefabricated housing elements 92, 115–16
Private Bank [H] 12, 15
Pulkinen, Mikko 144
Puotila Shopping Centre [H] 143

Raimoranta, Kari 196, **197–9**, 213, **214–15**, **216–17**, **218–19**
Raisio Town Hall 209
Rationalism 181, 186
Raunio 185–6, **194–5**
Rautatalo office building [H] 16, 107, 115, 116–17, **117**
Revell, Viljo 76, 99, 100, 101, 105, 111, 113–14, 115, 122, 147
 examples of designs **69**, **85**, **111–14**, **120**, **134**, **142**, **149**
Richards, J.M. 29–30, 33
Riihimäki, Paavo **69**, 76
Riola [Italy] Church and Parish Centre 3, 139, 148, 149, 151, **189**
Romantic classicism 29–56, 68
Rosendahl Hotel [Tm] 186, 189, **191**
Rotko, Matti 218
Rouhianen, Petri 228
Rovaniemi Airport **222–3**
Rovaniemi Art Gallery **200**
Rovaniemi Plan 95, 98
Russian rule 3, 19, 37, 87
Ruusuvuori, Aarno 15, 20n[34], 115, 139, 144, 145, 147, 195
 examples of designs **144**, **146–7**, **155**, **156–7**, **206**, **215**

Sääksvuori, Aila 145
Saarela, Heikki **190**, 211
Saarinen, Eero **71**, 75
Saarinen, Eliel 3, 6, 9–10, 11, 12, 16, 17, 41, 196
 emigration to USA 9, **17**, 18
 examples of designs **4**, **11**, **13**, **17**
Saarinen, Loja 10
Saarnio, Bertel 115

St Martin's Church [Tk] 61
St Michael Agricola Church [H] 18, 20n[15]
 see also Tehtaanpuisto Church
St Michael's Church [Tk] 5
St Thomas's Church [Oulu] **187**, 215
Sakkola Church 97
Salla Church 99, 105
Salminen, Pekka 195, 217
Sampo Insurance Office [Tk] 61
Sanaksenaho, Matti 228
Säresto Gallery [Kittilä] 173, 174
Särestöniemi, Reidar 174
Satamakatu residential building [H] 6
Sauna designs 98, **134**, **142**
Säynätsalo masterplan 95, 108
Säynätsalo Town Hall 2, 3, 10, 20n[38], **26–7**, 95, 102, 107–9, 177
Seinäjoki Church 107, 148, 149
Seinäjoki Town Hall 148
Seppala, Eero **70**, 75
Seurahuone hotel [Tk] interior 53, 54
Seville World's Fair Finnish Pavilion 224
Shopping centre designs 143
Sibelius Museum [Tk] 141, **152**
Sibelius Quarter residential building [Borås, Sweden] **203**
Sief Palace Area Buildings [Kuwait] **132**, 139, 161, 170–3
Siirtolohkare concept 224, 228
Siiskonen House [Mikkeli] 196, **210**
Siitonen, Tuomo 183, **190**, **202–4**, 211, 217, 223, **228–9**
Siivola, Juhani 195
Simberg, Kurt 141
Simons, Tom 137
Sinebrykoff Brewery [H] **182**, 183
Sipari, Osmo 99, 105, 153
Sipinen, Arto **205**, 209, **212–13**
Siren, Heikki and Kaija 101, 105, 111, 116, 122, 141, 143, 147, 157, 173, 183, 185, 186
 examples of designs **119**, **122**, **134–5**, **140**, **158**, **182**, **184**, **185**
Siren, J.S. (Jukka) 17, 18, **19**, 30, 43, 61–2, **63**, 88, 97, 105, 122, 143
Sjöström, Einar 18
Skogsböle House [Kemiö] 53
Snake House block of flats 105, **106**
Söderholm 183
Söderlund, Jan 211, 217, **230**
Sofianlehdonkatu housing [H] **198**
SOK [retail co-operative society] shops 76
SOKOS Building [H] 99–100, **110**

241

Sonck, Lars 3, 5, 6, 12, 15–16, 18, 175
 examples of designs **3, 4, 13**
Sortavala Church 54
South Karelian Tuberculosis Sanatorium **44**, 57
Southwestern Agricultural Co-operative Building [Tk] 57, 59, 108
Sparre, Louis 10, 20n[24]
Standardization
 and Alvar Aalto 90, 92
 reaction to 135–60
Stark, Albin 97, 98
Stock Exchange Building [H] 12, **15**, 16
Stock Exchange Hotel [Tk] **7**
Stockholm City Hall 17, 18, 19, 46
Stockmann Department Store [H] **10**, 16, 17
 extension 223
Strandell, F. **7**
Strömmer, Bertel 93
Studio Laurema [Espoo] **206**
Studio R-S project 121, 149
Summer/weekend houses **109, 125, 134, 142, 155–7, 206**
Suna School **213**
Sunila Pulp Mill complex **22**, 73–4, 78, 79, 89, 100
Suomalainen, Timo and Tuomo [brothers] 68, 69, **129, 144**, 154–5
Suomi Insurance Company Headquarters [H] **43**, 54, 57, 59
Suur-Merijoki manor house [Viipuri] **4**, 6
Suvikumpu Housing Development [Tapiola] 135, 137, 139, 161, **163**, 165–6, 229
Suvilahti Power Station [H] **8**, 16
Swedish influence 3, 17, 18, 32, 45, 62
Swedish Students' Centre [Otaniemi] **143**, 157, 181
Swedish Theatre [H] **71**, 75

Tallinn Art Museum 74, 81, 102
Tammisaari Library 192
Tampere church **1**, 175
Tampere City Library 43, **161**, 174–5, 192, 194
Tampere Civic Theatre **9**, 37, 39
Tampere [Lutheran] Cathedral **3**, 5, 12, 15, 175
Tampere Railway Station 11, **70**, 75, 83
Tampere Workers' Institute and High School 124, 141
Tampere Workers' Theatre 217
Taos House flats [H] **9**, 17
Tapani block of flats [Tk] 57, 63, 64
Tapiola Church 139
Tapiola Cultural Centre **173**, 192, **205, 212–13**
Tapiola Plan 115, 192

Tasa, Jyrki 196, **197–9**, 213, **214–15, 216–17, 218–19**
Taskinen, Heikki 216–17
Taucher, Gunnar **39**, 41, 68, **73**
Tavio, Markus 97
Tehtaanpuisto Church [H] 61, 71
 see also St Michael Agricola Church
Temppelikatu Church [H] 67, 68–9, **129, 144**, 154–5, 157, 181
Theatre designs **9**, 12, 37, 39, **71**, 75, 145, 147, **154**, 217
Thomé, Ivar 183
Thomé, Valter 5, 183
Tirkkonen, Jarl 228
Tiusanen, Aulikki 195, **209**, 211
Töölö Branch Library [H] **178–9**
Töölö Church [H] 45, 52, 102, 149, 178
Töölö [H] district plan **34**, 45
Toppila wood-processing plant [Oulu] 73
Toronto City Hall [Canada] 115, 147, **149**
Torpparinmäki Housing Project [H] 211
Traditional materials 1
Tukkila, Iiro 105
Turku Cemetery 99
Turku church 5, 12
Turku flats and shops **36**
Turku Funeral Chapel **24–6**, 55, **82**, 87, 88, 96–7
Turku Seven-Hundredth Anniversary Exhibition 57
Turku Town Hall 17
Turku University Library 99
Turun Sanomat Building [Tk] 2, 29, 30, 57, **58**, 59, 64

UKK (Urhu Kekkonen) Centre/Institute for Study of Health and Fitness [Tm] 211, **228**
Ullberg, Uno 18, 57, **62, 85**, 88, 99
UNIC Building [H] **202**
Union Bank [H] 32, **40**, 68
Utsjoki Restaurant [Kuruizawa, Japan] **185**

Vaasa Regional Museum 17, 43
Vähäkallio, Vaino 75
Valhalla Restaurant [H] **92**
Välikangas, Martti 30, **31–2**, 39, 88
Valio Headquarters Building [H] 189, 191, **192–3**, 217
Valio Maikkula Plant [Oulu] 217
Valjakka, Eero 144
Vallila Church 59
Valovirta, Erkki 217
Varkaus Paper Mill 183, **189**
Varkaus Parish Church 76, **79**, 87

Varkaus Saw Mill 95–6, 183
Vartola, Kalle 195
Vierumäki Sports Centre 61
Viinikka Parish Church [Tm] **47**, 52, 102, 149, 151
Viipuri Art School and Museum **62**
Viipuri Funeral Chapel 88
Viipuri Municipal Library 30, 32, 45, 49, **56**, 57, 59, 64, **66**, 67, 81, 85
 lecture room 71, 72, 74, 122
Viipuri Railway Station 11, 12
Viipuri Town Hall 18, 47
Viljanen, Kaarlo 211
Villa Erstan [Kakskerta] 54
Villa Ervi [H] **104–5**, 105, **107**, 144
Villa Grasse annexe [France] **182**
Villa Kokkonen [H] 139, 144
Villa Mairea [Noormarkku] 2, 10, **23**, 32, 71, 74, **76–7**, 81–3, 85, 102, 177
 Summer Module ('73) **184**
Villa Nuutila [Kuusisto] 53, **94, 95**, 97
Villa Oivala [Villinki] **33**, 43, 61
Villa Pietinen [Viipuri] 12
Villa Relander [Muurame] 144
Villa Remer [Altrupp, Germany] 12
Villa Schildt [Tammisaari] **130**, 139, 144
Villa Siren [Lingonsö] **158**
Villa Winter [Sortavalla] **11**, 12
Virtä, Kari 124, 141, 218
Vmpyrätalo office building [H] **134–5**, 141
Vormala, Timo 183, **189**, 195, 218
Vuoksenniska Parish Church [Imatra] 2, 53, **117**, 119, 122, 137, 148, 149, 162, 168

Waasa office building [Vaasa] 57
Wainemuine theatre/concert hall/clubhouse [Tartto] 12
Washington [Finnish] Embassy 223
Weilin and Göös Printing Works [Tapiola] 141, **144**
Wickberg, Nils Erik 32–3
Wikander, Einar 19
Wolfsburg Cultural Centre [Germany] 116, 137
Woodberry Poetry Room [Harvard, USA] **28**
Wooden construction 5, 9, 29, 30, 31–2
World's Fair Pavilions, see Antwerp...; Brussels...; New York...; Paris...; Seville...
Wurster, William Wilson 88, 89

Ylinen, Jaakko 186, **190**
Ypyä, Ragnar 87, 88

Zagreb Military Hospital **65**